ECHO OBJECTS

ECHO OBJECTS

The Cognitive Work of Images

BARBARA MARIA STAFFORD

THE UNIVERSITY OF CHICAGO PRESS Chicago & London

Barbara Maria Stafford is the William B. Ogden
Distinguished Service Professor at the University of Chicago.

The University of Chicago Press, Chicago 60637
The University of Chicago Press, Ltd., London
© 2007 by Barbara Maria Stafford
All rights reserved. Published 2007
Printed in the United States of America

16 15 14 13 12 11 10 09 08 07 1 2 3 4 5

ISBN-13: 978-0-226-77051-2 (cloth)
ISBN-13: 978-0-226-77052-9 (paper)
ISBN-10: 0-226-77051-6 (cloth)
ISBN-10: 0-226-77052-4 (paper)

Library of Congress Cataloging-in-Publication Data

Stafford, Barbara Maria, 1941–
Echo objects : the cognitive work of images / Barbara Maria Stafford.
p. cm.
Includes bibliographical references and index.
ISBN-13: 978-0-226-77051-2 (cloth : alk. paper)
ISBN-10: 0-226-77051-6 (cloth : alk. paper)
ISBN-13: 978-0-226-77052-9 (pbk. : alk. paper)
ISBN-10: 0-226-77052-4 (pbk. : alk. paper)
1. Cognition. 2. Mental representation. 3. Image (Philosophy) I. Title.
BF311.S67715 2007
153.3'2—dc22

2007009521

∞ The paper used in this publication meets the minimum requirements
of the American National Standard for Information Sciences—Permanence
of Paper for Printed Library Materials, ANSI z39.48-1992.

CONTENTS

ILLUSTRATIONS

ACKNOWLEDGMENTS

Although six years in the making, in many ways this is a Berlin book. I have taught full-time and nonstop for the last ten years. For five of those I was engaged in curating and writing the catalog, along with Frances Terpak, for the *Devices of Wonder* exhibition, held at the Getty Museum in Los Angeles in 2001/2002. Needless to say, I was profoundly grateful when I received the call to come as a Fellow to the Wissenschaftskolleg in Berlin. Without the free time to research and write in the idyllic setting of Grunewald and the collegial atmosphere of the Wissenschaftskolleg, this long-term project would never have seen the light of day.

I want to thank, first and foremost, Horst Bredekamp for enabling the invitation. My admiration and gratitude for his intellectual generosity is hard to put in words. Thanks as well to the wonderful members of the Bildwissenschaft seminar "Sense and Style" he assembled for the year 2005/2006. They were: Jean-Louis and Sophie Fabiani, Luca Giuliani, Charlotte Klonk, Suzanne Küchler, Reinhart Meyer-Kalkus, Aube Billard Taylor, and Monika Wagner. Tuesday mornings at 9 a.m. will never seem the same again! But there were other fellows, friendships, and discussions that also made a difference. I think especially of Augustin Emane, Ingolf Dalferth, Judith Frigyesi, John Hamilton, Mordechai Kremnitzer and Rivka Feldhay, Geert Lovink and Linda Wallace, Ashis Nandy, Dietrich and Dietlinde Niethammer, Oliver Primavesi, Robert and Marie-Génevieve Salais, Giuseppe Testa, and Paul Windolf. I must also mention the highly unofficial, and somewhat rowdy, group, the *femmes savantes:* Catherine David, Carla Hesse, Suzanne Küchler, and Monika Wagner: may our eating and conversational adventures never be forgotten!

This work has also benefited from the rich contemporary art scene. I think, in particular, of the major exhibitions held at the Deutsche Guggenheim during my stay, but also of studio visits to individual artists such as Olafur Eliasson and Warren

Neidich. I offer special thanks to Dr. Andreas Kärnbach, the custodian of the art collections at the Reichstag. This is not to forget the great museums housing art of the past—from the Altes Museum to the Pergamon Museum—and the incomparable libraries. I am thinking, in particular, of the Staatsbibliothek and the Kunst Bibliothek clustered around the Potsdamer Platz.

To my mind, the librarians are the greatest treasure of the Kolleg. I thank Gesine Bottomley for her continuous support. Gudrun Rein was unfailingly friendly and helpful even when I needed the most far-flung materials. But it is impossible to thank Marianne Buck enough. When it became apparent that image searches and the gathering of permissions for reproduction had become an even more horrendous activity than it had been for my previous books, she helped me locate the new archives, photographers, artists, galleries, and museums. The process, with notable and generous exceptions, now resembles gene patenting insofar as every single image is fragmented into purchasable bits belonging to different owners. I want to single out Kelly Haigh at the Department of Special Collections at UCLA and Julio Sims at the Getty Center as important exceptions. This was a vast project by itself, and I never could have gotten through it without her help and the help of Natascha Pohlman, my student assistant from the Freie Universität.

I have accrued many older debts as well. I thank Caroline Turner, director of the Humanities Research Centre at the Australian National University in Canberra, for the invitation to be a visiting fellow in the summer of 2003. From the exciting international conference on human rights, which she organized, to the stimulating stream of visitors, I was able to deepen my understanding of everything from British empiricism to color theory. Still vivid are the illuminating conversations with John Gage about Australian Aboriginal symbolism. On the anthropological side, I also learned a lot from the workshop at the Centre for Cross-Cultural Research run by Howard Morphy. Within the university itself, I need to mention the intensive series of lectures delivered by Ned Bloch in the philosophy department on the consciousness debates.

Equally vital to this project was my tenure as the MacGeorge Professor at the University of Melbourne with Jeannette Hoorn and Barbara Creed, as well as their colleagues in the Departments of Art History and Film and Media Studies, as my kind and enthusiastic hosts. My stay enabled me to immerse myself in the exciting Australian new media scene, including some memorable discussions with Stelarc. Most importantly, however, I was finally able to visit the Northern Territory and conduct research on the cave art central to chapter 4.

At the University of Chicago, my greatest debt is to the weekly seminars on computational neuroscience. Mark Siegler and the MacLean Center for Clinical Medical Ethics welcomed me and made me a member. I have also much benefited from conversations with Robert N. Beck, Jack Cowan, Naoum Issa, Patrick La Riviere, and Steve Small. The Sawyer Seminar, Computation and How It Is Chang-

ing the Disciplines, which I helped organized with Margot Browning at the Franke Humanities Institute in 2002, was also significant for me because it brought together neuroscientists and artist-engineers such as Antonio Damasio, Marcus Novak, and Simon Penny. I also thank the adventurous students who, over the past three years, have taken my graduate course on neuroaesthetics. Donna Schuld and Neil Varna, in particular, pushed me hard to ask the hard questions.

The dean of the humanities, Danielle Allen, has been both an intellectual and a financial support. I thank her and the division for a grant helping to defray the cost of photo and digital reproduction charges and for granting and supporting this year of sabbatical leave.

There is no writing a book without supportive friends. Ann Seeler and Hildette Rubenstein are for the ages. Sally Kitt Chappell has been a stalwart. Suzanne Ghez and Wadad Kadi know what a long and lonely intellectual haul it has been. Fran Terpak's continuing help has outlived our working together on an exhibition. I think fondly of the circle of encouraging faces at Wellstreams, but most especially of Mary Ruth Broz, Barbara Flynn, and Louise Gates. Kira, where would I have been without you to pull me straight!

As always my greatest, and inexpressible debt, is to my husband Fred who graciously agreed to return to bachelordom while I spread my wings in Berlin.

I should say, finally, while small portions of my essays have appeared here and there in other essays and articles, they have been so rethought, reconstructed, amplified, and set within a new framework, as to be considered all new work. In chapter 1, I have drawn on my "Romantic Systematics and the Genealogy of Thought: The Formal Roots of a Cognitive History of Images" in *Configurations* 12 (2004). Chapter 5 vastly expands the theme of a short essay, "From Representation to Mental Representation," which will appear in *Media ArtHistories,* edited by Oliver Grau, forthcoming from MIT Press in 2007. I also thank my three reviewers for their insightful comments. I have done my best to incorporate them.

INTRODUCTION

Well, that's the hard problem. The brain is an excellent information processing system, but there's no accounting for how and why we have subjective experience, emotional feelings, an "inner life."[1] STUART HAMEROFF

We need a thoughtful medium in which the qualities of a particular situation can be represented.[2] RUDOLF ARNHEIM

This book seeks out the interpretive blanks—the transdisciplinary challenges lurking in the picture of how the mind works that is now emerging from the sciences. It also seeks to insert the cognitive work of images more centrally within that enterprise. Like quantum physicists detecting elusive patterns in the cosmic void, or nanotechnologists descending to atomic dimensions at the bottom of matter, neuroscientists are plumbing a ghostly companion universe parallel to the solidity of our own.[3] In light of these exciting developments, those of us in the humanities and social sciences are being given wonderful new intellectual tools to reimagine everything from autopoiesis to mental imagery. Personally, they have compelled me to rethink the major themes of my life's work. I have tried to remake my views, to learn from, and adapt to advances in those fields that are showing how and where thoughts arise.

Yet this ongoing cognitive revolution continues to meet with the "intense reluctance" of art, cultural, and literary historians to consider seriously the biological underpinnings of artificial marks and built surfaces.[4] This is a sure sign that new concepts do not travel easily from one context to the next. I am proposing, however, that this difficulty makes it all the more important to look at the core concepts of our field against the backdrop of the questions being posed by our colleagues in neuroscience. As scholars of the myriad aspects of self-fashioning we can usefully enlarge, and even alter, our humanistic understanding of culture, inflecting it with urgent discoveries in medicine, evolutionary and developmental biology, and the brain sciences.[5] In other words, the role of culture is not just to stand outside, critiquing science, nor is science's position external, and acting on culture. Rather, we

are discovering at the most profound levels that our separate investigations belong to a joint project, at last.

Certainly, this attempt to frame some common research topics that span truly distant disciplines needs to be a two-way street. I am struck by the fact that, while the visual and sensory arts are frequently invoked by neuroanatomists, cognitive scientists, and philosophers of mind, rarely are the arts seen as being constitutive, not merely illustrative, of basic mental operations such as intuiting, inferring, associating, hallucinating, feeling arousal, and categorizing. I also argue that a broader range of visual material needs to be mobilized in the discussion of complex phenomena like attention or consciousness. Scale, of course, remains a major deterrent. The disappearance of the person—what John Yolton termed "the perceiver"—swallowed in a galaxy of neurons, awash in neurotransmitters, and dispersed in synaptic circuitry is indicative of an incommensurability that has to be bridged in much recent discussion of brain processes.[6]

Roughly, what I am after (paraphrasing Stanley Cavell) is to let art play a conceptual role in what neuroscience says about it.[7] At the same time, I want to give an accounting of how neuroscience has enriched our understanding of art and made it more comprehensive. In fact, findings from the brain sciences are putting pressure on venerable questions long held to be the property of cultural historians of every stripe: the nature of the subject and intersubjective relationships, mimesis, affect, the varieties of illusion, automaticity versus the will, and the many shapes of uncertainty.

Not coincidentally, these also constitute the themes of this book. By presupposing a shared commonality of endeavor, I believe we can get beyond both ancient and modern allegorizing philosophies of absolute difference to locate positions from which we might participate in an analogous horizon of investigation.[8] My method reflects this aspiration. I refract major concerns of the humanities through the lens of the neurosciences, cognitive science, and philosophy of mind: the epistemological significance of shape, the hold of visual formulas, the appeal of imitation, the haptics of spatial perception, the tension between streaming narrative and condensed performance, and the varieties of self-design or auto-organization. Taking a leaf from the discussion in chapter 2, intarsia is my artisanal and theoretical model. As in a mosaic, I set contemporary art alongside historical images. The resulting inlay not only permits us to look at the entire visual record anew but to understand more deeply the potency and longevity of certain types of representation, from the geometric intensity of abstraction to the affective power of facial recognition, thanks to the fresh perspective provided by neuroaesthetics.

I should say that my own longstanding research revolves around the complex workings of images operating at the interface between the arts, sciences, philosophy, and technology from the early modern to the contemporary era. I see the cognitive thrust of this book as a logical and necessary extension of my prior studies on

the body. These ranged from the *de profundis* of anatomy to the emotion-registering skin. Moreover, along with *Body Criticism* to *Devices of Wonder* (and everything in between), this project continues to probe what, from my perspective, has always been the great problem of how art makes visible the invisible.

Some six years ago, I realized that I needed to learn new fields and that I could not do this just by reading books. I reluctantly left the University of Chicago Humanities Center for the Workshop on Computational Neuroscience. These daunting sessions ranged from looking at single-cell models to synchronized patterns of neural network activity. Seeing brain operations allowed me to realize that the sophisticated sensory modalities of art are phenomenological and epistemological structures that simultaneously help us differentiate as well as construct aspects of our experience. By making discrete features of our surroundings salient to the brain so that we attend to them, they become cognizable, memorable, enduring.

The material formats of the spatial arts, the morphology of their compositions—not just their metaphorical constructs—are proof of a primitive perceptual order as well as that the brain is an evolved organ responding to changing contexts.[9] The epigraph that opens this introduction makes clear that Rudolf Arnheim was convinced of this inherent systematicity and plasticity early on. Following his lead, I want to understand how spatialized media first became, and continue to become, "thoughtful." Significantly, Arnheim believed they still had a long way to go before achieving full mindfulness. One of the sad ironies of the long, and almost exclusive, reign of social art history is that it has obliterated the concern of an earlier generation of thinkers with the vital issue of how images integrate information and make us aware of that fact. This has left the field ill-prepared to cope with the new cognitive turn. Repurposing Gauguin's famous questions, then, we might ask, who or what unites conscious experiences? Why is thought intermeshed with images and how does visual information translate into action? Where is the "echoic power" of locating the reflective self in others and being permeated by their actions going?[10]

As David Howes reminds us, it is not enough to look at the senses as mere energy transducers.[11] Evolving or "living" works of art do more than provide evidence for how information is gathered and modularly processed. Jean-Pierre Changeux, Antonio Damasio, and Gerald Edelman have each shown how objects also make the mind. But the neurosciences (think of the important studies by Steven Pinker or Terrence Deacon) have typically relied on an overly linguistic model of everything from self-awareness to the rise of symbol making.[12] I propose, on the contrary, to identify and analyze a number of key examples of mindlike *images* out in the world emerging at different moments in time and place. Such spatialized/sensorial "chunks" of thought—visible in social practices from the magical to the technological—instantiate the mutual interdependence of pattern generation with pattern recognition.

Again, by aspiring to what anthropologist Gregory Bateson called "the bonus of

understanding"¹³ that comes from the combination of two distinct realms of data, I want to get at those modes of visual communication that grapple with bringing all levels of cognition to perceptibility by focusing, aligning, calibrating, and attuning our attentional mechanism with the moving world. This deepening of biological with cultural information, and vice versa, will result, I hope, in a multiplied, even a transformed, object. The new thingly aggregate I am after gives us exponentially (not additionally) more than when it functions merely as an element within a particular discipline.

The following essays explore six embodiments of concrete thought. Each illuminates the notion of the person both as "a boundary for the mind"—in thrall to mostly unconscious, or spontaneous and intrinsically generated brain activity—and as a distributed agent entangled in the world.¹⁴ I selected issues that, at least in principle, meet the criterion of being found equally compelling to humanists *and* to scientists.

This book, then, is intended for all readers interested in images from the schematic to the iconic. But it is also a technical book: I try to be as precise and clear about the specific camp of neuroscience I am discussing and the analytical or continental philosophical perspective I am invoking, as I am about a particular aspect of the history of images or theory of art. To avoid abstractness and to point out the relevance of this difficult material for long-standing problems in the humanities and the social sciences, the neuroscientific, cognitive scientific, and philosophy of mind theories are instantiated in real cases and concrete works. Although I always define key terms in context, for readers who desire an overview there are good books available. I recommend V. S. Ramachandran's Reith Lectures for the BBC and Susan Blackmore's frank and illuminating interviews with leading neuroscientists and neurophilosophers that disguise none of the unresolved conflicts.¹⁵

What makes this book different, I believe, is the struggle to achieve parity: the mustering of visible proof of biology in culture and culture in biology. I try to "translate" the scientific into image-based cultural work and the cultural into scientific work without reducing either effort. I attempt to show that they are, in fact, mutually illuminating. Not only can the cultural material provide scientists and philosophers with new and different ways of thinking about cognitive problems, but the scientific evidence can invigorate historical studies. Since my goal is to bring these separate intellectual inquiries together around major issues that we are all passionately interested in, I do not survey the literature in these fields. My larger purpose is to stimulate analogous projects, not to have the final word.

I agree with Alexander Marshack that global traditions of marking—whether hieratic or mundane, explanatory or mnemonic—are cognitive forms.¹⁶ By this I

mean they are conceptual units that were used in myriad attempts to communicate with a broad spectrum of entities. We can think of this array of images as cultural symbols with which to reach our biological selves. But they also capture how the independent and wandering brain-mind discovers palpable connections at the interface between body and world.

Each chapter looks at a major structuring activity of perception fundamental to the visual arts, yes, but to all cultural and scientific production as well. Once again, I aim to show how neuroscience, cognitive science, and the new philosophy of mind are reshaping these basic functions and what the share of the humanities might be in this reassessment. The topics include form as providing evidence for general rules corresponding to similar intuitions shared by different cultures; compressive and split compositions as manifesting both symbiogenesis and the mechanisms of neuronal synchronization; mirror neurons, empathy, and the reflective work of social cognition; feelings of "depth" of consciousness and projective illusion; the questionable depersonalization and de-imaging of the "theater" of the mind; and, finally, directed attention and the limits of autopoiesis.

These themes are not just intellectual constructs but echoes of actual material objects and spatialized patterns: the abbreviated universal "grammars" of line and color created by the Romantics; the magic binding symbol of the ancients and its Baroque descendant, the intarsia emblem; associationism and the central claims of British empiricism regarding our correlational experiencing of the world; the phenomenology of addictive immersion stretching from the imprinted caves of the upper Paleolithic, to Australian Aboriginal rock art, to the hallucinatory installations of Hanne Darboven and Olafur Eliasson; the reassessment of a filmic stream of consciousness in light of a performative or "episodic" construction of the subject and, in closing, what the aesthetics of self-assembly (earthworks, bioart) can teach the "no one is at home" or responsible theory of mind.

This array is not meant to add up to a cognitive history of images but to indicate the potential range and some of the key elements of such a larger project. I follow the example of my colleague at the Wissenschaftskolleg, Hans Zender. Like this experimental composer—deploying isorhythm and after-sound (*Nachklang*)—I aim to write a "multipolar" work that integrates multiple phenomena but does not harmonize them. As I hope I have made clear, then, my topics are not merely idiosyncratic monads either.[17] It is precisely because these problems have been especially durable, replaying and reverberating across different fields, that they avoid the specter of "weak collage"[18]—similar phenomena coming from disparate eras and spheres that get strung together. Their resonating power permits us to take them as symptoms of typicality, as prime examples of major questions that will not go away and that are found on both sides of the imaging aisle, mirrored with equal intensity in the humanities as well as the biological sciences.

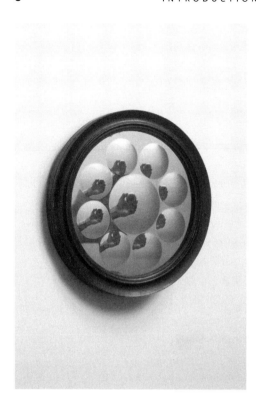

FIGURE 1
Anonymous, *sorcière* mirror,
eighteenth century. Glass,
metal, and wood. Photo: Getty
Research Institute.

While not exactly a household word, cognitive studies are undeniably afoot. The history of science, for example, has become fascinated with three-dimensional models as research tools. Such "epistemic objects," it is being argued, are mediators in the making of knowledge.[19] Science studies is increasingly preoccupied with "epistemic things," that is, the material entities and processes that constitute the objects of experimental inquiry.[20] These attempts to redefine "technical objects" and "technics"[21] (fashioning a complete theory of the machine) stand under the twin influences of Alfred North Whitehead and Bruno Latour. Recent discussions of cognition as an evolutionary machinic process draw both on Whitehead's philosophy of organism, which puts mind back into nature,[22] and on Latour's sophisticated analysis of the ways in which the material world comes to us in forms that are cognizable.[23]

"Historical epistemology" is busy mapping our current vocabulary onto the nineteenth-century image-laced vocabulary of mass culture. Analytic philosophy has pictorial realism in its sights, looked at from the vantage of the age-old debates over subjectivism versus objectivism—now filtered through neuroaesthetics. There are important literary studies devoted to cognitive fictions and cultural studies investigating concepts of identity before the creation of the modern self.[24]

Entire book series are being dedicated to the role of the five senses and the materiality of communication. In the social sciences, William James has become a growth industry.[25] Even psychoanalysis is getting reassessed as the "first great theory and practice of personal life"[26] partly because of the hypothesis that all mental life springs from neuronal processes and that patients can systematically alter their brains through use-induced cortical reorganization.[27]

In the political sciences, Michael Hardt and Antonio Negri have identified "biopower" as a new paradigm: rerouted from the Foucauldian forces formerly operating on our outer or public behavior to controlling the smallest structures of our inner lives.[28] Slavoj Zizek, extending Hardt's and Negri's negative view of displacement, speaks of scientific "parallax" or the "absolute gap" between the phenomenal experience of reality and the brain sciences' explanation of that experience (referring specifically to the work of Thomas Metzinger).[29] It is, however, such an *irreducible* antinomianism that this book challenges.

No doubt, all these developments are exciting. I hope to build on them as well as other approaches. But, as confessed, I am heading elsewhere. Like the discrete object caught and animated in the multiplying lenses of a *sorcière* mirror, I want to capture the added bounce that brain science contributes to cultural figurations from

the hieroglyphic to the technoscientific (fig. 1). This ability to reverberate across vastly different fields seems to me to be an essential characteristic of echoic objects. They are both ancient and modern since they fix the gaze time and again. Like that original rearview mirror, the Claude Glass, artifacts intensified by the double gaze of the humanities and the sciences have the power to refocus an issue that might otherwise sink from view or never attain visibility at all.

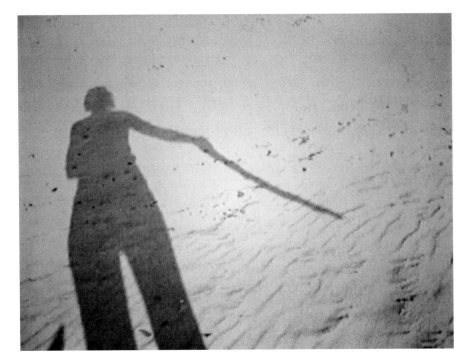

FIGURE 2
Joan Jonas, installation shot /
photostill of *Lines in the Sand*,
for the Renaissance Society
at the University of Chicago,
2005. Video. Photo: Courtesy
Joan Jonas.

1

FORM AS FIGURING IT OUT

Toward a Cognitive History of Images

[We can think of] art as an independent life form . . . inanimate artifacts, patterns of sound, scribblings that get insinuated into the activities of human brains which replicate their parts, assemble them into systems, and pass them on.[1] TERRENCE DEACON

. . . the natural object is always the adequate symbol.[2] EZRA POUND

LINES IN THE SAND

Performance and video artist Joan Jonas's 2005 installation *Lines in the Sand* begins, as Neolithic art might have begun, with her own elongated shadow blackening the bright floor of the Nevada desert. Then, with a stick, she starts to draw: incising the ancient ocean bed, depositing her traces next to its windblown stripes, and imprinting another, diagrammatic self beside the original flat and fleeting projection (fig. 2). By combining perception with action, she both gives shape to surface and feels the underlying order of the world.

Inspired by the work of the American poet H.D. (Hilda Doolittle, 1884–1961)—a member of Ezra Pound's imagist circle[3]—Jonas looks to myth as a way to configure self-awareness. Shifting sand—like the chalkboards, mirrors, masks, and video monitors she has deployed throughout her career—is first and foremost a distributable medium. Old as the earth, this granular material invites the expansive choreography of gesture and ritual, rather than the linear logic of text. This galaxy of scattered particles serves as a reminder of even more remote processes of patterning. Almost all star formation, astronomers believe, was in clumps and blobs for the first four billion years of cosmic history. Recognizable features—such *ur*-forms as flat disks, ellipses, spirals, and bars—coalesced from chaotic puffs of rich warm gas due to the merging pull of gravity.[4]

Fascinating though it is, we cannot follow Jonas's associative trajectory of eternal return: her deft transposition of the modern story of H.D. to the archetype of destruction and construction, Helen of Troy. Nor can we pursue—although we will meet these cognitive mechanisms later in this book—the geographical and temporal analogical jump from the epic sites of Iron Age Greece to the stepped façade of the pyramidal Luxor Hotel and the mirages of present-day Las Vegas. But what we do now need to keep in mind—prompted by Jonas's work—are the myriad specu-

lations on the connections between traditions. I mean the ongoing quest to locate points of connectivity between global practices centered on schematization born of contrasts from Egypt to Easter Island.[5]

Significantly, Jonas creates a time-based resonant object out of videotape recorder and camera. She demonstrates that this electronic medium has ancient roots in the situatedness of live performance. Not black and white, but grayscale monochrome—like early television—video images are a standing wave of electrical energy that *interrupts* the homogeneous space of the screen.[6] Her protracted piece oscillates between Jonas's real-time assemblaged self-image and what video pioneer Staina Vasulka called "gaunt" images.[7] These audiovisual forms are the linear patterns abstracted or cut from their source that get crystallized on the mirroring face of the monitor. As a result, Jonas's work links up with the venerable aesthetic practice of disconnecting, or freeze-framing, copresent formal elements from out of the spatiotemporal continuum. These *signals* oscillate between input and output, internalization and externalization. They both produce and broadcast information.

Using findings from brain modularity research as well as its connectionist critics, I want to reopen formalism as a serious, even generative, topic. Certain neurobiologists consider the brain as a collection of dedicated modular structures (in the case of V. S. Ramachandran based on his investigations of neurological dysfunctions or abnormalities such as phantom limb syndrome and synaesthesia) with each module doing a specialized job independent of the others.[8] But evolutionary psychologists, such as Steven Pinker, put the focus back on the interdependence of such units and on the specific aspects of the environment with which they resonate. Thinking animals, he argues, are always embedded within their changing natural and social habitats.[9]

Both positions, I believe, come together in the realization that we must sculpt our milieux as we move through them and that these spatiotemporal reorganizations or recompositions emblazon our minds in turn. Works of art—which I am defining as a special class of images that both coalesce and work to make the viewer coalesce large amounts of novel and taxing information—bring a crazy-quilt of physical phenomena to our notice. This constraining and compressing design makes apparent the normally hidden ways by which domain-specific interface systems (vision, hearing, taste, touch, smell, proprioception) render the ambient intimate for us.

I realize that *formalism* has been a dirty word for quite some time now. "Theories of embodiment," for example, are typically opposed to the description of a theory as "formal" as, say, in generative linguistics. Here, "formal" is a way of stating that it makes no claims about how components or processes hypothesized by the mind might map onto the anatomy and physiology of the brain.[10] The assumption, which I find problematic, is that formalism—revealing the significant morphological homologies and dissonances within and between ordered compositions—is necessarily antithetical to embodiment. In other words, that we are unable to de-

duce significant correspondences between our internal biological mechanisms and external configurational practices.

Equally limiting, I think, is the dismissal of literary and artistic "formalist criticism"—and with it attention to the efficacy of material objects in shaping through their shapes human thought and action. As Richard Strier has argued in defense of I. A. Richards or Cleanth Brooks—critics purported to uphold merely the perfect adequation of language and world , image and material, intention and meaning—they, in fact, assert that the results of a formalist analysis may well help us understand a specific historical moment.[11] Let me be clear: I am not promoting a revival. What I am saying is that the baby of content-in-patterning has gotten thrown out with the bath. We have forgotten the fundamental insight of British polymath D'Arcy Thompson that underneath the wild diversity of organisms lies an elegant and simple mechanism of shape evolution.[12]

Images—whether the result of natural imprints or artificial impressions—lay down tracks that affectively activate our eyes and mind. They stamp us with the marks and textures of the phenomenal world. As David Bordwell commented about the light traces and shadowy figures created in cinema, they demarcate an otherwise unpunctuated visual array for our attention.[13] Pattern formation and pattern recognition—from schematic outline to full-blown illusionism—illuminate both neural functions and symbolic processes resulting from social agency.

As Steven Pinker noted in *How the Mind Works,* "it is highly likely" that art helped ratchet up and sustain our capacity for design and so stimulated thinking beyond our inbuilt preferences.[14] According to this evolutionary biologist, art is not an adaptation, rather, it is one consequence of certain compositional resources appealing to our inborn cognitive preferences. We can think as well of anthropologist Albert Gell's remark about how not just human beings, but informational artifacts, have been widely assumed to be operational, that is, capable of initiating causal sequences through acts of mind.[15]

Figuring as form capture is a strategy to keep our eyes poised to alight in a changing environment. As Joan Jonas demonstrates, it is also a meditative practice, repeatedly pulling something that lies outside the contemplating observer inside, and vice versa—a sort of habitual condition of rethinking or redepicting of experience. In fact, researchers using magnetic resonance imaging scans have discovered that areas of the cortex associated with attention and sensory processing are thicker in subjects who have practiced meditation for many years thereby avoiding the thinning of the brain that inevitably comes with age.[16] Further, electroencephalograms (or EEGs) taken of long-time meditators showed a high level of synchronization among neurons, particularly in a certain frequency of electrical impulses.[17] Like mental training, as Jonas shows, the repetitive activity of drawing similarly stabilizes the mind. Copying snatches or abstracts enduring features from a flux of distractions.

When Plato's Diotima speaks of the "eros for form," she is describing the pleasure humans take in the recurrent search for order amid the blur.[18] Introspection is conjoined with externally directed kinaesthetic perception in the performance of coherencing, or figuring out any composite object over and over again in real time. Both the aesthetic and the cognitive problem of form—of concept formation and re-formation spatialized in visible unitive structure—is that not only are our surroundings built of sand, so to speak, but that the brain is such a chaotic and noisy place.

As Gerald Edelman describes it, the cerebral cortex is an amazing sixteen-layer structure with different connective patterns in each layer. This gray landscape stretching over two hemispheres is further subdivided into regions that mediate the different sensory modalities as well as motor functions. Certain of these compartments (the frontal, parietal, and temporal cortices) connect only to other parts of the brain, not to the outside world.[19] Beneath the cortex lodges the underlying white matter, thalami, and basal ganglia.[20] Imagine, then, this largely autonomous world within a world containing a vast number of firing neurons: some igniting simultaneously, others not. Imagine, too, the difficulty of achieving and maintaining complex patterns of dynamic activity with some neurons inhibiting or suppressing the firing of those that are excitatory. Imagine, finally, modular feature extraction and the mysteries of binding.

We get a real sense of the ephemerality of mental objects and the difficulty of sustaining their fixed or random structure from the work of installation artists such as Anne Wilson or Martha Whittington.[21] Their large-scale fiber pieces variously take on as their central theme episodes of individual dispersal and concentration. Physical handwork, material industry, and intellectual labor stand in for the hidden work of crafting self-awareness out of environmental fluctuations.[22] If higher-order consciousness can be defined as the ability to be conscious of being a conscious entity, it also enables us to re-create past events by re-collecting and re-bundling them. To remember a prior occasion long since dissolved entails becoming conscious of some isolated moment or concatenated thing, precipitated out from a crowd of other memories.

In *Feast* (2000), Anne Wilson performs a self-effacing ritual of retrieval. She brings to the surface—as at a banquet—traces of the chaotic entanglements, the mutant forms of domesticity, personifying the vanished guests. At the deepest level, her topological inquiry seems to address the mystery of the relation of the phenomenal world to the mental world. She shows how a small part of the Platonic realm of ideal forms subsists within the bits of geometry eddying about us every day. Using fabric evocative of domestic rituals, in this case a white cloth pinned to a long wooden table, Wilson reiterates, and thus isolates, the outlines of past rips and yellowed stains by circling these discrete memory holes with tufts of thread and her own dark hair (fig. 3).

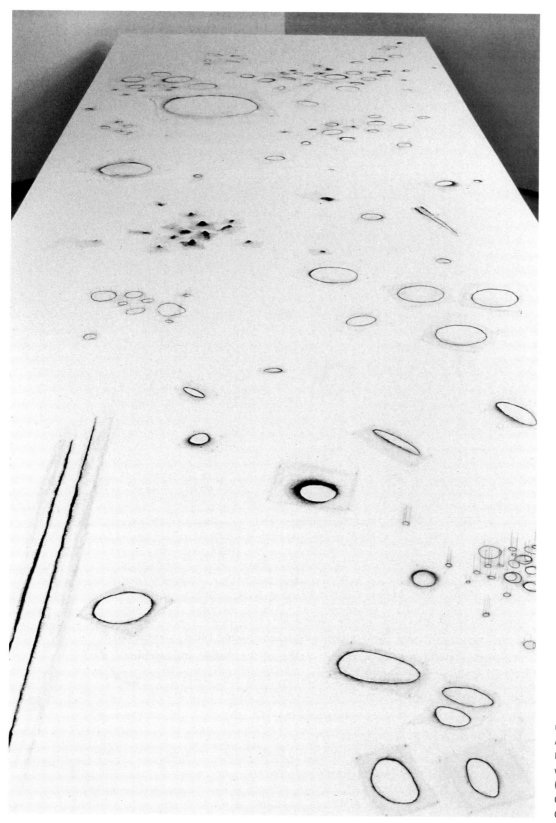

FIGURE 3
Anne Wilson, *Feast*, 2000.
Hair, thread, cloth, pins,
wood table 80 × 168 × 671 cm
(331.5 × 66 × 264 in.). Photo:
Collection of the Museum of
Contemporary Art, Chicago.

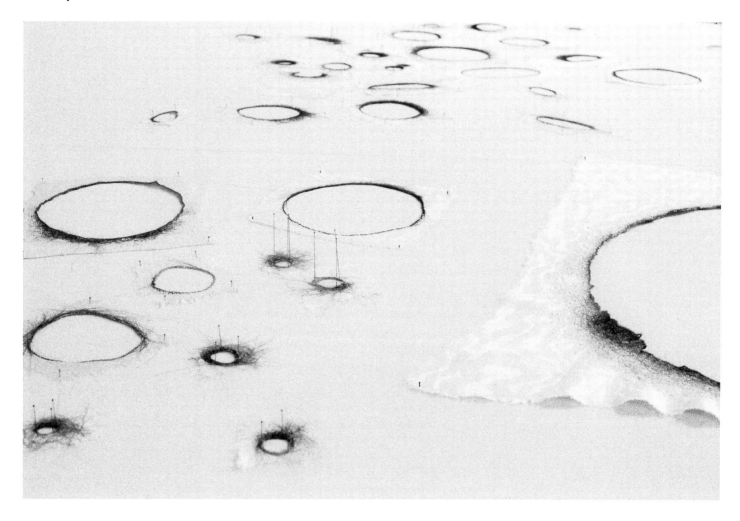

FIGURE 3 *(detail)*

As if visualizing mathematician Roger Penrose's quantum mechanical explanation of the "cytoskeletal control of synaptic connections,"[23] Wilson produces a wavelike organization of linen, crochet stitches, knots, thread, and wire. Coherence does not emerge but, like Penrose's microtubular view of consciousness (where "quantum superimposed states develop in microtubule subunit proteins [tubulins] within certain brain neurons"),[24] it is superimposed upon, or laced together from, such preconscious processes oscillating with discrete or "self-collapsing" conscious events. The table cloth's all-catching netlike structure is global, embedding the artist, the perceiver with her feelings, and the totality of the situation—past and present—within the matrix of its physical filaments. The centers of control (encircled circles) function like propagating electric signals in the nervous system. In this case, the messages are fibers distributed along the length of an animated tableau,[25] but which nonetheless manage to operate in concert.

Martha Whittington similarly shows how an activity that occurs in a localized region of space is able to retain its discrete and particular character despite its tidal

properties. Such "solitions" or wave-packets of energy appear, Penrose believes, in the innermost structure of the neuron, but they are evident as well in microbiology, in superconductors, and even in "the incessant interplay of vortices" of human invention.[26] We witness something like this nonlinear congruence of individual forms when Whittington dramatically reconfigures the customary contours of a room with amorphous puffs of black and white dust rising from felt sacks thrown against the walls. Obeying the mysterious law of self-organization, bundles of powdered charcoal and gusts of marble settle triangularly into corners and trace pendant circles on the ceiling. This elegant self-assembly of patterns in motion—turning dispersion into a geometry of transient afterimages—echoes Penrose's new physics of objective reduction (OR) addressing the formal ordering of the universe at its deepest levels.

These contemporary artworks are a profound commentary on the doubleness inherent in the process of remembering: its rippling as well as its contouring effects. As John Sutton remarked (regarding early-modern theories), there were two different pictures of memory's operations that increasingly came into conflict. Thinking of fluids made memories seem like animal spirits or motions, but thinking of collections made them seem like defined items or individual bodies.[27] Remembering's divided nature evokes a contradictory situation, not unlike the one that solition attempts to resolve.

The difficulties of conjunction, haunting the paradoxes of quantum mechanics, also surface in the very different connectionist models of cognition. Neural networks or parallel distributed processing models (PDPs) are also rethinking cognition as centered in the key problem of connection. Imagining cognitive processing as the spread of transitory activation across a network of interconnected neuron-like units still leaves open the question of how they combine with previously laid-down patterns.

The neural basis of object recognition—typically investigated by looking at the characteristic activity of single neurons—is grounded in the complex mechanisms for the retrieval and re-viewing of memories. Memory compaction is an intricate multistage process, moving from the immediate, to the intermediate, to the long-term. Short-term memory consolidates into long-term memory with synaptic re-entry re-enforcement. Primary remembering occurs so continually and usually so imperceptibly that we rarely notice it at all. Novel object recognition tests show that our short-term memory formation is extremely labile. Any disruption during a critical window makes it unstable. Certain things tend to get prolonged in the margins of our awareness before sinking from sight. But, as William James evocatively proposed, their disappearance leaves behind an echoing "penumbra." This reiterative aura fringes any new input, even though the prior event has exited explicit consciousness.

Secondary remembering—that is easy or labored recall—salvages experiences

that have entirely elapsed as live events.[28] Importantly, this resuscitation involves both retrieval and revival of previously experienced objects and circumstances that must be re-enacted or re-presented. It seems that Gyorgy Kepes was right. Structuring, or what he called the "discipline of forming,"[29] is a fundamental part of perceiving because either we forget to remember the passing show so quickly or, the bits we do attend to, still must be actively accessed later through mnemonic re-performance. In confronting the ruined monuments of the ancient world, Romantic artists, I will argue, engaged in analogous rescue work. Just as secondary memories are not rote copies of the original object or occasion but generative symbols, the famous cultural materiality of pyramids, cavernous tombs, and colossal statues were potent distillates of experience liable to further distillation as formal schema. Art as cognitive imagery can be seen to shadow forth certain underlying truths about brain function that we still intuitively recognize today.

These basic primes of perception are discernible in places, persons, things, and, most especially, on the body. The British psychoanalyst Donald Winnicott illuminated this prearticulate, performative tendency to reenact the outlines of what is presented to us and so make it present to mind. He understood the process of self-begetting as one of reconnecting or integrating to a unit. The psychological theory of object-relations assigns a fundamental role to form generally because, as Winnicott stated, it is "through forms that the end is in sight from the beginning."[30] Form mercifully counteracts the true birth memory, that original terrible feeling of helplessness, of being in the decontextualizing grips of something external. Paradoxically, however, it is by virtue of this repercussive resistance of "hard" reality to our formlessness that we gradually become aware of an independent world existing beyond the illusory projections of the mind.

Importantly, what Winnicott called the mere "environment-individual" undergoes a socializing transformation when he or she is constrained to visualize other separate forms existing outside his or her corporeal and mental frame. With edges thus eroded, the person is no longer an omnipotent totality and can begin to communicate with others building new structural relationships. For Winnicott, reality gains intensity for us precisely by surviving the continuous unconscious formal destruction to which we try and subject it.

Antonio Damasio has recently proposed that feeling as a subjective phenomenon arises when a physical system overcomes or resists the inertia of its ongoing mechanics. This "grappling" is particularly intense at the level of such neurocognitive behaviors as affect, attention, executive control.[31] Romantic artists, obsessed with retrieving the genealogy of human thought, were similarly convinced that these psychomachias of mythic proportion were imprinted in the line and color symbolism of ancient art. Now as then, such diagrammatic images correlated with equally basic hues, serve as reminders of the intuitively familiar. Object relations theory is thus just one important modern attempt to recuperate echoes of this past,

yet ongoing, drama. Affect-laden concept formation remains lodged deep within our present-day body. The modern dynamics of being are indelibly etched within the history of the system.

DIAGRAMMING CONCEPTS

If you want to know how someone once perceived and understood the world then you need to know what they saw and what they made (formed) from it. This "ecological" character of human cognition, as anthropologist Alfred Gell termed it, does not proceed propositionally but imagistically: "from the layout of people and things on the ground."[32] Gell's theory is grounded in French structuralism, similarly intent on asking how a framework or mental template—of which people may not be explicitly aware—materially orders the way in which they think and act. Levi-Strauss's central thesis was that the ensemble of customs—the manner in which they "form[ed] into systems"—always possessed a particular style revealing the inmost shape of thought.[33] Today, philosophers interested in the mind-body problem, might phrase such unearthing of a symbolist mentality as evidence that consciousness is a form of intentionality. It leaves signs behind of "the mind's direction upon its objects."[34]

Already two centuries earlier, Giovanni Battista Vico (1688–1744) traced the outlines of a sophisticated formalism before it had a proper name. In his *Principles of a New Science* (1725, 1734, 1744), the Neapolitan philosopher and jurist proposed an inquiry into the rule-guided productions of "primitive" man working backwards from the present to those crude Pleistocene hunter/gatherers who "wandered in the great forest of the earth" equipped only with a rudimentary vocabulary of gestures and pictures.[35] That obscure period, following the global destruction of the deluge, is commemorated in the "poetic characters" of ancient mythology, dimly bodying forth signs of the mentality of the first humans as they emerged from barbarism.

Vico distinguished between two very different kinds of beings that survived the universal Flood (fig. 4). This dark, cataclysmic period of our earth's history was one of bestiality before the arrival of the *optimates,* or children of the first families who lived in accordance with religious customs.[36] There were thus two, very different, kinds of descendants of Japheth, or Noah. Among their number were, first, the lawless giants who roamed the earth wreaking chaos and spreading iniquity. Second, humanity emerged from under the shadow of this primitive savagery, helped along by the guidance of wise legislators and rule-structured legislation. Vico's visionary science of collective social experience extending through time was predicated on analogy. Significantly, for him, there can be no dialogical communication without the leaps of inference or empathetic *fantasia*. The latter-day investigator, trying to bridge the gap, similarly needs a vivid imagination to reconstruct the modifications

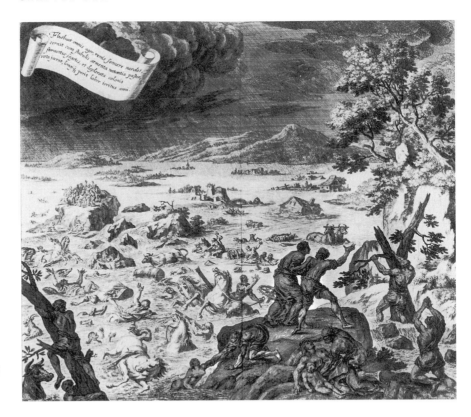

FIGURE 4
Johann Zahn, *The Universal
Flood*, in *Specula Physico-
Mathematico-historica
notabilium ac mirabilium
sciendorum*, vol. 1 (1696), pl.
397. Engraving. Photo: Herzog
August Bibliothek Wolfen-
büttel.

our mind has undergone from the scattered, concept-laden fragments that have
come down to us.

Vico believed that traces of those enduring inner patterns are detectable in art,
myth, language. But the only way we can go about retrieving or re-membering
what the ruined thought of the first humans might initially have looked like is by
scrutinizing our own cognitive processes. How do we continue to intuit and draw
inferences from external stimuli? Vico argued—in advance of J. J. Gibson—that our
evolved body knowledge is necessarily entwined with that of the evolving environ-
ment, thus potentially putting us in *direct* relation to the modes of perceiving/con-
ceiving operating in eras not our own. This power of apprehension (the famous
verum factum) stems from the fact that the kinds of formal order human beings
have invented—visible in the varieties of symbolism, ritual, dreams, the emotion-
suffused compositions of the arts and sciences—are only intelligible to us because
other human beings made them. Vico's position can be restated from the perspec-
tive of the field of coordination dynamics. There is a synergy between brain and be-
havior that allows us to reconcile coexistent tendencies or couple biological and so-
cial processes.[37]

Johann Gottfried Herder, the Enlightenment founder of the anthropological
turn in literary studies, realized—like Vico before him—that it was impossible to re-

call the entirety of a previously experienced outlook or vanished social milieu, no matter what method one used. One could only approach traditions phenomenologically, or by analogy.[38] In his *Plastik* (1778)—a wide-ranging essay on the aesthetics, philosophy, and physiology of touch—he argues, unusually, that it is the most fundamental of the five senses. In fact, it is "the foundation and guarantor of sight," for "in the sense of sight is dream, in the sense of touch truth."[39] Theologically, tactility invokes that *Urstoff* or prime matter that the potter-God of *Genesis* first shaped. Sculptors, as second creators, continue to re-form this protean, esemplastic substance. Psychologically, Herder connects touch to childhood and the origins of the education of the senses. The sculptor's art could only have arisen early and everywhere as "it arises among our children, in whose hands, wax, bread, and clay shape themselves."[40] Such in-forming not only captures the creativity of children's games but sheds light on *auto-plastik,* or self-modeling more generally—the myriad ways we shape our lives through the effort of coordinating what is all around us with what is inside us.

Herder comes closest to Vico's recuperation of the inner patterns signaling past subjectivity when he reevaluates touch as the most faithful of the senses—immune to the deceptions of *trompe l'oeil*. It puts us reliably in contact with the biological and physiological bottom of reality where there is no illusion. Tact (*Gefühl*) is a motion of the soul, more primal than reason (*Vernunft*) and thus connected to that common body of experience that human beings have always (explicitly or implicitly) brought to the perception of the life world as well as to works of art. For Herder, touch is key for understanding how humans intimate, the way they feel themselves into an experience, and construct their interiority through physical contact with a delimited form, contour, or edge.

Putting Vico and Herder's quest to define *Homo sapiens* as a symbolic animal in line with today's evolutionary biology, we can rephrase their formal interests as focused on how humans acquire, organize, and transfer information. The conviction that there existed an original, and to some extent recoverable, symbolic system that once enabled the construction of a shared imagined reality colored Enlightenment inquiry into the origins of language as well as of architecture, sculpture, and painting. This proposition should not sound strange today, accustomed as we are to a data-driven understanding of human actions. Network theory, in particular, looks for similar organizing principles across the structure of many complex systems.[41] It is not that Vico, Herder, or Edmund Burke, for that matter, believed in an ineluctably fixed human nature. Rather, as Isaiah Berlin has argued, they struggled to find the common transhistoric ground between human beings.[42] The signs of this common human nature—without which there would be no hope of intercommunication—are visible in the family resemblances linking communicative media despite their modifications.

What interests me, specifically, is the pictorial aspect of this vast pattern-seeking project into the general laws that structure art across space and time. Combining the root lines and colors of a primal formal system involves rules capturing the most important features in the linking of mind with matter (plate 1). This graphic grammar, composed of discrete character or cipher combinations, allows us to generate a range of denotative and connotative meanings from elementary forms.[43] The Romantic systematizers were convinced that such visual formulas revealed an ingrained shared mentality. They wanted an epistemic and systematic history of art able to detect and analyze those bundled patterns that get repeated despite the mutations undergone in the process of their transmission. This emphasis on innateness is very like psychologist Marc Hauser's argument that we are endowed with an abstract, unconscious grammar of action that generates analogous moral intuitions.[44]

In the days before the mathematization of biology,[45] reasoning entailed trying to figure out what the variables in the natural and social world were and then fitting them into their corresponding mathematical and geometrical symbols. The challenge, then as now, was to be equally at home with this abstracting mode of thought and with the biological and cultural complexities of real organisms to which they intuitively corresponded.

Since so much contemporary neuroscientific research is directed to understanding language formation, I need to stress that I am addressing pictorial expression. Terrence Deacon, taking up the vexed problem of the origin of language, asks us to conjure up a greatly simplified version that is complete in itself, but with a limited vocabulary and syntax that he says was most likely sufficient only for a narrow range of activities. Although he states that he means "language" in the generic sense, it seems to me that Deacon actually reduces symbolic communication to language. That is, he treats it as if it were the prototype of any synthetic system based on combinatorial rules. In the next chapter, I will challenge this hypothesis by examining compressive mosaic or intarsia-like symbolic image systems. Such artisanal genres are independent from writing and texts; they belong instead to the domain of jewelry, carpentry, textiles, ornament.

I want to highlight a key moment in the historiography of what will become a recurrent obsession with a "primitive" or "puristic" minimalism during the nineteenth and twentieth centuries. The Romantics desired to unearth what never disappears from the visual record. Hence their fascination with a graphic idiom whose universalist laws come simultaneously from nature and the mind. Despite my reservations, Deacon's theory of "offloading" redundant details from working memory is certainly helpful in understanding how early humans learned to simplify the mnemonic load, shifting from many rote associations to the extraction of a higher-order or symbolic regularity.[46] By segmenting forms out of a continual flow of im-

ages, we are similarly able to construct a world of local objects from the edges and gradients of our two dimensional retinal arrays.[47]

Consequently, art can be thoughtlike in two opposite yet equally abstract ways. On one hand, there are those worldwide artisanal systems of ordering involving plaiting, knotting, and binding that phase-lock or integrate segregated and split parts. We witness this lattice of contrasting forms, for example, in Baroque emblem construction as well as in the wrapped funerary effigies of New Ireland in the Pacific Ocean where the body emerges from fretwork.[48] Conversely, think of William Hogarth's conspicuous geometric symbolism where a limited repertoire of isosceles triangles, circles, squares, ellipses, crosses, curves, and arcs, encode not just physical but moral balance and order.[49] The schematic shapes that enframe the narrative scene of a country dance in plate 2 of his treatise *The Analysis of Beauty* (1753) concisely visualize a system of ethics as well as aesthetics.

By virtue of this comparative method, Hogarth reveals our unconscious moral judgment made on the basis of visual shape. Evenness or oddness, straightforwardness or deviousness were embodied simultaneously in well- or ill-proportioned figures *and* in rudimentary or caricatural outlines (fig. 5). Thus action, Hogarth says, is

> a sort of language which perhaps one time or another, may come to be taught by a kind of grammar-rules; but, at present, is only got by rote and imitation: and contrary to most other copyings or imitations, people of rank and fortune generally excel their originals, the dancing masters, in easy behaviour and unaffected grace; as a sense of superiority makes them act without constraint; especially when their persons are well-turned. . . . It is known that bodies in motion always describe some line or other in the air, as the whirling round of a firebrand apparently makes a circle, the water-fall part of a curve, the arrow and the bullet, by the swiftness of their motions nearly a straight line; waving lines are formed by the pleasing movement of a ship on the waves.[50]

Diagramming the directionality of emotions on the face or schematizing the gestures of the moving body created an abbreviated and transmissible archive of graphic symbols. It allowed the viewer to see, without ornamental obfuscation, the "absolute" conditions of formal expressivity, that is, perceptual shape-selection coordinated with cognitive inferencing. Part of a rule-governed system of signs, these stripped-down codes or characters were easier to pick up and get re-represented, eventually becoming incorporated into a larger communicative system of symbols. As Eva Jablonka and Marion J. Lamb have recently argued with regard to language (but, I think, equally applicable to late eighteenth-century pictorial "grammars of expression"), these symbolic networks provide "a fourth dimension to heredity and evolution."[51] Significantly, the authors argue that neither thinking about cultural

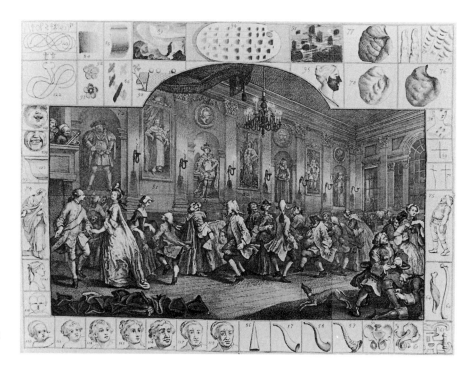

FIGURE 5
William Hogarth, *The Country Dance*, from *Analysis of Beauty* (1753), pl. 2. Engraving. Photo: public domain.

evolution as due to the evolved genetic basis of human behavior (memes) nor as the result of the brain's largely autonomous "mental modules" is adequate to interpreting this symbolic aspect of cultural sights and rituals.

The etymology of the word *schema* comes from the Greek, meaning "appearance." In Gestalt psychology, this visible shape or figure structured memory. Because forms were concise reminders of past appearances they were inherently figurative.[52] Though less abstract than numbers, such pictorial schema, similarly compressed large data sets.[53]

We should think of such condensed geometrical patterns as models, that is, as simplified and intuitive versions of a larger physical and theoretical structure. Instead of close reading or proximate viewing, these elegant summary shapes embody a type of knowledge congruent with "distance seeing."[54] These parsimonious forms are the scaffold that supports our thinking about nature and culture. As Raphael Rosenberg has shown, the habit of schematizing pictorial compositions—overlaying reproductions of paintings with tracing that bring out their underlying structure from a welter of shapes—dates to the late eighteenth century. Baldesare Orsini's, *Analogia dell'arte pittorica che contiene un Saggio sulla composizione della pittura* (1784), aimed to uncover the generic schema that made the great masters great. The visual power of Guercino's *St. Petronilla*, say, stems from opposite lines joining, an effect amplified by the very tall rectangle of the frame.[55] Jacques-Antoine Reveroni, the Baron de Saint Cyr's *Essai sur le perfectionnement des beaux-arts, par les sciences exactes, Ou calculs et hypothèses sur la poésie, la peinture et la musique* (1803) moves

beyond the pedagogical aspirations of Orsini's manual to approach metaphysics.

This minimalist "calculus"—with Neoplatonic overtones—exceeds the lowly aims of Orsini's extractive and subtractive tool for pictorial analysis. Rather, it attempts to seize the more intangible properties of form. Thus Rubens and Poussin —two masters with diametrically opposed styles—similarly use spherical shapes to conjure up supernatural laws and miraculous subjects, like the *Assumption of the Virgin* or *Time Rescuing Truth from Envy*. Poussin, in fact, habitually invokes the Platonic solids. In his *Landscape of Roman Campagna with St. Matthew and the Angel* (1639–40), for example, the two figures plus a white drapery flung across a nearby rock form the angles of an isosceles triangle (plate 2). This conspicuous creation of delicate balance mirrors the evangelist's equipoise, his affective mental climate. Poussin further accentuates the symbolism of a harmonious geometry of three by embedding the stable central group within a ruin-littered foreground. As a result, narrative flow is downplayed since the eye encounters all sorts of delaying shapes: toppled spherical column, rectangular plinth, square block, and a half-buried cornice revealing only its triangular edge. A smooth horizontal plane of water stretches away in the middle ground toward a dominant vertical façade that towers above the small cityscape in the distance. This comparative morphology encourages the beholder to focus on what is epistemologically and ontologically centric, not eccentric, both within the physical and the spiritual sphere.

Extricating the expressive character of triangles from the competing texture of oil paint (as Henry Fuseli, for example, does in his sorrowful *Silence*) or plumbing the emotional potential of cones, circles, and ellipses represents an important attempt to correlate affect with form (fig. 6). Fuseli's quest to "fix the imagination" through a "single stroke of genius" embodied in geometric figures[56] is also a significant example of "gist perception." The powerful impact exerted by a flat background together with a clear composition made up of figures arranged in strongly polarized poses demonstrates that such summary forms can bypass focal attention to strike the amygdala directly. This is the organ located deep in the brain that interprets the emotional content of an experience.

FIGURE 6
Henry Fuseli (Johann Heinrich Füssli), *Silence*, c. 1799–1801. Oil on canvas., 63.5 × 51.5 cm. Photo © 2006 Kunsthaus Zürich. All rights reserved.

The Anglo-Swiss artist was fully aware that novel forms were cognitively salient, gripping the viewer's sensory apparatus to rivet attention on the electrifying stimulus.[57] These signaling visual formulas attract us even as we wander the world lost in thought. The condensed "grammars of expression," fashionable during the late eighteenth and early nineteenth centuries, though consistent with the formulaic logic of the *schema,* go beyond categorizing the physical elements of the composition. Their goal is to visibilize the compressive structure of attentive thought, the way we are constrained to heed the most important features in the environment. This capacity to carefully notice is tied to the role of qualia in perception—the ways in which affect permeates not only the self-aware subject but symbolic forms.

We see this emergent, self-consciously "cognitive" style—the obsession with "simple" ciphers or condensed objects—in the outline drawings of Alexander Cozens, John Flaxman, and William Blake (fig. 7). These are the first, self-proclaimed, minimalists stressing the revelatory value of abbreviated forms. One of the aesthetic attractions of such radical abstraction was that it could lead to the construction of a new artistic object. Despite obvious differences, the graphic work of these resolutely diagrammatic artists shares a schematism that empties out the heavy corporeality of Baroque painting as well as the decorative accretions of the Rococo.

Bare line is a graphic gesture. On one hand, it is a spare reminder of a fuller material, even sensuous, lost antiquity, whether Indo-European, Semitic, Homeric, Norse, or Druidic. On the other hand, it brings the outlines of that shadowy realm into perceptibility. Such patterns are precious clues, rare fingerprints left behind with the passage of time and the accumulations of history. The faintness of this sensory information calls out for remembering. Synaptic reinforcement through material and mental reperformance strengthens the circuits (especially in the hippocampus) linking temporal events.[58] Fundamental to all ancient sign systems, this enactive graphism—from incidental geological cracks and fissures to scratched runic inscriptions[59]—was itself a fragmentary monument of a lost time and space. These rudimentary marks crystallized for the modern viewer a common ancestry composed of vestigial pictures.

Devoid of atmosphere, the abstract space forming the background to these late eighteenth-century drawings, engravings, and etchings set in relief the pure or stark designation of the object. Unembellished by description or definition, this mode of bald demonstration also owes to the technological developments of the Industrial Revolution.[60] The simultaneous symbolization and industrialization of contour could only become dramatized against a void or homogeneous plane. Flatness thus corresponds

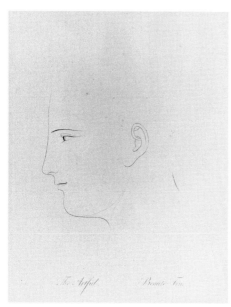

FIGURE 7
Alexander Cozens, *The Artful,* from *Principles of Beauty* (1778), pl. 16. Engraving. (Photo: Courtesy National Library of Medicine, Bethesda, MD).

to the absoluteness of naked geometric signs. We comprehend that such brief images are, in fact, a kind of logic for revealing states of mind.

In the pursuit of a cognitive history of images, the other world is always also the inner world. This quest to determine the birth of the universe, the emergence of art, the rise of early civilizations, comparative mythologies, remote religious rites: all involved the paradoxical realization that one had to go as far as possible outside the modern self to find the self.[61] Certainly, much of Romantic art and poetics deals with estrangement. The fragment as detached from some immaterial whole features in Novalis's (Friedrich von Hardenberg [1772–1801]) chemical aphorisms or the young Friedrich Schlegel's rhapsodic cryptology.[62] The Jena Romantics, in particular, challenged Kant's efforts to formulate a total epistemological system.[63] Reacting to the critical writings of Johann Gottlieb Fichte, they made the nondiscursive structure of consciousness—for which the symbol became the dominant correlative—resemble such arresting nonmimetic forms as mathematical formulas, algebraic combinations, arabesques, and allegories that were the perceptual isomorphs to concepts.[64]

This dissociative form—the graphic correlative to corrosive irony, bipolar madness, and the failures of reason[65]—also had an associative side. Coleridge, for example, conceived the fragment as a mimetic symbol. It bonded or bridged gaps instead of multiplying divisions. This affirmative analogical, not negative allegorical, structure was permeable, enabling the "translucence of the special in the individual."[66] William Blake also believed that diaphaneity was necessary to perceive ultimate shape with clarity. When the underlying linear armature of a composition shines through to the surface, the viewer is rescued by art—both ethically and epistemologically—from either sinking into the disorder of opaque matter or drowning in his or her own material sensations. It is to this lucid construction of the contours of the self as a way of reflective knowledge—in tune with an abbreviated visual system of universal ("unconditional") lines and forms—that we now turn.

The Romantic conviction, echoing Plato, that geometry constitutes a core set of intuitions present in all human beings is now in the process of being confirmed. Cognitive scientist Stanislas Dehaene of the Collège de France and anthropologist Pierre Pica of Paris VIII University have been using two nonverbal tests to probe the "conceptual primitives" of the Munduruku, an isolated, largely unschooled, Amazonian indigenous group. His team discovered that both adults and children were able to discriminate and make use of basic geometric concepts such as points, lines, parallelism, right angles.[67] Although Dehaene is careful to say he has described an innate ability rather than an innate knowledge—resulting from the brain's predisposition after millions of years of evolution to internalize space, time, and number from the external world—this finding suggests that across very different cultures one sees "common foundational sets of abilities."[68]

No group of poets, artists, antiquarians, and mythographers—despite their diversity—thought more about the formation of their own, other culture's, and other epoch's mental processes than did the Romantics. This comparatist generation was the first to make it a central premise of their researches that the study of life and the study of the earth was integral to the study of the mind and its evolution. William Blake and Samuel Taylor Coleridge, David Hartley and Erasmus Darwin,[69] Caspar David Friedrich and Philipp Otto Runge, William Young Ottley and D. P. G. Humbert de Superville: all paired historical inquiry into what Semir Zeki refers to as "the modularity of visual aesthetics," the extraction of constants and regular features of objects and surfaces through functional specialization,[70] with the pursuit of something larger. Like Vico and Herder, they were interested in finding the pattern behind mental development. Believing that nothing was more widely shared than the imagination, these polymaths hunted for the signs of an ever more primordial idiom as a testimony to the development of the human mind from animal-like conditions.[71]

This commonality is possible, as Jean-Pierre Changeux argues, because the human brain through a combination of innate predispositions and habits of learning by trial and error extracts regular features from the environment and organizes them into basic conceptual categories. [72] Importantly, Zeki points out that the brain can only have a Platonic ideal of a form that it has actually seen. If, through some pathological condition (like the well-known Molyneux Problem of having been born blind and only coming to see later in life), it will be unable to recognize or combine many forms into one. This Platonic pre-existing ideal is thus the stored visual record of a brain that has been exposed to many forms from which it then extracts/abstracts "what pre-exists within us."[73]

The brain's "quest for essentials"—the distillation from a succession of views of those formal constants that do not change from moment to moment (horizontals, verticals, diagonals)—also helps in understanding its projective/predictive tendency. The most notorious attempt to systematize this impulse to generate epistemological certainty from natural consistencies can be found in the anatomizing tactics of the late eighteenth-century "science" of physiognomics, and its extension in the divinatory "head reading" of phrenology.[74] These pseudosciences maintained that because cognitive functions could be "localized" at the psychological level they necessarily corresponded to individual facial traits or, in the case of the "Schädellehre" of Franz Josef Gall (1758–1828) and his dissectionist, Johann Gaspar Spurzheim (1776–1832), to separate neural compartments externalized on the skull and visible in its contours.[75]

Foreshadowing Zeki's and Ramachandran's research, nineteenth-century phrenologists posited the innateness of mental faculties and, in the words of the British surgeon William Lawrence, that "thought is an act of the brain."[76] More subtle as-

FIGURE 8
D. P. G. Humbert de Superville, *Animal Tracks and Hiero-glyphs*, from *Essai sur les signes inconditionnels dans l'art* (1827–32), fig. 94. Watercolor. Photo: Print Room of Leiden University.

sociative theories existed as well. Since the still image does not resemble the ever-changing appearances of the object, the eye is continually questing, imparting, or seeing meaning in things that have none. Such "real" marks, not just a visually projected extract of the natural space,[77] include the detection of figures in the cracks of stones and oracle bones to the decipherment of animal tracks as if they were glyphs (fig. 8).

To understand how humankind first began to think, we also have to look at evidence coming from evolutionary neuroscience: that vast, multilayered enterprise scrutinizing brain anatomy and physiology, but also drawing on diverse disciplines ranging from molecular genetics to comparative psychology. Unlike the chimp's, the human brain has been considerably reorganized. The disproportionate enlargement of the lateral prefrontal cortex with respect to the increase in absolute brain size (occurring some 50,000–100,000 years ago) helped increase the ability of humans to suppress reflexive responses to stimuli, thereby increasing behavioral freedom and the chances for rational reflection.[78] Genuine minds exceed either the in-

stantaneous reflex or the slow-based sensitivity of animals and plants to changing environmental conditions.[79] This rise of deliberation also has implications for the origins of art.

The recent discovery in Blombos Cavern three hundred kilometers from Cape-town, South Africa by anthropologist Christopher Henshilwood has dramatically brought the question of the origin of intentional making and abstract thought again to the fore. Henshilwood found nineteen small snail casings, each pierced with a small hole. This presumed necklace—since all the shells are the same size and have holes in the identical location—has been interpreted as 75,000-year-old "jew-elry," signaling that its creators "thought like us."[80] Not unlike Vico, Henshilwood deduces from this fragile archaeological artifact that modern thought arose when humans found the imaginative occasion to "hold" mental content in an external form.[81] The next step was distribution.

Among the important implications of the discovery of mirror neurons, as Ra-machandran reminds us, is that the explosive evolution of the ability to imitate or mime complex skills enabled their cultural transmission.[82] But we remain in the dark about the interactive context of such development. Perhaps this ignorance serves as a cautionary reminder of the limits of brain modularity research—despite its revelations. The complexity of the eighteenth-century inquiry forms a useful his-torical antidote to the downward slide of reductionism that haunts those branches of contemporary neuroscience investigating cortical geometries and brain modu-larity. Tapping into multicultural evidence for how we see, hear, and touch adum-brates Joaquin Fuster's call for a "Copernican shift" in functional models of the cortex, moving away from a modular and toward a connectionist network view of cognition.[83]

SELF-ALIGNMENT

What novel natural phenomena—abstractly or emblematically commemorated in the architecture and sculpture of ancient Egypt, India, and China—first made such a powerful cognitive and emotional impact on the observer's unconscious? We are completely unaware of this critical sensory system, which itself is but one of many nonconscious perceptual systems.[84] Yet it is precisely such systems that automati-cally organize and interpret information we take in through our senses. These sys-tems transform light, color, and sound waves into images or noises of which we are consciously aware. A great question for the Romantic generation was how does looking at the entire spectrum of art practice—from the archaic to the present era—help us access nonconscious modes of thought?

The new Romantic sciences of natural history, geology, paleontology, archae-ology, and prehistory offered tantalizing clues to the origins of the earth's pres-ent-day features, based on material evidence of multiple deluges and serial extinc-

tions. These cryptic "puzzle elements"[85] (fossils, fragments, relics, ruins) spurred interest in the investigation of the ongoing history of humanity. How does art, especially in its earliest incarnations, enable us to detect the cognitive apparatus of its original creators. Why, for example, do vaulted caves, pyramidal tombs, colossal funerary sculptures still maintain their power to seize attention and induce a sensation of sublime awe? (fig. 9). What makes people persist in replaying the formal categories handed down to them from the distant past? These are all questions that, when viewed from the perspective of neuroscience, reveal how forward-looking the Romantics were in understanding that creating, feeling, and decision-making functions somehow ride atop biological systems that operate largely beyond our awareness.

FIGURE 9
D. P. G. Humbert de Superville, *Colossus of Memnon*, from *Essai sur les signes inconditionells dans l'art* (1827–32), pl. 3. Engraving and watercolor. Photo: Print Room of Leiden University.

From Court de Gebelin's multivolume *Le monde primitif* to Humbert de Superville's *Essai sur les signes inconditionnels dans l'art,* a concise alphabet of geometrical forms was believed capable of unlocking the secrets to humankind's collective unconscious, that is, to its phenomenological/neural archive of evolution and development. As early as 1786, Sir William Jones recognized that symbolic meaning had been widely assigned to directional, specifically lateralized behavior. Even modern languages take note of the asymmetry of our bodies and the universe at large. But, more important for our purposes, Jones's affirmed that this orientation of consciousness was recorded in three ancient languages with strong affinities, namely, Sanskrit, Greek, and Latin.

The ubiquity of directionality, in this case the favoring of right and the tabooing of left (sinister!) commemorated in kindred languages is "[more] than could possibly have been produced by accident."[86] Orientation is also central to those small number of geometrical signs thought to distill the particulars of our primitive ancestor's traumatic encounter with hostile forces of upheaval. Cross-cultural comparisons—from the evidence of travel literature, comparative religion, and comparative mythology—made it possible to correlate these downward, horizontal, and upward oriented lines and shapes with a trinity of color terms: black (dark blue), white (light), and red. These visual formulas were believed to encapsulate traumatic, earth-shattering occurrences whose original mind-sculpting effects were reinforced when similar upheavals happened again. The stronger the impact, the more indelible the memory (see plate 1).

Much like Goethe's Paracelsian *Theory of Colors* (1810)—an "operative" science generating affinities[87]—this expressive system in which the sensual impression of light and color gave rise to a corresponding emotional response was part of a larger theory of an abnormally divided nature.[88] What is significant about Goethe's dialec-

tical theory of colors (in contrast to Newton's theory of the spectrum) is that hue is *inherent* in material objects and a *direct* manifestation of their primal substance.[89] Contrastive or broken chromatic phenomena—the actions and sufferings of tinted light as well as of the perceiving subject—were seen as simultaneously physical and psychological, sensory and symbolic. Significantly, this powerful and immediate phenomenon—visually summarized in the abrupt parataxis or side-by-side inlay of the color primaries—still closely corresponds to Brent Berlin and Paul Kay's twentieth-century "grammar" of universal color symbolism.[90]

Myth, from the Bible to the Vedas, was ransacked for clues of early humankind's mental states as it struggled to survive in a catastrophic universe. These apocalyptic narratives overwhelmed the reader with sublime moments of creation and simultaneous destruction. The Romantics intuited what we know today, namely, that as early humans colonized northern latitudes, they had to cope with the dramatic environmental changes of the Pleistocene. In this drastic atmosphere, the need for social cooperation became greater and gave birth to transmittable social behaviors and institutions as well as inevitable tensions.

Those initial vivid emotions of pain, pleasure, and joy—stimulated by the jaw-dropping sight of careening meteors, spewing volcanoes, tsunami floodings, postimpact cooling, followed by centuries of global warming[91]—persist in the remembered present of our neural networks and are reawakened today when we experience similar global traumas. This transformation of raw material events into psychological categories is not so strange when we consider that only now are brain researchers beginning to understand how fear and inhibition operate in the prefrontal cortex. We know, for example, that the premotor cortex (the center of activity for actions) responds more strongly to novel images than to habitual sights to which the observer has become desensitized.[92] Further, chronic stress due to habitat loss, the disruption of family relations, and sudden unprovoked violence is now being shown to affect a "trans-species psyche."[93]

Art and literature in the first two decades of the nineteenth century were dominated by catastrophism and by narratives of ruptured, broken, and decayed genealogies that conjoined biology with turbulent ecology.[94] William Blake's color-printed painting of *Nebuchadnezzar* (fig. 10)—forming a pair with *Newton*—evokes this dysfunctional primitive and material world in which the mad king eats grass.[95] The Biblical cataclysms of the young William Mallord Turner, Francis Danby, Jacob More, and John Martin in Britain, and the deluges of Girodet or the Dantesque horrors of Géricault and Delacroix in France attest to a new *mentalité* all too aware of disasters of cosmic proportions. These works are filled with acute anxiety and a spirit of prophesy anticipating a coming apocalypse. But the Romantics also defleshed and generalized these recurring devastations of legendary proportions. They were the first to purify the horrifying details of such geological upheavals, transforming them into a formal collection of pathos-laden signs.

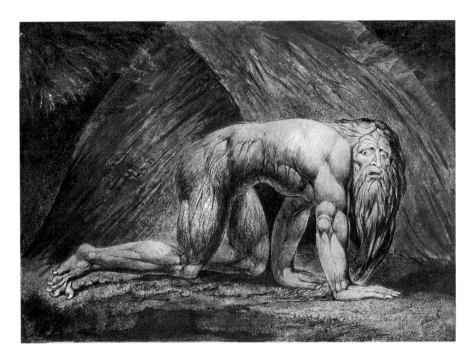

FIGURE 10
William Blake, *Nebuchadnezzar*,
1795–1805. Watercolor on
paper. Photo © Tate, London
2005.

Upward or downward-inclined lines, upright or inverted isosceles triangles, circles, and squares schematize the sublimated violent tale of the formation of the solar system and suppressed recollection of the battle-to-the-death for the survival of the fittest. Paleoanthropology supports the picture of combative cross-species rivalry during the dark time of the emergence of modern humans. The evolutionary branches that led to Neanderthals and us were ruptured half a million years ago.[96] Humanity was thus stained with blood at the very birth of the species.

If it is far-fetched to suppose, as some have protested, that modern humans and those evolutionary dead ends, the Neanderthals, must have had contact with one another at some point and that these grisly folk appear to live on, not in our genes, but in our fables and nightmares, then the problem of how we became human continues to tantalize. On one hand, Steven Mithen imagines a continuum. He accords our prehuman ancestors an important, if hypothetical, communicative capability— captured in the acronym "Hmmm" (holistic, multimodal, manipulative, and musical). These chunklike utterances, holistic units rather than words to be combined, he argues, constituted the original matrix from which *Homo sapiens* eventually developed grammatical speech.[97]

I find his theory of a limited "holistic" repertoire of grunted greetings, barked statements, and gestural requests—sustained in thought and behavior—and ultimately elaborated to incorporate mimesis (Hmmmm), provocative. His admittedly controversial proposal that separate words arose by a process of segmenting these primitive units, thus facilitating their compositional recombination, is especially pertinent. Not in the least because it corresponds to the Romantic view of early-human

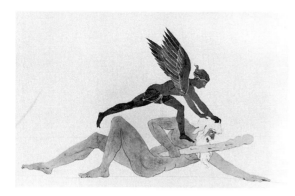

FIGURE 11
D. P. G. Humbert de Superville, *Genius of Death and Giant* from a Greek vase showing Hercules killing Alkyoneus (after Tischbein), from *Essai sur les signes inconditionnels dans l'art* (1827–32), fig. 102. Watercolor. Photo: Print Room of Leiden University.

condensed emotional expressions (visible in facial features, symmetrical sculpture, monolithic architecture) as evidence of mind. These chunked nonverbal *symbols* (which strong circumstantial evidence suggests were made and used by *Homo sapiens* as long as 100,000 years ago) were taken as demonstrations of early human's ability to imagine the emotional states of another individual as being similar or different from one's own.

David Lewis Williams, on the other hand, infers from the wordless evidence of cave art that there was a decisive break occurring between the period of Neanderthal man (c. 220,000–45,000 BC) and that of *Homo sapiens* (45,000–10,000 BC). The picture he paints of the Upper Paleolithic is of a time of social diversity and fierce change in which image making, like everything else, became an arena of struggle and contestation.[98] Gory legends of fierce giants and Medusan monsters fascinated the Romantics insofar as they came to haunt the myths of the first great civilizations (fig. 11). They were thought to be confused memories of actual fearful encounters occurring during a tumultuous period of hybridization that remained etched in the psyche.

Despite their differences, Williams and Mithen share a deep interest in archaic patterns of communication that range far beyond the privileging of language. It is precisely such mantic systems predicated on ritual and performance that had fascinated Vico and Herder incorporating everything from entopic imagery, to depictions, to sounds, and movements.

L'Essai sur les signes inconditionnels dans l'art (published between 1827 and 1832 although written much earlier) was part manifesto for a new, minimalist aesthetics, part general method or scientific protocol, and part diagram of the emergence of human consciousness. Its compact pictograms combined the utopian visionary projects of the French revolutionary era with the rise of *ideologue* universal-language schemes by Jean Delormel, Joseph de Maismeux, and Destutt de Tracy.[99]

Humbert thus stands in the distinguished line of such early linguists—stretching back to the Port Royal grammarians, forward to Noam Chomsky's Cartesian linguistics and Steven Pinker's nativist arguments on the similarity of languages.[100] His preoccupation with a theory of general grammar, similarly, has as its deeper aim the desire to illuminate our common intellective faculty. But, for him, the burning question did not revolve around a stark vocabulary of words. Rather, it was concerned with how elementary forms and colors net or catch intricate congeries of meaning over time. The belief in a universal skeletal graphism lurking beneath the diverse appearances of the visual arts takes us back to Renaissance and Baroque philosophers who devised a metaphysics from forms. The structure of this "characteristic" was based on the natural pictographic writing of things.

Pico de Mirandola, relying heavily on the later Neoplatonists Porphyry, Iam-

blichus, and Proclus, read nature as a book written by God in the formal language of mathematics—those triangles, circles, and other geometrical figures that Kepler would later cite. But unlike numerals, the efficacy of such "characters" used in natural magic came from their shape.[101] Marsilio Ficino, too, wanted to find the mathematical structure underlying appearances. The world soul, like the "triangular" powers of the human spirit, exhibited itself in a Platonic trichotomy. The human soul obeys a sort of arithmogony whereby its return from the sensible world to that of *mens,* or the intellect, is pictured as moving to the top of an isosceles triangle.[102] Giordano Bruno, evoking Pythagorean mathematics, used "figures" to understand the essential being and substance of natural objects. The mere sight of these geometric signs helped produce "coincidence" or congruity of contraries.[103]

Seventeenth-century scholars were also smitten by the prospect of unearthing a primeval theology from mineral-like traces. This fossil "script" was the natural corollary to the "curious" markings of Nordic runes or Etruscan letters.[104] There were numerous, less rhapsodic, attempts to create a communicative art of expressing our minds in succinct characters as well. Although one can dispute how rational they in fact were, the Royal Society launched many such schemes. George Dalgarno and John Wilkins wanted their universal languages to be "real characters," that is, systematic and "philosophical," discovering the true properties of things and motions to the user. James Bono has characterized this Galilean "drift away from words and symbols" toward a nature composed of distinctly etched geometric forms, as the "de-inscription" of the Book of Nature.[105]

But let's return to the specifically eighteenth-century couplings of grammar with a schematized logic in the construction of a universal language. These efforts at compressing complex information coincided with the broad educational ideals of the Enlightenment bent on discovering a single public system of communication that everyone could understand.[106] In the name of universal education, linguistic grammars were amplified by "visible language" methods of the sort that had been invented by that visionary reformer, Johann Comenius (fig. 12). The vast repertoire of Baroque emblem books—fabricated from a shared code of compounded images and "ready-made discourse"[107]—forms an important chapter in this pedagogical history. During the following century, however, this hermetic visual language also gets democratized in a popular literature of expressive "figures." These performative object-fictions wittily wrest depth from shallows or "pump up" a flabby form. Such comic novels, stocked with independently-behaving shapes and anthropomorphized artifacts, conjure up "round" or "flat" characters and "swelling figures" who freely auto-organize themselves and even expand their inner life with sensibility.[108]

This preoccupation with enactive symbols—high or low—points to a belief in underlying commonalities of thought. It represents the culmination of at least two centuries of concerted inquiry into linguistic universals, broadly construed. By the late eighteenth century, the history of language as a history of concept formation had been complicated not only by pictorial, but also by manual rhetorics. Attempts to rediscover the gestural codes of the distant past infused studies of the theater, pantomime, choreography, and the "hand-portraiture" or "finger-speech" of the deaf. According to Jean-François Champollion, even the Egyptian hieroglyphics were evidence of speech-in-action mediating the relationship between the realms of possibility and reality.[109]

Since the nested and relooping brain (especially the temporal lobes) seems to recruit the same areas and structures over and over in various combinations in the building of our experiences, it does not seem extravagant to argue that the sight of shape and color radicals might awaken memories of a distant cognitive heritage. This issue has been brought dramatically to the fore again. In light of the intense recent focus on isolated and mysterious Easter Island (now known as Rapa Nui)—revising its environmental history and the dates of the construction of its eerie statues—it is notable that Humbert de Superville was accurate in his analysis of the formulaic features characterizing the monuments, presciently linking them to eastern Polynesian commemorations of the dead.[110]

From current radiocarbon dates, it appears that the drastic degradation of the ecology of this marginal outpost in the Pacific Ocean coincided with the late appearance of the first humans (c. 1200 CE, rather than 400 CE, as previously thought). Moreover, the construction of the famous colossi is now thought to have occurred shortly after this initial settlement, not a century or so later.[111] This means that the rapid overgrowth of the founding population had an immediate, devastating, and visible impact on the landscape as well as the inhabitants. Visions of impending cultural collapse and inevitable death—accompanying the bitter realities of abrupt deforestation and the introduction of the omnivorous Polynesian rat—could well have prompted, so it is argued, the carving of these immense apotropaic memorials.

First discovered by the Dutch explorer, Jacob Roggeveen, the gigantic stone statues—many of them long since toppled—were scattered over the sides of the volcanic crater Rano Raraku, as well as transported to distant stone platforms lining the rugged coast. Roggeveen, who spotted the desolate and denuded atoll on April 5, 1722, described the fifteen- to twenty-foot looming black statues and the presumed red "hats" they were wearing (fig. 13). He did not realize that his expedition would deliver the final coup de grace to the remaining straggling natives since it introduced New World diseases to an already weakened, nonimmune population.

But it was Humbert de Superville who tied together the facts of the red (used for the heavy cylinder or crowning *pukao*) and dark gray / black volcanic tufa (used

for the quadrangular or hermlike bodies of these Moai) with the bones found beneath the *ahu* (platforms). The colored materials and geometric shapes, taken together with the dominant downward-slanting lines composing the diagrammatic facial traits, allowed him to connect these lithic giants to Polynesian funerary cults. The latter were widely known since Captain James Cook reported on his third voyage to the Pacific the discovery of analogous objects and rituals for the dead found on Cook and Society Islands, the Marquesas, New Zealand, and Hawaii. Vulcanism and the outbreak of other natural or manmade cataclysms were thus chillingly visible in the frightening destruction of Easter Island as well as other ancient societies stretching from Egypt to Mexico, as documented by their surviving monuments.

Putting together the local intrinsic information of the strongly abbreviated pattern of eyes, nose, mouth with the contextual cues coming from the torso allowed Humbert to demonstrate what scientists are proving today,

FIGURE 13
D. P. G. Humbert de Superville, statue of Easter Island (after La Pérouse), from *Essai sur les signes inconditionnels dans l'art* (1827–32), fig. 62. Watercolor. Photo: Print Room of Leiden University.

namely, the way visual brain areas progressively abstract away statistical regularities in the environment. But there is a combinatoric at work as well. Contextual cues participate more directly in object representations when the representations containing some embodiment of likely contexts in which a given object might occur.[112] That is, the depleted site is itself imbricated in the fragmentary appearance of these stark cultural remains.

Not surprisingly, given the age and complexity of the human brain's material makeup—part "wonder tissue," part oscillating electrical wave, part impersonating or mimicking computational system[113]—our experience of experience is correspondingly multileveled. This convoluted mental stratigraphy also sheds light on why many conscious events seem to possess both an abstract and a sensuous character. The brain is simultaneously an externally directed, selectionist mechanism—dynamically framing its environment through variance in the populations of neurons and an internally organizing system—solipsistically occupied with itself in the regulation of its diverging and overlapping dendritic arbors. This ambidexterity is brilliantly mirrored in the constructive combinatorics and self-generating automa-

ticity of the Romantic work of art. Whether embodied as broken fragment or immersive encyclopedia, the Romantic object possessed the dual ability to capture experience in discrete units and as a dream of engulfing immersion.

This doubleness of Romantic form receives added meaning when we consider that the brain-mind is a vacillating and oscillating organ of thought. Recall Keats's maddening injunction to juggle competing states of mind, resulting in the balancing act of "negative capability." Remember William Wordsworth's, Lord Byron's, and Charles Lamb's experimentation with "psychological theater," paradoxically yielding largely unactable plays.[114] In his dramatic pieces and essays, Heinrich von Kleist produced an almost irreconcilable tension between idealistic notions of individual freedom and inescapable automatism: the irony of conscious awkwardness and unconscious grace.[115] As Alan Richardson has argued, any number of motifs routinely assigned to literary Romanticism—a split psyche, the re-evaluation of feeling, the importance of instinct, an active rather than a passive mind—can be situated within the biological psychologies sprouting up in the period.[116]

I have added form/formalism to this impressive list. Think of the viewer's Coleridgean struggle to bring the multeity of aroused conscious and unconscious sensations into focused awareness when viewing Caspar David Friedrich's antinomian pictures of moonlit harbors, forest interiors, solitary oaks and cairns (fig. 14). These painted ciphers, often skeletally constructed from compass-drawn lines, are pervaded by a strong symmetry that dissolves solid objects into mathematical units of ones, twos, or threes and then precipitates them out again in thin coats of paint. We feel ourselves to be in the presence of some primal mentalese (a preverbal and autonomous representational system) that is simultaneously grounded in an abstract system of schematic polarities as well as in the opaque world of things. Without story, these thin structures visually coordinate inside with outside. The reedy silhouetted subject is thus attuned to the Spartan and moody environment and takes on its psychological coloring.

Further, these dark or "tragic" pictures stimulate an ongoing back-and-forth perceptual as well as cerebral juggling in the beholder. The viewer is impelled to shuttle between an underlying, self-assembling scaffold and a transparently overlaid ethereal landscape. These puristically distilled paintings, often conceived as emotionally contrastive pairs, are ruled additionally by a formal compositional logic. Works dominated by a strong vertical axis (ship masts, neo-Gothic monasteries, chalk cliffs) are set against those organized in ribbonlike strata (seashore, meadows, snow drifts).[117]

Even within the individual picture, the insistent dialogical structure never permits the beholder to lose sight of the deterministic mechanics underpinning the iconic scene tenuously floating above it. Each distinctive aspect of a natural feature —whether solitary oak tree, the ruined abbey of Eldena, or a rock outcrop in the Riesengebirge—is processed by a different micropart of the visual brain, as Semir Zeki has taught us, yet all layers appear to be reflected in consciousness at the same time (fig. 15).[118]

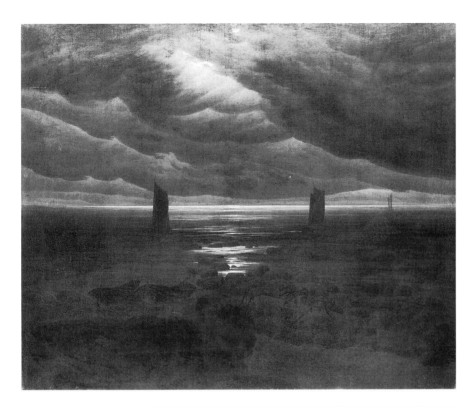

FIGURE 14
Caspar David Friedrich,
Coast by Moonlight, 1835–36.
Oil on canvas (134 × 169.2
cm). Photo: Fotowerkstatt
Hamburger Kunsthalle.

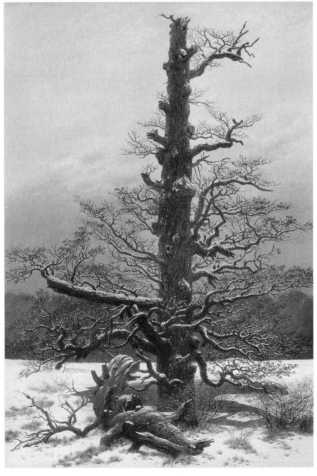

FIGURE 15
Caspar David Friedrich, *Oak
Tree in the Snow*, c. 1829. Oil on
canvas (71 × 48 cm). Photo:
Staatliche Museen zu Berlin.

This Romantic, situated and performative *prehistory* of formalism has been forgotten—overwritten by a poststructuralist art history of exhaustion. On one hand, the universalist side of the Romantic project (in fact focused simultaneously on the schematic *and* the empirical) became discredited as a case of logic-obsessed "historicism." Like the critique mounted against Georg Wilhelm Friedrich Hegel, Wilhelm von Humboldt, Auguste Comte, or Gottfried Semper, interest in the rules, laws, or patterns underlying historical representations was taken to be a sign of disinterest in their political and cultural significance or material situation.[119]

On the other hand, during the late twentieth century, the minimalist notion of form as a taut process shaping or making something present to mind was further overwritten by the negative and allegorical discourse of loss—think of Jacques Derrida's emphasis on break or rupture or Paul de Man's sense of futility. This bleak outlook ignores Kazimir Malevich's insight that nothingness is not an end but a pivot for renewal. Shapes—squares, circles, crosses, rectangles, triangles, disks, and lines—are otherworldly and joltingly direct, cerebral, and brusquely physical at the same time. Writing about Suprematism as a numinous art pregnant with creative possibilities, he said: "It is from zero, in zero, that the true movement of being begins."[120] But our more recent exposure to the formal repertoire of negation—pieced together from omissions, gaps, deferrals, and ellipses—makes it difficult to imagine ourselves back into a time when schematic figures were not hermeneutically overdetermined or, conversely, cold and empty, but revealed something essential about how the brain generates reality.

I want to conclude, as I began, with the work of a contemporary artist. Thomas Struth's photographic corpus represents a powerful alternative to the reductive and peeled-back rhetoric of impoverished words and pictures in which we have become trapped. His *Gallery* series illuminates how socially diverse and entropically scattered modern viewers, standing in the world's great museums, unconsciously align themselves with schemata implicit in the painting on the wall that they are beholding. A telling case is the group of tourists diagonally fanning out in front of Gericault's *Raft of the Medusa,* mimicking and so internalizing the compact triangular structure of this natural and human disaster until it gets lodged in the bone (plate 3).[121]

These deceptively matter-of-fact photographs implicitly underscore the psychophysical disarray accompanying the new logic of computer culture. Struth revealingly juxtaposes today's fragmented family groups, aggregated in twos and threes, or hordes of milling masses, with past systems of ordering. With these stark confrontations between the disorderly moderns and the hierarchical tiers of medieval saints and sinners climbing the façade of Notre Dame Cathedral in Paris (fig. 16), or with the oppositional frozen passions unfurling on the friezes of the Pergamon Altar in Berlin (fig. 17),[122] or with the layered and pyramidal social stratigraphy governing Raphael's *Stanze* in Rome, Struth profoundly historicizes our conception of formalism again.

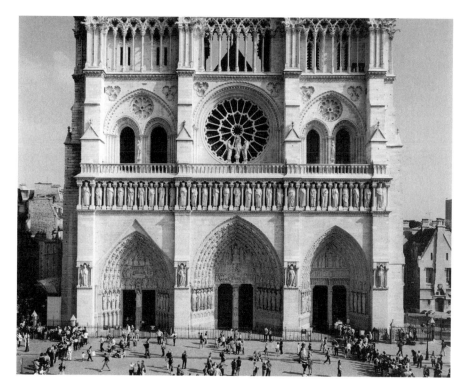

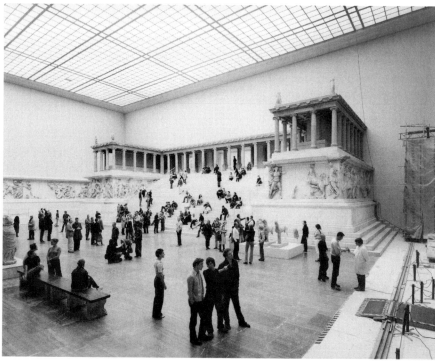

This is not to deny that, like Belgian installation artist Joelle Tuerlinckx, Struth also manages to capture the contemporary observer's cognitive disorientation stemming from too much familiarity with the Internet and too little with the world of tangible things. His viewers' disarray surely also owes to constant exposure to the database logic ruling many new media objects: endless and unstructured collections of images with every item possessing the same significance as any other chosen from the menu.[123] Only now, with the coming of the omnidirectional space of the digital—constantly varying its angles and coordinates—does the venerable organization of space with respect to our characteristic upright posture lose its privileged directionality.[124] But Struth does not stop with the new realities of distributed aesthetics. He penetrates the neural logic of selection itself—the ways in which our autopoietic architecture responds to what it has earlier assembled and still dimly recognizes.

Jeff Wall's monumental lightbox cibachromes similarly invent a new cognitive visual idiom, the staging of a scenography in which the process of attention attains visibility. Avoiding Struth's surface parataxis, Wall pursues the accretions of thought or the lengthening depths that exist behind every image. His *A Sudden Gust of Wind (after Hokusai)* prompts the viewer to recall the composition of a nineteenth-century woodblock print—whose memory is embedded in the schema of this late twentieth-century photograph (plate 4). We are enjoined to relive the structure of that past moment by internally reperforming it, just as Wall's figures reenact a now timeless formal order in which only the appearances of the actors have changed. Struth's horizontal, and Wall's vertical, procedure link these contemporary artists to the formal systematics of Romantic artists like Humbert de Superville and William Young Ottley who "discovered" for the diffuse nineteenth century the terse Italian "primitives": Giotto, Duccio, Orcagna, Buffalmacco, the Master of the Triumph of Death, and a host of other pre-Raphael *trecento* and *quattrocento* masters of expressive concision. In either case, our attention is shifted away from the distracting material object and immersed in the underlying creative formula or information-carrying signal.

This sort of self-consciously formal imagery, going out of its way to equip visualization with cognition, brings back deeper results. I have tried to show how the Romantics made the intellectual passage from a clump of earth to a sign. In his insightful essay on "Circulating Reference," Bruno Latour talks precisely about the problem of how people get transported from thing to representation, from three-dimensional objects to two-dimensional diagram, chart, table, drawing. He reminds us that what "we lose in matter through successive reductions of the soil, we regain a hundredfold in the branching off to other forms that such reductions—written, calculated, archival—make possible."

The summarizing, elementary forms of mathematics and geometry "make matter cross the gap that separated it from form."[125] But as the Romantic systematizers understood, these graphic elements could never be completely decoupled

from their material and psychological origins nor from their continuing historical evolution away from that original situation. Such mobilization applies to the viewer as well. If your moves are not to be wasted, you have to return with new *things*.[126] Latour also cautioned that these things that you have gathered and displaced—in my case the discussion of form/figuring from the neuroaesthetic perspective and vice versa—have to be presentable all at once to those you want to convince and who have not before gone to those strange realms. In his spirit, I have tried to invent new sorts of objects that have the property of being mobile—moving between disciplines—but also enduring in their reverberating presence and combinability.

COMPRESSIVE COMPOSITIONS

Emblem, Symbol, Symbiogenesis

Even remnants of "microbial mind" can be inferred from behaviors of thriving microorganisms. All of the eukaryotes, not just lichens or an animal's neurons, are products of symbiogenesis among formerly free-living bacteria, some highly motile. Eukaryotes have evolved by the inheritance of acquired genomes; they have gained all their new features by ingesting and not digesting whole bacterial cells with complete genomes.[1] LYNN MARGULIS

Most novels are merely compendia of individuals.[2] FRIEDRICH SCHLEGEL

TECHNIQUES OF INLAY

Cognitive scientist and neurophilosopher Andy Clark has proposed that complex and unruly problems are "representationally hungry." They exert special pressure on the neural system to create corresponding inner patterns that display this mixed state of affairs.[3] Antonio Damasio has come at this issue of extreme activity of the brain from the other side. As biological entities—largely subject to the invisible dynamics of self organization—our neural systems have to "grapple with the inertia of an internal ebb and flow of auto-perturbing patterns."[4] The argument of this chapter is that demanding image formats, inlaying, not blending, diverse sensory inputs, allow us to witness how the brain-mind cobbles together conflicting bits of information. Gapped or mosaic-like compositions make the labor of thinking inseparable from the perception of the object. Encapsulating structures specifically elicit both our considered attention and provoke the performative impulse to piece different stimuli together.

Reticulation springs from a powerful sense of fragmentation, an awareness that the phenomenal world is always in a state of sketchy build-up or of disintegration verging on ruin. Art has had a longstanding role as an almost magical coordinator as well as concentrator of elusive, shifting, and out-of phase experiences. But syncretistic or insetting genres, in particular, possess the special ability to make the difficulties of sensory and intellectual coherencing perceptible.

Synchrony—musically evoked by the Kaluli people of Papua New Guinea as "lift up over sounding" (a coming into unison above the incessant noise of drums, waterfalls, forest murmurs, cooperative singing)—perfectly captures the challenge posed to any formal structure intent on showing the coexistence of individualistic,

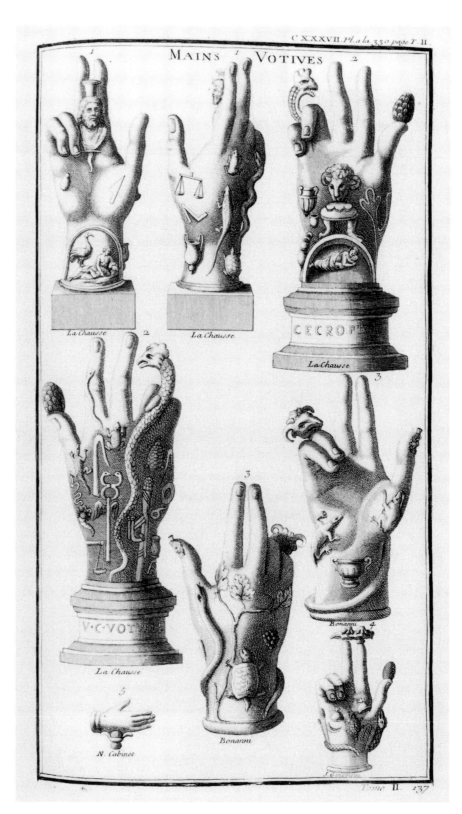

FIGURE 18
Bernard de Montfaucon,
Votive Hands, from *L'Antiquité
expliquée et représentée en
figures*, vol. 2.2 (Paris, 1719),
pl. 137. Engraving. Photo: Her-
zog August Bibliothek Wolfen-
büttel.

competing, and fissionable parts.[5] The anthropologist Victor Turner, in his analysis of rites of passage, argued that this coincidence of opposite processes and contrasting notions in a single representation characterizes "the peculiar unity of the liminal: that which is neither this nor that, and yet is both."[6] Certain dense and interstructural kinds of artwork, I argue, permit us to see the synchronizing cerebral processes involved in vision, that is, the process of an image of the visual world actively constructed by the cerebral cortex after having discarded extraneous information.[7] Such composites render visible neural cooperation and normally invisible operative forces of the central nervous system.

To be concentrated is to be symbolically powerful. Consider those two distillates: the double-faced *symbolum* and the tripartite emblem.[8] These time-honored modes of compacting myriad appearances into an intensified medley provide evidence for the phenomenological embeddedness as well as distributedness of thought in "effective environments" both natural and social (fig. 18).[9] As the Neoplatonic philosopher Porphyry said concerning the wonder-working capabilities of stamped seals and the correspondence-inducing operations of amulets that are able to contract the agency of a divinity within a material substance—such solid symbols are "mind-dependent but also real."[10]

As to emblems, I refer to those enigmatic complexes compressing enormous amounts of information that populate early modern European collections of prints. Such inorganic compounds appropriate the content-laden forms of other ready-made structures into a larger mesh or lattice. The system operates by detaching its constituent parts from more diffuse wholes and then integrating them into a new crystal-like arrangement. Isolating individual components from their customary background, or dissociating them from some overall context serves to exclude other data (fig. 19). This focusing procedure highlights images that would otherwise slip by our attention or be absorbed unthinkingly. When plucked from a narrative flow, they become salient objects for reflection. This dual process of first prying apart and then patching together into a novel unit yields ill-sorted and fantastic objects demanding to be noticed and thought about. Because the extrapolated items appear so unnatural as to be shocking (i.e., nonmimetic, not imitating or resembling any one thing in the world) they stimulate our imaginative powers of inference. More than that, they change the strength of our synaptic connections since their puzzling appearance counters habituation and augments sensitization.

The iconography of these obviously "made up" rebuses is simultaneously commonplace and ingenious: two eyes (without the rest of the face) situated against the backdrop of a stormy sky with arrows of lightning striking down to encapsulate the truism that "sight often gets human beings into trouble." Or, a

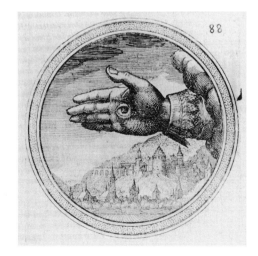

FIGURE 19
Julius Wilhelm Zincgref, *Oculata fides*, from *Emblematum Ethico—Politicorum centuria* (Frankfurt a.M.: Theodor de Bry, 1619–88). Engraving. Photo: Herzog August Bibliothek Wolfenbüttel.

bird perched on the summit of a rugged mountain peak accompanied by the terse motto, "I do not know" (*Quo me vertram nescio / Wohin? / Je ne sais pas / Non so*). Or, again, a disembodied hand descending from on high that holds a chain-link necklace to signify that "love seeks conjunction."[11] Or, finally, an eye embedded within a palm to show the necessary pairing of prudence with faith. Such tiled images or two-dimensional spatial groupings of unit cells set side by side allow the viewer to compare many different situations simultaneously. Interlocking decontextualizes ordinary objects and recontextualizes them as strange.

My interest in this special type of conjuncted form—popular from the sixteenth to the eighteenth centuries—is not as a historian of emblems, although that scholarship is deeply important to me and informs my argument. I believe the overtly assembled appearance of this intricate figure reveals something basic about such fundamental cognitive processes as reentry, connectivity, synchronization. Since the goal at hand is to understand the psychodynamics of images, my analysis focuses on the integrative structure of the *pictura* portion of the emblem. I am not alone in narrowing this focus. Nonetheless, it must be said that the complete emblem has a tripartite organization composed of a brief lemma or motto, the *pictura,* and an inscription (fig. 20).

The composite figure as artificial person proves that one's "parts" are not firmly attached to an invariant identity but scattered and recollectable from our surroundings, and put into relationship to one another. The "heraldic" body of the emblem is thus a matrix. This patchy shape stimulates the beholder to generate a hybrid entity out of the divided components of the universe.[12] Combinatorial symbols, too, as compressive cognitive acts tangibly externalize the otherwise hidden dynamics of synchronization. Further, because they compact detached or fractured forms, they demonstrate that, like the cosmos, there are many possible states that can coexist within a single visual format (see fig. 18). Covering a plane with closed shapes is both a physical and an epistemological action. It manifests how the brain's huge assembly of nonlinear oscillating elements gets swiftly tiled or integrated into temporally coherent aggregates. Perhaps more significant, it shows how a total visual scene suddenly presents itself to mind from an assemblage of partitioned elements.

This gnomic, ostentatiously pieced together body-object is also familiar to us from the present. In fact, it resembles a mechanistic or inorganic system. Like Humberto Maturana and Francisco Varela's autopoietic organizations, these composite machines self-define a domain of interactions in which their components can act with relevance to the maintenance of the system as a whole.[13] In this sense,

FIGURE 20
Georgette de Montenay,
"Sic vivo," from *Emblematum Christianorum Centuria* (Zürich: Ch. Froschauver, 1584),
pl. 21. Engraving. Photo: Herzog August Bibliothek Wolfenbüttel.

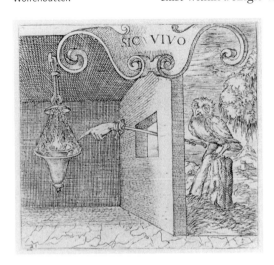

living systems (as well as aesthetic systems) are cognitive systems. Both represent different ways of looking at the same pattern dynamics shaping a relationship. One meaning of the term "artificial life" is the attempt to "make artificial combinations of matter behave like living protoplasm—that is, to make live matter out of the non-living materials lying all about us."[14] An additional connotation is the provocation of conjunctions between digital simulations and natural structures. This fascination with living organisms that are, ambiguously, also virtual artifacts, characterizes contemporary bioart.

Unabashedly a "creative" genetic engineer, Eduardo Kac invents new life forms whose competing forms of visuality uncannily resemble the segmented Baroque emblem.[15] The synthetic inlays of transgenic art—overtly composed of recombinant cellular bits and robotic pieces fabricated in a laboratory, like the quartered *devise* or heraldic *device* dividing Renaissance shields—similarly subvert the centrality of the human. Rather than anthropocentric ways of experiencing the world, what gets foregrounded is the alien and the mechanical.[16] Yet, paradoxically, both kinds of heterogeneous objects are artisanal products. Although coming from different times and places, they share the same virtuoso manipulation of material components and similarly flaunt the artifice with which they have been constructed.

The emerging universe of what Bernadette Bensaude-Vincent and Isabelle Stengers called "informed materials" is profoundly allied with those old undigested composites, the small inset emblem, and its prototype, the binding talismanic symbol of late antiquity.[17] In either case, instead of imposing a unitary shape on a mass of disjunctive material, the material structure self-organizes associatively through sympathetic correspondences.[18] One could say that the entire graphic system becomes richer and richer in information through the almost magical coordination of inserted parts. Importantly, both the ancient and the modern embodiment of the art and science of combinations is not so much concerned with discrete objects as with their relationship to complex informational and material ambients.

Today, we have become conversant with the ultimate type of self-assembling "little image." The inverted galaxy of the nanoscale (a nanometer is one billionth of a meter) world has been crisply captured in the opulent scientific photography of Felice Frankel.[19] Nanotechnology's compressive vertical engineering paves the bottom of the universe with embossed materials that paradoxically *are* the machine. This hybrid research attempts to understand and control matter at dimensions of roughly 1 to 100 nanometers, where unique phenomena enable novel applications. Nanofabrication looks at integrating bio-organic and organic materials by mixing and combining them.[20] Frankel's stunning computational visualizations of nanocrystals (collaborating with Harvard chemist George Whitesides) allow us to see that there is something inherently "emblematic" about this relational practice of making "little things" from small structures that interface with different materials.

Synthesis, not just nanosynthesis, remains a mystery. How do material entities, in Alfred North Whitehead's apt phrase, "enter into" or become present in the constitution of another entity.[21] Whitehead puts his finger on the dynamic nature of this intractable compositional problem. As James Bono has convincingly shown, this great, and still-influential, twentieth-century mathematician and metaphysician developed a process philosophy of organism rooted in the Harveian tradition of vital, working matter. Significantly, Whitehead extends this seventeenth- and eighteenth-century "ontologized" view of matter as situated in a world of agencies—documented in the medical and physiological treatises of Francis Glisson, Albrecht von Haller, Julien Offray de La Mettrie, Denis Diderot, and the post-Revolutionary anatomist Xavier Bichat—to deal with mutable living systems.[22]

If matter is inherently active, not passive or inert as mechanistic materialism would have it, the bedeviling conundrum remains: what animates this collection of molecules, cells, and organs? This simultaneously physical and metaphysical question concerning the configuring powers of matter—asking whether coherencing is innate or imposed upon, or added to, from the outside—is not restricted to chemistry and physics.

Whitehead's insistence upon the "unity" and "duration in time" of an "occasion of experience" (bearing a quality akin to "feeling") and its "infinite and undenumerable content" also haunts the neurosciences.[23] Are systems usually considered to be physical (the brain, for example), constructed in some sense from mental entities, instead of the other way around? Mentalists such as Leibniz, Whitehead, and Penrose variously think so, in opposition to strong materialists (Hobbes) or computationalists and hard proponents of neural functionalism such as Paul Churchland and Daniel Dennett. Andy Clark's distributed view of cognition is latitudinarian. Like David Chalmer's "pan-protopsychism," it is a double-aspect theory in which information has both physical and experiential features.[24]

Whatever one's position, the difficult question remains: how do we collectively build up a higher-order representation on the basis of many appearances, or construct consciousness from myriad global functional states. As Rodolfo Llinas puts it, when describing what he calls the "mindness state," it requires the conjunction or binding of all relevant sensory input to produce a discrete functional state that ultimately gives rise to a single self-aware action.[25] The difficulty, as Whitehead foresaw, is that the analysis of this dynamic inlay requires the isolation of one or more component parts, thus "injuring" the integrity of such "occasions."[26]

Every aspect of multilevel nervous system function—coordinating movement, feeling pleasure or pain, making decisions, forming concepts—is an act of combination that poses anew the problem of active synthesis. Significantly, the brain's vast network of neurons is connected at specialized junctions called synapses. These tiny bits of jelly form the bridge where an axon of a presynaptic neuron contacts

a dendrite of a postsynaptic neuron. A chemical signal neurotransmitter, released into the synaptic cleft from the axon terminal, binds or is received by receptor proteins on the other side.[27]

I find it striking that just as neuroscientists are demonstrating that the brain and the mind constitute a monist mosaic of emergent relations, new media artists are cobbling biological bodies to objects made by design. Neither entities are frozen abstractions nor do they merely programmatically unfold. Rather, their scattered parts must be spatially and temporally gathered together. Relying on imaging and electronic technologies, these shared scientific and aesthetic combinatorics oblige the observer to piece together a synthesis from computer modeling, data extraction, simulation, and other visualization modalities, just as the constitution of the living organism is the product, among other things, of long-term associations.

We see this replacement of things by processes in Eduardo Kac's *Genesis Project* (1999). This relational "event"—tying together genetics with computation—is as much a splitting experiment in synthetic biology (customizing microbes, remaking bacteria) as the wholesale remodeling of an organism's architecture.[28] In godlike fashion, Kac enables gallery viewers as well as Internet participants to create and compound bacteria mutations (plate 5). To be sure, beginning with the 2002 Corcoran exhibition, *Molecular Invasion* mounted by members of the Critical Art Ensemble, there have been many subsequent artistic probings of genetic breakthroughs including works by Kac himself. But *Genesis* still perfectly captures the persistence of the "brought together" emblematic process and its overtly configured appearance down to the present day.[29]

The work on *Genesis* began with the artist's translation of a line of biblical text into Morse code. The code was then recursively encoded into DNA and inserted into bacteria. The resulting live mosaic—with its fast-moving multiple components brought into sharp contrast—is displayed on a microscopic slide that is projected, enlarged, onto a screen in a darkened room. The installation—as a systematic interactive process—can also be accessed online, allowing the user (with a click of the computer's mouse) to focus ultraviolet light on the display, causing mutations in both the bacteria's genome and in the coded message. Art no longer imitates life, instead, as Kac states, "art is creating life."[30]

But this tinkering is also a compression of life. Creating living machines and biological devices (bacteria that blink on and off like Christmas tree lights or that can reproduce photographic images) collapses complicated biological circuitry. The human-as-machine approach abstracts or overwrites "hot, twitching, furry, and wet biology."[31] In her *Butterfly in the Brain* (2002) installation, Suzanne Anker explores at the macro-level what happens when diverse genetic materials become condensed through superimposition. Photographed through high-speed scientific instruments, including microscopes, telescopes, and MRI scanners, nature's morpholo-

gies morph. Enriched figures result from the precise overlaying of butterfly wings, constellations, chromosomes, neural patterns. These equivocal emblems are then transformed and defamiliarized into flat intarsia: they are laid alongside each other like colorful patterns in a tapestry and hung on the walls, or are set enamel-like into jewel-case vitrines (fig. 21).

The logic of concision also looms large in *Origins and Futures,* from her *Golden Boy* installation of 2004. Compression-by-juxtaposition governs the deployment of dazzlingly white embryo- sculptures scattered across the gallery floor. The perfected, archetypal male child—made with the help of the new reproductive technologies—is emblematized both as a sort of unique fossilized ammonite and as the depersonalized serial product of computer lathing. This bright, smooth artificial life form—repeatedly resulting from the visible merger of molecular biology with on-screen synthesis—is intercalated with glittering chunks of black pyrite that unfurl like some primeval carpet (fig. 22).

An assemblage of reprotech, interspersed with rough crystals belonging to the prelife earth and constituting the template for RNA, thus fashions a coarse pavement from genomic, geological, and cultural debris.[32] Redirecting Claude Lévi-Strauss, then, not just myths but artisanal emblems show the persistence and global distribution of such compounds able to "think themselves" in people's minds without their awareness.[33] Coupled to the evolutionary mechanisms of the phenomenal world, these synthetic entities possess no centralized self-consciousness. Rather, they embody the cold fusion of different realms of reality.

The contemporary topography of information is littered with similar logos and monograms—detachable figures laced together into a graphic composition or articulated into a relief.[34] As in *Pattern-Recognition,* William Gibson's fashion-allergic novel on global advertising, there is hardly an item or "design-free zone" of the world that has not been branded.[35] The current marketing maze of mismatched and decontextualized labels descends from such ancient bimedial structures. These, too, stand alone, not only existing independently from their surroundings but equally prone to excision from their larger contexts.[36] This compounding of fragments, whether old or new, marks a turn toward the lamination of different dimensions: their veneering, not synthesis.

Let me return to my larger purpose: to open a zone of interaction between cognitive psychologists and neurobiologists who are trying to understand how the patterns of firings of nerve cells in the brain *bind* to represent objects in the outside world, as well as historians of images who are trying to crack the abstract intarsia of nonmimetic symbols. Such ancient abbreviated systems, I think, offer an alternative model to contemporary neuroscience for a theory of "mental representation" that is imagistic without being Lockean.

Significantly, it is still largely unclear how the electrical signals delivered by the eye's rods and cones assemble into full-scale visual perceptions. Another enigma

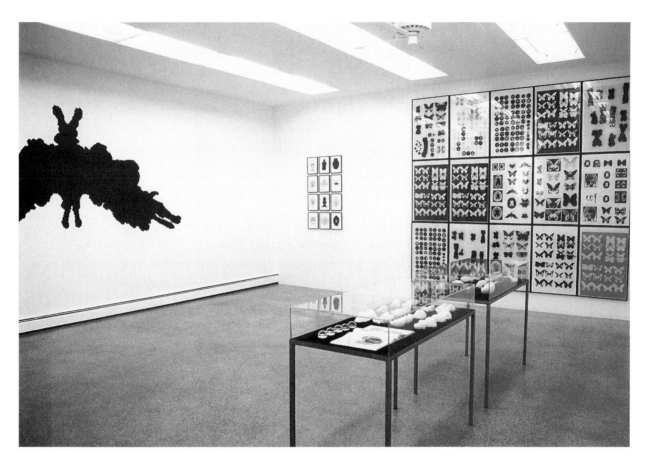

FIGURE 21
Suzanne Anker, installation view: *The Butterfly in the Brain*, 2002. Genetic tableaux: wall painting and mixed media. Dimensions variable. Photo: Suzanne Anker.

FIGURE 22
Suzanne Anker, installation view: *Golden Boy*, 2004. Rapid prototyped sculpture, pyrite, plexiglass, installed on steel table. Dimensions variable. Photo: Suzanne Anker.

is the relationship between embedded neurophysiological processes—findings, for example, that suggest neuronal groups increase their impact on target groups through precise oscillatory synchronization[37]—and coherent conscious experience visually communicated in convergent, "phase-locked" images. Further, what is the interplay between the brain's intrinsically generated activity and its modulations by external input? Just as the intarsia-like emblem is pieced together from a multiplicity of juxtaposed fragments, each of which belongs to some dispersed, invisible whole, assembly, synchronization, and the combination of complex streams of information are predicated on the coordination of features of a given datum spread over an interconnected system. But what are the mechanisms that bind them together and determine information representation?

We should consider the ancient and the modern emblem, then, as both an embodied mode of "short" thought and as a construction of conceptual reasoning—a cognitive genre—like "impressed" hieroglyphics and "solid" symbols. All make visible a combinatorial process of agency. They illuminate coinciding ways of doing that structure concomitant ways of thinking. I agree with anthropologist Alfred Gell that art is a "system of action, intended to change the world rather than encode symbolic propositions about it."[38] The emblem and, more distantly, the symbol—can thus be situated within the larger problem of patterns that compress space and time. Consequently, these formats transcend the specific emergence of emblematics as a distinctive genre around the first half of the sixteenth-century in Europe.

Certainly, there are many types of compressive visual structure and many types of visual compression. I am concerned with one of them: vivid visual insets, or what Hans Sedlmayr described, in speaking of Pieter Bruegel the Elder's metamorphosis of figures from paintings like the *Netherlandish Proverbs, The Land of Cockaigne,* or *Dulle Griet,* as "a [disintegrating] multitude of vivid patches with firmly enclosed contours and unified coloration that all seem to lie unconnected and unordered."[39] Because he was elaborating a theory concerning the "experience of estrangement," Sedlmayr did not consider the patch as a positive shape or performative means to condense different dimensions of existence. But as Mark Meadows recently and acutely observed, there is a peculiar accumulative manner of design visible particularly in the *Netherlandish Proverbs,* one strongly reminiscent of early modern picture collecting as well as the educational procedure of culling useful textual passages and reassembling them in commonplace books.[40] These conglomerations echo the juxtapositive ways by which our associative cortex arranges, categorizes, and stabilizes what it gathers.

Rather than the deconstructive, it is the re-constructive aspects of ancient tight-figure formats that are pertinent for the inlaid "look" of the emblem. To begin, let us recall some early examples of material compression that are echoed by the intarsia process. The desire to compact information is, of course, as old as knowledge ac-

quisition. Among the many available styles of concision, those that allow us to sense the copresence of the distributed parts are most relevant.

Printed book formats, for example, embody a foliated order that perceptibly intermingles scattered information. But the ritualized act of turning a leaf also breaks up the assembly of the text. The practice of thread binding, both in the West and in China, created an interruptive "economy of reversal."[41] The mere fact of tying loose papers together enabled accidental manifestations of the unexpected and the unknown to show themselves. Discontinuity and fragmentation was thus lodged at the heart of serial structure. Between the sixteenth and the eighteenth centuries, texts were further broken up by the inclusion of stylized, interlaced, flower and garland designs. These graphic symbols, produced from metal moveable types, were interpolated either to "rest the eyes" from the labor of following long passages of print, or, conversely, to refocus the weary reader's concentration.[42]

Similarly, the vast realm of optical technology promoted visual practices that diminished the rapid scanning accompanying successive flows of information. These tools for compression plucked discrete units out of the continuum of phenomenal appearances. Despite their different functions, all imaging modalities share the ability to generate visual epigrams—that is, ingeniously augmented images whose emphatic quality strikes our sensations and directs our attention.[43] These heightened pictures possess a redoubled *enargeia,* an indicative vividness that transforms them into more than their naturally diffuse, uncrystallized selves.[44]

Whether we think of magnifying instruments, such as the simple or compound microscope with its long tunneling column and synecdochic slides (fig. 23), or projective devices, such as that aperture-punctured black box—the *camera obscura*—object intensification is achieved through the compression of light and the screening out of scatter (fig. 24). Recall that, when speaking of the power exerted by new electronic media and global branding, Paul Virilio coined the phrase "phatic signifiers" to describe analogous contemporary digital images that "bypass volition, obliging you to look at them because of their insistent emphasis."[45]

An important by-product of this invasion of our inmost self by a forceful other, both in the past and the present, is that it instantaneously binds physiol-

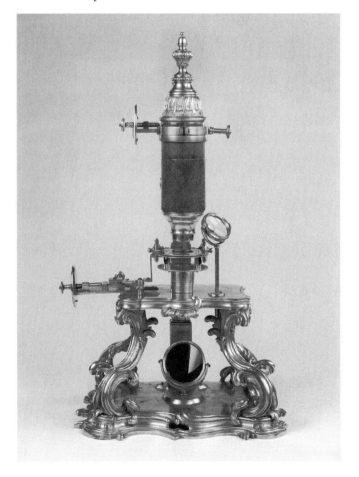

FIGURE 23
Micrometric stage invented by Michel-Ferdinand, duc de Chaulnes. Compound microscope, c. 1751. Gilt bronze; glass and mirror glass; enamel; shagreen (47.9 × 27.9× 20.5 cm; 1 ft. 6 7/8 in × 11 in. × 8 1/16 in.). Photo: J. Paul Getty Museum.

FIGURE 24
Benjamin Martin, *Ox Eye
Installed in a Wall,* from *A New
Compendious System of Optics,* pl.
opposite p. 186, 1740. Engrav-
ing. Photo: Department of
Special Collections, Charles E.
Young Research Library, UCLA.

ogy with psychology. This compacting process—precipitating the world, body, and self-consciousness into a single physical entity aware of itself—reminds us that from Henri Bergson to J. J. Gibson all perception was identified with action. To perceive the environment is actively to also perceive oneself moving in or through it.[46] I will return to this theme of material monism resulting from sudden saliency and bonding "sympathy"—when I take up the connection between the early modern emblem and the oracular or ominous symbol.

The accentuating activity of compressing heterogeneous shapes inside a tight framework is shared with other, conspicuously crafted early modern cultural materials: enameling, tiling, marquetry, and tapestry (fig. 25). Jean Menestrier in his *Traité des Tournois* (1669) significantly connects the art of devices ("des expressions ingénieuses de quelque passion secrète") with a whole range of decorative festival constructions visible at jousts, tourneys, and ballet or theater *intermezzi*. These *mélanges* included not just paratactic blazons or stridently inlaid coat of arms.[47] They extended to symbolically colored livery, arabesques, and mauresques covering horse harnesses, damascened armor, tapestry, carved furniture, painted and engraved glassware, and even those temporary architectural "machines" erected for special occasions, such as cipher-encrusted obelisks, porticos, pyramids, temples.[48]

Such artisanal (and frequently anonymous) products tend to be depersonalized collections of reusable patterns without a foveal center. The insistent grain of wood intarsia levels the inlaid image (geometric designs, conventionalized floral bouquets) into a distributed pattern. Lapidary *pietra dura* work overrides recognizable foreground figures because of the saliency of the small, repetitive, interlocked *pieces rapportées* dotting the background.

Woven tapestry borders are typically filled with interlace, arabesques, and grotesques—all detachable ornamental elements that refuse to add up to a naturalistic narrative. Less complex than the three-dimensional array of knots or cryptic spun *khipu* that the Spanish conquistadors observed in sixteenth-century central Peru,[49] European tapestries, nonetheless, are a symbolic communication system in fiber—not strings, but threads. In Horatian fashion, these textile fragments seem to stitch themselves together before our eyes dynamically obeying an innate rule of self-assembly. Whether we are speaking of the varieties of lithic or cloth intarsia, or of the ideo-

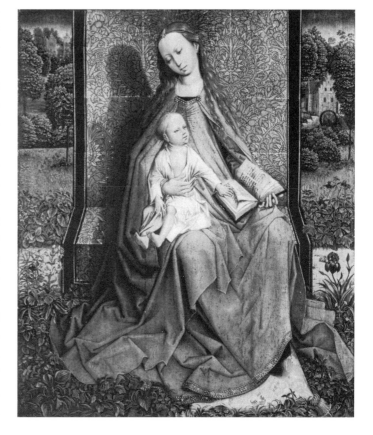

FIGURE 25
Master of the Embroidered Foliage, *Madonna and Child in a Garden*, fifteenth century. Oil on wood. Photo: National Gallery of Scotland, on loan from a private collection.

grammatic emblem as instantiating the inorganic *stilo a mosaico* of the Renaissance humanists, the concept of *inlay* is central to these performance-based practices.

Along with these rudimentary—yet highly ordered—patterns embodying thinking without written language, the emblem can be defined as a nonnarrative, nonillusionistic, or nonprojective picture grounded in a relational aesthetics that is at once commonplace and idiosyncratic. I follow Daniel Russell's lead in proposing we think of an "emblematic process" whose *ur*-form is the device.[50] We see this ideogrammatic, nonlinguistic, and artisanal mode of communication in action, for example, in Daniel de La Feuille's characteristically undigested image of *Intellect* as the figure of a young man who never grows old. He wears a crown garnished with a flame, holds a scepter to indicate his control over the passions, while staring at an eagle seated at his feet to demonstrate his perspicuity in understanding higher things (fig. 26).[51]

Such framed symbolic diagrams—adaptable to unlimited situations—and possessed of autonomous powers of ordering would seem to be connected to Locke's concept of the "punctual self"—a fruitful notion that derives, in turn, from Descartes' portrait of the disengaged solitary subject.[52] The self-sufficiency of our rational faculties, already formulated in late sixteenth- and early seventeenth-century Neo-stoicism, is bodied forth in these dispassionately constructed "pointillist" pictures. As Caesare Ripa said, "There is a kind of [juxtapositive] image which includes things inside man himself and which are inseparable from him, such as his thoughts, habits, & virtues, which are properly painted by a human figure since man, according to Aristotle, is the measure of all things."[53]

According to this moral philosophy of self-improvement, the individual—not unlike the automaton—withdraws from the flow of normal customs and daily routines that go along with living in a social world to be methodically reassembled from numerous things that could as well belong to someone else. This retooling praxis also structures the emblem. As we saw, the figure or person is literally objectified, that is, disengaged from his or her proper shape to be refashioned into a new self through the symbiotic merger with alien others assimilated from the environment.

This vexing metaphysical question of the deeper relation of the one to the many, of discrete forms to dappled experience, also suffuses the fascination many seventeenth-century scholars had for semiotics. Specifically, they were intrigued with sign systems that have more in common with the bevy of magical symbols used by prehistoric peoples, the Christian cross, and medieval heraldry than with language.[54] The put-togetherness of emblematic structure, too, cannot be separated from the pictographic juxtaposition of vivid fragments found in Egyptian hieroglyphics and Chinese script. But the ideogram, the cipher of the artificial language movement, the figurative geometry of Giordano Bruno—those archetypal diagrams internal to

the mind—and other graphic shorthand or notational systems, stimulated a more general study of abbreviated symbols for their own sake.[55]

The great Jesuit polymath Athanasius Kircher instantiates this widespread conviction that by deploying succinct pictorial symbols one could arrive at something more profound: the "original" representation of things and notions. The brevity of this alphabet of "primitives," or abstracts of human thought, was indebted to the occult tradition and the idea that a limited set of atomistic symbols stood in direct relation to a pristine reality. Like the emblem, these sign systems were cognitive because their "real characters" both corresponded to the art of thinking and exhibited its compositional combinatorics.

This pictorial logic of invention is manifest in Kircher's *Ars Magna Sciendi* (The Great Art of Knowing, 1669). Within its pages, he formulated a vast system of Baroque hieroglyphics out of a basic set of twenty-seven symbols intended to express every aspect of human thought.[56] His monumental frontispiece belongs to the Baroque tradition of the habitual formation of ideas in images (fig. 27). This complex picture is itself a visual compendium of a compendium, a conglomerate composition that lays out the terrain of knowledge in a bizarre mosaic of summary images and pithy labels.[57] The personification of Wisdom sits on her throne flanked by celestial bodies. The sun is a radiant blazon next to her heart. She holds a tablet with three rows of nine hieroglyphs: the symbolic ciphers of the Great Art.

Significantly, the organization of the frontispiece is not seamless but ruptured. The upper two-thirds of the composition are dominated by the "unnatural" compressive emblem that looms in dramatic contrast over the "natural," illusionistic landscape unrolling across the bottom edge of the frame. An implicit narrative of before and after infuses this realistic scene of an erupting volcano and a storm-tossed sea, set in counterpoint to the inlaid, timeless firmament reigning above. Kircher's reprocessing of ancient allegories tellingly oscillates between an emblematic structure—impersonally compressing heterogeneous data into a coherent format (sharing this technical proclivity with lists, charts, codes, storage cabinets, and, looking ahead, even computers)—and a mimetic structure—inducing a judicious comparison between the viewer's personal situ-

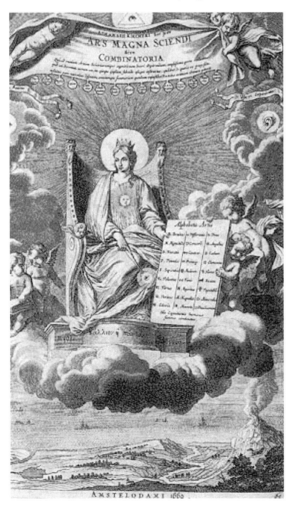

FIGURE 27
Athanasius Kircher, frontispiece, *Wisdom*, from *Ars Magna Sciendi sive Combinatoria*, 1669. Engraving. Photo: public domain.

ation and the impersonally changing environment. Consequently, his theo-secular emblems are at once an encyclopedically cross-referencing cosmic system *and* a reproducible collection of hallowed patterns or detachable and repeatable ornaments.[58]

ORGANIC INTARSIA

With this emblem fresh in mind, I want to turn from the cultural realm to biology. Compendious formats such as Kircher's, compressing everything from bits of language to nature's singularities, stretch backward to animism and forward to distributed networks. They acknowledge the existence of a compositional complexity, not just in culture but in nature, that connects across genes, species, features of life, and, however elusively, even manages to couple the external world to our internal thoughts and feelings. No matter what the scale, it is always the same problem of integration. At the level of the neural: how does all this distributed activity get combined into a single percept?[59] At the level of Darwinian evolution: what is the material and ontological coimplication of animals, plants, rocks?[60] At the level of art and the cultural, more generally: how do we interiorize exterior things *physically,* making them part of our very being, and then re-externalize them? In other words, what are the shapes of integration?

Exchanges of substance as well as junctures of information embracing multiple times and spatial realities occur across gaps in everything—from cybernetics spanning the technological and the human, to synapses connecting billions of neurons. Recall that these clefts separating "mere wisps of protoplasm"[61] are the highly specialized cell to cell junctions which neurotransmitters (signaling substances or the brain's messengers) must "jump" during mental activity.[62] Thus every aspect of the nervous system is a relational balancing act involving neuronal communication across synapses in specific brain circuits.[63] But exchange and uptake are also fundamental to the recombinatorial strategies of evolution.

Lynn Margulis's provocative theory of integral symbiogenesis—the scientific correlate to Coleridge's contraction of "All in Each"[64]—offers a reconceptualization of the kingdoms of nature and their relationships—from chloroplasts to sea slugs to the entire ecosystem of the planet. Margulis is one of the chief crafters of the ascendant "fateful encounter" hypothesis.[65] The nature of endosymbiotic adoption—literally "living together inside"—has come in for considerable disagreement concerning the manner by which the initial relationship was launched. She defines this evolutionary term in relation to symbiosis—referring to partner physiology, the long-term physical association between members of different species, and ecology. Symbiogenesis, on the other hand, is "the evolutionary consequence of symbiosis."[66] Although it might seem counterintuitive, I believe she is closest in her view-

point to Penrose's quantum neural physics, which regards experiential phenomena as inseparable from the physical universe and deeply connected to the laws and fundamental theory of matter that governs it.

Margulis, the primary author of serial endosymbiosis theory (SET) and Gaia theory (Earth System Science), investigates cytoplasmic systems. Her research points to the profound interconnectedness of the earth's (Gaia) biological, atmospheric, oceanic, and geological processes.[67] Specifically, she wonders why eukaryotes (some algae, protists, fungi, plants, and animals) have separate nuclei and other organelles, thus possessing a more complex cellular organization than simpler prokaryotic archaea and bacteria. Her innovations, which incorporate autopoiesis, cybernetics, and systems theory, transcend their use for the explanation of evolution and speciation. More generally, they suggest a model of synthesis that incorporates everything from the cell to the biosphere.

The emblem book—a collection of puzzle pictures with mottoes—is inseparable from technologies of assimilation, invention, and design. Emblem making was popularized and diffused into a variety of everyday situations *different* from the high culture in which it originated in the sixteenth century.[68] Significantly, the emblem as "a sort of tool" for moral thinking joins visual memory, metaphor, and pictures together through a machinic procedure. At a fundamental level, this autonomous uniting and spreading of pieced-together cultural materials resembles the new cellular partnerships of former strangers described by Margulis. These puzzle-objects, too, evolved into more permanent symbolical and theoretical relationships through physical integration.[69]

In both the biological and the cultural instance, the overall form is a sort of template into which disparate entities have been inserted. This process of ingesting satellite phenomena also structures the reciprocal combinatoric of distributed consciousness inlaying personal cognition with impersonal world. In the specific case of the concentrated emblem, the constant interaction of free-standing images and texts within small confines leads to the cultural persistence of a new abstract unit disseminated through the art of printing with movable type.[70] Chance combinations of artwork and accidental mutations in layout, owing to artifacts of the machine, similarly can yield formats that fail to conform to graphic expectations.

The early modern publishing industry—like the self-assembly happening in the natural world—was able to bring images together that were not normally found together. This fusion of pictorial fragments occurred through the systematism of the printing press: the ease with which it automatically juxtaposed and mechanically reproduced unanticipated conjunctions. Seen from the perspective of information theory, this inherently coincidencing technology—not unlike biological systems—collects, transmits, and *transforms* information. In design terms, it added value to existing, deliberately devised structures and new forms which, in turn, it helped to standardize. Ultimately, it launched new and vexing patterns into the in-

tellectual environment that had to be rethought by the viewer and thus contributed to the remaking of the self.

What Margulis terms "symbiogenesis" thus offers a rich and provocative biological precedent (at the level of cellular systematics) for the conceptual "symbolical way."[71] I am proposing that the geophysiological inlay she is describing could equally be called an "organismal symbol." Just as the "real" symbol-as-deed of late antiquity produced compressed relationships (conjoining incommensurables like the finite with the infinite, the many with the One, and so on), she articulates a practical *savoir-faire.*

In some cases, this workmanlike insertion of one organism into another over the long term can lead to the creation of new forms or many different features (new organs, new tissues). Perhaps she might even recognize an echo of what could be termed her concept of intercellular rapport in the writings of Alciato, one of the founding fathers of the emblematic art. Among other things, this polymathic Bolognese professor of jurisprudence grappled with Roman law.[72] In his hands the *emblema,* too, embodies the craftsmanlike know-how of conjoining an autonomous natural or historical motif with a developing argument. It is standard practice in the construction of legal briefs to "drop" encapsulated quotations and discrete citations, coming from disparate classical sources, into the ongoing rhetorical flow. These separate units coexist and need to be reconciled, just like foreign bacteria within a larger host cell.

We see an analogous combinatorial process in the Baroque fascination with pictographic and ideogrammatic methods. Kircher is the past master of this checkered manner, as we saw in one of his many frontispieces. But there are other masters as well. The formal amalgamation of predicates with subjects in the shorthand notation of seventeenth-century artificial languages by George Dalgarno and John Wilkins, for example, or, more anciently, the graphic embedding of concise figures of things with terse ideas (often enframed by a cartouche) in hieroglyphics (fig. 28), are all instances of engulfed materials. They resemble the physical consolidation undergone by originally free-living bacteria that were acquired by nearby cells but not digested by them, creating composite systems. The structural and functional assimilation of simple bacteria into alien cells to form a fused, split picture, then, provides fascinating insight into the bonding or "sympathetic" kinetics of symbolic synthesis.

This horizontal motion of incorporating desirable traits not originally part of a host body is mimicked in the distributed nature of human thinking and thus presents us with an exciting alternative method for linking problems in the sciences with those of the humanities. Movement, life, and line are not just the concrete signs of genetics and evolutionary biology but the "real characters" of an acquisitive formal genealogy of thought, more generally. As in Leibniz's atomistic art of combination, or "Characteristica Realis," it is the synthetic, not the divisive, operations

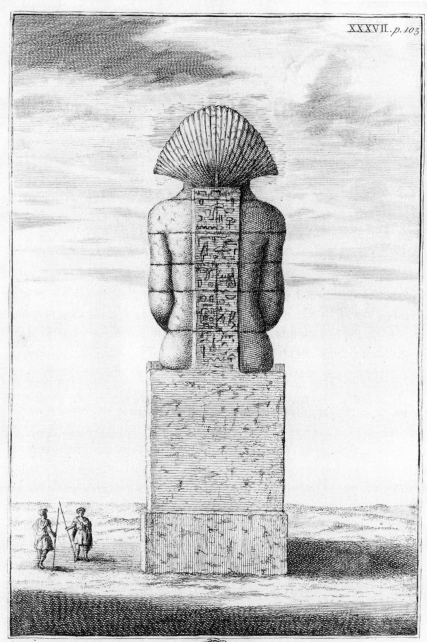

The *STATVE* of *MEMNON.*
To Charles *Stanhope Esq.*
DEO ET REGI

FIGURE 28
Richard Pococke, *The Statue of Memnon*, from *Description of the East*, vol. 1 (1745–47), pl. 37. Engraving. Photo: public domain.

of logic that capture the fact that everything is connected to everything else in the universe.[73]

But to return to Margulis's provocative model. This primitive process of ingesting, not digesting, the useful fragments of another—a sort of intuitive bodily intelligence—helps us reimagine something as fundamental as self-organization. The epoch-making birth of complexity resulting from the marriage between mitochondria in animal cells and plastids in algae (sometimes referred to as the Big Bang of biology) opens up a dizzying perspective. Is this physical assimilation or enclosure of the bits of someone else's specific functional features into a coherent unit so different from the emergence of a single unified conscious experience out of "a hundred billion or so neurons stuffed into the skull"?[74] Both, after all, are cases of different kinds of localized patterns and activities becoming integrated.

The biological phenomenon of one organism moving to take up residence in another also sheds light on the contrary psychological impulse of avoidance or withdrawal: the opponent process of reasserting one's identity as someone apart or the invention of a secret life when we feel we are being absorbed by a group.[75] More generally, it illuminates dynamic styles or methods of cooperative coming together of distinctive elements as well as their separation or detachment. Significantly, recent research on "autism spectrum disorder" has noted that its chief diagnostic signs include social isolation and an absence of empathy. This is most likely due to a reduction of mirror neuron activity in the prefrontal cortices.[76] But even more interesting is the problem autists have in understanding metaphors. This ability to map meaning across domains is, after all, the mental correlate to the physical unification of dissimilar entities. Motor systems thus appear central in the cognitive construction of actions and goals necessary to any biological organism under evolutionary pressure to learn or to predict future moves to survive. The reverse of the connective drive to communicate is the extraction of the organism from a stressful sight or a captivating sound.

An additional cognitive implication of Margulis's theory is that it decentralizes and disperses the role of the human in the universe. Not only do organisms restructure their environments to simplify a problem (niche-construction), but the environment retools organisms. The implicit lateralizing movement of deanthropomorphization is helpful in considering how emblems or collections of anonymous commonplaces—composed of nondiscursive and nonprojective figures—seem to self-generate much as our brain, largely automatically, makes the mysterious transition from objective physical neuronal operations to subjective experiences. For neurophysiologists like Vittorio Gallese, the brain is an "agent-free" dynamic representational system that is subpersonally self-organizing. But we are in the dark as to what are its "ontological assumptions," that is, the implicit assumptions about the unified structure of reality or the invariances that guide its decomposition of the target space in a certain way so as to create a coherent internal world-model.[77]

As in musical improvisation—the real-time discovery and exchange of forms—order is found not imposed.[78] Rather than being under the control of a "user," the system itself promotes the bidirectional initiation and generation of a response. Such dialectical exchange embedded in the organization of the system also recalls the idea of "ecological inheritance" in evolutionary biology, meaning that just as a sequence of generations of organisms changes through the pattern of intergenerational inheritance, the environment to which they respond likewise changes through ecological inheritance.[79] Can we, then, further enlarge our understanding of the dynamics of emblem construction and transmission by relating it to some of the additional findings coming from the biological sciences and brain research?[80]

Whether we are dealing with biological organisms or cultural artifacts, stunningly limited entities routinely seem to find in one other the occasion for an otherwise impossible whole. This relational self-composition places a premium on the physical (including visual) and conceptual distillation of particular forms into a cooperative union. Such compressive strategies, collapsing the physiological into the psychological, are manifest in Romantic poetics. Think of Wordsworth's foundational symbol, the involuted and convoluted "spot of time."[81] We also see them at work in the visceral aesthetics governing Thomas de Quincy's opium eater. These confessions of bodily heights of pleasure and depths of pain reveal the monistic materiality of the mind's life.[82]

A similar compressive concision occurs in Blake's attack on psychological dualism. The poet-illuminator's archetypal "bounding outline" is emblematic of expansive "energy" capable of unifying two conceptions of experience (fig. 29).[83] Thus his color print *The Dance of Albion* (*Glad Day*) and its monochromatic variants formally capture the rejuvenation of this exultant "ancient man" who "rose from where he

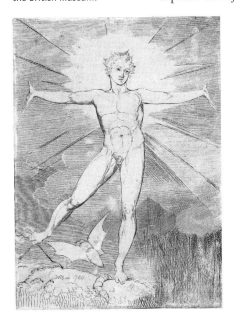

labored in the Mill among Slaves" to ascend into the firmament.[84] Simultaneously a soaring figure and a leaping trace, this mediating performance joins the visible to an invisible realm. Blake presciently recontoured the neurological divide cleaving our brain into two opposing regions. Only now is functional magnetic resonance imaging (fMRI) demonstrating the degree to which the left and right hemispheres work in concert. This integrative picture of sensory/psychic operations is reminiscent of Blake's prophecy of reconciliation when the lion will lie down with the lamb. In a futuristic vision, the artist imagined a time when conceptual, logical, and analytical skills—the purported antitheses of feeling, imagination, and integrative ways of perceiving—finally stepped across a false epistemological divide.[85]

What makes these crisscrossings so notable is the fact that, although the human brain contains one hundred billion nerve cells, no two patterns overlap. Consequently our attentional resources are

efficiently and compressively focused on one entity at a time.[86] This normally invisible labyrinth of electrical impulses, transmitted from one nerve cell to another, as well as the autonomous activity of searching for and isolating a recognizable form from a chaotic environment, has migrated into the cultural domain. We see the work of heterochronous correlation precisely in those grouped images, or *Sinnbilder,*[87] that collapse divergent sensory messages into a coherent vision. Such symbolic configurations become physically impressed upon the mind because they are already congruent with the formal template of "mental" representation.

Thus the *emblema, impresa,* or *device*—like the quartered heraldic crest, detachable livery, or wearable coat-of-arms—makes manifest the elusive neurophysiological processes of association binding word and show into a single concrete object.[88] Isolated bits tacitly signal their need to be consciously incorporated, not automatically blended in (fig. 30, top panel). Importantly, this is because such assortments of competing things correspond to our ancient evolutionary habit of scanning a scene.[89] The so-called old pathway—whereby messages from the eyeball on the retina go through the optic nerve to the colliculus lodged deep inside the brain stem—is responsible for mediating our performance of complex maneuvers without really being aware of them. Spatial navigation—for example, our instinctive avoidance of obstructions—depends on the spontaneous creation of a symbolic representation of the spatial layout of the external world. Moving across a prismatic maze from one stimulus to another, our visual system unconsciously gropes for recognizable patterns surfacing from the chaotic array.

THE PERFORMANCE OF BINDING

I have been suggesting throughout that the emblem, at its most fundamental level, belongs to the larger category of the connection-seeking and relation-making symbolic. In this final section, I want to make explicit how it operates as a paradoxically inverted instance of solid symbols, that is, information and representation-hungry material complexes that form an integrated entity. Recently, Peter Struck has convincingly demonstrated that the symbol-as-deed of the late fourth- and fifth-century allegorizing Neoplatonists was a very different formal construct from the classical notion of it as a contractual token—literally the pieces of a broken terra cotta pot doled out to claimants.[90] While there are connections, to be sure, between the earlier and the later meanings, it is the latter, theurgic heritage of divination rituals, binding rites, animation praxis, and ominous chance meetings that I believe are especially pertinent to emblem construction. These techniques and technologies, I think, shape relationship.

Although precursors can certainly be found among the followers of Pythagoras, who were fanatically devoted to his secret teachings, it was the sophistic "Neoplatonists of the Cave" who transformed that elite and esoteric learning into a trans-

mittable and enduring logic. It was Plotinus, Porphry, Iamblichus, but above all, Proclus, who fused two contrary claims regarding reciprocal and nonreciprocal likenesses. In their hands, the allegorizing symbol became a special sort of composite image-object, one that juxtaposed a sensuous representation meticulously faithful to mere perceptual reality with an abstractly intelligible hidden meaning. Such conjunctive strategies have a lengthy horizon of reception, visible both in the early modern emblematists and in the later Romantics. The attractiveness of such connective practices was two-fold. First, it created an epistemological equivalence between things available to ordinary perception and things-in-themselves requiring reflection. Second, it not only interwove the worlds of becoming and being into a set of information relationships, but made that interplay overt in inlaid structures. These complexes corresponded to the covert networking of the mind as well as the cosmos. Infusing every physical object and imprinting the psyche, sympathy—like Lynn Margulis's symbiogenesis—is "the broadest concept of the force that underwrites relatedness."[91]

The vast Neoplatonic "technology of spent magic": carnelian, chalcedony, or rock crystal seals, stamped amulets, and engraved talismans capable of mysterious binding operations, embodied a material metaphysics that mirrored the shapeshifting structure of the universe to initiates.[92] We get some inkling of the bizarre, nonverisimilar look of these simultaneously sensual and cognitive compounds, as well as the fascination they held for the eighteenth century, from Bernard de Montfaucon's multivolume *L'Antiquité expliquée et représentée en figures* (1719; see fig. 18) to Richard Payne Knight's collection of partitioned ithyphallic gems (fig. 31).[93] Embodying both sensory fact and complex idea, such grotesques are in fact made up of little independent modules. They thus join other kinds of interactive *realia* such as glowing moonstones, paper charms, geomantic tableaux, dustboards, or tablets of sand that break down experience to build it up again. These operational objects belonged to the ancient domain of the *mantes* (the popular diviner), who was not only charged with observing portents but with provoking connections among distant pieces of reality. As Giulio Tononi has argued, the modular function of the cerebellar cortex may hold the key to why things can be connected to a system and not be part of it.[94] From this perspective, it is notable that the *magoi* spent hours in necromantic contact with physical substances, concatenating repeated questions, fabricating charms, and drawing out healing incantations: all done in order to pluck the associative secrets of sympathy and antipathy from separated materials.

The special performative ability of this symbolic matter to precipitate a body-mind conjunction echoes the primal power exerted by "phatic" apotropaic images. The mythic Medusa, whose head rivets the unfortunate beholder's perceptual system and freezes it, is only one well-known example of forceful entities who ravish the spectator and thus bind physiology with cognition in a single stroke. The huge class of natural wonders, both ancient and modern, is similarly penetrating. *Achei-*

FIGURE 30 *(facing)* Stephan Michelspacher, *Mirror of Art and Nature* (with heraldic blason and crest), in *Cabala, Spiegel der Kunst-und Natur in Alchymia* (1663), pl. 1. Engraving. Photo: Herzog August Bibliothek Wolfenbüttel.

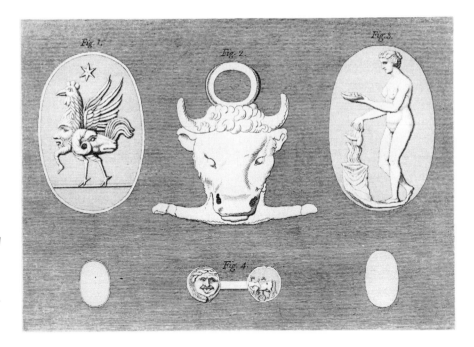

FIGURE 31
Richard Payne Knight, *Figure of Ammon Compounded of Forms of Ram, Cock, Mask, Aquatic Fowl* (fig. 1); *Medusa Head with Serpents as Emblem of Life* (fig. 4), from *A Discourse on the Worship of Priapus* (1786), pl. 3. Engraving. Photo: Getty Research Institute.

ropoetic images, that is, those objects *not made by human hands,* stock the annals of Hinduism, Buddhism, Islam, and Christianity.[95]

Such startling, unwrought prodigies—like the Black Stone set within the Ka'bah in Mecca, said to have fallen from the sky like a meteor, or the miraculously provided icons of Byzantium—involuntarily invade our sight and jar our consciousness. They make transcendence immanent in a sublime material experience.[96] Today, we are reminded of these efficacious wonders, at the heart of world's major religions, when standing in Sir Norman Foster's *Andachtsraum* (1998–99) of the Berlin Reichstag.[97] Among its symbolic sculptures and wall installations, designed by Günther Uecker, are two monumental sand paintings. Evoking the foundational moment of Islam, a scattering of black stones punctures the back of these pictures to partially exit from the front of the canvas—much like the divine shower of rocks originally pierced the desert floor (fig. 32).

Well aware of this animate universe whose incursions were hard, if impossible, to control and even harder to resist, Renaissance historians traced the origins of the heraldic *device/devise* to analogous apotropaic signs. Since antiquity, a clash of abstract color blocks, horizontal and vertical separations, the jolt of motley beasts, were emblazoned on the shields that soldiers used to inspire fear in the enemy and protect their own bodies.[98] These striking inlaid forms were designed to surprise and thus to inhibit rational decision making.[99] The immediacy of their sensory impact made it difficult to "frame" any options other than fleeing. It is as if this strident patchwork was deliberately designed to suppress analytical thought, seizing the thalamus, organ of attention, as well as the primal limbic system. Significantly, this

"Medusa effect" continues in post–September 11 television reportage, inundating viewers with horrible sights from which they involuntarily recoil or toward which they addictively turn.[100] Further, this violent montage cuts through the brain's abstracting and decontextualizing mechanisms used in guiding choice behavior to activate basic emotional responses directly in the amygdala and the insula. We glimpse the rudimentary elements of this preconscious circuitry as well as feel the immediate registration of this potent information.

The cognitive linguist Terrence Deacon has argued that in the move from *homo erectus* to *homo symbolicus,* the limits of neuroplasticity changed over time. The "phatic," or visually and emotionally salient, shapes of a special sort of correlational symbol, I believe, pushed the limits of that plasticity through reentry. Simultaneously, such forceful images allowed the binding and synchronizing dynamics of complicated distributed networks to express and even modify themselves.[101] The adapted mind—the human brain conceived as a network of many specialized adaptations[102]—and the sculpting of the secondary repertoire, then, helps us understand at a deeper level why such compressive checkerwork is found so extensively and why the desire to bind heterogeneous elements is so enduring.

Reentry is the third component of Neural Darwinism or Neural Constructivism. Since his *Remembered Present* Gerald Edelman has been investigating brain mal-

FIGURE 32
Günther Uecker, *A View of the Interior of the Andachtsraum,* in the *Deutscher Bundestag,* 1992–99. Sand on wood panels. Courtesy of the Parlamentsarchiv des Deutschen Bundestages.

leability: what happens after the process of competitive selection of cell groups occurring in the primary repertoire.[103] The secondary repertoire, resulting from that initial variability, correlation, and connective reentry, emerges to form a new representational map. By a selective pruning process, this secondary repertoire or secondary network will have become a more effective representational and classifying instrument for perception, memory, and behavior than the primary dense and variable population of neurons.

In brief, temporally tethered, but spatially separated neural networks that fire together synchronously and in parallel gain synaptic dispositions that favor them over other neurons and neural networks not linked in such assemblies. Binding is an important part of reentry. It facilitates the way neurons, neural networks, and neural maps—both locally and globally—are linked to each other and to intensive and extensive objects. To paraphrase Jean-Pierre Changeux, large-scale integrative processes that link the results of local processing throughout the brain by means of extended horizontal connections between distinct cortical areas in one or both hemispheres make it possible to speak of a "network architecture." Simple rules allow the brain to combine a great variety of signal-processing structures with the capacity to integrate and globalize activities of the brain, both from the top down and the bottom up.[104]

Superimposed upon this intrinsic system of dynamic interactions and binding rhythms, however, is another important process: selective attention. Attention, at any given moment, is the result of the combat among multiple concurrent competing stimuli. Significantly, particularly salient ("phatic") stimuli have a competitive edge over others that are less obtrusive in terms of neural responsiveness and selectivity. Equally significant for the discussion of the emblem as well as the symbol is the fact that this competition is biased in part by bottom-up neural mechanisms that separate figures from their ground (both in time and space) and also, in part, by top-down mechanisms that *select* objects relevant to perceiver interests and behavior.[105]

Together with mantic symbols (entrails, bird flight, animal tracks, handprints), charged images and efficacious objects clearly demonstrate the effect of directed attention enhancement. By increasing neuronal sensitivity to stimuli, the inner domain of the person gets abruptly coupled to an otherwise impersonal universe governed by chance.[106] These successful response strategies were perpetuated in a broad spectrum of compound images ranging from the ribald, Menippean political caricature of James Gilray, William Dent, and George Cruikshank, to the monstrous couplings of Goya's half-lit *Caprichos* (fig. 33).[107] These nominal formats use the device of harshly mixed modes

FIGURE 33
Francisco de Goya, *All Will Fall*, from *Los Caprichos*, pl. 19, 1799. Aquatint and etching. Photo © 2006, Board of Trustees, National Gallery of Art, Washington, D.C., Rosenwald Collection.

or "shards of satire" to ridicule and counter vice. The Spanish artist's invitation to discover forms concealed within the dark tangle of etched lines and black aquatint extend to the genetic artists with whom this essay began.[108] Eduardo Kac and Suzanne Anker visualized the dual aspects of the contemporary body. Like Goya, they put before our eyes a juxtapositive graphic code—a collection of dislocated emblematic notations that both reveal and obscure the complex structures of life (see figs. 25, 26).[109]

Such compressed art forms, while otherwise different, share the compositional principle of conspicuously interlocking shapes. Simultaneously corporeal and metaphysical, these tight-form amalgams are catalysts violently yoking different orders of experience. As message-bearing vehicles, they hook up the material with the immaterial, the worldly with the otherworldly. As pictographic sign systems that do not simply encode language, their ancestry stretches back to the magical symbols used by prehistoric peoples, such as the pictographs of the Indus civilization (3200 BCE).[110]

As mantic or presence-based performatives, their nondiscursive brevity stands in stark contrast to discursive or informational images rooted in distanced and dispassionate observation. The "objective," "factual," or "disinterested" informational image, in contrast to the emotionally biased and invasive image, elicits quiet attention (fig. 34). This venerable aesthetic and ethical distinction sharply divides the self-forgetting motion outward toward an object in the self-conscious intellectual effort to understand or interpret it from irrational or unreflective reaction. The emblem,

FIGURE 34
Pehr Hilleström d.Ä., *The Gallery of the Muses in the Royal Museum at the Royal Palace, Stockholm*, 1796. Oil on canvas, 45 × 61 in. Photo: The National Museum of Fine Arts, Stockholm.

I believe, oscillates between such a primal, body-based ritual and a reflexive herme-neutics of critical judgment. It is the moral face of the crafty, magical, and trans-formational symbol—all those thaumaturgical substances that cunningly engineer the reintegration of a disintegrating world and also our shifting relationship to that mutable world.[111]

To conclude and to bring our inquiry back to neurobiology: the conundrum of individual and intersubjective synchronization belongs to the larger mystery of why bridges and skyscrapers vibrate, hearts beat, and neuronal networks oscillate. What is fascinating about the problem from a humanistic standpoint is that several rhythms can temporally coexist in the same or different structures and interact with each other. In compressive graphic formats, such as the emblem, there must also be a synchrony of pictorial and textual information or a convergence of discrete in-puts into an elastic configuration. Juxtapositive design encourages the fluctuation of viewer attention between different types of inhibitory and excitatory sensory signals. We should think of this format as a "small-world" network, a densely con-nected assembly with resonating visual and verbal features.

Detailed biophysical studies have shown that even single neurons are endowed with rhythms, suggesting that the timing of their pulsing activity within neuronal networks could represent information. This hypothesis led to the provocative the-ory that perception, memory, and even consciousness could arise from synchro-nized networks.[112] What is certain, however, is that perception is not a continuous event "but subject to the cyclic changes of the networks processing the input."[113] The enigma remains, however, how single neuron dynamics can be conjoined into large-scale behavior.

The performing brain is composed of distributed networks of neuronal groups that are transiently synchronized by dynamic connections. The underlying activ-ity of cortical microcircuitry and cellular and synaptic biophysics is made mate-rially manifest, I think, in precisely such "phatic" combinatorial art forms like the symbol, device, and the emblem. Through a rhythmic alternation of strengthening and suppressing functions, reenacted by the viewer's selective attention and abetted by their saliency, they dynamically achieve spatiotemporal coordination. This bio-logically and socially enmeshed sharpening process also accounts, in part, for the durability and distribution of such compressive forms as they continue to become ever more sophisticated in their "attention-grabbing" qualities—linking up through the system of reentry to form new inlays or rapidly expanding neural networks of stimuli.[114]

It seems, then, that one place to begin thinking about the close relationship be-tween the far-flung fields implied by the term *neuroaesthetics* is simultaneously in the neurosciences and in the history of images as the history of human making as a struggle to cohere.[115] There is a significant isomorphism between biological phe-nomena and artistic practices as well as between their overarching principles of

order. Neuronal synchrony is defined by the temporal "frame" within which some trace of an earlier event is retained and that, in turn, influences and combines with the response to a subsequent event. This global consolidation of patterns into momentary balance comes about because complex brains have developed specialized mechanisms for the grouping of principal cells into transient temporal coalitions and for the synchronization of local and distant networks.

The compound symbol, and the emblem that I take to be an arbitrary symbol without its transcendent talismanic presence, concretely manifests the way in which the brain-mind associates the structural fragments coming from various sensory inputs and that get retrieved and linked across two brain hemispheres.[116] The sympathetic symbol is thus the external image of an inborn framing device, the universal organizational template in which and by which myriad patterns get encapsulated bit by bit. Or as Iamblichus would have said, the divine powers recognize and respond to their symbols, the material traces of themselves that they have previously sown in the world.[117]

3

MIMESIS AGAIN!

Inferring from Appearances

Although of importance, the type of neural computation and neurodynamical phenomena brought to the fore in these [neural connectivity mapping] approaches is somewhat disembodied and selfless. Consciousness is indissociable from the pervasive class of phenomena that we refer to as a "feeling subject." Such an embodied sentient entity is the core of consciousness and is hardly explained by these approaches.
DAVID RUDRAUF AND ANTONIO DAMASIO[1]

Whenever she saw me she gazed at me intently and with interest, but she never attempted to read anything in my face. In those days I often found that people became uneasy when they couldn't read my face.[2] YOKO TAWADA

MIRROR NEURONS AND THE SIMULATIONISTS

There is an old photograph that has haunted me all my adult life. Small, with the two figures still sharply salient after all these years, it shows an elegantly dressed young woman in a nursery. Caught from above and behind, she is seated and looks down at the infant in her lap that squirms, quizzically frowns, and warily returns her gaze. I see clearly the fashionable angel-wing hairdo, upswept from the temples, that also framed the perfect features of such film idols of the 1940s as Hedy Lamarr and Marlene Dietrich. I easily decipher the fitted cut of the ribbed wool sweater with the glinting carnelian maple-leaf brooch pinned just below the left shoulder blade. Maddeningly, what I cannot see is the expression on my mother's face, although I have supposed what it might have been many times.

The intense, ongoing neurobiological research into so-called mirror neurons is part of what Jaak Panksepp has called the single most important question in emotion research today, namely, the neural organization of the emotional brain.[3] The recent excitement over mirror neurons, or "wireless" visual communication, has infused everything from linguistic study of the role of mimicry and gesture in speech to the role of visual signals in the perception of the external world and one's own actions.[4] Most importantly, from my point of view, however, this informationally based self-organization that supposedly vanishes when the subject closes his or her eyes again has returned mimesis to its rightful aesthetic significance after a long post-

structuralist hiatus. It renders questionable the broad assumption, voiced by Daniel Dennett, that "our royal road to the knowledge of other minds" is language.[5]

The Foucauldian and the New Historicist view of the subject as always under construction has had the paradoxical effect of sustaining both the logic of remote agency as well as the romantic belief that I am principally the maker of my own identity—to be sure, along with the help of the state, social institutions, and the outer milieu. Identifying with another, however, begins with the involuntary: shared emotion. This primal impulse demonstrates that we are not autonomous agents but unconsciously mimic the mobile features and incorporate the implicit content in the facial expressions of those whom we behold.

Consequently, it is not merely metaphoric to say that we reciprocally paint our affective lives inside one another. But this re-enactment requires, as Aristotle observed about the perceived nearness of our perceptions of pleasure and pain, that the objects of sense be close at hand. Additionally, some sort of personal desire, needs to be at work because we are moved either to draw experience in, making it intimate, or to rebuff it, making it distant.

This dialogical motion suggests that learning, affective control, and the capacity to distinguish self from others is echoic. As social beings, we seem to bounce off one another. But noticing and noting also involve complex memory mechanisms like the declarative recall of specific people and events or the procedural retention of habits in our muscles. Moreover, it requires the hard work of volition since it is always easier to take one's own perspective.[6] Not coincidentally, the deliberate reproduction of persons, actions, and situations is also one of the historical tasks of art. In the early modern sense, this type of second creation "connoted the work of the human hand in imitating nature."[7] What rendered art artful or ingenious—and science scientific and generative—was precisely the material and the epistemological difficulty of reshaping what the eye sees. The venerable problem of mimesis—that is, the fabrication of faithful representations—can be restated as just this tension between first-person experience or individual witnessing and coming to know another through a double process of internalization: by intuitive copying and willed repetition.

Antonio Damasio, who pioneered the neurology of the emotions, captures the visceral dimension of an organism's awareness of its physical and psychological interior when he observes that it is the intimate flow of body representations that support our feelings and our sense of continuity.[8] Damasio's thesis is that the emotions are part of self-regulating homeostasis—those steady-state, coordinated, and largely automatic physiological reactions required to maintain balanced states in a living organism.[9] The question remains: what simultaneously embeds us and lifts us out of the sensual particulars of our body?

Mimesis, I believe, is central to Damasio's system since he speaks of the brain-mind being composed (among other things) of plural images of our own multiple

body functions. These microrepresentations of our own body parts—caught in homeostatic action—also catch their modification in response to environmental stimulus. Mimesis orients beings—both animal and human—toward or away from more or less determined parts of the environment.[10] If the human instinct for mimesis, imaginative make-believe, or inner rehearsal is a central feature of our cognitive archaeology—as Aristotle believed—what more nuanced models of the self might we now imagine?[11] How do we make sense of the fact that subjectivity emerges when the brain-mind simultaneously produces not just self-images and the organism's responses to its surroundings but something else as well: an organism in the act of perceiving and responding to some external object?

The face has become the prime site for reflecting not only on the nature of another's mind but our own as well.[12] This extreme "facialization" of the body is the springboard in the search for deep-seated sensations or haptically experienced feelings.[13] In 1992, Giacomo Rizzolatti and his research team at the University of Parma discovered—using wired macaques—that brain cells in an area called F5, which is homologous to Broca's area in humans, fire in response to watching actions in others.[14] That is, not only do these cells fire when the animal itself is doing goal-directed, hand-to-mouth movements. Parts of the frontal lobes concerned with motor commands—and now other regions as well dedicated to planning ahead such as the premotor cortex, the posterior parietal lobe, the superior temporal sulcus, and the insula—were found to become similarly excited when, for example, monkeys watched other monkeys, or even human beings, raise peanuts to their lips or drink water, as if that behavior were their own.[15]

Mirror neurons, apparently, become activated at birth and function best when observer and observed are positioned face-to-face. Andy Warhol in this, as in so much else, anticipated the importance of frontality (fig. 35). In his colossal portrait of Fluxus artist Joseph Beuys (1980), Warhol captures Beuys's legendary empathetic engagement with the beholder during his lengthy performance pieces. Reversing the usual positive and negative values of a photograph , and accentuating the master's features and signature hat with mauve-colored diamond dust, Warhol presents Beuys the empathetic activist-teacher. Riveted, the viewer stands face-to-face with the shimmering, oversized countenance of the man whose artistic practice depended on the identification of autobiography and work and who summons us to do likewise.[16]

Intimately bound to feeling states, mirror neurons are first engaged when one is very young, when a child observes another child or an adult and then practices performing what he or she sees. And this reflective habit—as Beuys or Chuck Close or, indeed many other artists understood—continues for the rest of one's life. Richard Gregory has suggested that such "interpolation" or "kinetic intelligence" assists in creating the continuous behavior necessary to higher organisms constantly confronted with interrupted signals.[17] Consciousness is thus apparently associated with

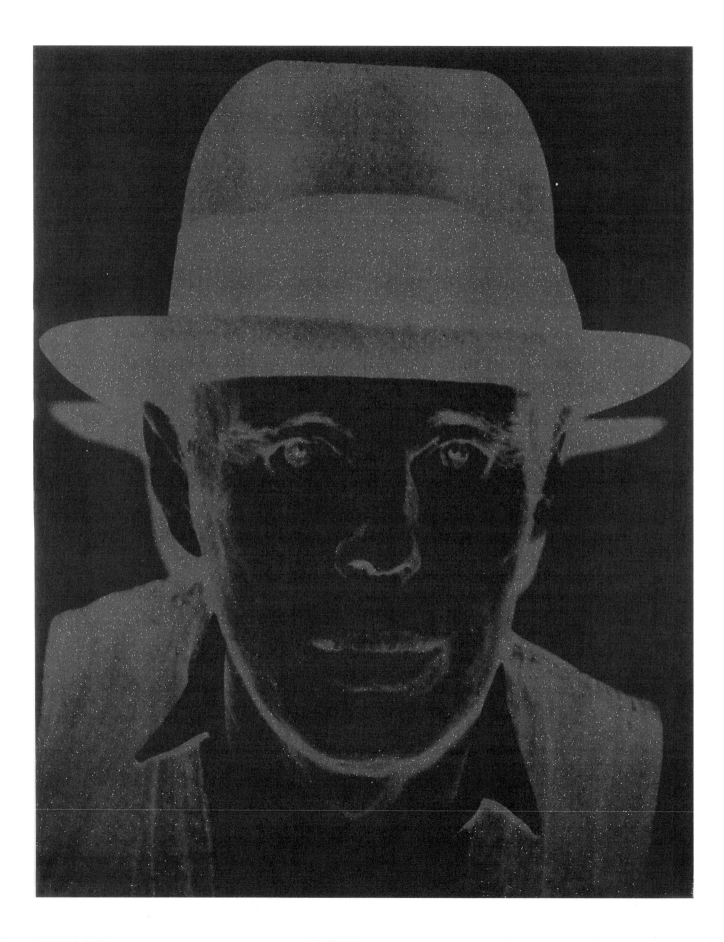

the obverse phenomenon, with surprise or the failure to predict. That is, we come to recognize just how ingrained these mimetic responses are in those self-aware moments when they are thwarted.

Jean-Baptiste-Siméon Chardin, notably captured single individuals who were, in Michael Fried's words, "absorbed" in their tasks.[18] With averted gaze, downcast eyes and face caught obliquely or in profile, they raptly paid attention to the object immediately before them and not to the beholder (fig. 36). The tension between refusing to engage the observer and confront him is particularly startling in large eighteenth-century multifigure paintings of family groups. Sir Joshua Reynolds, for example, brilliantly invokes the complexity of repercussive looks and competing lines of sight in his portrait *George Clive and His Family with an Indian Servant* (1765–66). Although this picture represents the family of George Clive of Whitfield and not that of his famous cousin Robert Clive of Plassey, as formerly was thought, it is equally redolent of fortunes made on the subcontinent.[19] Most likely it depicts some of the precious "curiosities" collected by the man simply known as "Clive of India."[20]

The little girl dressed in a thin cotton gown and bedecked in gold jewelry forms the focal point of this composition, which is unusually intense and intricately designed for Reynolds. Arguably, the real subject matter of the picture is the direction and indirection of looks (plate 6). The standing child, dramatically framed by a sumptuous curtain swag and a lavishly damasked chair, takes center stage. Along with her mother, she stares boldly and unflinchingly at the viewer. The gaze of the father, especially, underscores the pervasive effect of psychological distance separating the sitters despite their physical adjacency. While he has eyes only for the mother and daughter, these two are emotionally unavailable to him since their attention is focused entirely outward. The paternal gaze is literally from a distance since he stands at the edge of the composition and in profile. But the pointedness of his desiring scrutiny is contrasted with the physical and emotional obliqueness of the young nurse to his left. This exotically bedecked *ayah,* with her glistening black hair, kneels to support the little girl and, in so doing, looks down and away. While we can guess the pride of the father, the submissive and hooded glance of the servant remains impenetrable.

A very different webwork of avoidance and facing organizes the Romantic landscapes of Caspar David Friedrich. During the decade following 1816, the German artist obsessively depicted individuals who turned their backs on the viewer to gaze at infinite horizons, into bottomless abysses and fog-shrouded scenes.[21] This emotional and cognitive inaccessibility is profoundly subversive, thwarting the beholder's natural impulse to simulate the

FIGURE 35 *(facing)*
Andy Warhol, *Portrait of Joseph Beuys,* 1980. Screenprint and diamond dust, acrylic on canvas. Photo: Heiner Bastian © 2006 Andy Warhol Foundation for the Visual Arts / ARS, New York.

FIGURE 36
Jean-Baptiste-Siméon Chardin, *The Draftsman,* 1737. Oil on canvas (81 × 67 cm). Photo: Staatliche Museen zu Berlin.

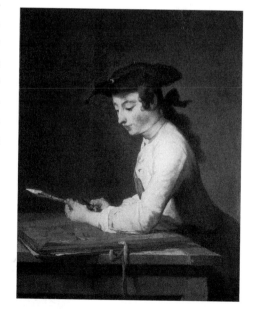

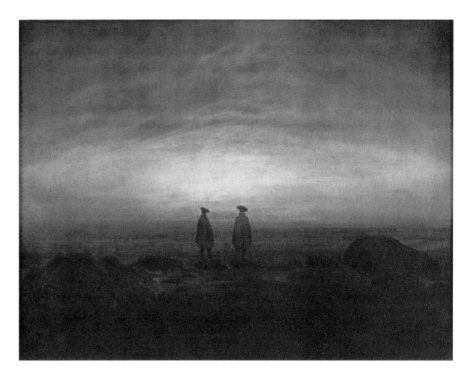

FIGURE 37
Caspar David Friedrich, *Two
Men Looking at the Sea*, 1817. Oil
on canvas (51 × 66cm). Photo:
Staatliche Museen zu Berlin.

figures' expressions and so comprehend the situation. Uncertainty and ambiguity reign. We are left frustratingly adrift about how Friedrich's personae feel or what they think (fig. 37).

The aura of melancholy and psychological remoteness emanating from his pictures owes in large measure to his deployment of the *Rückenfigur,* raised to the level of a pathos formula. Regarding the scenery means disregarding the reactions of the painter's viewers to his work. Distinctly separated and silhouetted individuals seen from the back perfectly accord with Friedrich's abstract pictorial calculus. Such schematic human beings create negative intervals or fragments of intensity within the total composition.[22] Not unlike the artisanal inlay, they foreground the gaps or tears in the fabric of existence.

This art of yearning for the unattainable—despite all efforts to reach out and grasp what lies before the viewer—returns us to a consideration of mirror neurons. Certainly, many species can copy the object selected by the role model (the peanut, a glass of water) that they are imitating. But there is a second-level of imitation when the individual copies not the role model's choice of object but, rather, its motor action. The beholder must perform a mental representation of the visibly perceived action (say, approaching or withdrawing from someone or something or turning one's back) and produce an action conforming to the representation.[23] Even infants can do this, but most species cannot, excepting chimpanzees.

The flow of imitation—from novice to expert—can be reversed by teaching. The parent or teacher observes the child, but more than that, judges and modifies

the person observed. What happens if this natural iterative ability to imitate the facial expression of another is countervailed by a subsequent process: the correction of errors real or illusory? Rizzolatti has gone far beyond his initial hypothesis of the 1990s to argue that there are many mirror neuron systems and that these are involved, not just in imitating the social behavior of others, but in something much more elusive. Currently, he is in pursuit not merely of how individuals engage in recognizing those they behold, but how they come to comprehend the intentions of others. I will return to this assumption that there is a "copy" in the brain that not only allows us to "mind read" the emotions of others but that "automatically" imitates their perceived joy, sadness, or distress and thus quickly allows us to understand what we see.[24]

These fascinating neuroscientific findings, and their accompanying claims, raise the broader issue of inferencing. In his conversations with Paul Ricoeur, Jean-Pierre Changeux lingered over this problem of the genesis of intentions and their realization in programs of action.[25] The brain is an ancient projective system grafted onto that other basic activity, emotional motivation. I refer to that proleptic flash forward when the viewer leaps ahead to make predictions from analogous visual patterns with which he or she has been confronted in the past.[26] Inferencing, consequently, is closely allied with the imagination—the process by which scenarios and situations that are not presently available to perception get conjured up in the mind's eye.[27]

Sympathetic magic, shamanism, and wonder-working charms are all based on such experience projection and role taking: the "Law of Similarity and the Law of Contagion."[28] Recall that the talismanic symbol of the late Neoplatonists also operated by revealing the kinship of events, the secret bonds linking words, objects, and things. Further, the prognosticating aspirations of the entire history of physiognomics resides precisely in the will to tell in full that which graphic signs can only schematically indicate, or from whose allusive forms future events can only partially be foretold. This divinatory practice is similarly grounded in the belief that the material forms we see all around us mirror the deep structure of the cosmos. The fact that we dimly apprehend these connections helps to explain our innate cognitive proclivity to mimic and to respond swiftly to features of the ambient that correspond to our neural architecture.[29] This memory phenomenon is connected to others involving resemblance as well, such as the déjà vu experience, clinically defined as "any subjectively inappropriate impression of familiarity of a present experience with an undefined past." Interestingly, the double perception explanation of déjà vu points out that when a feeling has swept through us and another similar, fainter wave succeeds it, the secondary feeling will be falsely taken for a vague remembrance.[30]

The intense fMRI research focus on the fusiform face—made much of in the pseudoscientific physiognomic theories of the later eighteenth and nineteenth centuries as well as in the world of children's toys (fig. 38)—is showing that face cells distinguish faces, in fact, on the basis of visual shape, especially roundness. The neu

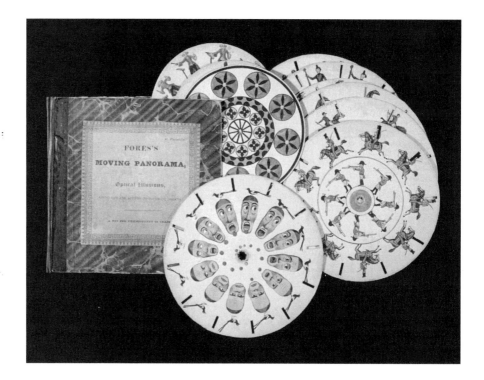

FIGURE 38
Alphonse Giroux et Cie,
Phenakistoscope, 1830. Card-
board box (24 × 24 × 3 cm),
eighteen disks (each with a
diameter of 18 cm). Photo:
Department of Special Col-
lections, Charles E. Young
Research Library, UCLA.

ral basis of this extraordinary ability, it is suggested, is mediated by specialized mod-
ules in discrete regions of the temporal lobe.[31] Although they had their vocal crit-
ics, the physiognomists of the past were similarly interested in understanding the
complexity of shape selectivity. The fear surrounding such mechanistic models of
the mind was that they made psychology dangerously resemble physiology, raising
the dreaded specter of materialism.

Laurence Sterne, for one, memorably challenged the physiognomist's dream
of transparency when in *Tristram Shandy* he ridiculed that ancient "fixture of *Mo-
mus'* glass in the human breast." Ever the skeptic, the clergyman-author affirmed
the opacity of the mind beneath the skull and the radical inaccessibility of our skin-
cloaked interior—resistant to even the most revealing of optical devices. The crys-
talline thoracic window is an illusion because "our minds shine not through the
body, but are wrapt up here in a dark covering of uncrystallized flesh and blood, so
that if we would come to the specifick characters of them, we must go some other
way to work."[32]

Sterne's objections notwithstanding, these early face-interpretation systems,
based on our empathetic responses, importantly recognized that "the body over
there reminds me of my own body and my experience also contains the bodies of
others."[33] Hogarth, for example, constantly invokes such formal analogies linking
the beholder to the behavior of his painted or engraved characters (fig. 39).

Today, the argument in support of brain modularity from the evidence of the
face is that we need specialized neural machinery because faces, apparently, are the

FIGURE 39
William Hogarth, *Death of the Harlot*, from *The Harlot's Progress* (1732), pl. 5. Engraving. Photo: National Library of Medicine, Bethesda, MD / public domain.

only stimuli requiring nuanced discrimination between thousands of examples that all share the same basic structure of the individual features and overall round shape. Thomas Willis, the famous seventeenth-century English anatomist who coined the term "neurology," invoked these specialized controlling structures in the brain in connection with an embodied "doctrine of the soul." Significantly, he located such psychological categories as reflection (reflex) or the imagination (mania and melancholy) in such dedicated areas of the brain as the corpus striatum, the thalamus, and the corpus callosum.[34] He laid the groundwork, then, for the nineteenth-century concept of brain specialization put forward in the "organology" of Franz Josef Gall and his disciple Johann Gaspar Spurzheim. The return of localization is visible in the conjunction between neurophysiology and imaging-based research conducted on everything from autism, to synaesthesia, to the walking wounded as in the famous case study of Phineas Gage documented by Antonio Damasio.[35]

But we should not get ahead of ourselves and need to look more closely at the scientific inquiry into motor neurons. This interdisciplinary field is rapidly becoming all-inclusive in its quest to comprehend the behavior of others—ranging from the emerging psychology of "animal personality,"[36] to decision-making strategies, to the creation of "public information" by monitoring the ways different people interact with their surroundings. Imitation, it is being hypothesized, may even trigger the transmission of behavioral patterns among individuals in a process akin to culture—that is, the cross-generational copying of social interactions that can change the phenotype.[37]

Yet another important category of research looks at "seeing the world in the same way," by using fMRI (functional magnetic resonance imaging). Invoking the visual arts and popular culture as evidence, scientists are trying to predict whether viewers watching the same segment of a film (in this case, a thirty-minute emotional segment from *The Good, the Bad, and the Ugly,* starring Clint Eastwood) have the same kinds of things happening in their brains in response to a common stimulus.[38] Synchrony, or the discovery that individual brains, as it were, "tick together," seems to be enabled by perceptually salient moments such as those often captured in photographic snapshots and the movies.

One reason realistic films, together with sound, have such a profoundly unifying effect on an audience (generating interbrain correlations) is because they deploy cinematic techniques that create animated salient images. At any given moment they insure that the most important bit of the story is isolated for the viewer. The close-up for dramatic emphasis and sharp editing to produce strong contrast are two notable examples. Sergei Eisenstein, who believed that the mind reveals its functional structures in its artistic procedures, deploys such schemata in the powerful Odessa Steps massacre sequence of *The Battleship Potemkin* (1925). His theory of film montage held that perceptual elements embodied concepts. Witness the nonnarrative diagrammatic starkness of the fallen body of the sick boy, gunned down by soldiers, and positioned in graphic conflict with a run of steps. The horizontal dynamics of this exterior scene are abruptly cut, creating an artificial tableau that pictorially frames a single orienting view.[39] With very different realist techniques and a rather Bergsonian "continuity style," Charlie Chaplin also achieves the vivid effect of pulling a subjective condition out of the spatiotemporal flux. He carefully shaped comic sequences to make his own actions prominent by using long, uninterrupted shots, universally high-key lighting, and unobtrusive editing.[40] Chaplin kaleidoscopically highlights significant facets of information plucked from the image-flow, but without the conspicuous modernist geometry of Sergei Eisenstein. For Chaplin, self-consciousness emerges from the material intersections that compose any situation.

Such saliency is also connected to empathy. The problem of imitation is not limited to the intellectual comprehension of another person's intentions but embraces the ability to intuit and feel along with what another person is feeling at any given moment. Intuitiveness, in turn, is related to the neurophysiological question of binding. How does our brain mobilize for every object of perception "the respective aptness of a large set of feature sensitivities to yield coherence?"[41] Marc Jeannerod has termed this spontaneous reaching for another at a distance, "emotional contagion," that is, the involuntary impulse to mimic, replay, or simulate someone else's waves of feeling within ourselves.[42] This, in fact, is an old issue in communication theory. Theophrastus, citing Empedocles' filmic theory of vision, maintained that sense perception takes place by means of a subtle incoming "effluence." Outbound translucent "skins" shed by the surfaces of objects and persons are launched

toward the perceiver's eyes, so that "like is borne toward like," enabling all creatures to know their kin.[43]

Empedocles proposed that to see we do not need the fully fleshed object but only the thin membrane or film that it releases into the air. Similarly, the diagrammatic directional sign of a full-blown emotion can often suffice to produce the same effect on the beholder as when it is embedded in the surrounding musculature. Features reduced to their basic geometry: such as round faces, large eyes, small symmetrical noses, high quadrangular foreheads, pointed chins, for example, have been shown to elicit judgments about competence or incompetence.[44] Apparently, "the mere presentation of an arbitrary cue [can] . . . signal the feeling state of another person."[45]

An entire class of *sensible* eighteenth-century paintings—from William Hogarth to Jean-Baptiste Greuze—depends on just such a mimetic "arousal theory" of emotion. The startling frontality and immediacy of pictures that were intended to be seen in crowded spaces—think of the dense floor to ceiling "hangs" of the London Royal Academy or the Paris Salon[46]—are a tacit acknowledgment and calculated use of the fact that we tend to animate all manner of sights and sounds. Seeing a descending line, like hearing a lower or falling note, easily gets transposed into a human emotion, such as sadness.[47] Thus for pain-related empathetic responses one does not have to activate the entire pain matrix (the secondary somatosensory cortex, the insular regions, the anterior cingulated cortex), but only that component associated with the affective dimension of a particular pain experience.

This sign-based, formal anatomization of emotion is clearly visible in famous print series such as *Marriage à la Mode* or *The Rake's Progress* (fig. 40), as well as in painted portraits, conversation pieces, caricatures, and genre pictures that finely dissect every nuance of suffering from the barely hurt to the agonized. Hogarth and Greuze—those masters of mimesis—instinctively realized that pain, like pleasure, was one of the homeostatic emotions, reflecting the internal conditions of the body. Or, as Antonio Damasio might phrase it, they make us aware of the fact that the unseen operations of the physical body are the cognitive objects of the human mind.[48] Through haptics, or the visual *touching* of our sensibility, we gain access to the invisible biological conditions of life mapped onto visible social behavior. The representation-in-brief of joy and sorrow diagram what is not so easy to see: the full-blown feeling contents of the emotions. Such sign systems have modest aims since they claim to do no more than outline a fuller experience whose global contents can only be inferred.

These artists, and they are not alone, realized that there was a distinction between emotional registration—merely noting the fact of negative or positive subjective feelings in another person—and the creation of deep, second-order representations that actually make us conscious of the perturbations affecting others. The large "candlelight" paintings of science demonstrations by Joseph Wright of Derby, such as the *Experiment with the Airpump* or *The Orrery*, for example, do not just pres-

FIGURE 40
William Hogarth, *The Morning After*, from *Marriage à la Mode* (1745), pl. 2. Engraving by B.Baron. Photo: HIP / Art Resource, NY.

ent a spectrum of emotional reactions to a single event. The central figure of the demonstrator, or even the riveting scientific instrument become the occasion for empathy, conduits for the complex feelings the viewer experiences when the various gazes in a group are either focussed upon the performer, engaged with his epistemic apparatus, or unfocussed in rumination (fig. 41). This knowledge-by-acquaintance is also an understanding of movement and action.

In what has been termed the mid-eighteenth-century "culture of visibility," people and personalities are routinely presented to one another's gaze not only to teach us how we should look at ourselves, but how to behave or not behave.[49] Viewers stand riveted in front of paintings, as Diderot argued, like theater audiences transfixed by a spectacular illusion. Both the art gallery and the stage, then were public schools for refining the social emotions, but they also taught the techniques of counterfeiting and make-believe.

Automatic imitation—a mirroring of physical motions—could be subverted by pretending to mirror them. In a group of melodramatic pictures ranging from the moralizing *tableau vivant* of the *Village Betrothal* (Salon of 1761) to a parade of single-figure studies devoted to distressed and disheveled maidens, Greuze, in particular, brilliantly analyzed the human ability to uncouple manifest emotional reaction from "true," that is, authentic feeling as actually experienced (fig. 42).[50] The social ability to lie, to feign, all those false signs that lead us into errors of judgment

FIGURE 41
Joseph Wright of Derby, *A Philosopher Giving a Lecture on the Orrery*, 1768. Monochrome study for engraving (17 3/4 × 23 in.; 45 × 58.4 cm). Photo: Yale Center for British Art.

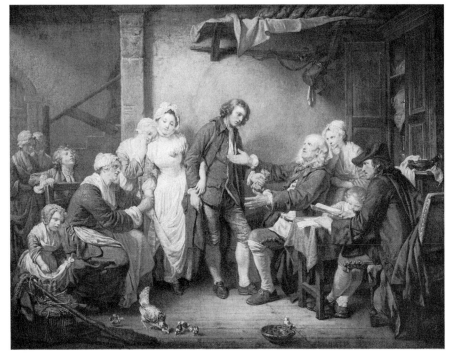

FIGURE 42
Jean-Baptiste Greuze, *Betrothal in the Village*, 1761. Oil on canvas. Photo: Erich Lessing / Art Resources, NY.

regarding the real feelings of others gave rise to more elaborate technologies of detection. Consider the creation of exquisite physiognomic systems—such as that assembled by Johann Caspar Lavater (1741–1801)—requiring finer and finer powers of discrimination to assess another person's credibility. The beholder was urged to engage in heroic feats of perspicacity to avoid being duped and was always on the alert for potentially deceptive signals concerning the real thoughts, beliefs, and intentions of those with whom he had to communicate.

Needless to say, the latest fMRI technology mobilized to map the neural circuits behind deception is turning this scanner "into a new kind of lie detector." Functional imaging, we are told, by using a powerful magnet to track fluctuations in blood flow to groups of neurons as they fire "reveals the pathways that thoughts have taken through the brain, like footprints in wet sand."[51] Moreover, research on subjects with impaired memory has pinpointed the orbitofrontal cortex at the base of the anterior brain as the critical area for the occurrence of confabulation. This curious tendency to make up stories reveals both the imperfections of memory as a reconstructive process and as a result of inaccurate perception.[52] The disinhibition that goes along with confabulation is interesting because it highlights the failure to read the mind of others.

In an odd way, Lavater's celebrated *Physiognomische Fragmente* (1789–98)[53]—with its almost desperate attempts to probe and penetrate the errant psyche by analyzing its visible characters—acknowledges the dialectics of emotional contagion. The weak link in this mnemonic perceptual process is the fact that it is also a process by which memories are constantly reactivated, associated, and thus inevitably altered when re-encoded. This intuition concerning the complexities of executing an accurate reach toward another person pushed physiognomics to greater microanalysis. It was not just a matter of honing our detective skills to grasp the deep order of the world whether located in faces, places, or works of art, but improving our powers of predictability based on simulation. This strategy of dissecting cognitive processes ever more finely continues apace within the contemporary medical imaging community, which seems convinced, along with Lavater, that each minute part of a unique form bears within it an image of the entire structure.[54] Therefore one can deduce from the tiniest element (the curvature of an eyebrow, the arc of a forehead, the flare of a nostril, the shape of a mole, the shadow print of a hand) the inmost meaning of the whole (fig. 43).[55] Here Lavater comes close to his pathognomy-supporting rival, Georg Christoph Lichtenberg, who claimed there were more impressionistic ways to recognize people. As one man suffering from face-blindness (prosopagnosia) recently put it, you can take your emotional cues "from the way a person's pants crease and bunch."[56]

FIGURE 43
Johann Caspar Lavater, *Contours of Foreheads,* from *Essays on Physiognomy* (1791), pl. 2, p. 173. Engraving by Thomas Holloway et al. Photo: Getty Research Institute.

I want to return to the image of the uncomfortable, suspicious baby and the gaze aversion with which I began since some researchers maintain that even infants "understand" that others may hold false beliefs.[57] Apparently, there is a mirror system for movement and action comprehension. For example, it is a basic feature of human experience to feel soothed in the close presence of others and distraught when rejected by them.[58] So is there added knowledge that comes from performance? Social separation as an action that creates distance from those to whom one wishes to be attached is signaled not only by pain registered in the anterior cingulate cortex corresponding to the thwarting of an involuntary response, but by direct matching in the motor cortex. It is not duplicitous actions per se that are the real issue, the general "truth decay" that many teachers lament, or the lying that the fMRI industry is dedicated to rodding out.[59] The nagging existential question lies elsewhere. It is the problem of determining the very nature of intention itself—not just its where and when.[60] In affective ingestion we do not just repeat another's actions, we grapple with them.

If the neurosciences are rightly reminding the humanities of the deep biological embeddedness of imitation and the existence of a common echoic code, then the humanities have something to say about observing as well as grasping a shared situation.[61] There are many things that people recognize but refuse to admit, like the fact that the missing are really dead or the visceral acceptance, by folding in, of a primal absence.[62] The humanities can deepen scientific inquiry by demonstrating that it sometimes requires a lifetime to come not just face-to-face, but in touch with certain gestures. This is not because the actions are deceitful but because they are either so veiled or, conversely, so blindingly clear, that they cannot be immediately assimilated.

ASSOCIATIONISM AS ATTACHMENT CHEMISTRY

Mirror neurons, it is hypothesized, are potentially a neural correlate to empathy. But, as we saw, this automated, observing-executing matching system is complicated. The perceptual and conceptual process of another person getting under our skin, so to speak, is not always pleasant. In her violent and disturbing novel, *The Piano Teacher,* the Austrian Nobel laureate in literature, Elfriede Jelinek, captures the pummeling that can go along with physical and psychic imprinting. "People are always pushing their way into HER field of perception. The mob not only grabs hold of art without being entitled to do so, but it also enters the artist. It takes up residence inside the artist. . . . What upsets HER most of all is the way these people dived in one another, the way they shamelessly take possession of one another. Each pushes his way into other minds, into their innermost attention."[63]

Paradoxically, in addition to making us more sensitive to our own actions and their infringement, mirror neuron research also illuminates the opposite condi-

tion, that of depersonalization. Through inferring and associating, the brain-mind diffuses or leaps outward. Once in the environment, it gets distributed among the shifting material objects and facialized structures to which we intuitively respond (fig. 44). François Desportes's sumptuous still life of peaches, repercussively captured and reflected in artfully positioned silver trays, reveals the face- and headlike character of these bilaterally symmetrical fruits. Such repetitive and hypnotically round objects are a bit like peeking into the basic mechanisms underlying face selectivity—except now displaced onto analogous cranial objects circumscribed by similar circular contours. Offering a unique opportunity for exploring high-level form perception, these suggestively anthropomorphic shapes help us understand the process by which the brain recognizes and locates itself in the larger world to which it is attuned.

This seamless extension of private cogitation beyond the margins of the body and the reciprocal envelopment of the perceiving subject by a corresponding ambient intelligence is one of the core claims of eighteenth-century associationist theories. The resulting compression of subject-object relations in empiricism and, with it, the collapse of distance between self and surroundings, both produces, and is a consequence of, material monism. The pattern-seeking mind, like the patterned environment, belongs to the same realm of agent-things. By executing this reach, then, the pointillist self becomes further subdivided into differentially responsive sensory systems (visceral, homeostatic, proprioceptive) that inform the brain about discrete body states. But these simple sensations and perceptions, in turn, are augmented and compounded by their entanglements with correlative aspects of the world.

Pantomime, or reciprocal mimetic exchange, breaks down sharp causal frontiers between the mind and the environment since it demonstrates the interdependence of perception and action.[64] This binding process, as Wordsworth puts it in his preface to the *Lyrical Ballads,* is the task of the poet who considers man and the objects surrounding him as echoically "acting and reacting upon each other, so as to form an infinite complexity of pain and pleasure." Functional brain imaging research is catching up with this fundamental Romantic insight that individuals, things, and scenes constitute a resonating system. Together, they excite "sympathies" and "associations" in the onlooker.[65] Consequently, face-recognition (localized in the so-called fusiform face area and the inferior occipital gyrus)—or getting a strong reaction when the observer looks at someone—is only the tip of the iceberg.

House façades, chairs fronts, landscape features cause widespread, overlapping activity across neighboring neural regions.[66] Eighteenth-century prints and paintings are dominated by this belief that all things possess a face or are stamped with character. In this spirit, Hogarth animates a line of laundry: generous bloomers—so often dropped in the harlot's life—droop suggestively over her in death. Downward sliding stockings and mercenary gloves whose fingers still reach and grasp hold the memory traces of the working body that now slumps defunct below. These expres-

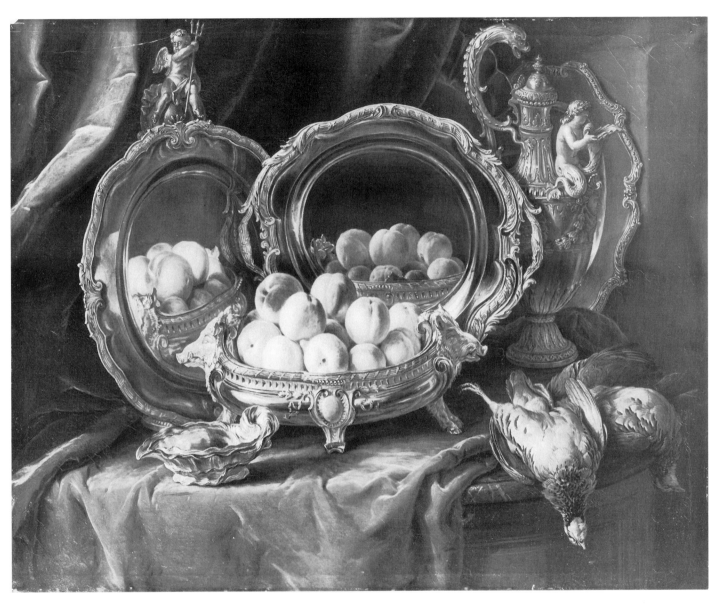

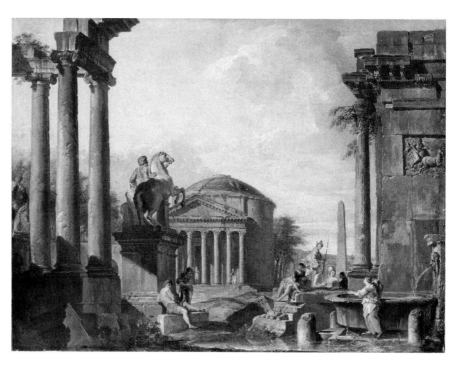

FIGURE 45
Giovanni Paolo Panini, *Fantasy Landscape with Roman Monuments*, 1735. Oil on canvas (98 × 134 cm). Photo: Staatliche Museen zu Berlin.

sive flannels of the poor stand out against the expanse of a crumbling plaster wall whose eroded edges evoke a succession of cloudy forms and embedded sketchy features (see fig. 39).

On a more serious note, even the collecting and depicting of antiquities does not escape this tendency to facialize all objects (fig. 45). It is impossible to think of the large corpus of *capriccios*, such as the *Fantasy Landscape with Roman Monuments* (1735) by Giovanni Paolo Panini, without calling up the distinctive façades, rear and profile views of the famous monuments with which they are recognizably littered: the Pantheon, the Horse-Tamer, the Sallustian Obelisk, the Arches of Trajan, and Severus—each carefully exhibited to showcase its unmistakable identity. The selection of which moldering ruins to copy in a painting seems determined, at least in part, by their mien, that is, by their ability to affectively address the beholder. The "portrait" potential of architectural and sculptural remains also seems to determine what kinds and which aspect of natural scenery to depict. Consider those staple features of the Sublime landscape that Joseph Wright of Derby incorporated into his *Cloister of San Cosimato* (1789). An eroded, vegetation-covered stone bridge greets the viewer head-on. A raging cataract flows beneath it to precipitously emerge between the walls of a steep ravine. Significantly, the entire brooding composition is flanked by the beetling brows of overhanging cliffs. Looking at landscape is like reacting to a countenance: we are moved by what is moving and what moves head-on toward us.

Bertrand Russell, it seems, was right. There is no separation between the "mind stuff" and the "physical stuff" in the universe. This means that our cognitive appa-

ratus is not a computer, nor a rabbit warren of functional modules, but a dynamic representational structure comprising the nervous system, our body, and the environment.[67] If motion is indeed central to the process of mental inferencing and intentionality, then perception is always dilated, dispersed, distributed.[68]

Contemporary performance art demonstrates the truth of this distributed awareness of the self as always conjoined with its milieu. In performance, the body of the perceiving subject is both the organ of perception and of movement. But if expression, as we saw with mirror neurons, typically incites similar expression, what are the dynamics of exchange when communication is asymmetrical? This is the question posed by performance artist and poet Yoko Tawada. Taking the "faces of letters" as her theme, this bilingual writer, who composes both in Japanese and German, meditates on the perennial desire of the foreigner to discover a recognizable shape behind strange forms and illegible ciphers. At a deep level, her work is concerned with kinesthetic sensations. She explores the ways by which all those who feel themselves to be strangers in an incomprehensible land struggle to detect a common identity in the same object, even when it is distributed across its partial representations in various alien idioms.

For her performances, Tawada wears a single white glove with the text of her poem written inside, in touch with the skin, secretly animated by every gesture. At the end of the reading she tosses silvery sparkles into the air to signify the copresence and physical commingling of her thoughts, body, and the thingly environment in real-time and space. Evocatively, the author-artist calls her tactile words *Pulverschrift*—a powder-script scattered like motes on the wind by people always on the move.[69] The displacement of Yoko Tawada's body in shuttling continually between different countries mirrors the changes undergone by familiar objects mobilized in unfamiliar words. She asks: does one become another person if one speaks a different language? Is the same thing, or something else, reproduced when one uses foreign terms? "Does a little seahorse look different if it is no longer called *tatsunootoshigo* (the lost child of the dragon) but rather the little horse from the sea? Will I no longer cook rice but eat it uncooked if there is only one word *rice* for cooked rice (*gohan*) as well as uncooked rice (*kome*)?"[70]

Tawada's demonstration that action is material communication reveals the propensity of mind and world to interpenetrate. Association helps one to become an agent by bringing things together that would otherwise remain dispersed in our visual field. This conjunctive or analogical activity—whereby people extend related systems from one domain to another—also coalesces the person. Since the human mind has a long evolutionary history, these reenactments and re-collections of a dissipated object get disseminated across wide physical and social networks. If the neural constructivists are correct, we remain open to profound kinds of neural growth and rewiring and these changes loop back to transform the cultural domain.[71] This experiential approach to cognition challenges the classic propositional picture of

the mind in which concepts are abstract, amodal, symbolic representations congruent with the reduction of thinking to computation.[72]

The computational hypothesis—based on isolating the repeated sensorimotor interactions between agent and world—that has dominated cognitive science for decades is in the process of being revised by cognitive scientists themselves.[73] As one of the key architects of a re-constructed view of cognition as distributed, Andy Clark argues that brain, body, and world can be participants in episodes of dense, reciprocal causal influences. Organism and environment become temporally/spatially attached, or echo each other, through "mutually modulatory, non-decouplable co-evolution." But he admits that a potent challenge to this connectionist understanding of an interwoven brain-mind/environment arises when the web of causal influences grows so wide and complex that it is impossible to isolate any "privileged elements" on which to pin specific, information-carrying roles.[74]

In a nutshell, Clark recapitulates the promise and the problem of British eighteenth-century associationism, which also grappled with the nature of the interrelationship between apprehension and movement. How can the affective intellect perfuse a wide array of natural and cultural domains? Mirror neuron research adds a new dimension to this old conundrum. Recall that these cells in the premotor cortex are activated and display the same structure of activity both when the animal or person is accomplishing certain movements and when the same actions are observed in and re-enacted by others. The importance of personal agency—not just spontaneous mechanism or autopoieis (see chapter 6)—is thus reinstated in accounts of perception and awareness.

Specifically, I want to recuperate the sophisticated historical doctrine of associationism in light of today's investigation into the distinction between voluntary and reflexive motion. John Locke, Francis Hutcheson, David Hume, and Adam Smith were passionately concerned with how the susceptible self preserves its individuality when it is continuously imposing its own organization on its surroundings and the surroundings, in turn, are continuously eroding its singularity. Another way of getting at this is the problem of relations. For Locke, as for Robert Boyle, there is a fundamental difference between nonrelational qualities that belong to things whether we perceive them or not (mass, figure, motion of the parts) and relational qualities. It is these latter observable qualities, actions, and powers—that are a function of the environment of bodies—with which the mind interlocks.[75]

Thinking and motion brings about this cohesion of separable parts. For Locke, but others as well, movement mobilizes the body as well as activates the spirit. True, relations exist in nature. But relative ideas arise when the mind ranges between and among things in pursuit of comparisons. Associationism is thus inseparable from the eighteenth-century culture of tourism and travel accustomed to walking, climbing, sailing, or otherwise exploring while thinking. Encountering shifting shapes as one physically navigates space changes the viewer's outlook as locomotion changes

one's limbs and position. Given this bi-directional flow, how does one recognize a self-produced action from one imposed from the outside?[76]

Empiricism was a philosophical movement of the later seventeenth and eighteenth centuries originating and centered in, but not confined to, Great Britain. Unlike Descartes, Spinoza, and Leibniz—who placed less emphasis on sensory experience and more importance on a priori reasoning—the empiricists were interested in what John Yolton has termed "the status of appearances."[77] In his many studies investigating what constitutes "presence to mind" in the Anglo-French philosophy of the early modern period, Yolton convincingly demonstrates that there is shift from the spatial presence of objects in the mind to their epistemic or cognitive presence.

Numerous philosophical consequences follow from this transformation. The crystallization of things as mental "objects" view gets abandoned in favor of their apprehension as "winding," "turning," "waving" figures. As Hogarth remarked, "the love of pursuit, merely as pursuit, is implanted in our natures." Thus meandering sights and diversionary images lead *the eye a wanton kind of chace*" through the "serpentine lines" and the chromatic maze of the ambient.[78] As we progress through this intricate environment, we become cognitively "acquainted" with what we inspect. We become one with the shapes and motions we view on the fly. "Ideas" thus are experience-dependent resulting from our selective attention or tracking of information.[79]

What specifically interests me is how the brain-mind opportunistically seizes the structures it encounters, and how the surroundings, in turn, are repercussive, reflecting back the patterns the viewer seeks. We see this correlating associative drive at work in Thomas Gainsborough's later paintings submerging the sitter in a misty landscape. The enfleshed body is one thing among other visible and mobile things. Actively engaging with the malleable stuff of the world, the mind of the perceiver is cut from the same gauzy cloth as the surrounding living matter.[80]

Vitality is not a characteristic imposed from the outside. Instead of being isolated from one another, or in opposition—as the "Mechanical Philosophy" or the New Science of the seventeenth century would have it—nature and mind dynamically operate on one another. This fact of being embedded in a mutual sentience permeates Gainsborough's life-size portrait of legendary iron master *John Wilkinson,* captured lost in thought (c. 1775). Painted after the artist's return to London from Bath in midsummer 1774, it belongs to the brisk portrait production he engaged in during his voluntary exile from Royal Academy exhibitions.[81] Gainsborough captures this major ordinance manufacturer just after he successfully patented a technique for producing guns less likely to explode and with a more accurate bore (plate 7). The long, heavy face is not disguised, though the terrible smallpox scars have been tactfully removed. By modulating coarsened features and disfiguring blemishes, Gainsborough is able to create fluid transitions between the no-longer executive self of the inventor, wrapped up in atmosphere, and a more than haphazard world. The

powerful industrialist is cross-blended with the sketchy tactility of the scenery and, conversely, imbued or softened by its melancholic autumnal cast.

Wilkinson's ponderous body—more accustomed to furnaces and casting-houses than idyllic landscapes—bonds with various external props. It weighs down and claims a rugged outcrop. His left elbow sinks responsively into a tree stump. But the real world of tactile objects also augments him physically and psychologically: his ungainly frame is reciprocally sheltered by a cavelike bower formed from an angled tree. In the late afternoon sunlight, we can just make out the jagged mountains in the distance indicative of analogous asperities in the sitter's character. A muted roughness permeates the canvas both literally and metaphorically. The bravura *impasto,* or the texturing brushstrokes of thick oil paint that weave the scene together, evoke a visual association to the implicit forcefulness of the man. This psychic energy, in turn, gets distributed or ceded to the welter of surrounding foliage and the scumbled surfaces that explicitly act it out.

Like reverie, which is less accessible to consciousness, the process of associating acknowledges that there is a material resemblance between our imagistic inner life and the streaming outer scene. But this is not to claim, as Jerry Fodor does in his objections to connectionism, that the dynamics of the environment are automatically sieved through the brain.[82] An agent's voluntary, as well as involuntary, memory must strive to tie together fleeting events. Kant attempts to do this in his account of synthetic a priori judgments.[83] But we see the problem of empirical conceptualization, of reconciling the phenomenal and noumenal aspects of experience defined much earlier. I take associationism, therefore, to be a much more serious activity than it is usually credited with being. Rather than turning us into slaves of context and in thrall to the ambient, it makes us sensitive to the co-occurrence of the thinking self with the items presented in experience.

The "copy principle" or mimesis is central to David Hume's empiricism. Identity and the formation of our idea of a unified self depends upon the associative relations of resemblance and causation: the fluid transitions we make from past to present perceptions in acts of memory. This "natural inclination" to find similarities or connections, common to all humankind, is visible in the social urge humans have to imitate one another. Steven Pinker makes a similar point when he argues for the evolutionary function of art: the power to impress others with one's social, not just genetic, status.[84]

Such contagious communication also underwrites mental operations, like the passions (which we are led into by the sight of others) and analogical inferencing (the probabilistic transfer of a prior resemblance onto something that is not exactly the same). Reflection ("inward sentiment") mirrors sensation ("outward sensation"). But our "promiscuous" imagination, independent of the understanding, can permute and combine simple "ideas."[85]

Hume the skeptic is everywhere in evidence in *The Treatise on Human Nature*

where credulity is the universal weakness of mankind and the opposite of the positive drive to find connections.[86] Precisely because Hume has a view of the mind that is active and constructive, he feels obliged to attack the deleterious "influence of resemblance" arising from unthinking custom and the imagination prone to "enthusiasm," as it is difficult to control, tending to wander beyond its proper limits.[87]

The nature of causal connection was thus of fundamental concern to him as it had been for Thomas Hobbes, Nicolas Malebranche, and George Berkeley. The "extensive" sentiment lies at the root of knowledge construed as the synthesis of distributed things. It also transforms atomistic sense impressions into a manifold. But the problem was how does association produce unity from aggregates, complex ideas from simple notions? What are the neural mechanisms linking past with present experience? Can we accurately infer from the fact of something having been once repeated that it might habitually occur in the future? Newton's theories about cause and effect offered Hume a physical model for the working of attraction in the mental and moral spheres.[88] He transposed the Newtonian celestial mechanics of gravity into the affective pull of association. Because it was a profound social force—taking us outside of ourselves and our own particular positions and interests—Hume rightly saw his principle of the association of ideas as his most important philosophical contribution.

Significantly, Hume's conviction that we have instinctive social inclinations was shaped by aesthetics. Francis Hutcheson, a fellow Scot, was one of the most original moral philosophers and writers on the formation of a common "taste" in the eighteenth century. In *An Essay on the Nature and Conduct of the Passions and Affections* (1728), he posits an inner sense responsive to beauty that is automatic and independent of the will. Reacting intuitively to the perceived properties of uniformity amid variety, this natural power in the mind leads us outward and leads us on, establishing a "double relation" between subject and object. This inner sense is proleptic of Hume's theory of the imagination, able to carry us beyond and beside ourselves to form a conception of what another person's sensations might be.[89]

For both philosophers, motion is an intrinsic component of emotion. Perceptions arise in us, "nor can we alter, or stop them while our previous Opinion or Apprehension of the Affection, Temper, or Intention of the Agent continues the same; anymore than we can make the Taste of wormwood sweet, or that of Honey bitter."[90] Or, as Thomas Reid would subsequently rearticulate it, perception is the formation of immediate belief.[91] Sympathy leads a long life in the Scottish school of moral philosophy, rhetoric, and belles-lettres. In addition to Hutcheson, and Hume, Adam Smith, Hugh Blair, and Thomas Reid were likewise interested in sympathy as both a "chaining" mental operation and as a system of comparison—much like an art collection or a literary anthology. What this activity of gathering shares is an imaginative self-projection into an outsider whose standards and responses we reconstruct by the ability to feel as he or she does.[92]

Hutcheson, and later Hume, were acutely aware of the difference between controlled and uncontrolled mimesis. The excesses of the latter stem from the automatic nature of much emotionality, those powerful primal circuits that elaborate reflexive pleasure seeking, fear, anger, and sorrow. Most affective knowledge stems—as we know today—from either the reptilian brain in the basal ganglia and extrapyramidal motor system or the visceral brain in the limbic system, and is predicated on primitive behavioral mechanisms in response to archetypal situations.[93] Darwin recognized that the way humans experience emotions is indebted to our animal ancestry.[94] We thus continually oscillate between absorbing a changing outside world and struggling to maintain a balanced sameness of self.

As much as Enlightenment thinkers recognized the dangers of mimesis, they also believed that, in its sympathetic form, it could mold responsive social beings by having them internally re-perform the condition of others. They thought that learning, art, and culture could channel pure arousal and reward systems—attracting the viewer toward or repelling the viewer from desirable or undesirable things. One might say that the entire pedagogical drive of the Enlightenment rests on the conviction that a fundamental characteristic of being human is the ability to inhibit direct impulsive responses. Uncoupling the signifier from the signified is the conceptual analogue to antipointing or antisaccades.[95]

On the positive side, then, the associative process produces an empathetic "Publick Sense," that is, "our determination to be pleased by the happiness of others and to be uneasy at their misery."[96] On the negative side, as Hume subsequently underscored in his writings against miracles and religious superstition, "Fancy" comes in, begetting "such wild associations of Ideas, that a sudden conviction of Reason will not stop the Desire or Aversion, anymore than an Argument will surmount the Loathings or Aversions, acquired against certain Meats or Drinks, by Surfeits or emetic Preparations." Such foolish or "fantastick associations" sweep in like a "contagion," hurried on by the violence of the passions. Only a vigorous "constant Attention of the Mind" or a disciplined "Abstraction" can separate out false opinions and extravagantly confounded ideas.[97]

DISTRIBUTED AGENCY

Nothing could be more foreign to the contemporary media scene than Hutcheson's reflective summons to stop all action before "a calm Examination of every circumstance attending it, more particularly, the real [versus imagined] values of external Objects, and the moral Qualities or Tempers of rational Agents, about whom our Affections may be employed."[98] Yet the dividing and doubling of identity implicit in associationism as well as the transfer of identity—a procedure it shares with eighteenth-century theories of acting and masquerade—continues to live an ironic

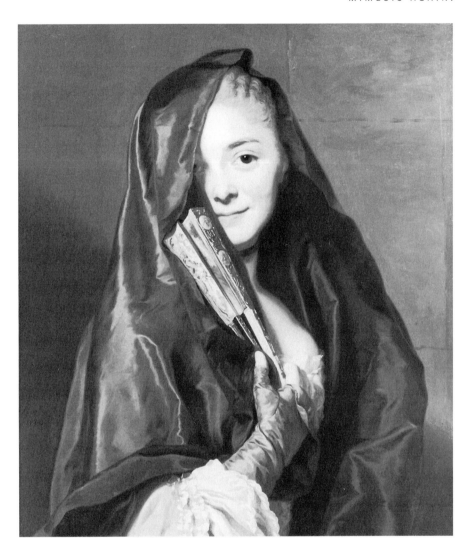

FIGURE 46
Alexander Roslin, *The Lady with
the Veil: The Artist's Wife*, 1768.
Oil on canvas (65 × 54 in).
Photo: The National Museum
of Fine Arts, Stockholm.

afterlife (fig. 46).[99] What has disappeared is the person as agent of his or her actions. Agency itself has gotten lost within distributed, mostly autonomous, brain functions responding to powerful, turbulent, or extravagant effects—distant heirs of the Burkean Sublime with its discourse of excess and inescapable responses. As David Chalmers puts it: the structure of consciousness is "mirrored" by the structure of awareness and vice versa. Mirroring, in this context, implies an automatic doubling, a spontaneous reflexive relationship between phenomenology and psychology.[100]

Self-assembly—or the autonomous formation of natural components into organized structures—has become a larger cultural paradigm for a range of self-driven performances.[101] Significantly these embedded processes, requiring the component parts to move spontaneously with respect to one another, must take place without any human assistance whatsoever. Inspired by the ubiquitous model of infor-

mation technology—today's global ruling metaphor—self-design embraces everything from amorphous computing to nanotechnology to synthetic biology, and, of course, to the eruption of consciousness from a neural substrate.

Beginning his career as a cognitive scientist and continuing now as an artist, Warren Neidich uses photography, video, and film as ways to investigate not the extension, but the substitution, of people by their molecular media components.[102] The agglomerated individual, as one more self-assembled structure among many, is engulfed by an autonomous overlay. Neidich demonstrates—as the composite emblem of the Baroque era and the condensing caricature of the nineteenth century had previously done—the ongoing construction of artificial persons (plate 8).

Today's global subjects are, on one hand, anonymously and mechanistically assembled from the multiplexing reports generated about them. More coordinated patterns than living organisms, such compacted forms of information add up to a novel distributed being that Neidich simply calls *Earthling*.[103] On the other hand, everywhere we look we are reminded of how much despairing personal energy is expended in the painstaking construction of identity. From the photographs of transsexuals by Diane Arbus, to Orlan's televised bouts of cosmetic surgery, to the hermaphroditic wax sculpture of Robert Gober, we are confronted with what a recent exhibition has called "playing with sex."[104]

In either case, such flagrant amalgams are the product of a new excursive vision that gathers into itself and redirects whatever it encounters in the outside world as well as on the Web. Informed by the Neural Darwinism of Gerald Edelman, the masklike self-presentation of *Earthling* is especially noteworthy. This arch-specimen of the contemporary networked entity is the result of a coevolutionary process whereby the conditions occurring in the culture and those happening in the brain are seamlessly linked together. Edelman's discussion of the importance of synaptic populations in individual brains that *match* value systems or rewards seems of particular relevance for the creation of associative structures whose feedback and re-entrant loops recursively affect their own conditions of being. Because of this continuous back-and-forth motion, they are more likely to survive or contribute to the production of future behavior.[105]

Neidich takes the human face—that venerable symbol of self-identity, expressiveness, as well as of the endless demand for imitative responsiveness—as his prime subject. But the face in question is not mobile, open, or vulnerable, but stealthily lurks behind the eye slits cut into the graphic front-page stories of a newspaper or a magazine in which these itinerant personalities feature. Specifically, he uses video to capture the "real," moving and blinking eyes of such immediately recognizable world figures as George W. Bush. The remaining facial traits comprise an expressive dead zone since they are masked by petrifying headlines: the garish assemblage of the daily news made up of competing stories and morphed photographs. The "real"

George Bush, embarking on well-publicized visits, is thus detached, displaced, or distributed behind the tall tales told about an obviously constructed figure.

Mimesis is back with a vengeance. Everywhere we turn, advertisements and branding create the impression of having a clear message to communicate. Just like enigmatic corporate names (Aon, Enron, Sysco) and the impenetrable façades of their black-glazed corporate headquarters: you do not know what they mean or contain, but meaning and product are reflected in there somewhere.

Somewhat surprisingly, idea art is back as well. This new conceptualism, however, is not concerned with intellectualism and philosophizing about the meaning of art that characterized the productions of its initial exponents in the late 1960s and 1970s: the language-based elaborations of Sol LeWitt, Mary Kelly, Joseph Kosuth, and Mel Bochner. As Jack Burnham wittily remarked, "even the printed page represented for this group an unavoidable belaboring of the point, since telepathy was their ideal medium."[106] The cognitively inflected work of the twenty-first century, in contrast, deterritorializes and reterritorializes the findings of the neurosciences into an artistic practice that is embodied both mentally and experientially.

As evident in *Earthling,* we now have a rematerialization of the work of information, demonstrating concretely how it is processed, synthesized, and synchronized—with or without our conscious attention or will. From this perspective, it is useful to recall that Lucy Lippard had famously dubbed the nonvisual procedures of the first conceptualists, the "dematerialization of art." Influenced by linguistic analysis, artists like Daniel Buren or Dan Graham formulated propositions about society and cultural institutions. The resulting monochromatic, or sparsely inhabited, paintings and rudimentary geometric forms belonged neither to the preaesthetic "biological stage of mimicry" nor had they attained the scientific postaesthetic stage enabling "the manufacture, distribution and consumption of a perfect art product." The latter, it was thought, would ultimately lead to the "disintegration of art" and with it, to the "abstraction and liberation of the idea."[107]

Instead, we seem to be heading not in the direction of a radical idealism but toward a radical material monism. Perhaps we are even on the verge of a direct realism of the sort called for by J. J. Gibson who argued that the matter-mind distinction should be eliminated.[108] But perceiving as an implicit inferential process as we wend our way through the environment, or stand struck by its sights, has become a more complex type of locomotion than it was in Gibson's day (fig. 47). If anything, his kind of associative looking as a form of doing is indebted to the persistence of picturesque aesthetics.

From William Gilpin to Sir Uvedale Price, experiencing natural scenery entailed travel through the ambient optical array. Vision is animate, a bodily sampling of one's changing surroundings that locates the viewer in a particular territory in a direct experiential way.[109] For eighteenth-century tourists as well as a host of

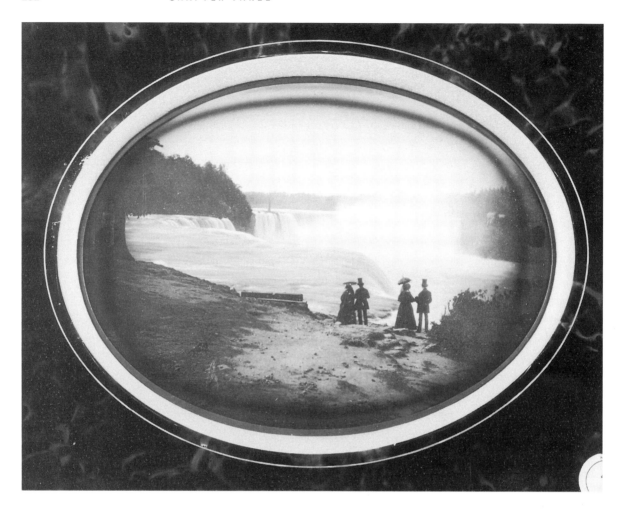

FIGURE 47
Platt D. Babbitt, *Scene at Niagara Falls*, c. 1854. Whole-plate daguerrotype (5 13/16 × 7 1/8 in). Photo: The J. Paul Getty Museum.

later theorists and ongoing practitioners of picturesque garden design—just as for Gibson—seeing was more than viewing. It was more than just the pickup of stimulus information.

The sensuous landscape garden of the eighteenth century was simultaneously a material thing (or collection of things), an object of reflective study—the attention paid to the natural topography, to the built environment, and to oneself within this affecting palimpsest—and an epistemological way of knowing the world. Such mixed-use sites typically consisted of a broadly framed environment alternating with cropped scenes and uncropped expanses. Although from Claude-Henri Watelet, to William Chambers, to C. C. L. Hirschfeld, to Dezallier d'Argenville there was little consensus on what the "natural" or *pittoresque* garden might look like, these designers nonetheless agreed that what was essential was the externalization of different expressive "characters" dwelling in the rugged or smooth patterns of the ground, the rise or fall of the setting, the allusive cultural and geographical situation.[110] The

vision of the walker was as mobile as the plasticity of the constantly changing life-world through which she circulated during her self-shaping itinerary.[111]

Mimicry in the garden was thus an attempt of the wanderer both to resonate with the elemental and, conversely, to discover human agency within organic and inorganic substances. The physical and temporal exploration of land and life was not only a psychosomatic act but a rhythmically responsive—even an antiphonal—performance of identity. Melding with, or blending into the unfurling milieu, necessitates a constant mapping and connecting between the animated inner landscape of the experiencing subject and the echoic objects in her surroundings.

But eighteenth-century landscape gardens were an arena for more than lateral linking. They were domains for vertical attachment or feeling your knowledge. While Gibson's flow certainly remains at the heart of dynamic perception, what sort of holistic horizon of experience can still be captured in an information environment to which everything has become internal? Does vision as the archetypal distance sense, and with it cognition, really get beyond the skull and extended into an external situation when it is decoupled from whole-body activation? An analogous point regarding the necessary interplay between physical and mental exercise is raised by neurologist Frank Wilson when he argues that the human hand and brain coevolved as a behavioral partnership. Understanding as the result of corporeally applying learning—as in woodworking or origami—engages our environment directly and so "develops our intelligence primarily through the motor agency of our hands."[112]

The limitations of describing cognition as abstract information processing is being acknowledged in the computational community itself. The imaginative design of textual "machines," developed by Graziella Tonfoni of the Istituto Glottologia at the University of Bologna is a case in point. These Baroque pedagogical devices for self-metamorphosis—reminiscent of Ramon Llull's or Athanasius Kircher's transformational metaphor machines—make tangibly visible the physical *activity* of reading and writing in the same way that a wheel models walking, or the proprioceptor senses inform us about the state of our muscles and the positions of our limbs. By visualizing and experiencing the motion of rotating hubs, gridded pyramids, memory "carriages," and highlighting textual "lenses," users in this virtual reality can recover something of the lost physical sensation of reading and writing, that is, the materiality of these interconnected intellectual processes.[113]

The situationist, embedded, or distributed view of cognition has refreshingly proposed that what is cognitively important is our lifting anchor and moving beyond our own skin. Take the mental chemistry of Humean associationism—where more or less solid attachments precipitate out of an environment in perpetual solution. Or consider eighteenth- and nineteenth-century cerebral localization theories[114] that connect specific psychological functions to specific areas of brain tissue.

These instances of coordination demonstrate that topography and cognition have long been connected. Historically, the many faces of mimetic art provided endless opportunities for developing exploratory behavior between agents and their settings.

The contemporary and near-ubiquitous navigation of a synthetic data space, however, has only accentuated the venerable problem of how we go about determining that something belongs either to an internal or an external space/place. As Michael Heim observed with a little help from Plato and Leibniz, the primitive origin of cyberspace lies within the human psyche. Virtual worlds are the latest metaphysical laboratories for probing our sense of reality and for examining the psychophysiology behind our easy surrender to the dreamlike allure of the Cave.[115]

If mimesis has become a more complex reality-reflecting and -reflected construct so, too, has our neuropsychological architecture—intermeshed as it is with natural as well as artificial landscapes. The emergent cognitive artwork will have to reckon not only with connected layered worlds through which we willingly move but our tendency to spin irreality within reality, and vice versa. How is the visual system, in tandem with the nervous system, engaged in world making, in the generation of a universe of symbols? How does the sensing body and its surroundings get funneled into "global organism-environment processes which in turn may affect (via downwards causation) their constituent elements."[116] Mirror neuron research affirms that there is indeed a world outside the perceiver, one that we imitate and internally re-create. But, as yet, it does not explain why something less-than-real so powerfully stimulates our propensity to visualize.

4

PRIMAL VISIONS

The Geography of Interiority

Why is this "no-man-fathomed" trope so ubiquitous? Because, we suggest, it derives from human consciousness and the sense of "sinking away," of "falling" into sleep and hence mysterious realms where—sometimes—we feel we can grasp truths, but all too often we struggle to make sense of it all, "whatever the terror"—or perhaps because of the terror. That is why the notion of depth permeated Neolithic thought even as it does our own. Their brains functioned in the same way ours do.[1]
DAVID LEWIS-WILLIAMS AND DAVID PEARCE

To the Land of No Return, [The Great] Earth.
Istar, Sin's daughter, set her mind
Yes, set Sin's daughter her mind
To the house of darkness, the abode of Irkalla,
To the house which he who enters does not leave,
To the road whose course does not turn back,
To the house where those who enter remain deprived of light,
Where their sustenance is dust and clay their food,
They see no light and dwell in darkness,
Clothed, like birds, with wings for garments;
Dust has settled upon door and lock.[2]
SUMERIAN POEM

HALLUCINATORY HAUNTS

Art enables us to observe the space inside our bodies. It gives a face to the secret life of consciousness. The history of images, in turn, can be fruitfully informed by research coming from neuroanatomy, cognitive science, evolutionary psychology, as well as cognitive anthropology and cognitive archaeology to ask how visual perception becomes endowed with emotion. How does our unconscious internal spatial map become conscious as an actualization or presentation: that is, as a concrete image or extrapersonal place to which we are attached?

Take the case of the subworld of the eye-brain. It automatically preprocesses the huge data flow brought to it by photonic wave fronts. But before it is sent back to the visual cortex for final processing, these electric waves "are received along a narrow sliver of the electromagnetic spectrum, [which] refracts them by transmission

through clear colloidal suspensions and gels, brings them to a color-corrected fo-
cus on an organic substrate packed with sensors specialized for brightness or hue,"
and then preprocesses them again.[3] The optic nerve, then, is not merely a conduit:
it does something magical with the raw sensory data it carries.

This chapter is the concave mirror image of chapter 1. There I sketched the
combined aesthetic and epistemological fascination of the Romantics with the ge-
nealogy of human thought embodied in minimalist designs. Here I look at the per-
sistence of certain geometric formulas from the inside out and ask why they never
completely disappear from the visual record. These bedrock representations, I be-
lieve, externalize how the brain-mind breaks down its surroundings into many small
areas, each represented by activity in specific cells.[4] There is a natural connection,
then, between mathematical abstraction and the richness of visual representation.
We witness the birth of spatial arrangements, marked by the struggle to distribute
modular elements across an uneven plane, in the roughly textured mineralized sur-
faces of ancient underground sites. Such resolutely material, low-lying places allow
us to perceive the conversion of normally hidden inner representations into ideas.
Generated and then reproduced inside the deepest caves or the darkest temples,
such object-events are not illusions but *present* what the brain-mind creates.

Edgy luminous forms allows us to enter the strange realm of sharp, brightly lit
hallucinations. Rock art and pictographs are among the oldest examples of closed
shapes that are discrete, superimposed, as well as interpenetrating. As we shall see
from the neurobiology of addiction, hallucinations curiously support both the pri-
macy of perception and a phantasmatic realism of the sort that Plato classed with
echoes, dreams, reflections, and footprints.[5] Strikingly, from Australian Aboriginal
cave painting, to the emblematic characters of ancient Mesopotamia, to the car-
touche elements in Egyptian painted reliefs, the framing of hieratic designs is con-
spicuous. Hallucinating, importantly, both generates recurring crystal-like patterns
and turns them into feverish phantoms with no reality of their own.

Our contemporary narcotized electronic technologies similarly either delete the
contour from digital objects or give them a false edge. Especially with the rise and
spread of the global phenomenon MMORPG (massively multiplayer online role-
playing games) the line between synthetic worlds and real life has become blurred.[6]
Unlike anything before, however, online fantasies have come to shape real life be-
cause they provide something more: elaborately detailed visual environments and
a system that governs action and movement, leaving most decisions to the players
themselves. That is, most of the interactions of daily life have been simulated in
computer scenarios.

On another front, the so-called dark side of drug addiction—learning mecha-
nisms engaged perhaps aberrantly by major classes of addictive substances—may
illuminate certain features of Jackson Pollock's poured paintings. These have re-
cently been discovered to contain a fractal geometry. Fractal patterns (which repeat

themselves at different magnifications), are associated with chaotic systems. Physicist Richard Taylor claims to have found two types in authentic Pollock's: large-scale fractals that are a "fingerprint" of the artist's body in motion—and small-scale fractals that are determined by how he was standing or bending over the canvas and his selection of the angle and force behind the thrown pigment.[7] Although Taylor does not make anything of this fact, Pollock was also a chronic alcoholic.

Findings about how molecular mechanisms foster compulsive drug seeking by means of counteradaptations in the brain's reward system contributes to our understanding not only the problem of the addict's repeated vulnerability, but the abstract shape of his delusions. The brain's doomed attempts to maintain stability cannot be normalized by taking more drugs because the hedonic set point has been altered.[8] The resulting vivid pictures, as Roland Barthes said of Courbet's fictitious objects in the *Studio,* eventually turn toward and look at the spectator to haunt him.[9]

In sum, the neurosciences are putting the hallucinating brain under a microscope to understand the inner ambient of human beings, both ancient and modern. With this research in hand, I explore the graphic systems of the prehistoric cave. Gaston Bachelard invoked the house as model of the mind as a type of dwelling. In this psychological and cosmological shelter, the basement—by virtue of its vertical remoteness from the sky as well as from the airy granary in the sun-shot attic—is shrouded in shadows. He termed this cavelike chamber the oneiric dark being (*l'être obscur*) lurking inside the labyrinthine home and below our conscious awareness.[10]

Memory research has many mansions. Of particular interest is what it can tell us about how spatial memories are represented and consolidated in the cortex. Explicit memory of space requires selective attention, filtering some objects for further processing. Implicit memory is involuntary; it is where the unconscious emotional perceptions get processed. The hippocampus is a brain region important for the multisensory representation of space external to the subject. How are spatial memory maps constructed, and do networks of "attractor states," in fact, exist? The latter denotes the conditions under which all neurons abruptly and simultaneously change their electrical discharges in relation to the ongoing experience of an animal. Rats, for example, who explore differently shaped environments (moving, say, from a circle to a square), experience major remappings in all their specialized "place cells."[11] While creating new memories, or learning how organisms discriminate features in unfamiliar surroundings, is culturally important so too is the discovery that there is no single internal image of "space" in the brain. Rather, there are two different anatomical circuits; both involve motion. One, as we saw in the previous chapter, is driven toward face recognition while another flows toward the control of movement.

As the embryologists like to point out, we are standing and walking with parts of our body that would have been used for thinking had they developed in another section of the embryo.[12] No wonder, then, that cognition is interwoven with

FIGURE 48
Paul Klee, *Inscription*, 1926.
Watercolor and India ink on
paper, mounted on cardboard.
Paper (9 × 5 ¾ in), cardboard
(12 × 8 in). Photo: Solomon R.
Guggenheim Museum, New
York; © 2006 Artists Rights
Society (ARS), New York / VG
Bild-Kunst, Bonn.

"motor intelligence." As the *flâneur* Impressionists instinctively realized, walking and thinking heightens our ability to oscillate between an inner and an outer world.[13] Alluding to this concurrent shaping of the flow of ideas as we rhythmically swing along, Paul Klee wittily remarked in his *Pedagogical Sketchbooks,* that a drawing results from "taking a line for a walk"—unifying choppy moments in smooth motion (fig. 48).[14] What separates us from other primates, then, is not our capacity for mimicry but the finesse and differentiation of our cortical motor neurons that transformed us into a new sort of primate or "manipulation/articulation animal."[15]

Cognitive intelligence is interwoven with hand to mouth coordination, speech, complex musical rhythms,[16] fingering of all sorts, and the organized movement of our body through space. Thus, in addition to informing us about context-dependent episodic memories, there is another important line of neural research focused on understanding just what exactly is the representation of space in the brain if not for enabling the movement of our bodies about in it. Consciousness, therefore, according to Michael Morgan, is nothing less than "the state of the whole pathway from vision to action, perhaps not even including the retina."[17]

There are two central conundrums dogging the history and philosophy of visual perception. The first is that seeing begins with an optical image in the retina and somehow ends in an entirely different image or representation of the external world (see chapter 5). Second, sometimes visual perception does not produce an optical image at all. Instead, it reenacts a memory from the past stimulated by touch or gesture. Or, occasionally, it might present us simply with the jigsaw puzzle of raw sensations: colored bits of the environment or bright pieces of mental imagery before they get autoassembled and interlocked in the primitive visual cortex. People with eye diseases—macular degeneration, glaucoma, and Charles Bonnet syndrome—frequently suffer from hallucinations showing, among other things, exactly these sorts of patches of color, bright flashes of pattern, or as one patient put it, "little tiny geometric shapes that all fit together."[18]

Phenomenologically inclined neurobiologists like Rodolfo Llinas, and more recently Thomas Metzinger, have argued that the world we see around us is internally created and fundamentally a subjective experience.[19] They take conscious perception to be subserved by intrinsic activity in the thalamocortical circuits (including cortical pyramidal neurons and relay cells in specific thalamic nuclei). In the state of normal wakefulness—as opposed to unconstrained dreaming, vivid reverie, or, say, pathological states such as schizophrenia[20]—our internal functional modes are merely constrained, not determined, by external physical reality.

Like ordinary perception, hallucination arises in the focus of attention. The difference between the two lies in the fact that when our perceptual processes lose their constraining relationship to the outside world, our unconscious attentional preoccupations take over. We can glimpse these dual internal attention-suppressing, or external attention-commanding, properties of perception clearly at work in the artistic productions of early cultures. Particularly revealing are those embodying situations in which hidden presences become visible. In speaking about the split mentality of the Iron Age Mycenaeans, Julian Jaynes remarked that Homer's heroes were "noble automatons."[21] That is, the gods—corresponding to what today we would call a conscious executive function—emerged like hallucinations from the swirling mists, or gray seas, or the echoing caverns of their landscape—spurring the individual to an action that he or she could not yet fathom.

The intuited form of space that surrounds us consists psychologically, in August Schmarsow's words, "of the residues of sensory experience to which the muscular sensations of our body, the sensitivity of our skin, and the structure of our body all contribute."[22] How does this inner intuition of being harbored or walled-off from external peril translate into actual architecture? What are the sequestering hideaways—the natural and erected shelters—that give form to our fenced inscape with its vibrating phantasmagoric imagery and eerie projective agency? Otherwise stated, why are the durable impressions made by chance lines drawn in the sand, the horizontal scoop of a valley, the vertical cleft in a rock face, or a diagonally funneling mountain passageway, a sure prompt to our spatial imagination?

There appears to be an echoic relationship between the carpentered outer world of edges and our staked-out mind-brain. This hypothesis of congruency is supported by different kinds of research. First, the cortex has long been known to be made up of geometrically defined repetitive units. These cellular "crystals" are now the subject of mathematical investigations into the patterns of connection linking the retina, the striate cortex, and the neuronal circuits in V_I.[23] Second, Roger Penrose has convincingly argued that neuroscientists must take into account the fact that the behavior of both the physical and the mental world is grounded in quantum and other theories enabling the overlap of the very massive with the very small.[24] Third, biophysical studies of the kinetics of synapses and their adaptation to different situations also attempt to join mind with world, energy with matter.

On the last point, recent work on neuronal synchronization is of special interest. It proposes that the cerebral cortex and the thalamus constitute a unified oscillating system because the neurons in the thalamocortical circuits possess an intrinsic rhythm. According to Wolf Singer, the dynamic binding of distributed, noncontinuous cortical regions involves the grouping of neurons at each level of processing. This self-organizing activity binds subsets of responses together "according to the joint probabilities imposed by the specific input pattern, the functional architecture

of the coupling network, and the signals arriving through reentry loops from higher processing stages."[25]

This suggests that our primal, protectively hedged interiority corresponds to equally primordial enclosures in the external world. First discovered in the environment and then imitated and improved, these consciousness-redoubling configurations were made to summon and control—as on Shakespeare's stage—ancestral ghosts, wandering spirits, and questing revenants.[26] We get an insight into this ancient unconscious and conscious neural process of coordination, from examples of contemporary art focused on the culture of the dead and the performance of revivifying rituals. These self-defining sites—where perceptual uncertainty reigns—visualize the continuum linking the troglodyte's cave, to the chiaroscuro Egyptian hypostyle hall, down to William Kentridge's epiphanic theater of animated shadows (fig. 49).[27] They demonstrate that the human brain captures the outside world in the anatomical lattice of its cortex, but is also capable of building a mesh of representations of its own. Physically enfolding the subject in darkness apparently encourages our sensory neurons to wander free. The overshooting brain, operating as a "hyperactive agent detective device" obeying its mimetic impulse to find agency, thus emblazons the walls of subterranean chambers across the globe.[28]

Hanne Darboven's Berlin installation for Deutsche Guggenheim, *Hommage à Picasso* (2006), is the closest modern analogue I know to an archaic and deeply engrained cave mentality. She engulfs the viewer in a vast, tomblike enclosure inscribed with handwritten ideograms. Walking down the main passage cutting through this steep, calligraphic architecture arouses an intense sensation of materiality. Like an archaeologist on a dig, the visitor is simultaneously embedded within

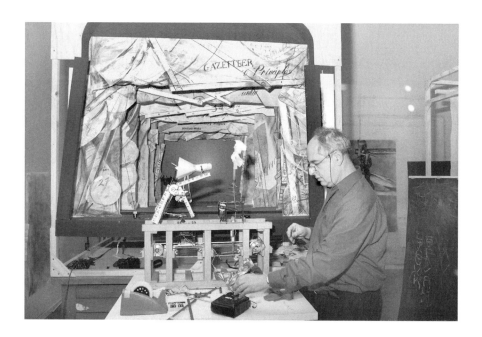

FIGURE 49
William Kentridge in his Johannesburg studio during preparations for Black Box / Chambre Noire, 2006. Photo: John Hodgkiss, © William Kentridge, Deutsche Guggenheim, Berlin.

an occult palimpsest and dwarfed by a cathedral of thought. The thinglike "shapes of time," as George Kubler remarked, imply certain kinds of motion. Our nearly identical successive moments of exploration begin to accumulate, "drifting by minute changes towards large differences amassed over long periods."[29]

Darboven's cryptic symbol system constructs an insulated netherworld composed entirely of numinous letters and numbers. Rising obsessively from floor to ceiling, 9,720 of the artist's characteristic rectangular sheets of paper—encased in 270 hand-painted glyphic frames—tower above the visitor.[30] Although comprising both a temporal record of the twentieth-century's end—counted down in musical notes, words, numerals—and a tribute to one of modernity's most creative archetypes, these immersive confines also conjure up remote vanished worlds (fig. 50).

Reckoning with dwindling time in calendrical form links Darboven's magical combinatoric to the tiered lithic cosmos commemorated in the monuments of Western Europe: Stonehenge, Avebury, New Grange (10,000–5,000 BCE), the early

FIGURE 50
Hanne Darboven, *Hommage à Picasso*. Installation view, Deutsche Guggenheim Berlin, 2006. Pencil on paper. Photo: Mathias Schormann, © Deutsche Guggenheim Berlin; Courtesy of Galerie Crone.

cult of stone in Japan, as well as the more recent Egyptian pyramids.[31] These signature subterranean styles—invoking the highest and the deepest physical and mental forces—are based on the reiteration of a small set of the same or similar motifs. Not coincidentally, this condensed universe of unconditional and self-reflexive signs turns up in imagistic culture after culture.

Deliberate sensory deprivation reigns in Darboven's seemingly airless house of the dead. Flat panels composed of horizontal and vertical bands comprising a repetitive pattern set against an abstract white background uncannily resemble the vibrating imagery hovering in the silent passages and dark chambers of the spirit realm traversed by mantic shamans in their spiritual journeys. Like the present-day beholder of Darboven's installation, these bygone mental travelers between a multiverse of dimensions also had to coax the release of accumulating weightless figures from inside their responsive inorganic support. Moreover, she helps us comprehend, in contrast to Daniel Dennett's passionate atheism, the transcendental nature of the spell cast by these cavelike spaces.[32] Inside these protective compounds the contracted individual, as well as small groups, were dilated into something bigger than the daily grind of self-preservation by inducing expansive and escapist mental states. Early religion (primitive tribal myths and rituals), in fact, was produced and can be reproduced under *controlled* conditions. The perennial sprouting of religious practices owes precisely to their grip on our neural mechanisms.

Although undeniably contemporary, Darboven's destabilizing realm of the in-between makes us keenly aware of how place has never merely been a location but, rather, always the experience of one. She situates viewers within a communal shelter that expands into a forest of symbols that we are induced to imaginatively roam. During this psychic excursion we come to realize something fundamental about the spectrum of human consciousness and its connection to the human nervous system that is shared by all anatomically modern people. Neuroimaging studies of Buddhist meditation practices are revealing in this regard. They document that brain areas triggered in so-called higher-order cognitive processes (for example, the posterior parietal lobe involved in creating mental representations of the self and its orientation in space) are also triggered in intensive meditation. This finding suggests that mystical experiences are mediated by complex patterns of neural activity occurring in structures of the autonomic nervous system, the limbic system, and the occipital, parietal, and prefrontal cortices.[33]

Cognitive archaeologist David Lewis-Williams has proposed that the revolutionary changes during the Neolithic period that produced permanent dwellings, new hunting tactics, religious rituals, complex burials, and mural as well as portable art had been preceded by major changes in thought, and not the other way around. His theory is grounded in Jacques Cauvin's challenge to ecological and materialist interpretations of the so-called Neolithic Revolution (c. 12,500 BCE).[34] Cauvin, who has long studied the prehistorical settlements in the Levant—stretching back to

the invention of blade industries around 80,000 years ago and the diversification of tools and weapons during the Levantine and European Aurignacian, some 45,000 to 20,000 years ago—argued there was a "revolution of symbolism" occurring around 10,000 BCE, that is, before the adoption of a farming economy. Significantly, his theory refashions the linguistic-based structuralism of Claude Lévi-Strauss. Since the verbal myths painstakingly analyzed by Lévi-Strauss are unavailable to the student of these first cultures, he argues that there are nonetheless "some fundamental, structured relativities between these symbols [simple prehistoric *images*] on the basis of spatial analysis."[35]

From his study of the South African shamanistic San religion, David Lewis-Williams similarly notes that in the cave cultures of the Upper Paleolithic, people most likely developed a set of communally shared mental images. This largely geometric repertoire complements the bestiary of extinct and living animals (both paintings and figurines) discovered worldwide with fossils in Ice Age caves.[36] Such emotionally charged visions, experienced during altered mental states, are universal and correspond to the electrochemical function of the human brain. These visionary forms, emerging and receding from behind the pliant rock face, were fixed in paint so that one could reach out and touch them or hold them in place. Given the revised view of formalism proposed in this book, I find compelling his thesis that the specific contents of individual minds are not totally provided by culture and that "not every facet of every culture is unique and non-generalizable."[37]

Some of the earliest rock art in the world is in Australia—a continent occupied for at least 40,000, possibly 60,000 years. These imprinted caves, still obliquely alluded to in contemporary Australian Aboriginal art from the Central Desert and the Northern Territory, give us a visceral sense of how such cavernous spaces could become symbolic of an otherwise impalpable cosmic architecture. Further, this supernatural underworld is also an instantiation of the hallucinating mind. As Merleau-Ponty recognized with regard to the animal paintings at Lascaux, these depictions are not *on* or *in* the wall the way the cracks and fissures are in the limestone. Rather, they appear pushed forward in some places, and pulled back in others, without ever becoming unmoored from the uneven rock face. In fact, one is "hard-pressed to say *where* the painting is I am looking at."[38]

Early place making, in Australia as in Northern Europe, was characterized by figures that were physically and conceptually integrated with their site.[39] This material commingling was the product of a mental commingling: the voluntary attention paid to oneself focusing on specific sensory information suggested by seemingly pulsing rocks, and excluding the rest. But these bright moving form constants were also the result of involuntary projections generated during trance experiences. This spectral effect of floating and hovering in a liminal region is not unlike that witnessed in nineteenth-century spirit photography similarly intent on making the invisible visible. Cameraless types of pictures are especially pertinent, not only

because they, supposedly, automatically record the ectoplasmic emanations of fluid thought produced by the direct exposure of a photosensitive plate or paper to light and shadow, but because of their abstract look.[40]

The discontinuous sequence of "stills," or kaleidoscopic patterns that people see under the special circumstances of light and possibly acoustic deprivation are the structures of their own brains, the "shadows of their minds" cast on the wall.[41] Oliver Sacks has studied this decomposition of visual continuity, or what he terms the "chronophotographic" lack of synchronization, in abnormal conditions such as migraines and autism.[42] But hallucinations seem to indicate something more general—not just pathological—about the location of the objects of experience. It seems these are less the result of contact with the outside world and more the construction of neural networks. Even under normal conditions, the higher neural centers are "operating more upon information about the sensory stimulus supplied by the processors at various hierarchical levels than upon the raw sensory data."[43]

Bundles of discrete percepts are wired into the human nervous system and can be generated anywhere along it, not necessarily in the eyes. These autogenerated patterns develop along an intensified spectrum moving from a universal grammar of geometrical forms (scintillant phosphenes or flickering and combining dots, grids, zigzags, catenary curves, meandering lines), to a narrow tunnel, to a brilliant blaze of full-sensory visions. The geometry of hallucinatory form constants has been classified into four groups (gratings, lattices, fretworks, checkerboards; cobwebs; tunnels, cones, vessels; and spirals).[44]

Moreover, fascinating mathematical research into the nature of contoured pattern-formation, owing to the functional and anatomical organization of the primary visual cortex in cats and primates (V1), show that it has a distinctly *crystalline* structure. This means (since V1 cells signal topographically and retinotopically the location of a stimulus in the visual field) that neurons respond *preferentially* to particular features of the external environment. These include orientation preferences that change continuously except at pinwheel-singularities with which they now appear to be correlated.[45]

Significantly, the existence of this physical lattice in V1 helps to explain the natural emergence of double-periodic patterns as well: rolls, hexagons, and squares; in other words, these patterns are not just the result of mathematical modeling or simplification. The authors thus conclude that not only are there two distinct circuits operating in V1 (one dealing with contrast edges and another dealing with the orientation pinwheels involved in the processing of textures, surfaces, and brightness), but that there is a strong connection between the known types of hallucinatory images and the underlying crystalline structure of the visual cortex.[46]

Another remarkable link exists between the active generation of radiant form constants seen in geometric visual hallucinations after ingesting LSD, cannabis, or mescaline and the vivid painted or imprinted hallucinatory images found in pre-

historic caves. Since these are usually beheld with both eyes and move with them, such images are taken to be generated in the brain.[47] Yet, the multifaceted investigations into the varieties of flashing phosphenes demonstrate not only that visual hallucinations can be seen in many situations (on waking up or shortly after falling asleep, following deep binocular pressure on one's eyeballs, or after ingesting hallucinogenic drugs), but that they are a consequence of rhythmically firing localized and delocalized cells. In fact, they belong to a distributed system of bidirectional flows of information interlocking the brain and the parts of environment congruent with it.

Just as a place moves, stretched by unconscious action, so too the varieties of perception are augmented by memory. There seems to be something addictive—that is, potent and persistent—about the generation of such insistent patterns that are *not* central to human survival. Neuroscientific research into what Dr. Stephen Hyman has called "extreme memory" looks anew at the connection between substance abuse and "pathological learning."[48] Why, for example, after years of being "clean," does someone relapse into destructive behavior patterns? Investigation into the negative impact of drugs and the genes linked to addiction is, I believe, equally informative about other kinds of nonpathological repetitive behaviors. The brain evolved to identify essentials such as food and water. When these are found or, apparently, when one only expects to find them, the chemical messenger dopamine gets released.

Drugs (and, I think, "magical," epiphanic, or "visionary" images that "narcotically" reveal or transport the viewer to a desirable, less effortful realm) usurp the survival systems in the brain. They release an excess of dopamine so that little else can compete within the extended amygdala. These surges, according to the revisionist theory of addiction, contribute to the laying down of long-term memories and associations aversively remodeling neural connections, by paradoxically recruiting stress, not reward, systems. Importantly, they can last a lifetime. Do the fugitive images seen in hallucinations similarly (and ironically) reinforce the anxiety they were meant to ease in what originally was a pleasurable process?

The present moment is always animated by prior hidden events impressed, like finger fluting, into the dynamics of our cognitive system. This suggests that body-based habits, including an escalating compulsion to get rid of any intervening medium between desire and fulfillment, are culturally transmissible.[49] Repetition merely imprints memory objects more forcibly. Reentry is a sort of revivification. It reactivates previous perceptions and their multiple connections along with subsequent modifications occurring at the physiological, biochemical, neuroanatomical, and functional levels.[50]

As anyone who has traversed this vast and astonishing country knows, the circle is a universal motif in the Aboriginal art of Australia. Its rudimentary essence makes it suggestive of a wide repertoire of spatial constructs signifying inclusion.

FIGURE 51
John Mawurndjul, *Namarrkon
ngal-daluk (Female Lightning
Spirit)*, 1983. Earth pigments
on eucalyptus bark (136.9 ×
40.4 cm). © John Mawurnd-
jul; Photo: VG Bild-kunst,
Bonn 2006.

These range from broadly columnar natural monuments, such as Ayers Rock, ris-
ing steeply from the red desert floor near Alice Springs, to rainbow serpent-painted
caves in the vicinity of Mount Borradaile, that holy spot on the western border of
Kakadu National Park (plate 9).

But this primal figure also derives from a long tradition of performance prac-
tices exhibiting an ongoing engagement with forces greater than the self. Such vi-
sual formulas are predicated on seeing the world as a forceful agent continually do-
ing things to its custodians. As Andrew Pickering comments, much of everyday life
possesses this character of coping with material agency "that comes at us from out-
side the human realm and that cannot be reduced to anything within that realm."[51]
For Australian Aboriginals, specifically, the circle represents the unhierarchical ar-
rangement of waterholes or billabongs and the round campsites typical of nomadic
groups. But this configuration is also the graphic reperformance of core rituals: the
concentric imprints of men's footprints stamped in the sand during initiation cere-
monies, so different from the tracklike dances of the women.[52] Such encompassing
forms re-enact the signs of social cohesion that were first pounded into the ground
by early hominids in a musical choreography of communication.[53]

The circle, then, along with a limited number of other geometrical figures (zig-
zags, honeycombs, ovals, points, straight and curved lines), constitute the austere
formal combinatoric of Aboriginal art both ancient and modern (fig. 51). Taken to-
gether, these forms map the body, earth, and the sea ontologically, ecologically, and
socially. They are "the ancestrally determined pre-existing template that is not only
enacted in ritual but can be seen in the pattern of the landscape and the cycles of
nature."[54]

This basic graphic idiom dominates the two major types of rock art: pigmented
pictographs and hollowed out or "engraved" petroglyphs. Moreover, it is still de-
ployed today to hide the real subject of a painting. This is always and forever the
land, and more remotely, the material traces of those foundational presences that
came before and still inhere in "abiding events" but need to be brought forth or
made to appear.[55] As John Gage commented about present-day Arnhemland art
practices, insistent patterns such as dots are used to edit out and cloak secret geo-
graphical features (themselves illustrative of what first existed in other forms) from
the uninitiated public eye.

In the Northern Territory, figurative elements are similarly used to divert atten-
tion from the true focus: in this case the underlying geometric shapes that map the
symbolic sites of the Dreamtime—that spiritual domain in which the Ancestral Be-
ings had their existence and moved about creating plants, animals, and people.[56] It is
significant that the contemporary Aboriginal artist John Mawurndjul, for example,
who has considerably expanded the traditional iconography of Northern Australian
eucalyptus bark painting, nonetheless still embeds all figures within a webwork of
crosshatched concealing lines. Tellingly, *rarrk,* in the kuninjiku language, signifies

formal condensation and the encryption of motifs that originally stemmed from ancestral rock markings (fig. 52a). Not coincidentally, his paintings are composed of the same mythic materials—those global primaries red ochre, yellow ochre, white chalk, and charcoal—often found ground or pounded into cupules.[57] These are the small potholes that "wound" the free-standing stone, the vertical walls of some rock shelters, and are analogous to the cicatrices on the bodies of Aboriginal girls— releasing the life essences lurking behind these diverse surfaces during secret initiation ceremonies (fig. 52b).

FIGURE 52A
Aboriginal stick figures, from cave near Mount Borradaille, Arnehemland. Prehistoric? Earth pigments on rock wall. Photo: Fred E. Stafford.

FIGURE 52B
Aboriginal cupules, from cave near Mount Borradaille, Arnhemland. Prehistoric? Red earth pigment and rock. Photo: Fred E. Stafford.

By giving dynamic shape to thought through rhythmic gesture and marking feet, dancing is not unlike dreaming. Aboriginal dreaming stories are mantic manifestations of the transformations of the acts, body parts, and effluvia of mythic beings into landscape features whose spatial array must be experienced by foot.[58] Before these ancestral sculptors emerged from beneath the ground to shape the wasteland and stud the sky, these spaces were flat and featureless, unpunctuated, unconfigured, and unmapped. After this initial carving, imprinting, and molding of everything from rivulets, to sand dunes, to cliffs, to termite mounds, to rain forests, to stars: the cartography of heaven and earth became dense with meaning. The generative act of these originals, however, could only be imitated by humans, that is, rediscovered in a dream or witnessed in a special vision.[59] Cave paintings assisted the emergence of this bright spirit society from the smoky darkness and out of the stone.

The caves of Australia are filled with gestural art, but not all of it is intentional or human-made. Natural animal markings abound. As Josephine Flood summarizes them, there are the shallow scratch marks of bats or swallows, the claw marks of megafauna, the climbing marks of possums and reptiles, the deeply gouged marks of species unable to climb the walls, and shallower, enigmatic "exploratory" marks.[60] These accidental surface abrasions subsist along side, and are mimicked in, deliberate tracks. As Condillac would have claimed, this physical "language of actions"— whether animal or human—comprises "signs of their thoughts."[61] Interiority is the product of the contact senses. In-ness is the manual reperformance of outness.

In these patterned underworlds, we find a compact psychophysical thesaurus: finger-fluting (the "macaroni" of the European Paleolithic), pecked or hammered grooves, along with scratchings of "sacred" geometrical figures like the circle, straight lines, honeycomb segmentations, concentric whorls, and spirals. Such *dirnu* signified a kind of command for the performance of an exemplifying action.[62] The repeated removal of intractable layers of matter can be seen as an intensifying command to the numinous power lodged within substance to manifest itself. Significantly, the sensorium—or the functional space within the nervous system—one of the deepest levels of neurocognitive organization and the place where the phenomenal aspects of the cognized environment are constituted moment by moment— coordinates the gestures of the maker's body with the symbols he enacts.[63]

In the case of painted handprints—whether made negatively by outlining the silhouetted fingers, or positively, by dipping them into wet pigment and pressing them against the wall—the process was essentially haptic. The hard-won emissions were to be ritually touched again and again (plate 10). Alexander Marshack, an early cognitive archaeologist, has been arguing for more than three decades (from the evidence of the Ice Age caves in southwest France) that symbolic notation needs to be considered within a broader network of intersensory information. Heel prints, such as those found in the Dordogne, and by extension Australian hand prints surround and ritually support the painted imagery.[64] These direct body imprints are often

found in the most inaccessibly narrow or high locations, reminding us of the theory that our hominid ancestors were palm-walkers.[65]

Even today, it is easy to hallucinate in these low-vision tactile rock shelters where the site-specific imagery and the visitor's mental imagery interlock. Nor is it difficult to imagine how the brain-mind of these first Aboriginals interacted with the fluctuating topography of the chthonic sites over which they walked or crawled.[66] The Aboriginal epistemological position was and is one of becoming minor, imperceptible, level with the land or harbored inside a deep place.[67] There is much to be learned, then, from this performative philosophy of lying low. The ancient concept of site-specificity illuminates, for example, the entropy implicit in more recent earthworks.[68] Temporality invades even the most timeless of environments acknowledging the inevitable disintegration of all structure. In a dialogical relationship, the perceiver's flow of sensations is thus contingent upon a continually dissolving and recrystallizing nature.

Robert Smithson's *Spiral Jetty*, built on Rozel Point in Utah's Great Salt Lake, offers a dramatic case in point because, among other things, it is a colossal petroglyph that once ethereally floated in an Ice Age sea of pink algae (fig. 53).[69] Although it has often been compared to an abstract landscape painting,[70] this vortex (begun in 1970) is much closer to its Paleolithic predecessors: magically drawing everything in the harsh environment toward its concentric whorls. Getting to such a remote spot is something of a vision quest in itself. This project lies in the desert on the northeast shore of the drought-lowered lake. Once submerged, Smithson's 1500-foot coil of black basalt rock has gradually re-emerged from the receding waters. Ghostlike and encrusted with white salt crystals that shimmer in the heat, it now is completely exposed. More optical illusion than material thing, this apparitional geometric form is pushed up and out into shallow relief from the bottom of the primitive lake bed.

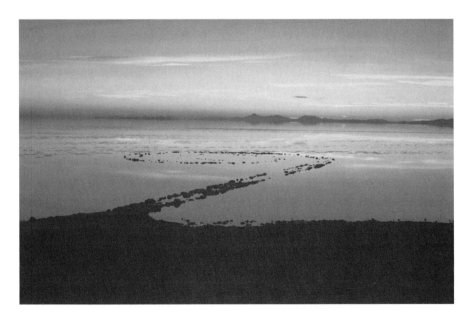

FIGURE 53
Robert Smithson, *Spiral Jetty*, April 1970, Great Salt Lake, Utah. Black rock, salt crystals, earth, red water (algae). © Estate of Robert Smithson / Licensed by VAGA, New York, NY. Courtesy James Cohan Gallery, New York. Photo: Center for Land Use Management.

Unlike Jean Dubuffet's "de-defining" *art brut teratologies* of the late 1940s and 1950s—where raw substances, organic debris, and emulsions of sand and gravel were applied to the canvas to give the effect of crumbling shale or rotting pastes—Smithson performs directly on the matter of the world.[71] Neither existentialist nor turbulent, the geography of his vast sculpture hovers between the realities of mud and an illusory space. Because crystal growth does not obliterate past accretions but builds around them, it mirrors all moments of its development and holds them up contemplatively before us.[72] Everything is changed but nothing is obliterated.

Analogous to the ancestral punctuation of the featureless terrain during the Dreamtime—and retraced or reexperienced by Aboriginals during their walk-about—current visitors to this mythic continent risen from the depths are recontouring it. I believe that Smithson—who opened up the narrow borders of art when he mapped the margins of fabulous lands (Atlantis, Lemuria, Gondwana)—would not have been displeased by this reiterative turn of events. Exhibiting a sort of innate geospatial intelligence, people now patiently walk the volutes of the new *Spiral Jetty* as if it were a labyrinth.[73] Rather than appearing fragmented or collaged, mineralized formation and meditative explorer are caught up in a single transfigurative symbiotic system. As the place disappears into the foreground, the moving perceiver sinks into the background.

Examining archaeological finds ranging from the Jericho plastered skulls, to the painted bestiary of totemic animals (aurochs, wild horses, fallow deer) in the limestone grottoes of France and Spain, David Lewis-Williams states the evidence for neurologically generated altered states of consciousness. He claims these were first entered into by the *Homo sapiens* of the Upper Paleolithic, and not evident in the remains left by the Neanderthals of the Middle Paleolithic (c. 220,000–45,000 BCE). Making contact with the supernatural through a mobile vortex, or "cave in the mind," involved harnessing form constants induced through trance experiences. Recall that this involuntary generation of radiant entoptic (within vision) phenomena arise totally independent of an external light source—a condition corresponding to the typically occluded depths and constricted windings of these prehistoric sites. Under the burning Utah sun, however, Smithson recaptured this primal bodily unconscious: the domain of gesture melded with notation breaking out of the earth.

INSTRUMENTALIZING DEPTH

Consciousness seems to be tied to the experience of depth. As Michel Serres remarked "the soul, [that] quasi-point, discovers itself in volume." But, as Georg Simmel said: it is also tied to the experience of distance, the ways in which we push the external world of objects away from our subjectivity.[74] Our inner life thus advances and retreats, stretches forward, backward, but, above all, away and down. From the scientific research on hallucination, we now know that this directional view of a

neurobiological experience—one that is also a complex cultural construct—is not just anecdotal.

The vortex or the spiral, like the convoluted cave, does indeed volumize both space and being. Like Merlin Donald's "exograms"—material things that embody memories and combine algebraically with the brain's distributed "engrams"—these dynamic object-events are cognitive happenings.[75] Elastic rock walls that appear to move shift animated patterns into a distance far beyond immediate reality. Ciphers dancing on a supple surface-screen merge with vertiginous out-of-body encounters. This collapse of the here and now with what lies beyond creates a sort of virtual world bringing remote phenomena near.

This coupling of ambient with beholder in a kind of Humean constant conjunction ensured that layers of space got superimposed and compressed over and over again, resulting in an enriched spatiotemporal overlay. From the perspective of the connectionist's theory of extended mind, Andy Clark describes such "structure-based physical unfoldings" as requiring the additional sculpting of natural selection and lifetime learning to complete the loop of reciprocal causation.[76] In the specific case of the ecstatic densification of the everyday world, this cycling back and forth between brain and surroundings transforms what is flat and ordinary into a vivid mass—a mythic concentrate exceeding our normal coordinates—toward which we continually reach either down or, conversely, up.

Like the enigmatic complex symbol, the equivocal content of revelation is not describable but must be unveiled and shown. Jean-Luc Marion, in analyzing negative theology and the concept of transcendence deriving from it, says it should be conceived not as a "passage to the limit," but rather as the "beyond of the limit."[77] Significantly, this hyperdimension of excess is both lofty and external as well as deeply internal to the subject. Thus the Greek term *to krupton* is more than a cryptic reference to the ascent of the soul toward conscious knowledge of the distant and inaccessible god of light (the Apollo at Delphi). It also invokes the opposite direction in a lengthening cognitive hierarchy, one in which the human brain has no awareness of its own functioning. This is the steep descent into chthonic regions and the nocturnal rituals (associated with Dionysius) that remain forever unattainable to the uninitiated.[78]

Projective technologies have long been sacred technologies. If the archetypal art of the grotto—the hybrid grotesques of Altamira, Peche Merle, or Font-de-Gaume—attests both to burial and to initiation ceremonies, it also attests to rites involving the comingling of mental projection with prompting topographic features.[79] The existence of epiphanic optical devices demonstrates the archaic will to mechanize and harness this dual tendency of the human brain inwardly to replay, and even remix, what it has remembered and to leap outward in association.[80]

We know of such metamorphic and transporting visual technologies from the mirrors deployed in Egyptian temple magic and from the transparencies and silhou-

FIGURE 54
Guckkasten or Vue d'Optique
Box, eighteenth century.
Wood. Photo: Courtesy of the
Getty Research Institute.

ettes manipulated by priests behind a clothlike screen during the Isaic Mysteries at Eleusis.[81] One might argue that even without the use of apparatus, the mere fact of hallucinating had already turned the numinous cave of the Paleolithic into an immersive mediasphere—replete with ambiguity surrounding the source of the imagery that was not dispelled either by its vividness or apparent instantaneity.[82]

The vast domain of self-extending optical technologies, I believe, goes back to that primal, never-satisfied desire to reproduce consciousness-altering conditions. Virtual reality is only the latest in a long series of cave-like boxes (fig. 54) seeking to re-create the brilliance and immediacy of the brain traces we see during altered states.[83] There is, of course, an important difference between the slow viewing self-enhancement encouraged say, by a *Guckkasten*, or the subtle, gradual transformations from day to night that occur when we peer at pricked and top or back-lit *vues d'optiques*, and the instantaneous gratification of electronic media. The heightened anticipation of change and bated-breath experience of waiting for something wonderful to happen gets lost (figs. 55 and 56).

It is not accidental that South African animator William Kentridge returns to premodern dramaturgical practices (including projection and shadow play) to put art to work in the face of unspeakable horrors (see fig. 49). These "toy" technolo-

FIGURE 55
Carlo Ponti, Venice, Grand
Canal and Serenade, 1880s.
Albumen photograph, hand
colored and pricked. Photo:
The J. Paul Getty Museum,
Department of Photography.

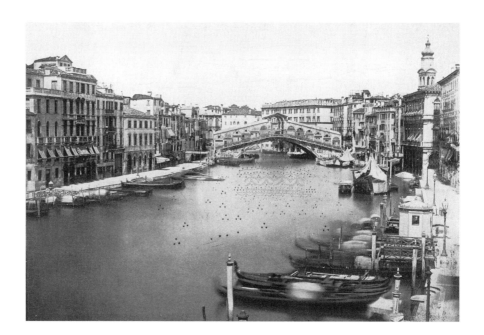

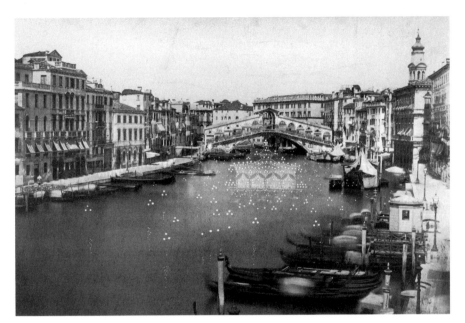

FIGURE 56
Carlo Ponti, Megalethoscope
slide depicting the Grand
Canal in Venice, 1880s. Albu-
men photograph, hand col-
ored and pricked. Photo: The
J. Paul Getty Museum, Depart-
ment of Photography.

gies are repurposed to help us think about what it means to be human in relation
to other human beings. Kentridge specifically draws on the capacity of earlier me-
dia to let us witness the dark side of existence. Like Goya, he believes that personal
shock, not speed, is what counts in order for us to change our behavior. Speed, by
contrast, is what counts in the new virtual territories of the blink. What claims at-
tention *external* to the digital domain resembles a sort of momentary black out from
the encompassing illusion. Paul Virilio termed this postmodern break from the elec-
tronic continuum, "picnolepsy"—a microlapse of consciousness or tiny state of jar-
ring unconsciousness.[84]

We have circled back to the cave as the prime site of hallucinatory apparition.
But this cave, unlike its painted and sculpted Neolithic predecessor, is the ances-
tral *camera obscura* (fig. 57). This repeated mechanization of the subterranean rep-
resents the historical attempt to replace an insoluble epistemological problem—
penetrating the obscurity enveloping all those higher and deeper things that we
most ardently want to know—with a technical solution. I refer to the invention of
all those devices intent on dissolving physical, not hermeneutic, opacity.[85]

Whatever else this optical equipment does, it removes the divided line Plato
thought separated the noumenal from the phenomenal worlds. The cavern as ap-
parently unframed or borderless dark room is the originary site for all those optical
technologies that not only mimic the different functions of the eye and the sepa-
rate operations of the visual brain but are responsible for constructing our mod-
ern sense of interiority as a phantasmic slide show unrolling in the "theater of con-
sciousness" (fig. 58).

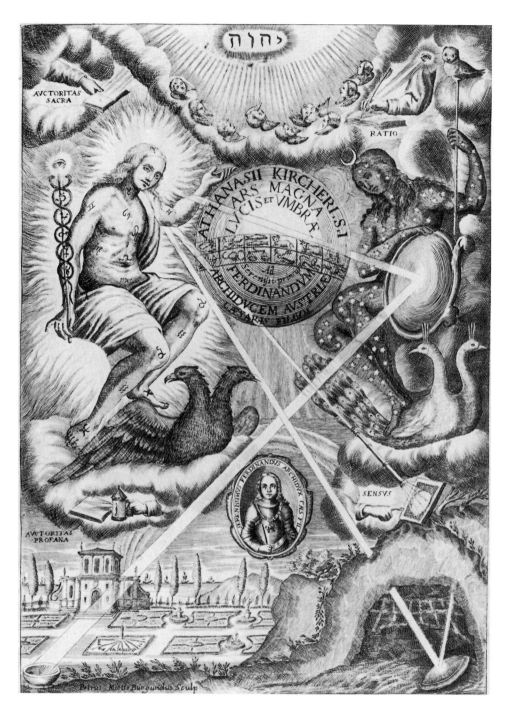

FIGURE 57
Athanasius Kircher, frontis-
piece, from Ars *Magna Lucis et*
Umbrae, in X libros digesta, 1671.
Engraving. Photo: Herzog
August Bibliothek, Wolfen-
büttel.

If the introspective pupil is recapitulated in the pinhole cut high into the sides of a self-enclosed box—pulling the streaming phenomenal world into its confines in an intensified way (see fig. 24)—then the lens emulates foveal compression, selective attention, as well as kaleidoscopic metamorphosis (fig. 59). The magic lantern, like the rest, similarly requires a dark chamber for the unfurling of its glowing effects. It is the prototypical projective mechanism—revealing spectral realms and casting

FIGURE 58
Magic Lantern Slide, astronomical glass slide, c. 1880. Wood and glass. 10 × 38.2 × 0.5 cm. Photo: Getty Research Institute.

FIGURE 59
Athanasius Kircher, kaleidoscope, from *Ars Magna Lucis et Umbrae* (1641), p. 818. Engraving. Photo: public domain.

FIGURE 60
Athanasius Kircher, Magic
Lantern, from *Ars Magna Lucis
et Umbrae* (1646), p. 768.
Engraving. Photo: Herzog
August Bibliothek Wolfen-
büttel.

otherwise invisible phantoms on the wall (fig. 60). Finally, that absolute device, the reflecting mirror— from which all the others in one way or another subtend—collects and brings within its circumference all that lies scattered about us and relaunches it in sharper or cloudier form (see mirror below microscope in fig. 23). With the exception of mirror, these technologies are all nocturnal, fabricating a secretive and artificial night stocked with hypnotic phenomena.

The durability of this mental thrust toward fictitious realms makes me question Steven Pinker's assertion that our cognitive faculties (like our perceptual faculties) are attuned to the real world and that this fact is most obvious from their response to illusions. Our mental faculties "recognize the possibility of a breach with reality and find a way to get at the truth behind the false impression."[86] This is too hard and fast a position; it does not take into consideration the antiquity of forms deliberately made ambiguous.

On one hand, neuroscience has convincingly demonstrated that illusionism has a prehistory. As we saw, clefts or fissures in the earth are a perfect example of an external form that complements natural functions of the biological brain. These hollowed-out sites are conducive to "a kind of extraneural memory store" where we can observe both the intertwining of conscious with unconscious experience and how this complex process gets materially deposited outside the self in artifacts.[87] On the other hand, there are many questions still dogging the neuroscientific study of illusion. Chief among them is that old conundrum: in the early stages of sensory processing, does the brain perceive reality or an internally spun charade?[88]

Even though there is no simple answer to the question of how the brain perceives reality versus illusion, a more nuanced view of illusionism in art might help in arriving at some plausible solutions. On one hand, the many separate disciplinary discussions swirling around the nature of illusion tend to reduce it either to an aesthetic game or merely to scientific evidence for perceptual rivalry. (In the latter case, drawings or paintings of figures that switch from one orientation to another, or metamorphose into another figure, are educed as signs of bistable or multistable neural circuits, as in fig. 61.)[89] To be sure, from Giuseppe Arcimboldo to Salvador Dali, artists have been involved with the technologies of vision and the making of "curious perspectives." The virtuoso "trickery" of puzzlingly dual *Vexierbilder* as well as montage composites—whether actually animated or still—serve as potent examples.[90]

But making the viewer aware that she can see something quite different when the picture is looked at differently, or its orientation is rotated, is much more than

just an ingenious deception. John North's re-
cent analysis of Holbein's much-cited anamor-
phic skull in his painting of *The Ambassadors*
(1533) represents one such attempt to invest this
cognitive illusion with its proper ontological
implications.[91] Camouflaged images make us
conscious of a spatialized metaphysics. They re-
mind the beholder that there is a stratigraphy of
hidden forms lodged beneath any painting or,
indeed, any material surface dense with inlaid
information for which we require a perspectival
or subjectively angled key.

On the other hand, as Baroque painting
constantly reminds us, the elusive space of rev-
elation is the reverse of the transparent space
of mimesis. Countless seventeenth-century pic-
tures show the radiant divine or, more ellipti-
cally, the numinous bursting miraculously into
the natural or social world to momentarily in-
terrupt its unthinking flow (plate 11).[92] Perhaps
this fascination with the intrusion of the appa-
ritional owed to the fact that the supernatural
no longer belonged seamlessly in the sublunar
world; it had to be forcefully or artfully conjunc-
ted with it by the modern imagination. Trying

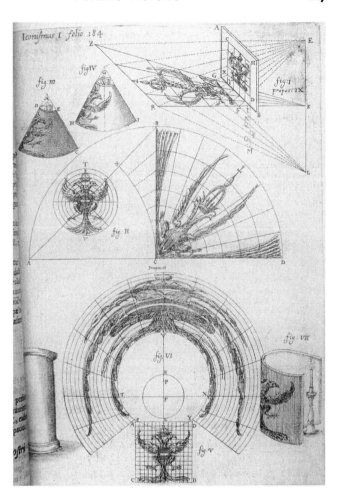

FIGURE 61
Athanasius Kircher, Diagram
of How to Draw a Cone Ana-
morphis Image from *Ars Magna
Lucis et Umbrae* (1646), plate
opposite p. 184. Engraving.
Photo: Department of Special
Collections, Charles E. Young
Research Library, UCLA.

to capture the sudden entrance of this imaginary realm into our customary topog-
raphy required the juxtaposition of two distinct spheres of action.

This intrusive process thus resembles a common type of verbal ambiguity in
which two apparently unconnected meanings are presented at the same time.[93] Ex-
ceeding the effect of opposing figures of speech, however, contrary visual struc-
tures not only alter our bodily position in a given place and at a specific moment,
but change our psyche. Spaces, like shapes, that are athwart of one another force
the beholder to *attend* to the fact that he must simultaneously register two antithet-
ical pieces of information: that of being rooted in the physical body and located in
the material world while, simultaneously, being in the full presence of a richer else-
where.

The findings of Bernard Baars regarding the constant interweaving of conscious
with unconscious experience seem particularly pertinent to understanding this men-
tal condition of doubleness. He challenges neuroscientists to study consciousness
utilizing a "contrastive phenomenology" so as to incorporate the contribution of a

subject's phenomenological experience into the biophysics of internal states. Baars acknowledges a mosaic psychology. He proposes that "for most conscious events we can find unconscious ones of comparable complexity."[94] Combining the evidence of PET (positron emission tomography) scans with phenomenological evidence, he argues that internal functions formerly thought to be separate—for example, conscious as opposed to automatic brain processes—are actually continuously being compared and related by the organism. But a conscious experience of internal tension, or feeling of disconnected connectedness, only occurs when an image / mental object coexists as two things at once.

Ray Jackendoff describes in detail the grappling nature of this binding activity looked at, in his case, from the perspective of the neuroscience of language and how semantic relations are to some degree signaled by the syntactic structure of the sentence which must then be correlated to the linear order of phonological words.[95] For meaning to be grasped, this total structure must be functionally present all at once. In the theory of vision, the comparable binding problem, too, centers on the question of how our neural apparatus wrestles bits of color and fragments of shape—encoded in different parts of the brain—into the experience of a single object, thus transforming percepts into an integrated concept.

Certain types of phenomenologically immersive artworks permit us to see ourselves seeing the world. We are able to watch those independent and autonomous sensations link up into a coherent perception to which we attend for shorter or longer periods of time. The posterior parietal lobe, involved with creating mental representations of the self coupled to its spatial orientation, plays an important role in this process. More generally, neuroscientific studies of religious and mystical experiences have discovered that the brain areas involved in so-called higher-order cognitive functions (complex visual perception, attention, and verbal conceptualization) are integral to this holistic beholding experience.[96]

TAKING THE EDGE OFF THINGS

Early modern optical technologies that "threw" shapes from a distance pushed the technically produced image even deeper into metaphysical territory. Although during the Enlightenment the creation of artificial visions became a parlor game, this was not mere sport. Concealed convex mirrors projecting phantoms so that they hung in midair, swaying above billows of smoke, were an attempt to make visible the invisible powers of sympathy or antipathy animating nature (fig. 62).[97] Beyond such relatively simple mirror reflections, however, stretched a sophisticated world of "idealist" imaging devices. Take the Belgian thaumaturge E. G. Robertson's fantoscope (run on tracks behind a muslin sheet to create a translucent moving image that expanded or contracted as the re-engineered magic lantern was pushed toward

or away from the screen).[98] This instrument for reanimation dramatically theologized an already ecstatic medium. Accompanied by the otherworldly sounds of the glass harmonica, and taking place in the cryptlike confines of a black-shrouded room, an illusory scenography unfurled within an immersive atmosphere of sensory deprivation.

Robertson's rapturous conjurings commemorated the disappearance and ghostly reappearance of individuals torn from the natural world. In the wake of the French Revolution and the Terror, the vanishing of loved ones and their miraculous, if fleeting, machinic resurrection as cloudy or crystalline lightforms could not be interpreted as just entertainment. From the summoning conjuration of the magus Cagliostro to the Romantic "novels of dread" of Friedrich Schiller,[99] the augmented magic lantern functioned as an ontological instrument. As a cognitive device, the fantoscope performed the work of memory, making the absent present. But what was recalled was not the same someone or some thing that had once been known in the life-world. Rather, and akin to cyberspace, entities were accessed somewhere "out there," in a realm beyond our normal dimensions, and re-experienced while in an altered state.[100]

Such mental devices—generating a flickering procession of images meant to be seen in the dark—are thus the remote descendants of an archaic "fire culture"[101] where people huddled in rock shelters blackened with heavy smoke, smoldering flames, and sudden blazes. As we saw, the symbolic geometrical and figural compositions accumulating in the decorated caves of the Upper Paleolithic also fitfully started out of the chiaroscuro gloom. Like those "time-factored" notations inscribed on stone, antler, bone, or ivory, shining electronic images continue to trace a route of evanescence on an increasingly thinner support.

Contemporary installation artists, as well as twentieth-century Minimalists whose work is now being reassessed in exhibitions, are reminding us of the cognitive significance of immersive technologies, both old and new.[102] James Turrell's illusory skyscapes hang pure light and color—cloudlike—in space as sculpture.[103] Not coincidentally, Turrell developed his lifelong interest in working with aerial environments not just from flying planes, but from his early study of mathematics and the use of information theory to analyze problems in experimental psychology.[104] These high-intensity *Projection Pieces* (made during the mid-to-late 1960s) create subtle, suffusive atmospheres. Working with slide projectors, then quartzhalogen sources, and ultimately the more versatile xenon equipment then used in the Southern California film industry, he produced hovering cubes that play with

FIGURE 62
Karl von Eckartshausen, *Female Apparition Appears to Two Men*, from *Auffschlüsse zur Magie*, vol. 2 (1788–91), pl. 1. Engraving. Photo: Courtesy of the Department of Special Collections, Charles E. Young Research Library, UCLA.

FIGURE 63
James Turrell, *Afrum I*, 1967.
Xenon projection. Photo:
David Heald, © The Solomon
R. Guggenheim Foundation,
New York.

the notion of spatiality. These luminous, if equivocal, "solids" were liberated from the constructed illusionism of post-Renaissance painting to enter the volume of surrounding air (fig. 63).

Turrell thus inextricably combines the Minimalist appreciation for the literal, physical thing (in the sense of Robert Morris's objecthood) with a first-order sensation of the body as being-in-the-world. His ethereal suspensions draw attention to the materiality of the modern museum interior whose hard-edged geometry is simultaneously softened by the diaphanous presence floating within it. Since the viewer is also contained within this architectural container, she is saturated by the same spatiotemporal phenomenological conditions: becoming done and undone by the equivocal framing and unframing of space.

By using an illusion (an apparent geometric form) to dissociate the perceived image (the percept) from the real image (the stimulus or actual input from a video projection), Turrell lets us see the ambiguities in how the primary sensory cortex represents visual images. The subjective perception of a three-dimensional cube remains unshakably strong unless the viewer deliberately searches for the perceived stimulus in the beam of light and integrates this perception with the topographic representation of space detected by the peripheral sensory system. These apparitions, then, are optically present, like a hallucination, without being physically present. By embedding us within a situation or a William Jamesian object-event—symbiotically born from the relation obtaining between subject and thing—Turrell makes us

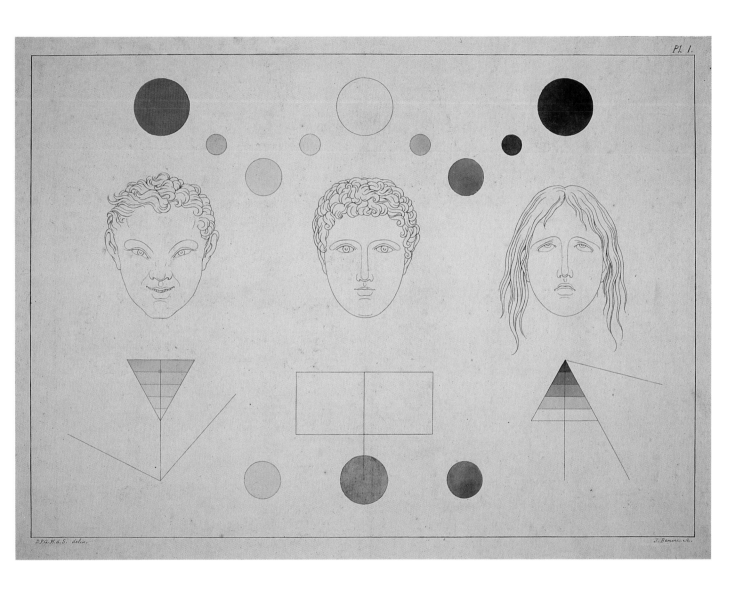

PLATE 1

D. P. G. Humbert de Superville, *The Principle* (Synoptic Table), from *Essai sur les signes inconditionnels dans l'art* (1827–32), pl. 1. Engraving and watercolor. Photo: Print Room of Leiden University.

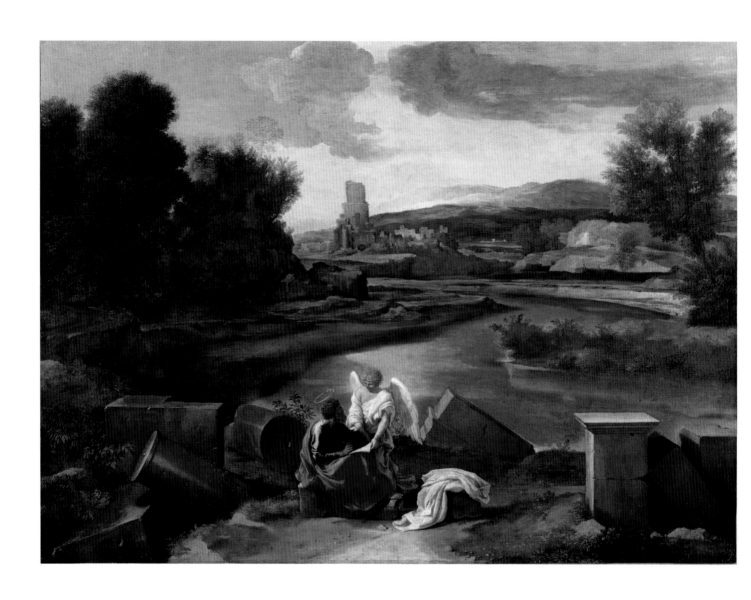

PLATE 2
Nicolas Poussin, *Landscape
of Roman Campagna with St.
Matthew and Angel*, 1639–40. Oil
on canvas (99 × 135 cm). Photo:
Staatliche Museen zu Berlin.

PLATE 3
Thomas Struth, *Louvre IV, Paris*,
1989. C-Print (137 × 172.5 cm)
© 2006 Thomas Struth.

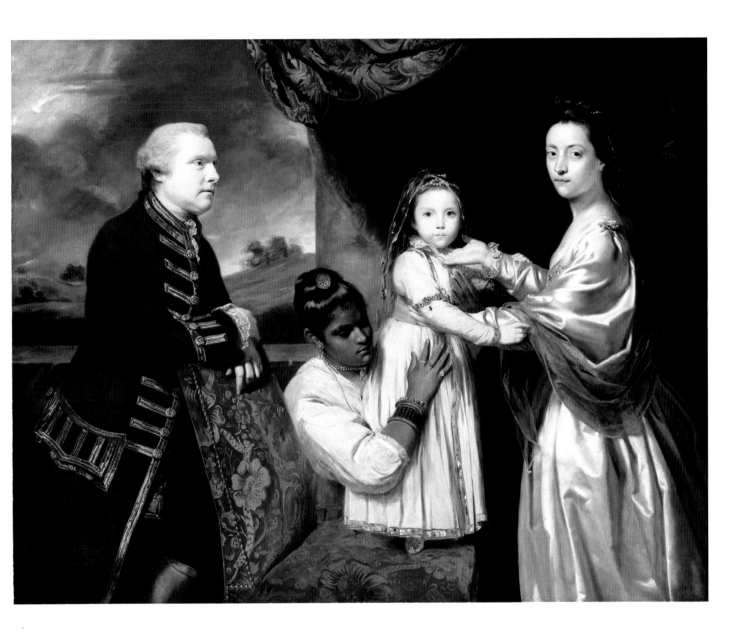

PLATE 4 (facing, top)
Jeff Wall, *A Sudden Gust of Wind (after Hokusai)*, 1993. Transparency in light box (229 × 377 cm). Cinematographic photograph. Photo © Tate, London, 2005.

PLATE 5 (facing, bottom)
Eduardo Kac, *Genesis Project*, 1999. Transgenic work (detail). Edition of 2, dimensions variable. Courtesy of Karpio + Facchini Gallery.

PLATE 6
Sir Joshua Reynolds, *George Clive and his Family with Indian Servant*, c. 1765–66. Oil on canvas (140 × 171 cm). Photo: Staatliche Museen zu Berlin.

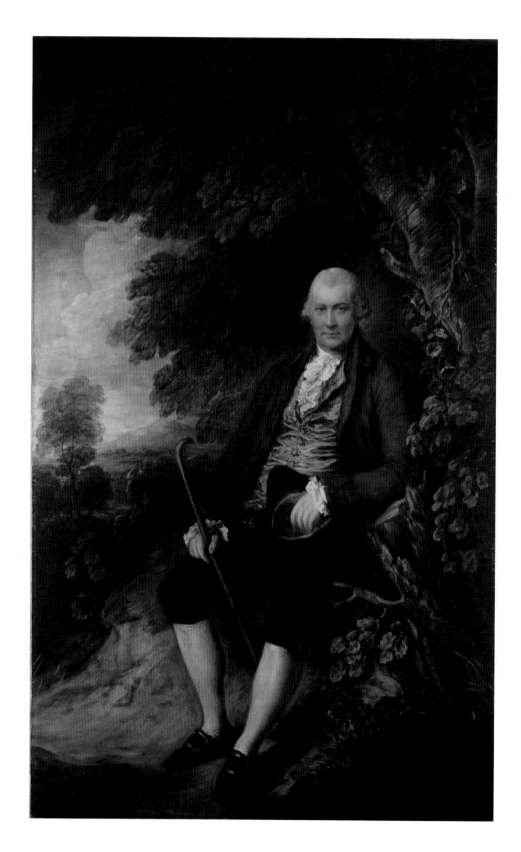

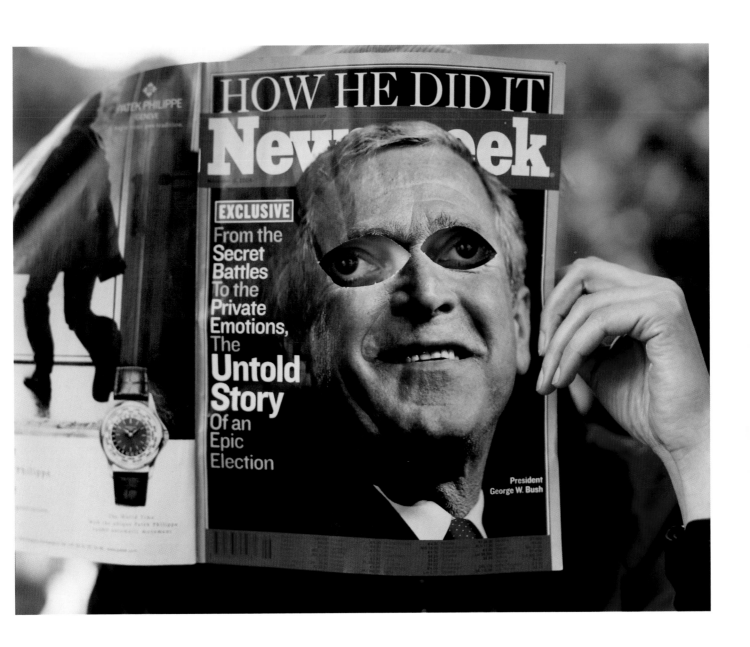

PLATE 8
Warren Neidich, *Newsweek/Paris*,
2004. C-Print (30 × 40 in).
Courtesy of Michael Steinberg
Fine Arts, New York City.

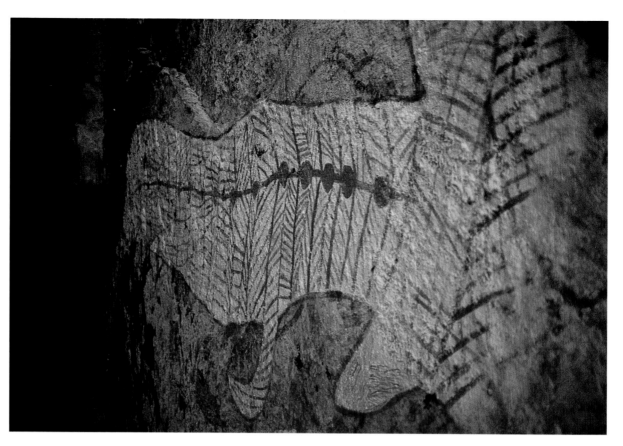

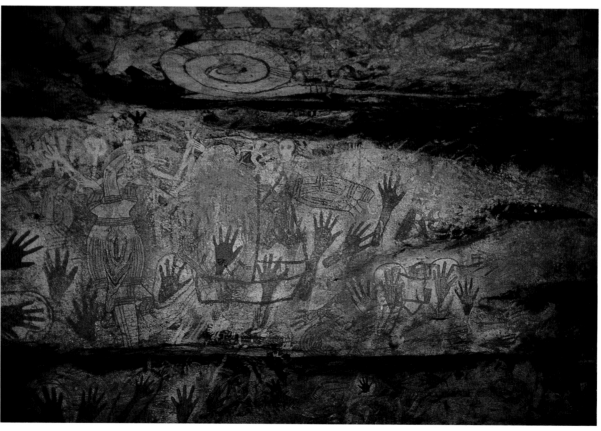

PLATE 12
Laura Kurgan, *Monochrome Landscapes*, 2004. Digital image from satellite imagery. Photo: Courtesy of Laura Kurgan.

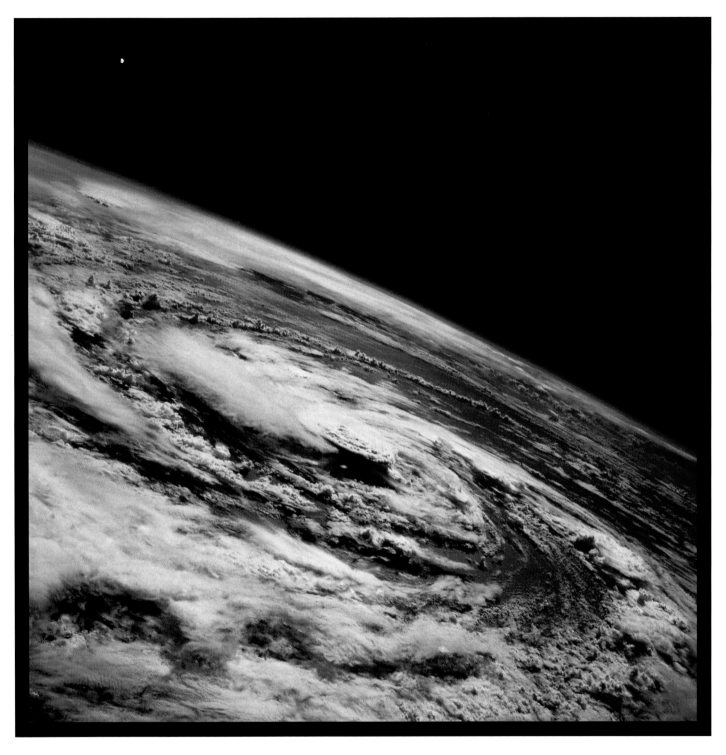

PLATE 13
Michael Light, *Hurricane Gladys Over the Gulf of Mexico* (#112), from the project FULL MOON, 1999. Photograph (24.5 × 24.5 in), edition 50. Photo: Courtesy of Craig Krull Gallery, Santa Monica.

PLATE 14
Beverly Fishman, *F.M.P.*, 2005.
Silk screened vinyl and collage
on powder-coated metal (64
³/₄ × 48 in). Photo: Courtesy of
Beverly Fishman.

acutely aware that, unless we make valiant efforts to the contrary, the brain generates what it perceives.

Dan Flavin does for the dark corner what Turrell achieves in the dim gallery. Both artists took the edge of certainty off of things. Jan Vermeer had memorably shown the potential of this triangular space to function as a refuge in his paintings of intimate, boxlike interiors. The seventeenth-century Dutch master illusionistically sliced off the front of a rectangular room—much like a portable *camera obscura* does—to conjure a secluded, yet numinous, area apart. Analogously, Flavin's site-responsive fluorescent tubes radiate white or colored light into the ambient from cave-like dark corners, thus transforming industrial brightness into epiphanic vapor.

The physical terrain in front of the luminous array is dissolved as the moving viewer gradually becomes enveloped by a radiating, quasi-psychic substance. It is important to underscore that, while Turrell and Flavin may work with illusions, their interest does not lie with creating trompe l'oeil. Rather, their installations recall both late Neoplatonism, German idealism, as well as contemporary global workspace theory since they situate us within an unfurling metaphysical experience, not merely in front of an optical deception. This concept refers to the integration of the brain's different functions with the phenomenal coherence of my lived reality, giving rise to a coherent global state. This neural holism, significantly, is expressed as an ongoing dynamic "containing" of one's physical environment.[105]

Recent artists are building on the phenomenological insights of these earlier Minimalists to create installations that coax an out-of-body experience in the viewer.[106] I close with two, very different sorts of visual experiments because, I believe, they bring us full circle: back to the glyphic primordial wall that triggered hallucinatory experiences in the first place. This backdrop of already-old soil stimulated the invention of myriad technologies for experience-amplification and the mapping of three-dimensionality into metaphysical depth through the use of instruments.

Architect and artist Laura Kurgan is a cartographer of remoteness. Her work asks, what does it mean to be distant in a world of electronic media and interfacing information technologies? Kurgan's *Monochrome Landscapes* (2004) only superficially resemble Ellsworth Kelly's primary color-field paintings of the 1970s (plate 12a–d). Actually, she purchases digital satellite photographs online from private satellite companies.[107] These capture the earth's vulnerable terrains: a desert in Iraq, the rain forest in Cameroon, the tundra in Alaska, and the Atlantic Ocean off the coast of Ghana.

At first sight, and from the disembodied heights of outer space, such threatened biotopographies appear flat and homogeneous: a vaguely textured yellow, green, white, or blue. When, with the aid of a computer, however, we plummet visually downward into these high-resolution vertical fields, we are confronted with the physical remains of the environment seen in relation to human intervention.

These surface notations—visible only when we are close-up—are as symbolic as petroglyphs: they succinctly inlay the geography of the past with present-day signs of change: two, gnat-like military helicopters hovering above the sand, the expanse of a pristine forest scarred by logging roads, muddied snow, oil tankers on waves. In their presence, we are reminded that these vanishing materials of globalization (desert, vegetation, land, water) are as fragile as cultural ruins.

Olafur Eliasson goes about capturing this global field of instability rather differently. His work, too, belongs to the ever-widening horizons of the eye in the age of physiologically expanded and technologically extended human faculties.[108] If Kurgan's secretive images can be forced to yield their embedded content—suggesting that there is a real world outside the frame—Eliasson's installations of ephemera intimate that the world is propagated from the internal perturbations and compensations of our neurophysiological system. Like the Op Art experiments of Bridget Riley and Victor Vasarely in the 1960s—but without the obligatory psychedelics—Eliasson urges us on to explore the recursive nature of our deepest self-organizing processes. In his auratic *Weather Station* (2003), he theatricalizes Flavin's slow overcoming or taking possession of the spectator. Instead of enticing the viewer to contemplate a single, potent light object, Eliasson stages a dreamlike scenario bathing the cavernous Turbine Hall of the Tate Modern in an aqueous ineffability.

Eliasson sums up his intention as "exposing and integrating our movements into the exhibition in a way that enables you to sense what you know and to know what you sense."[109] Untrammeled, we are absorbed into this total-surround ambient with the help of a huge and corrosive sun (composed of hundreds of monofilament lamps that suppress all colors except yellow), an occluding fog, and a mirrored ceiling. Self contemplates other selves contemplating one another: there is no distinction between subject and object in this addictive, nebular, and ontologized mass medium (fig. 64).

Eliasson openly emulates the atmospheric coastal, mountain, and meadow scenes of Caspar David Friedrich (see figs. 14 and 37). He thus continues the strange connection between Romanticism and Minimalism in their joint interest in "the activity of the Sublime."[110] Friedrich is famous for showing solitary or paired viewers, caught from behind, and captured in the self-conscious act of looking at a mist-suffused nature in which they are physically immersed but from which they remain psychologically separated. Beyond the obvious compositional similarity to Friedrich's motifs, Eliasson's internalized weather system conjures up, more specifically, the information-rich phantoms of earlier projective technology. These, too, claimed to have the capability of putting the spectator in the full presence of alien things without revealing their spatial location.

Eliasson's installations as self-described "phenomenon-producers"[111]—requiring the participation of the beholder for their completion—acknowledge that we have a

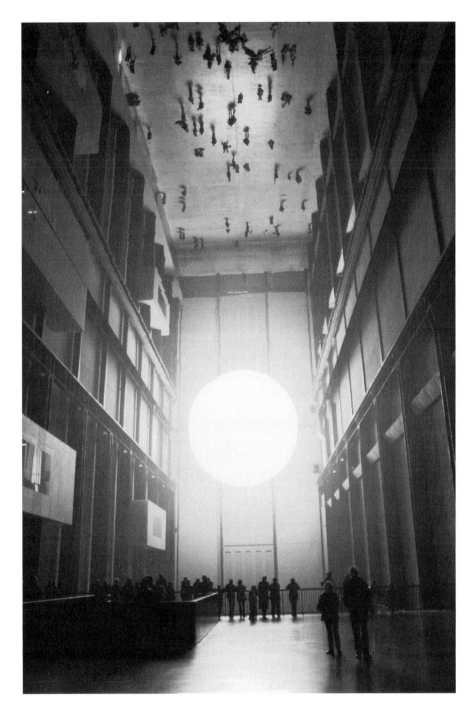

FIGURE 64
Olafur Eliasson, *The Weather Project; Turbine Hall*, Tate Modern, London (the Unilever Series), 2003. Digital image, installation shot. Photo: Thomas Pintaric, courtesy of Olafur Eliasson.

tirelessly generating, fantasy-staging nervous system. His ongoing spatioperceptual experiments—where the viewer must forge a passage across lava fields, over an icy floor, through wood smoke, or to the elusive end of retinal afterimages, seems a fulfillment of the prediction that we will soon attain a [negative] "theology of media." The philosopher Norbert Bolz describes this state as occurring when the connection of "various media and its users has progressed to such an extent, immaterialization will have reached a critical boundary and all subjectivity will dissolve."[112] In the extreme neural phenomenology of Thomas Metzinger—recently taken up by Slavoj Zizek—this position is stated as Plato's cave projecting itself into the center of the mind's actorless theater of shadows.[113]

One might have thought that mirror neurons—only visually activated when another agent is observed acting in purposeful ways with other agents or things—would clarify this existential ambiguity. But as Eliasson's installation brilliantly shows, it does not. All those people walking and looking up, or lying on the floor, looking at reflections of themselves as well as others, may be simulating the actions of another agent. But, in this windowless hall of mirrors, does the self-reflective neural system understand that it is replicating or impersonating behavior that lies outside itself? As Will Wright, of *Sims* fame says of computer games: "watching someone play a game is a different experience than actually holding the controller and playing yourself. Vastly different."[114]

5

HOW PATTERNS MEET
From Representation to Mental Representation

The retina has an analogous mesh organization [i.e., akin to the crystal-like organization of Purkinje cells in the cerebellar cortex]. So why not imagine that the cerebral cortex is also organized in cellular "crystals" piled up to form the various cortical layers allowing for the interconnection of neurons of different, superimposed crystals [to yield] a piled-up cellular crystal model.[1] JEAN-PIERRE CHANGEUX

I make things, but I need somebody else to see it with me. I look at an object on the table, and I have no empathy with it. I think, I am in a way senseless, but then you come into the room and the object starts to glow. I need you to know the world is there, which is why I am so obsessed with the structure of the world.[2] OLAFUR ELIASSON

EMBLAZONING THE INTERFACE

The new brain-mind has been depersonalized and de-imaged. This long tradition of pictorial evacuation stretches back to the Enlightenment. In contrast, I want to restore a particular kind of echoic image to recent models of the mind, one that catches the outside world in the cellular crystals of the perceiver's cortex. To that end, I have been exploring compound genres whose meshlike styles challenge the viewer to fit them together, that is, genres where it is impossible to separate thought from object. Much like a Samuel Beckett dramaticule, these reticulated formats renounce narrative, description, scene, and conventional character.[3] What they give us instead of the traditional forward motion of story and the surrounding explanatory context, is the graphic and direct confrontation with a lattice that tiles congruent and incongruent fragments of reality. It is precisely such nondiscursive arrangements, I argue, that make us "intimate" with the world.[4] Further, this intense embedding of the viewer in raw, nonillusory experience lies beyond language and speech. Think of Beckett's silence-studded work. I argue, rather, that compression and the elimination of the incidental reveals the conflictive dynamics of the neural system (especially sensory integration) with itself and to which normally we have no access.

This blazon-type of extreme inlay work walks the line, as it were, at the *interface* between autonomy and variance. Heraldic coats-of-arms, decorating quartered shields and motley livery, challenge the brain with impediments. We gain insight

from confrontational formats like these how physical stimuli get galvanized into action and crystallized into thought. Gapped configurations more generally display the cognitive crafting of ideas from sensations.[5] We have been looking, so far, at a range of compressive and encapsulating compositions that embody this laying down of facets of the self alongside facets of the world. Diagrammatic schema, hybrid emblems, the superimposed "multiple operative optical perception" of cave art command our notice. They rupture the closure of the organism, locked within its autonomous and recursive adjustments, thus bringing consciousness up to surface attention.[6] By drawing our focus momentarily to details of the world and their intense presence for us, we are lifted out of a false plot or illusory flow.

Because conceptual binding is innately "checkered," artworks that systematically couple heterogeneous elements also open a "conduit allowing [us to see how] environmental magnitudes exert constant influence on behavior."[7] Further, compound patterns, I believe, reveal how neuronal oscillations facilitate synaptic plasticity. That is, they make manifest something of the labor of spatial coherence: how transient rhythms function in the coordination of cross-domain mapping.[8]

The inlay, mesh, net, lattice, and grid: all pose the problem of fit. They require enactment. To perform, as Joseph Roach reminds us, means "to bring forth, to make manifest, to transmit," and, secretly, "to reinvent."[9] Improvisational performance, specifically, makes one aware that self-definition occurs in the presence of other agents and things. This furnishing forth (*parfourner*) or executing of an involving action at a particular moment in time and space reminds me of those eighteenth-century accordion-pleated toy theaters that reconstitute player and audience alike. Stimulating the entire sensorium, these self-contained, yet serial, paper worlds allow us to witness the ongoing conversion of physical into conceptual and symbolic processes (fig. 65). Participatory games that parse experience, arranging and changing it, reveal how the apparent "stream of thought" flowing in the self-observing subject is actually "packaged" in fractions of seconds. As Walter Benjamin remarked about toys and rhythmic gestures in general: "imitation (we may conclude) is at home in the playing not in the plaything."[10] They teach us that life is experienced in episodes.

Encyclopedic in iconography, these charming pastimes enabled the player to grasp every phase of social experience from mundane and repetitive farm work, like apple-picking, to extraordinary revolutionary happenings, like the Lisbon earthquake (fig. 66). Analogous to mantic or "sympathetic" practices, the most ordinary objects could become meaningful during reperformance. The contribution of measured handling to high-order comprehension is even more important, however, when the events are complex. By restaging the Lisbon earthquake, for example, the player was able to internalize the perceived gaps or incongruity between the regularity of the quotidian universe and the singularity of an immense catastrophe. The complex intellectual lesson to be physically ingested was not just about geology.

FIGURE 65
Martin Engelbrecht, *Fall*, from
the Four Seasons, Engelbrecht
Theater, c. 1730–50. Etching,
engraving, and watercolor
(5 × 8 in). Photo: Getty
Research Institute.

FIGURE 66
Martin Engelbrecht (and
Johann David Nessenthaler),
The Lisbon Earthquake, Engel-
brecht Theater, c. 1730–50.
Etching, engraving, and
watercolor (8 × 8 in). Photo:
Getty Research Institute.

The desolation left in the wake of this environmental cataclysm was matched by a no less fundamental epistemological upheaval destroying belief in a rational causality. It is difficult cognitive problems like this that the Engelbrecht theater instinctively addressed by showing how discontinuous and multilevel phenomena might be mentally integrated through physical means. In fact, they can only enter our awareness in sequences of momentary microstates. The ongoing crafting of subjectivity is the complement of how things are made to appear or come forth *for us*.

Consider how these toy theaters were actually manipulated by the user. In a simultaneously world-revealing and self-revealing ritual, the eyes coordinated and stabilized colorful patterns spread across a series of plates. The agile fingers sorted and re-sorted the prints, feeling their way to unity. This conceptual groping by touching, in turn, synaesthetically released the scent of rag paper intermingled with rising dust and the rustle of inserting and removing a painted set from the wooden runners of the frame. Performance thus dynamically "fit" the composing organism to the successive instants of editable and moving graphics.

This childlike, but far from childish, playacting stemming from a bygone era is a useful reminder of how mimetic "representation" has been largely supplanted by nonmimetic "mental representation" in the construction both of the cognitive and the object world. There is an unrecognized parallel between the various shatterings of the unitary self—differentially visible in everything from brain modularity studies to "embodied-embedded" cognitive science to artificial intelligence-oriented robotics—and the almost complete disappearance of any imagistic model of mental representation. Half a century ago, Merleau-Ponty tellingly remarked that "the word 'image' is in bad repute because we have thoughtlessly believed that a drawing was a tracing, a copy, a second thing, and that the mental image was such a drawing belonging among our private bric-a-brac."

But if in fact it is nothing of the kind, "then neither the drawing nor the painting belongs to the in-itself any more than the image does. They are the inside of the outside and the outside of the inside." Any painter, the phenomenologist continues, while he is painting, practices "a magical theory of vision. He is obliged to admit that objects before him pass into him . . . he paints, in any case, because he has seen, because the world has at least once emblazoned in him the ciphers of the visible. He must affirm, as one philosopher has said, that vision is a mirror or concentration of the universe or that, in another's words, the *idios kosmos* opens by virtue of vision upon a *koinos kosmos;* in short, that the same thing is both out there in the world and here at the heart of vision."[11]

That is, a single phenomenon has the ability to be two things at once. The ciphers of the visible reveal the universe to be, in fact, a clash of forms and colors. But these qualitative prismatic sensations, in turn, "emblazon" the interior of the perceiver. The interface occurs where parity is achieved: the living system continuously reacting to changes within its structure consciously attends to the incoming

patterns to which it is attuned. The heraldic crest or *device* to which Merleau-Ponty gestures, was, as we remember, primarily an identification badge boldly announcing the presence and manifesting the identity of the wearer. Significantly, it is a type of visual experience that is also a form of action: flapping banners, defensive shields, crested helmets (see fig. 30).[12] Such striking hues and flamboyant signs embedded in cloth, caps, trousers, shoes, cloaks—in short, a wealth of signaling or informational materials that were always in motion—blazed forth the subject for all to see. Blazon as a doubling image—capturing the subject's immersion in and meshing with situated experience—is thus a powerful, direct mapping mechanism generating visceral motor responses. It is a kind of mirror system for how we immediately recognize and picture emotion-laden behavior of all kinds.

While no friend of an unoccluded picture model of vision, Jacques Lacan's theory of the gaze is predicated on "a picture, certainly, [being] in my eye [the retinal image]. But I am not in the picture." Nonetheless, he seems to refer obliquely to Merleau-Ponty's comparison of the mental image to a nonillusionistic courtly pennant exploding with bright, contrasting hues and flatly quartered into an aggressive geometry of stripes, circles, triangles, diamonds, and squares. Instead of the identity-grid decorating an escutcheon, Lacan speaks of a refractive, jewel-like light that opalescently "paints" a substantitive iridescence "in the depth of my eyes" and that does not require a screen for projection.[13] Like Icelandic artist Olafur Eliasson's foiled reflecting pools, silvery cable webs, and open work crystal or mirror systems (see cover), the blazon has a structure that cuts through interior to exterior space, and vice versa.

These allusions to the direct sensory impact made by warring shields glittering in the sun or facetted gems sparkling inside a dark chamber point out how narrow, by contrast, the range of pictorial or artistic references standardly is within the neurosciences, cognitive science, and the new philosophy of mind. Throughout this book, I have underscored the importance of neuroscientific findings for research in the humanities. But I have also sought to demonstrate, in the weave of my arguments, the diverse workings of a gamut of images. Acknowledging their existence might add a real-life complexity to the artifices of neurophilosophy at home with such constructs as "zombies" or "qualia freaks."[14] By drawing on the full spectrum of imaging, neuroaesthetics, too, might be encouraged to do more than just mine visual art for tricks (i.e., as evidence for involuntary feature-recognition and Popperian preselection).[15] This reorientation would uncover a different inner ecology—one where variegated experience becomes personal for us, revealing how we catch ourselves in the intimate act of feeling and seeing.

Although their issues are not exactly the same as mine, I side with the "reconstructivists" who claim it is time for a fundamental shift in the orthodox philosophical foundations of cognitive science.[16] In this section, I will begin by reviewing the key varieties of mental objects that are out there. I then take up the cognitive

aspects of the noncomputational "picture." This generative *com-position*—engaged in binding the fitting with the nonfitting—is biologically grounded in visual attention.[17] The notion of mental representation is connected, I believe, to how we track and collect riddling appearances in space and time and interlock them into device-like objecthood. What is interesting about artful images, then, paraphrasing the Russian formalist Viktor Shklovsky, is their "removal of [objects] from the sphere of automatized perception."[18]

Representation, "representational genera," a "representative theory of perception and meaning," occupy center stage in philosophical and neurobiological discussions of unconscious and conscious awareness.[19] But what, exactly, do these terms mean? When refracted through the glass of the neurosciences, humanists are troublingly reminded of how equivocal these concepts have become in their own fields. Conversely, when the same concepts are viewed from the perspective of the history of images, it is striking how the neurosciences are struggling to find "neutral," that is, unproblematic, replacements for the venerable and nuanced humanistic vocabulary of "representation," "symbol," "resemblance." Ray Jackendoff captures the tortuous nature of these exercises in definition when he refers to the latter as those "construals" that model a "cognitive structure" in the mind of the speaker (or viewer). Recognizing, however, that even the use of the word "mind" is fraught with epistemological and ontological dangers, he feels constrained to replace it by "f-mind," or "functional mind" as in the functional organization of a computer.[20]

John Searle is unable to make sense of the notion since it requires resemblance between the form of representation and what is represented. Gerald Edelman sees representations arising as the result of conscious discriminations and classifications. This does not imply, however, that the "underlying neural states" are representations.[21] Jean-Pierre Changeux prefers the term "mental objects" to "representations" and sees them as the "capacity" of our brain to produce parallelism and hierarchy (i.e., through the simultaneous analysis of signals coming from the physical and social environment, such as color, form, motion, analyzed by the visual pathways and subsequently integrated into a global synthesis).[22]

Francis Crick and Christof Koch note the importance of representation to the description and analysis of yet another enigma: consciousness. What we are aware of at any moment is in no sense a simple matter. Citing face recognition as an example, they summarize this complex process of latent (stored), active, and multiple, interacting sensory representations as arising from "neurons in your brain whose firing, in some sense symbolizes that face" (fig. 67). But the total represented object (as evident, for example, in Jacques-André-Joseph Aved's portrait): the whiteness of the wig, the darkness of the iris, the chiseled nose, the contrasting parallel motions of the pursed lips and the deep under-eye circles of the hard-working secretary to Louis XV—not to mention the complex décor—is, in fact, distributed over many neurons.

FIGURE 67
Jacques-André-Joseph Aved,
Portrait of Marc de Villiers, Secré-
taire du Roi, 1747. Oil on canvas
(57 ¾ × 45 ⅛ in; 146.5 × 114.5
cm). The J. Paul Getty Museum.

Expanding on these complications, Crick and Koch comment that "although the main function of the visual system is to perceive objects and events in the world around us, the information available to our eyes is not sufficient by itself to provide the brain with its unique interpretation of the visual world. The brain must use past experiences (either its own or that of our distant ancestors embedded in our genes) to help interpret the information coming to our eyes."[23] For these neuroscientists, mental "representation" thus appears to be the diverse appearances of the same pattern of firing neurons as a visual image, or as a set of words and their related sounds, or even as a specific sensory modality, such as smell or touch.

A new existentialist like John Haugeland wants a philosophy of mind and science that recognizes the constitutive activity of understanding (or representation as the intentional "standing-in" for something else) as different from the mere pick-up of information. The generative linguist and revisionist Chomsky student Ray Jackendoff argues that most "computations" carried out by the brain rely on "conceptual structure" (an algebraic structure composed of discrete elements) as a "core type of mental representation used for thinking."[24] Nevertheless these two distinct positions share the key assumption of an epistemological richness prior to linguistic structure. While Haugeland finds iconic (as opposed to logical and distributed) representations to be distinctive because they are "somehow" isomorphic with the contents for which the representation stands-in for,[25] Jackendoff seems to say that conscious thoughts are little more than words and images resounding in our heads. Rules are "not representations in the learner's mind, they are just there."[26]

In brief, I want to get a clearer view of what such terms as visual awareness and mental representation mean within the leading, and often competing, neuroscientific communities. In what ways is the notion of a projected-upon or projected-into inner space (or "arena," or "theater") more than a metaphor? Does the brain-mind require some sort of mental form or "image" to create vivid viewer-centered "representations" requiring attention, not just the registration of the relevant neurons firing? Is the brain a material "support" for images as the world is a physical "support" for individuals?

In other words, instead of the typical view of what vision does, as Zenon Pylyshyn sums it up: "computing a representation of a scene that then becomes available to cognition so that we can draw inferences from it or decide what it is or what to do with it (and perhaps a somewhat different version of which may also become available for the immediate control of motor actions)," there is another important part to this story. Images are what they are. Whether they depict objects that exist or nonexistent monsters and hybrids (see fig. 31), they make them positively present, even if they are negative or self-contradictory entities.[27] While images can represent an actual situation—whether in vision or thought or language—as "falling under a certain concept," they can also do something else. Additionally,

they can conjure up the fact that something is creatively in the making. Representations of such incomplete situations are not merely "preconceptual."[28] Rather, performative images or inlaying patterns let you perceive, as well as feel, how concept and world are constructed together.

Recall that from Malebranche's occasionalism to Hume's empiricism, the dominant epistemological opinion moved away from conceiving ideas as proxy objects to making them identical to perceptions. This meant, generally speaking, that there was no third substance, whether Epicurean film or other numinous medium, intervening between perceiver and world. Eighteenth-century associationism is a good example of the collapse of this delicate tripartite faculty psychology since it diluted the self with its surroundings and suffused our surroundings with self. Thomas Lawrence, following in the footsteps of Gainsborough, brilliantly exhibits the reciprocity and directness of this psychophysiological motion whereby the textured traces of animal spirits in the brain intermingle with the vaporous corpuscularian matter of the physical environment. Benefiting from the shoulders-up pose (probably owing partially to the fact that the artist never mastered conventional anatomy),[29] the vivid likeness of *Lady Caroline Lamb* literally melts into air (fig. 68).

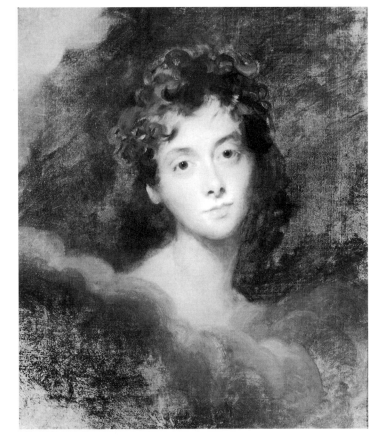

FIGURE 68
Thomas Lawrence, *Lady Caroline Lamb*, 1805–28. Oil on canvas. © Bristol's Museums, Galleries & Archives.

The nervous fluids of the outgoing mind, the river of personal identity concentrated in the extraordinarily luminous and thoughtful eyes, as well as the flowing substance of the natural world, all run together. John Sutton has argued that the fusive elements of associationism, notably formulated by David Hartley, are not structured syntactically in the manner of Jerry Fodor's "language of thought."[30] Rather, as the stunning immediacy of Lawrence's portrait demonstrates—with its boundary-blurring, vibrating pigments—no part of this "distributed" system is ever inactive. Psychological information constantly oscillates between the organism and the ambient.

But to return to the historical makings of a representative theory of perception. As John Yolton explained, it has ideas making objects *present* to us. Drawing upon Late Scholastic sign theory, Locke's term *idea,* for example, depends

upon *representation* as that fundamental function of making present to our aware-ness objects as *formal signs* (not as things), regardless of their proximity in the envi-ronment.[31] Recognition is responsible for self-consciousness as an act of self-posses-sion or self-ownership in the midst of obtruding sense impressions. Representation is thus assimilative, it has the capacity to "join itself" to the episodic actions, patch-work thoughts and memories of other beings and things.[32]

For Locke, as for Berkeley, "ideas, notions, phantasms" possessed an epistemic existence—as things perceived in that which perceives it. But their view challenges self-coherence, since the individual and his or her sense of interiority is constantly being ruined by an absorptive acquaintance that elides the distinction between consciousness and its prismatic objects. Thomas Reid, in advance of Kant, chal-lenged what he called this "Ideal Theory"—positing that what is immediately before the mind is always some (resembling) impression. Instead, influentially, he proposed his own version of the Ideal Theory, claiming that ideas do not resemble any external object or quality.[33] For Reid, there exists what the Romantic system-atizers would call a "grammar" of perception: a unifying a priori component, un-like fragmentary sense impressions, that precedes them and is always already im-plicit in our judgments.[34]

Certainly, Reid and Kant's argument of nonresemblance, while much refined, seems to rule the day. But I wish to reclaim the validity of Hume's and Berkeley's arguments for nonmediated access to ordinary objects as well as to their underly-ing prismatic faceting (updated as the blazon theory). I will return to these points when I discuss the continued pertinence of J. J. Gibson's correspondence theory of affordances in the second section of this chapter. For now, I want to underscore that what makes something present to our consciousness is the fact of its having been enriched by attention. There is much significant research investigating object-recognition mechanisms. These are so important because our brains appear to be constructed such that they avidly seek out and attend to patterns to which they im-part meaning.[35] In a crowded visual scene, we typically both focus our attention on behaviorally relevant stimuli but, equally typically, we must search through the dis-tractions to locate the desired object based on such distinguishing features as shape and color. The critical quality of the light, often unmentioned in scientific experi-ments, enhances or detracts from the probability and the speed of finding what we are seeking.

Take the case of Pehr Hilleström's (1732–1816) painted narrative of the Indus-trial Revolution, the forging of anchors in the blackened smithy at Söderfors (fig. 69). Our lines of sight get entangled in the overlapping brawny bodies of the strain-ing, half-clad workmen who are incongruously counterpointed to the stiff and isolating poses of the cloaked, upper-class visitors. Whether merged or discrete, these opposed groups are difficult to make out in the chiaroscuro gloom with its

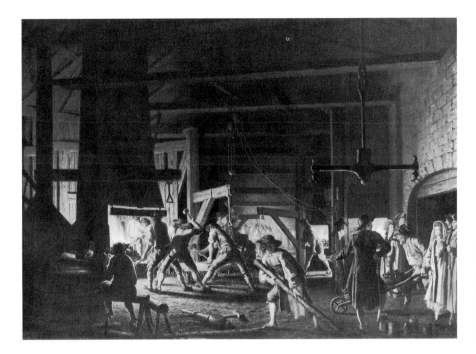

FIGURE 69
Pehr Hilleström d.Ä., *In the Anchor-Forge at Söderfors. The Smiths Hard at Work*, c. 1800. Oil on canvas (137 × 185 in). Photo: The National Museum of Fine Arts, Stockholm.

strong shadows and flaring fire. The elegant symmetry of the monumental, but dim, anchor—suspended specterlike above the factory tumult—is not immediately optically available. Rather, its contrastive, feature-selective and salient geometry seeps into our awareness only after our free gaze has explored the multiple chaotic stimuli competing for attention below. I am suggesting that the perceptual situation is more complicated than matching. In fact, not unlike life, we often do not know what we are looking for until the artist helps us find it. Another way of saying this, is that viewer of the painting does not locate the anchor as a token corresponding to some preexistent concept. Rather, the sensory experience of the anchor strangely comes after cognition, that is, after the transitory data and the fleeting qualia have already been ordered by the structure of perception.[36]

It is now thought that object selection in visual search is mediated both by our scanning the scene sequentially (serial search) until the target is identified *and* by nonspatial attentional mechanisms. The latter are sensitive to features (parallel search) that bias visual processing in favor of neurons that represent the target's features simultaneously throughout the visual field.[37] The visual part of the neocortex responds amazingly rapidly to incoming signals. It categorizes them and then tries to find the combinations of active neurons able to represent, on the basis of remembered past experiences, the relevant objects in the visual field at any given moment.

Attention thus works like framing around and within a picture. An image implies a necessary boundary just as intellectual focus preserves the brain-mind from

total seepage into the streaming lifeworld. We discover the anchor, for example, only because it is ringed by the back-reflection of the chimney's flame. This primary edging is repeated in the secondary re-framing performed by the rectangular beams defining the back wall of the interior, further setting this object in relief from the surrounding darkness. Consequently, Hilleström shows how attaining the goal of a visual search can be knowingly deferred, prolonging the capture of the eye within material substance and deepening visual attention so that the cognitive system can examine additional properties.

As Zemon Pylyshyn has argued, it cannot just be the case that the visual system is only able to pick out things in a scene that satisfy its (pre-established) conceptual representation. John Hyman seems to be making a similar argument when he says that an object's color is not illusory but part of its appearance. That is, it is *really* part of how it looks. "Being red is not like being a token or a gift—where *being* and *being counted as* are roughly the same. . . . The invisible structure of matter causes us to see an object's color: its color does not have this effect on us itself."[38] Similarly, Hilleström's radiant nimbus anchor addresses, like an agent, the visual system directly. It therefore appears to fulfill the conditions of being a "demonstrative" inlay of information appealing to "something like a visual indexing mechanism which preconceptually picks out a small number of individuals."[39] But, as I remarked earlier, this blazon process can be performative and enactive, not just automatic and "preconceptual." As Novalis presciently argued, the sort of viewing that wittingly pieces together fragments is complexly driven by identification, desire, and observation.[40]

The insufficiency of the "description view" of visual representation (the hypothesis that we pick out and refer to objects solely in terms of their categories or encoded properties) brings me to one of the most striking aspects of current representation theory. It is the killing of first-person perspective. The description view, considered later as the "narrative view," is the view from no one. Following Daniel Dennett, Thomas Clark insists we must "extirpate" any lingering notion that we "witness" experience.[41] The philosopher Daniel Dennett has been mordant in his criticism of classical representationalists. He takes to task those thinkers who believe, in contradistinction to Descartes (like Locke or Hume), that perceptions involve resembling representations.[42] He asserts that it is simply wrong to imply that the perceiver is aware of an inner picture on an inner screen. Further, if an image is to function as an element in perception at all, it will have to function as the material, not the end product.[43]

Most recently, John Hyman has criticized the promiscuous use of the word "image," rightly underscoring the need to abandon the notion that we perceive our retinal images. A screen image is caused by light that has been focused by a lens and then reflected onto a surface. He observes, first, that a screen image can only reveal the appearance of an object if it is seen. And, second, he notes that the light

reflected by the retina does not cause the changes in the nervous system that, in fact, enable us to see.[44]

One result of his draconian analysis is to deny that colors are relative to systems of concepts or to observers. While Romantics from Blake to Goethe and Humbert de Superville would support his antirelativist stance, they would not agree that this shuts out the shaping subject. Thinking never separates itself from its objects: they are penetrated by intuition and we are permeated by the sight of familiar and unfamiliar forms. As Friedrich Schlegel comments about the binding powers of intellect (ingenuity, wit): there is always the overriding "Imperative of Synthesis."[45] Further, Hyman does not tackle the moving observer's part, as Gibson did. Nor does he wrestle with the fact that the screen image the retina reflects actually contains the complex informational structure of the ambient light. Thus the viewer's vision depends on the affect-laden effect of this structured ambient light on the retinal cells.

Such "killing of the [first-person] observer" is nearly universal. This procedure takes various forms. The first person is polished off by Dennett's functionalist claim that all that is directly available to us is the content delivered by sensory representations, not the fact that the content is represented or styled by someone. Note the operative anonymity and implicit third-person model of self-assembly in this typical passage: "Mental content becomes conscious not by entering some special chamber in the brain, not by being transduced into some privileged and mysterious medium, but by winning the competitions against other mental contents for domination in the control of behavior, and hence for achieving long-lasting effects—or as we mistakenly say, 'entering into memory.'"[46]

To be sure, there are numerous cognitive camps. But this emptying out and depersonalization of mental space runs pretty much through the lot. Think of neuroanatomist Antonio Damasio's analysis of the key role of the homeostatic system in continually monitoring and updating an overall somatic situation. In lieu of a central consciousness, Semir Zeki proposes a superimpositional system of "microconsciousnesses." Then there are the "illusionizing" hypotheses formulated by the contrastive phenomenologist Bernard Baars. In my opinion, an extreme version of this position is discernible in the hyperneurophenomenology of Thomas Metzinger. Both researchers posit an internal stage with no actor treading the boards. Instead we have special epiphenomenal tricks transparently cast into a "global workspace" from the magic lantern of ongoing neural functions.

Baars eloquently conjures up a theater with no one visibly present. "As the house lights begin to dim and the audience falls silent, a single spotlight pierces the descending darkness, until only one bright spot, shining on stage, remains visible. You know that the audience, actors, stagehands, and spotlight operators are there, working together under invisible direction and guided by an unknown script, to present the flow of visible events on stage. *As the houselights dim, only the focal contents of*

consciousness remain. Everything else is in darkness."[47] The automaticity of these sub-liminal performances create the deceptive illusion that there is an actual performer of subjective experience.

For the almost negative-theological restatement of Baars's position, here is Thomas Metzinger. What goes on in his theater of the mind might be called "virtual reality immersion," and it is indistinguishable from our being-in-a-world. "A self-model (a mental self-representation) precisely emerges from drawing a self-world boundary. If this boundary is conflated with the boundary of the world-model, phenomenal properties like mineness, selfhood, and perspectivalness will disappear. However, . . . phenomenal events integrated into the self-model will, interestingly, at the same time be experienced as taking place *in a world* and *within my own self."*[48]

Each of these views embed psychology within resolutely monist and physicalist frameworks.[49] This decomposition of dualism—summed up in Patricia Churchland's description of the self as "a connected set of representational capacities that is a locus of control"[50]—dovetails with the again almost universal agreement that mental images do not represent in the manner of pictures. Among current philosophers of mind, Jesse Prinz is one of the few to argue that we still need to take seriously the imagism of the British empiricists, and that that it is "less wrong than is often assumed."[51] I agree with him that we need "a properly modern empiricist account" and will return, in the next section, to an examination of two central ways in which images carry or give form to thought—a venerable notion that stretches from Epicurus and Lucretius, to Locke, Hume, and Berkeley (see chapters 1–3). I too want to regard conception in perception.

I say thought is an image (since the different sensory modalities also generate "images") that incites us to re-perform (in the manner of mirror neurons) what we perceive. We can only know that we are having thought when we bring some specific event "inside," but do something with it outside. This action-oriented view of internalization and compression allows us to see (or feel, or hear, or smell) its correspondence to one or more of the otherwise invisible competitive processes going on inside our brain. Reorienting Andy Clark's insight concerning "re-representation," thought-as-image forms the embedded information in the brain that is being processed so that it can be re-represented.[52]

Nominally, Colin McGinn belongs among the image defenders. But this phenomenologist is an ironic apologist, more reminiscent of those Romantic algebraicists Novalis and Friedrich Schlegel than the Thomistic Goethe. To be sure, he takes seriously the powerful attraction of the notion that a visual image is a mental picture. He argues that we literally see with our mind, that is, the mind is "centrally a device for imaging."[53] Like Prinz, he focuses on images (or the products of our [constructive] imagination) and percepts (that put us in touch with the outside world), but these are very different constructs. McGinn wants to draw a sharp distinction between two kinds of conscious visual experiences such that visual im-

ages arise from an experience-producing autonomous "faculty" in the brain. This "mind's eye" emerges from the "body's eye," that is, the cortical system so carefully scrutinized by Zeki and Ramachandran, which produces visual representations of external objects. Such images can be willed because, unlike percepts, when we deliberately form an image of something "it appears to be accompanied by some kind of frame which has a spatial character."[54] Space, therefore, is not inside the image, but appears to be the medium in which it is suspended and by which it is surrounded.

McGinn sketches a nonmimetic theory of the "active power" of the mind or the creative imagination. It is rather Coleridgean in its outlines[55]—a system that itself is deeply indebted to the ontology of the late Neoplatonists and thus grounded in the long, but far from unproblematic, allegorical tradition of negative dialectics.[56] As I understand McGinn's alternative argument to the empiricist and analogical theory of perceptual acquaintance, no mental picture is actually invoked. Strangely, he ignores the research on hallucinations and entopic imagery. We do not see pictures in our head; there are no "special objects" distinct from the ordinary objects we perceive and think about. What images share, however, with certain kinds of pictures is the simultaneous representation of an ensemble of properties associated with different sense modalities.

Both pictures and mental representations are composites produced from that venerable combinatorial faculty, the imagination, which conceives as the Jena Romantics and German Idealists supposed it did: negatively and nonresemblingly, spinning that which is not so. The "mind's eye" / imagination is a sort of sophistic magus presiding over an illusory world of shifting light, color, and optical effects. His thesis is actually quite close to the position of Thomas Metzinger. Most likely, he would also agree with Wolf Singer who thinks that global oscillatory patterns "literally are our thoughts, perceptions, dreams." But McGinn's argument is far from clear. In fact, I find it as deeply equivocal as those of his Romantic precursors.

There have, of course, been many valid objections to the view that we never conceive without an image. These objections often cite nonperceptible entities or hard-to-image properties (what in *Body Criticism* I called the great aesthetic problem of visibilizing the invisible). Abstraction also poses a major difficulty, but only if one conceives of it, as is usually done, as merely a subtraction from the perceptual specificity and particularity of experience. Recall that there is an entirely different tradition of abstraction. Emblems and "real" symbols (see chapter 2) are a sort of combinatorial "ready-made." To remind us of the fractured appearance of such intarsia, I offer the simple "bits and pieces" format of such popular art forms as jigsaw puzzle maps. As in game theory, the interactive system possesses a delimiting structure within which permutation can occur (fig. 70).

The player cannot absolutely control the terrain but must relate to it. In more elaborate versions of this mutable cartography, the mosaic of topographic features

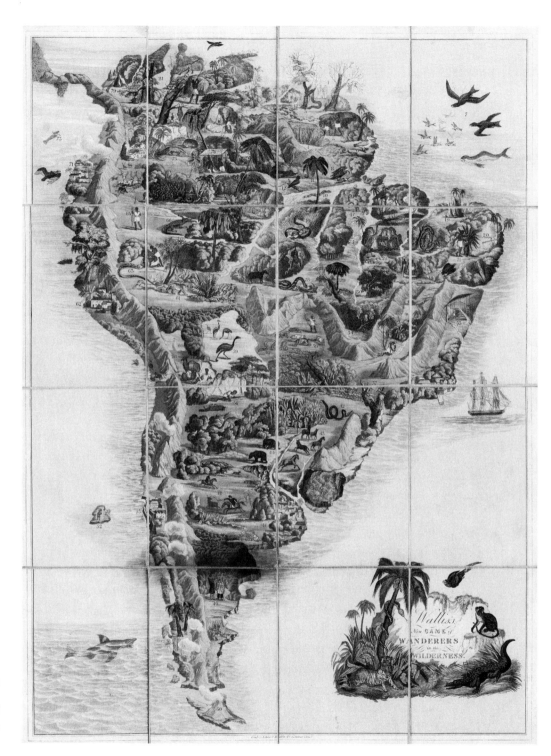

FIGURE 70
Edward Wallis, *New Game of Wanderers in the Wilderness*, c. 1830. Game board. Hand-colored board consists of an outline map of South America (61 × 51 cm, folded to 18 × 14 cm). Photo: Department of Special Collections, Charles E. Young Library, UCLA.

is set into a single figure that wittily coalesces into a salient national type. But this strong or emphatic organic shape is simultaneously undone or broken up by peripheral incidents: for example, the geophysical features characteristic of the particular country that eat away at any formal self-containment (fig. 71). This double-edged process leads me to ask if recombinant maps, metamorphic toys, or combinatorial "recreations"—which encourage the user to rethink as she reperforms the labile composition (fig. 72)—are not instances of Prinz's conception in perception? Such mass-reproduced toys, like the myriorama, a game popular in the first half of the nineteenth century, used a series of twenty-four illustrated cards to form an overall view while each card remained completely interchangeable. In these game environments, the mental and the extramental world resemble one another. Both are composed of fractured intarsia, or a paratactic combinatoric of images, that get correlated in the act of playing.

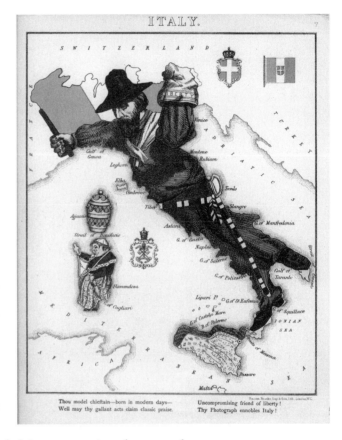

In this spirit, Edelman speaks of reentry as helping an organism abstract and structure complex experiential changes. His complementary notion of a "remembered present" captures our continual composition, the ongoing integration of self with nonself.[57] Is there not a profound truth, then, to the long "myth" of pictures inside that corresponds to the correlational or inlaying work of neural binding, rhythmic oscillations, aligned cellular crystal models, and even symbiogenetic cellular ingestions? Specifically, the blazon is closer to the electrophysiological evidence supporting a packaging view of mentation (that is, brain activity as discrete, global, brief, temporal chunks) as opposed to the first-person continual "stream of thought" view. Such conspicuously patched, abruptly juxtapositive image-objects allow us to see the construction of an interface where the processes of sensing and acting meet up with the intricate formal structures of the visible world.

But it also acknowledges the importance of the affective *field*, not just point-to-point synaptic junctures. The emotional effect of the blazon is to cut through the divide between inner and outer reality so that sensations not only bleed into one another but feelings permeate different areas of the brain blurring modular mechanisms. Consider, for example, Joseph Mallord William Turner's corruscating late landscape paintings. Confronting the raw physicality of light and color in these

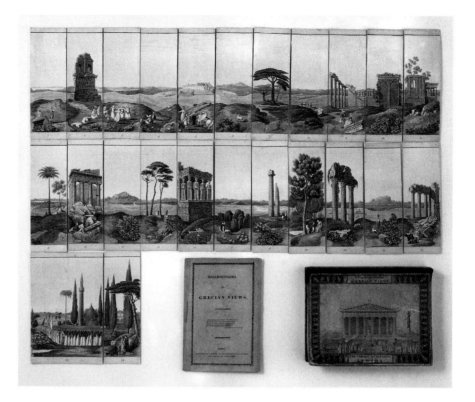

FIGURE 72
J. Burgis, *Hellenicorama or
Grecian Views*, c. 1800–25.
Aquatint, etching, water-
color. Photo: Getty Research
Institute, Special Collections.

pictures requires the beholder to expend a concomitant level of energy.[58] Mental
images resemble Turner's radical acts of sensation: striking the beholder like a coat-
of-arms with "atoms of thought and emotion."[59] But because these chromatic mist
environments also disperse and coalesce, like our vision, they enact the coming and
going of consciousness, how it lets us see and feel the moment in a single blow as
the body moves through a space that it simultaneously crystallizes and clouds.

NARRATIVE VERSUS PATCHED MODES OF BEING

Galen Strawson recently argued that it is a great fallacy of our age to suppose that
human beings typically experience their lives as a sustained narrative. This is to sup-
pose that self-awareness is a kind of inner speech or running commentary. More-
over, he challenges the unitary assumption that when I am apprehending myself as
an inner mental presence, this self-consciousness must necessarily carry with it the
"feeling or belief that what is remembered happened to me, to that which I now ap-
prehend myself to be when apprehending myself specifically as a self."[60]

I agree with Strawson's observation that our inner life is not exhausted by the
description of plotted flow or a teleology of past, present, and future. But Strawson
does not adduce the neuroscience that supports the justness of this claim. My argu-

ment is that an important neuroscientific as well as phenomenological fact about consciousness gets lost when this *granular* inner sense of self gets subsumed under the blending structure of an "ongoing story" we silently tell ourselves. One of the key insights of contemporary cognitive science is precisely that mental faculties can be decomposed, not just into multicomponent information processing systems, but into two different kinds of nervous systems. The specialized cells of one operate in parallel, unconsciously, with some autonomy. But there is another nervous system that is serial, internally consistent at any given moment rather than distributed, and strongly associated with consciousness.

What the nonnarrative, nonmetaphoric genres we have so far considered (the "real" symbol of late antiquity, resurfacing in the fragment theories of the Jena Romantics, the inlaid emblem, and the patchy heraldic device) all share is their performativity. As in mantics, as opposed to hermeneutics, these sutured forms are operatives, efficacious like a charm or talisman. Further, such compounds demand an *inherently imagistic* activity of structuring that is, at once self-structuring. Such genres, I maintain, challenge the dominant paradigm of thought as unfurling self-talk.

Owen Flanagan, with his "expanded natural method," for example, makes the case for wanting to "corral consciousness by paying attention to how it seems (its phenomenology), and how it is realized (its neurobiology)."[61] In his neurophilosophical account, as well as in literary "postclassical" approaches to the study of narrative and narratology, the focus similarly tends to be on a discursive psychology. It is true these new theories move away from a cognitivist approach to language—where texts are depictions of the external world or representations of our psychic lives. Nevertheless they still presuppose that "minds are always already grounded in discourse."

While the cultural norm today clearly seems to favor the supposition of long-term self-continuity—a diachronic view stretching back to Plato and forward to Graham Greene—history offers plenty of evidence for nonpathological, "episodic" literary types who do not habitually gather their lives into a coherent story. Michel de Montaigne, the third Earl of Shaftesbury, Novalis, Samuel Taylor Coleridge, Ford Madox Ford, and Samuel Beckett overtly pieced, or oblige us to piece, their isolated and discontinuous accounts together. Strawson's "episodic" authors possess an interruptive style that resembles more the "fretwork" imagism of Ezra Pound's poetry—tellingly modeled after enameling, damascening, or emblazoning pictorial strategies—than they do "what led to what" causative fiction.[62] Further, this emergent style of self-presentation is ultimately modeled, not on texts, but on "patchy" artworks. Such paratactic visual compositions, favoring side-by-side connectivity, emphasize simultaneity and effortful co-construction.[63]

Divisionist techniques are inherently juxtapositive. They atomistically inlay heterogeneous, and even antithetical, elements rather than blending them, thus placing

special pressure on the viewer to improvise their joining into a coherent scene. Just as a coalescent self-awareness must continuously emerge from tangles of neurons, the activity of pictorial piecing involves an ongoing relational system. If narrative turns the world into a plot, gapped configurations undercut automaticity, illusion, and the feeling that one is in the grips of remote control. They thus provide an insight into how we consciously struggle to make the weird details of the world hang together. Patching is a form of communicative action where two or more people and/or a variety of differentiated things must coordinate their agreement (fig. 73).

Such compressive mosaic work can operate at different micro- and macrolevels. It can move down in the cosmological and epistemological scale to the pointillism of Seurat and Pissarro, ratchet up to the fragmentary symbol and the composite emblem, or rise to the disconcerting montage of assemblagists-in-the-flesh such as Hannah Höch, and photographers of heteroclite curiosities, such as Rosamond Purcell.[64] We see this performative process at its most monumental in the German Reichstag. In his restoration of the building, conducted between 1992 and 1999, Sir Norman Foster exposed the graffiti on the walls of the vast *Plenarsaal* (General Assembly) level of the Bundestag. These had been scratched on the exposed surfaces of the interior by the Soviet soldiers billeted there until the end of the war in April 1945. Before Foster's renovations, they had been covered over by various restorations (fig. 74).[65]

The contemporary reinstatement of selective features and prior episodes to this still-evolving building does not just turn it into a museological object.[66] Rather, by conspicuously inlaying fragments of Germany's past with its present-day concerns, a new enactive kind of civic space emerges. As Walter Benjamin claimed in his aptly incomplete *Arcades Project* (begun in 1927 and preoccupying him for the rest of his life), history has a habit of decaying into crystallized shapes, not stories.[67] These shards, like the Soviet graffiti, are unmoored from any smooth or secure account. They show that vision, like history, is always in motion responding to the granularity of contingent stimuli and the particularity of changing circumstances.

In this sense attentive consciousness, too, is comprised less of "small spatial stories" or "creative blends" and more of a montage of eruptive graffiti and singular tesserae.[68] To be sure, there are as many variants of pictorial narrative as there are of literary narrative. Nonetheless, these permutations of the genre share the presupposition of continuity. As in the Venetian painter Palma Il Giovane's *Venus and Mars* (c. 1605–9), the two protagonists—despite their physical separation—cannot resist being telescoped into a larger, preexistent order. The actions of these gods necessarily go together and are projected or moved toward one another by the viewer who knows the story beforehand (fig. 75).

Rephrasing Santiago Ramón y Cajal's findings that memories involve strengthened neural connections, performance as the resonance between feeling, sensing, and doing would seem to aid long-term potentiation—one of the most widely studied types of neuronal plasticity occurring both in excitatory and inhibitory inter-

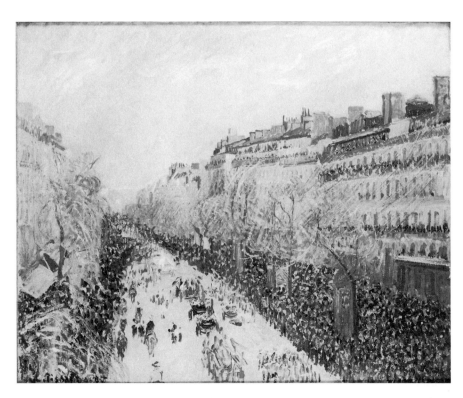

FIGURE 73
Camille Pissarro, *Mardi Gras on Boulevard Montmartre*, 1897. Oil on canvas (64.9 × 80.1 cm). Collection of Maurice Wertheim, Class of 1906. Courtesy of the Harvard University Art Museums.

FIGURE 74
Deutschen Bundestages, General Assembly with Graffiti. Courtesy of Deutschen Bundestages.

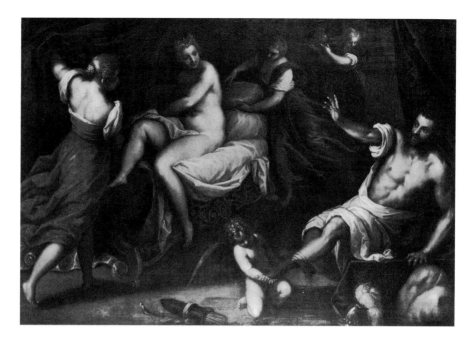

FIGURE 75
Palma Il Giovane (Jacopo Negretti), *Venus and Mars*, c. 1605–9. Oil on canvas (80 ⅞ × 56 ¼ in; 200 × 110 cm). Photo: The J. Paul Getty Museum.

neurons.[69] Self-shaping or defining techniques are dramaturgical because self-staging involves a public. Engaging one's surroundings thus stimulates a type of synaptic enhancement going on when new tasks are re-played while we are awake (and even when we are asleep).[70] Finally, this communication in the presence of others is also distributed, embedded in experience-intensifying traditions of magic, technical wizardry, and ritual. Such inventive whole-body practices give rise to an extraverbal understanding by constructing "living pictures" that extend beyond the borders of the self.

Because the delusory and autonomous "theater of the mind" paradigm is so prominent in recent neuroscientific discussions, I want to show that there are other possibilities for this mental "stage" beyond making brainwork appear deceptively continuous. The venerable "theatrical" genre of *tableaux vivants*, for example, is episodic not narrative. Like the Engelbrecht theater writ large, it is a type of performance requiring inlay work on the part of the beholder. We can still witness how this ancient mantic process actually worked in the famous Southern California Pageant of the Masters.

These riveting charades occur biannually at Laguna Beach and have been enacted for more than eighty years.[71] The ceremonial presentation of glowing *tableaux vivants* under the velvety canopy of the night sky immediately plunges the modern viewer into the ancient realm of operative images. These potent, force-filled objects do something both in the mind and in the world. The re-creation of John Singer Sargent's *The Sketchers* (1914; 1999) is an example of performance, in director Richard Schechner's term, as "twice-behaved behavior," that is, always subject to revision.[72]

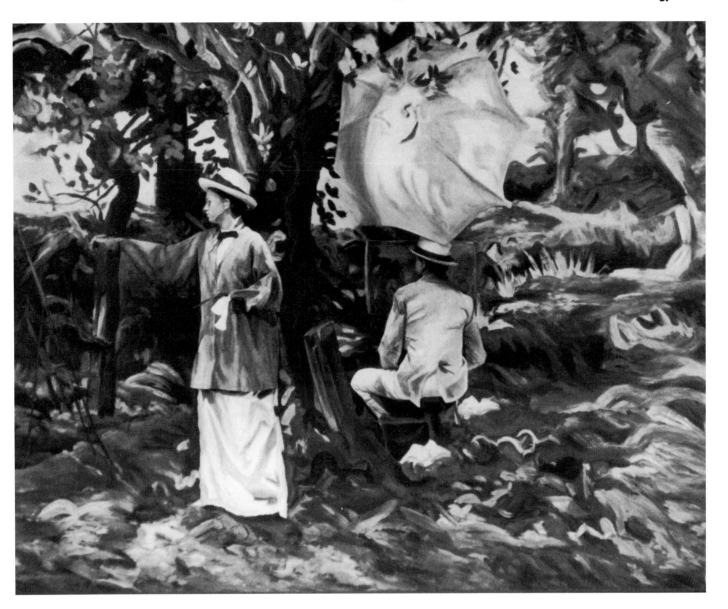

But it is also restored behavior, giving people a new way of experiencing an age-old, ritual-based interactive method. Simultaneously a physical installation, a nexus of individual agents, and a direct image, this "livepainting" poses the paradox of a picture that is not a picture (fig. 76).

The pageant originated in a parade of volunteers costumed and cosmetically enhanced to look like famous artworks. This line of people succeeding themselves before the eyes of spectators has, over time, been transformed into combinatorial images that pass in review, helped by the addition of a stage, painted and sculpted sets, and music. Figures-in-the-round are the statuesque stand-ins for the initial depiction

FIGURE 76
Pageant of the Masters, John Singer Sargent's *The Sketchers* (1914), 1999. Tableau vivant. Photo: The Festival of Arts, Laguna Beach, California.

FIGURE 77
Pageant of the Masters, John
Singer Sargent's *The Sketchers*
(1914), 1999. Detail of tableau
vivant. Photo: The Festival of
Arts, Laguna Beach, California.

on a plane. The performers coming from our three-dimensional world, and despite all efforts to confine them to the flatland of the chromatic surface, noticeably belong to a mixed, co-created space (fig. 77). These tears in the fabric of seamless illusion are evident elsewhere as well. At least two things are always going on: the theatrical reproduction of the total scene and the smaller, revealing slippages between the willed reenactment of Sargent's bucolic landscape and the involuntary extemporaneity of the actors. Contemporary spectators thus discover (not just rediscover) the dynamism inherent in the original Impressionist artwork precisely by glimpsing, and participating in, the labor of its rethinking. Conversely, this animate mosaic receives its stabilizing "frame" from the memory of the a priori structure organizing the actual painted picture.

Unlike sequential narrative, what the performance or remediation of Sargent's metapainting of the activity of painting manifests is social cognition: the interplay of form and content in a particular experiential situation. It never lets the audience forget that pattern making occurs during every moment of an unfurling present and requires our collaboration. We thus have a blueprint for the ways in which self-consciousness is ritualized as an activity. It resembles performance-based art—shaping itself from moment to moment—just as a distributed array of optical features and motor properties are continuously compounded into a collective structure.

The distinctive components of performance—like embodied concepts—are the always- being-constituted images, supplemented by reentry from the environment. But this mobile relational process is preconditioned by the demands governing attention. We see an analogous use of the image as an attention-capture device in a late nineteenth-century pricked and back-lit *vue d'optique* showing Loie Fuller dancing in a cage of lions (fig. 78). Symmetry, a dominant central area of focus, motion, and pulses of light are all salient features to which our eyes are irresistibly drawn. The total aesthetic experience is thus conditioned by our past interests, our hardwired neural mechanisms, and the vividness of the performance itself.

Certainly, keeping track of the shifting behavior of others in real time is an ancient survival strategy. Evolutionary biologists have shown that both humans and animals form social groups in which cooperation and reciprocity prevail—at least among many species—and this entails carefully watching, responding to, and remembering the faces and actions of others.[73] A more nuanced history of the origins of ethology is also now emerging, investigating the phenomenon of "imprinting" first studied by Konrad Lorenz in the 1930s to help explain the mechanisms that trigger instinctive responses in different species.[74]

As I argued with regard to mirror neurons (see chapter 3), this does not necessarily entail falling into biological determinism. Rather, it is an opportunity to reconsider the bidirectional operations of imitation/attachment within a broad spectrum of performative genres old and new from the "valenced" emotions of caricature to the art and poetics of "naïve" improvisation.[75] Consider, for example, Byron's vagabond *Don Juan*—one of the best-known literary cases of the risk-taking poet-hero able to adapt immediately to the most alien and challenging events.[76]

FIGURE 78
Loie Fuller dancing, from
Ombres Chinoises Game, 1880.
Chromolithograph. Photo:
Getty Research Institute.

Romantic painting, similarly, seeks to overcome the divide between body and psyche through perilous gestures. Antoine-Jean Gros's *The Pesthouse at Jaffa* (Salon of 1804) conjures up a Messianic-Napoleon impelled by the sight of suffering to heal open plague sores on the spot (fig. 79). Or think of the anxiety-producing give-and-take solicited by Goya's aquatinted and etched diabolical print series, *Los Caprichos*. As in Max Ernst's ominous frottaged/grattaged "decalcomania" of a century later, Goya's agitated chemical process pushes and pulls resin and ink into sinister stains.[77] By soldering bistable percepts together—that is, blotchy shapes that uncannily look like one thing to the beholder one moment and quite another when the shadowy image either gets turned ninety degrees or the viewer physically rotates himself—

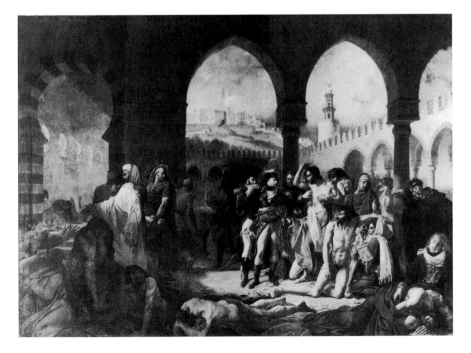

FIGURE 79
Antoine-Jean Gros, *The Pest-
house at Jaffa*, 1804. Oil on
canvas (532 × 720 cm).
Photo: Réunion des Musées
Nationaux / Art Resource, NY.

the artist demands that each print be separately reenacted. Conversely, there is a kind of material intelligence in these molten forms that mass and mutate, organizing our perception in the process of structuring themselves. Shapes grow and disperse like organisms before our eyes. We respond viscerally and cognitively to this individuated dynamism of coming and going (see fig. 33).[78]

Identity as well is a kind of fitful self-performance, an impromptu way of physically and mentally composing oneself in public. This playing out is distinguished from the solitary Wordsworthian confluencing of scenes—edited and recollected from prior serial witnessing. But it also highlights the difficulties of standing alone, the cost of Romantic independence. Going against the cohesiveness of the group, whose positive or negative reactions one is perceiving in real time, is now thought to be registered in brain regions associated with emotional salience (in the right amygdala and right caudate nucleus).[79]

Making one's own existence in the present—whether in a *tableau vivant,* the dialogical gestures of a Romantic improvisation, or in the liquid thought of paint—is the opposite of the usual narrative apparatus. Strawson might well have cited the virtual remix as the premiere contemporary example of the persistent obsession with sustained scene or story. Such hypernarrative reflects the synergistic coming together of hip hop, mass media, and artistic production. If one accepts continuity as a central feature, then remix compilations embody the taking to extreme of narrative to infinity. I mean the fantasized, digitized, resequenced blur that exists only to be remixed (fig. 80).

FIGURE 80
DJ Spooky (Paul D. Miller), still image from DJ Spooky's *Rebirth of a Nation,* 2006. "Mashed" digital images. Photo: Courtesy of Paul D. Miller / DJ Spooky "That Subliminal Kid."

The near-ubiquitous grabbing of iconography from everywhere and, hence, no-where—snatches of old-master paintings, photography, anime, movies, television, club videos, the street, fashion (the stunning success of Prada's retro re-fashion-ings)—and extending it indefinitely now engulfs us. Paul D. Miller (a.k.a. the char-ismatic DJ Spooky) celebrates these new techno-landscapes of globally connected existence through which images, text, and sound are processed and get redistrib-uted. In *Rhythm Science,* he praises sampling—bits of data set adrift from their origi-nal contexts and meanings and smoothly reconfigured through electronic scanning. The forever ongoing negotiation of information that the raw technology of turnta-bles, scratching, and video (VJ's) entail signals that we are on the threshold of "multi-plex consciousness."[80]

This is identity as repetitive, hypnotic, and referring to anything "that flamboy-antly flashes and glitters."[81] As artist Warren Neidich remarks, we have entered the era of "visual and cognitive ergonomics" where "objects, their relations, and the spaces they occupy, affect changes in the brain."[82] Jamie Hewlett of Gorillaz, "the world's greatest live, pre-recorded, re-mixed, animated pop band," unintentionally highlights the narrative implications of this audiovisual sampling and filtering that interfaces with our deepest physiology. He points to more and more cultural groups that are "cross-pollinating," thereby auto-organizing themselves into a vast concep-tual network.[83]

Unlike twentieth-century cut-and-paste collage techniques—juxtaposing recog-nizable snippets of the world—or earlier divisionist intarsia from mosaics to cari-cature, the new electronic recombinant media are seamless and endless.[84] Such ag-gressive repurposings are not about creating physical and spatial adjacency among incongruent fragments. Rather, their intent is to procure morphed synchroniza-tion across complex multidimensional data. While knock-off sampling appears to be dealing in small-scale deconstruction, the remix, in William Gibson's words, ac-tually *"generates* countless hours of creative product."[85]

AMBIGUOUS STATES

We are thus living in paradoxical times when the remote or original unit of refer-ence is being continuously blended into an equivocal, bootlegged or "mashed-up" hybrid. Given the hypermediation and anonymous communality of the remix, un-certainty rules. Can we know whose mind-at-work we are actually witnessing? Has the paradigm of the computational remix subtly warped our view of the self as being no different from the customized bit whose meaning derives from the auto-mated link-up? Conversely, is self-awareness as well as a keen sense of the present just a momentary rupture in the ongoing processing between the frontal regions and the posterior perceptual brain, between the face-recognizing system and the amygdala and the hypothalamus, areas associated with the emotions?

There are some significant alternatives to this scenario. In contrast to extolling communication by bit transmission, "small worlds"—like podcasts and blogs—are laying the groundwork for individual programming. These devices (along with cell phones, Blackberries, iChat) miraculously achieve a nearness through remoteness. While not unambiguous, they still let you get a hold of the transmitting person as a particular nexus of far-flung distributed connections.[86] Paradoxically, and reminiscent of earlier projection technologies, the agent or object of the broadcast is shifted into the distance away from our immediate reality in order to be brought machinically close to the user. This simultaneous extension and collapse of range also recalls the dazzling rhetorical performances of the romantic *improvisatore*.[87] Such virtuoso flights of invention brought the creative act closer to the spectator while making the ordinary members of the audience acutely aware of the gulf stretching between themselves and the singular poetic mind at work.

The new kinds of improvisational content providers offer a different sort of mixture, then, from the amalgamations of pirated tracks, hot jams, diss songs, and street styles that have become promotional tools for commercial record labels trying to build a buzz.[88] Although still highly eclectic, they empty out the centralized and anonymous conglomerate of big-market media systems.[89] Such intimate "dynamic appliances" function by fitting or tailoring an impersonal technology to the biological capacities and cultural needs of the user, but *without* any sensation of gap unless the software fails.[90] With their moment-by-moment picturelike framing of the extemporizing subject, these content providers rescue our psychic life from dispersal in a stream of bits that is always disappearing, reappearing, disappearing.

Revisiting Strawson's terminology, are we right to suppose that the "episodic" self must somehow be resistant to the automatic binding drive that connects the topographically distributed sensorial packets in our cognitive field into linked associations? Does this staccato interior life—unlike the molten progressions of narrative—just begin anywhere and stop anywhere without closure or summing up? Further, what does such selectionism tell us about the patterned ways in which the brain integrates different types of information? Significantly, PET and fMRI imaging experiments have demonstrated that connectivity problems—a lack of correlation between visual areas in the back of the brain and the inferior central cortex governing action planning and other coordinated activity—are central to autism. Characteristic of more high-functioning instances of this disorder is the easy memorization of discrete facts but difficulty in collecting particulars into a coherent concept. In short, this want of cross-cortical cooperation is not just a form of "the extreme male brain" (i.e., impaired empathizing and enhanced systematizing),[91] but an *extreme* or "broken mirror" form of nonnarrative experience.[92]

Many autistic abnormalities occur when a person focuses on details and is unable to integrate the clear-cut elements—whether facts, words, visual stills—into broader patterns of reasoning.[93] It is as if one sees the world pixilated or "parceled,"

in tune with the genetically determined operations of what Gerald Edelman calls the "primary repertoire."[94] This microbiological architecture of the brain relates to different functional capabilities (color, form, motion detection), each of which responds to a partial aspect of an object. These dispersed partial features only become selected and bound together into a whole during "reentry."[95] But binding remains a "problem" because of the absence of an explanation for the ordered integration of many and varied sensory elements into a subjective experience.[96] During this temporal process, neural mappings mysteriously become communicating components in a large network of synchronized electrical signals. The story of the self somehow emerges from this widely distributed pattern of signals. And it is from the resulting functionally coherent assemblies that the illusion of unfurling reality derives.

I want to mobilize and expand Strawson's insight that there are two, contrasting sorts of from-the-inside experience to head in a different direction. The distinction between recounting oneself as a developmental continuum and figuring oneself as an irreducible formal fact without apparent causal connections with what went before or what comes after the present moment historically characterizes two major types of artistic representation. I now want to make these procedures explicit. The "illusionistic" strategy tries to find or create continuous sequences in an otherwise unconnected manifold. This smoothing of the disjunctive aspects of sensory experience is one of the major reasons that the visual arts have long been accused of being merely clever "systems of imposture."[97] Certain kinds of images magically gather heterogeneous material into a seamless flow, thus confirming the bias that *all* images are, at their core, deceptive.

But there is another tradition. Sensory intarsia resist two major aesthetic impulses. They renounce, first, any attempt at euphonious harmonization. Second, attention-holding material inlays undercut the inflationary tendencies of the Burkean Sublime. The Sublime's upward-driving, transcendent dimensionality—never content to focus on the present or attend to the moment—is particularly evident in the Kantian and post-Kantian formulations of *das Erhabene*. Containing echoes of *Erhebung* and *Erbauung,* the German term doubly connotes being swiftly elevated above the common ground and being morally raised to the heights, that is, edified.[98] By its insistent verticality and ecstatic elision of antipodal realms, this phantasmic style of synthesis stands in strong contrast to Pound's correlational marquetry. The imagist poet memorably constructed the world as well as the work of art as fretwork, as autonomous checkered thing "thrown free of its creator."[99]

Throughout the twentieth century, many artists commented on the autonomy of the artworks they made. They also reconceptualized the age-old aesthetic battle between the creation of intense optical effects versus a rigorous structural combinatorics. "Machine art" (fig. 81),[100] the long shadow cast by Russian Constructivism, the process aspects of Conceptualism, the field or ambient concerns of Minimalism, as well as systems and procedural art: all set in relief not only the smooth

processes of self-assembly but those of discontinuous emergence as well. Consider again Dan Flavin's phenomenological discovery of the dark corner, rarely used by other artists before him.[101] Unlike Donald Judd—exulting in the objective rigidity of geometry as sustaining interest without illusionism all the while creating milled aluminum boxes that evaporated in an epiphany of light—Flavin openly embraced dissolving color.[102] By dint of pressing a single eight-foot fixture into a cavernous angle, or leaning a fluorescent tube into the triangular penumbra, or crisscrossing a shadowy hollow with a chromatic grid, he revealed the otherwise inaccessible depths of the black background. Simultaneously, the dim foreground was made to disclose an unsuspected burst of cool white or a hothouse radiance of pink, blue, and yellow (fig. 82).

While Flavin's off-the-shelf, mass-produced fixtures are monuments of continuously emitting illumination, they are equally performative bars of discrete light. This ritualistic aspect of Minimalist work is also found in Smithson's "non-sites." His assemblages of dirt, sand, shells, or salt—piled up to support mirrors that multiplied and dematerialized the heaped materials—has tended to get overwritten by flowing, cinematic models. Andreas Kratky's *Software Cinema Project* is consistent with the remixing software age of DJ Spooky. These multiframe narratives demonstrate how cinema, human subjectivity, and the variable choices made by custom software combine to create films that run infinitely. Admittedly, this series never exactly repeats the same image sequence, screen layouts, or stories.[103] Yet visuals, sounds, and even the identities of characters are autoassembled from multiple databases allowing myriad media to "bleed through" real and on-screen spaces.

The artistic experiments of the 1960s and 1970s that explored the complex "situationism" of a specific environment and the subject within it form an important bridge to contemporary artwork that questions the hold of the consolidating cinematic model, paradoxically within the filmic medium itself. These hybrids instantiate what Alva Noë has termed the "enactive approach" to perception.[104] Hiraki Sawa's lyrical video *Dwelling* (2002) plays on the questionable assumption that what we call ordered or conscious thought necessarily has a beginning, middle, and an end. If this sequence is broken, then it is assumed that the thought no longer makes sense.[105] In important ways, he returns to early twentieth-century filmmaking and to Charles Pathé's *ciné-romans* where the dreamlike blend of a long tale is interrupted by an inlay of details (fig. 83a).[106]

Sawa turns the truism of narrative causality on its head when he conjures up the spatial continuum of a domestic interior constantly undercut by the discontinuous landscape of touch. In this almost aquatic flow of still shots taken of different areas of his sparsely furnished London apartment, he addresses the fact that most tactile sensations reach us indirectly, through the eyes. Sawa uses toy airplanes as visual fingertips. Like a whisker paintbrush, they sweep over, slip or slide, and otherwise come up "against" a textured object time and again. Thus the information we

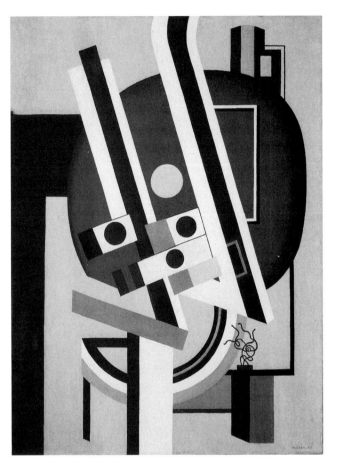

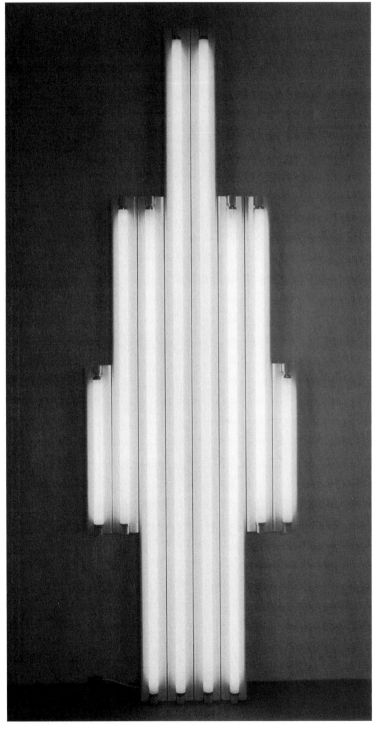

FIGURE 81
Fernand Léger, *Composition (definitive state)*, 1925. Oil on canvas (130 × 97.4 cm). Solomon R. Guggenheim Museum, New York; © 2006 Artists Rights Society (ARS), New York / ADAGP, Paris.

FIGURE 82
Dan Flavin, *"Monument" for V. Tatlin*, 1969–70. Fluorescent light fixture. © 2006 Board of Trustees, the National Gallery of Art, Washington, D.C.

FIGURE 83A–B
Hiraki Sawa, stills from *Dwelling*, 2002. Digital video on DVD. Photo: Courtesy of James Cohan Gallery, New York, and Ota Fine Arts, Tokyo.

derive from touch about our surroundings seems less prone to deception.[107] The artist shows how by gliding or roving over ambient textures, we make sense of jumbled incoming data and transform them into a mental objective image. The video confronts the viewer with eerily uninhabited rooms suddenly enlivened by an aeronautical fleet. Toy planes silently launch themselves from a kitchen table or from a shorn rug, cruising through an airy hallway, settling on a rumpled bed, in a glazed bathtub, or upside down on a ceiling—as if propelled by some invisible force (fig. 83b).

As a result, the experiential stream gets ruptured, creating little pieces of infinity. Sawa demonstrates that the world only makes sense to the beholder through salient motion and haptic interaction, that is, when we build or shape a coherent composition from details we have personally collected and figured out. "One airplane on the floor inexplicably nudges into motion, gathers speed, lifts its nose, takes off while casting a convincing shadow, and angles through the air. You rationally know that this is all artifice, but you still perceive it as astonishing, indeed with a childlike sense of wonder and delight."[108] Sawa's work enthralls in its doubleness: appearing effortlessly self-generative—indeed, mysteriously performative like some amazing eighteenth-century automaton. But it also appears lapidary and resistant to illusion as the same objects make contact with qualitatively differentiated surfaces. The introduction of sensorimotor contingencies oblige us to focus and concentrate. One hallmark of attention is the allocation of neural resources in what is a perpetual push and pull of attractions. Orienting and selecting the movement of the eyes, as Sawa does with his unexpected breaks in routine, has the effect of bringing the stimulus to the center of the retina where the receptors are tightly packed and it can be best analyzed. This additionally refined image activates the inferior temporal cortex, where it is further scrutinized in relation to associations deriving from past experience. Its spatial characteristics, in turn, are analyzed in the posterior parietal cortex, and the outputs of the two cortices get sent to the executive networks of the frontal lobes generating top-down controlling signals.[109]

Sawa's video (as well as Flavin's, Judd's, or Smithson's process pieces) exhibit something important about how we come to know through repetition (the unconscious internalization of repeated acts) and through accentuation (when something consciously becomes a discrete image or reality *for you*). With the example of these artists fresh in mind, I want to return to the problem of defining the nature of mental representation—less from the debates within neurophilosophy, as I did at the beginning, and more from the findings of the neurosciences. Nevertheless, these hypotheses mutually influence one another and are impossible to keep entirely separate.

The conundrum of relating what we see—variable surfaces directly visible to us together with their outline, orientation, color, texture, movement, which become collected into a sketchy representation that is additionally processed by the brain into a three-dimensional representation of which we are probably not visually aware—is closely tied to what Francis Crick and Christof Koch call "the overwhelming question in neurobiology today." Finding the neural correlates of consciousness (NCC) involves "trying to put neuronal events into correspondence with mental events."[110] The two experimentalists go on to say that most neuroscientists—harking back to William James—think that *all* aspects of the mind, including awareness, are the result of material processes.[111]

Central to Crick and Koch's theory of mind (as well as to V. S. Ramachandran's and Semir Zeki's) is the conviction that the way reality looks to us depends on its encoding of discrete aspects of the world. In a sort of neural Platonism, what we see is determined by the prior nature of our internal mental representations, by our previous neuronal connections, and perceptions. Incoming stimuli must somehow couple with this constantly changing matter of the mind. From fleeting sensations of transient events in the environment, the brain—relying on personal and ancestral past experience—goes on to construct a viewer-centered representation. The autonomous and ephemeral memory image gets associatively and spontaneously linked to other mental objects and to data coming from the ambient mysteriously resulting in something we pay cognitive attention to. A major question arising from this correspondence theory is just how does any sustained or broader structure emerge from one hundred billion neurons? What is the underlying grammar connecting neural images created by neural linkages across different layers and regions of the brain? As Jean-Pierre Changeux reminds us, each of these rhythmically firing cells has on average about 10,000 discontinuous contacts. And the resulting "forest of synapses "yields as many possible combinations as the number of positively charged particles in the universe.[112]

Distributed cognition, on the contrary, does not explain mental representation as an intrinsic matching of lines, edges, contrast to the neurons sensitive to these primitives. But it, too, manages to kill the "first-person perspective" on experience, that is, the illusion that we witness it or see the world directly.[113] The optic nerve was once thought of as a simple vehicle carrying raw sensory data to the brain. Now we know it shapes its information in transit. The brain, in fact, leaps out into the world through its light receptors and actively seizes photonic data.[114] Therefore, mental objects (the physical state produced by the activation of large populations of neurons resulting in a coherent representation of the world inside our skull) is a consequence of the localized and delocalized analysis of signals coming from the physical and the social environment as well their internal organization into hierarchical levels of integration.

A locationally "wide computationalism" thus maintains that some of the sys-

tems that drive cognition, in fact, lie not only beyond sensory discrimination and integration but exceed the organismic boundary. Since the dynamical structures of the brain becomes affected by the reactions to what perturbs it, this mechanism is equally situated in nature and outside of the head.[115] Recall that Antonio Damasio and Thomas Metzinger offer two interesting attempts to reconcile these contrasting internalist/externalist perspectives. The former outlines how affect challenges the closure of the organism; the latter virtualizes the world. For the pantheistic Damasio, the feeling of a coherent self is built from the autonomous, global representations of inner homeostatic functions. While unconsciously maintaining our inertial bodily integrity, the homeostatic system registers our emotional reactions to external events. This causes a disequilibrium that must be grappled with to maintain the stability of normal operations. This costly and conflictive confrontation with the invasion of sensations, Damasio maintains, monopolizes our resources and energy.[116]

Metzinger, on the other hand, belongs to the *"mens*-class of Idealism,"[117] along with Berkeley and Leibniz, since he argues that material bodies do not exist as extramental realities but only as phenomena within the mind. He thinks of consciousness as the epiphenomenal by-product of an illusionizing projection and the human self-model as a "continuum of self-representational contents."[118] Not unlike the latest views on schizophrenia—where normal perception, dream imagery, and hallucinations are mainly manifestations of the same internal creative process (located in the thalamocortical circuits), differing only with respect to the degree by which they are constrained by sensory input—Metzinger claims we constantly hallucinate the world.[119] But these autonomously generated visions flowing outward must, at some point, collide with the sensory influx streaming inward.

Dissatisfaction with the strict encoding view of mental representation has also led cognitive psychologists such as Merlin Donald to argue that there is a "mind beyond itself." According to this view, a performative memory system incorporates aspects of the environment. Our epistemological apparatus is enactive since awareness comes about in the very activity of representation. Because individuals must perform the extraction and deployment of information, representing oneself as a subject involves an agent "enmeshed" in the world, someone with world-involving capabilities.[120]

Bearing in mind again that brain scientists are far from unified in their view of neural operations, I nonetheless want to try and pin down a definition of the elusive concept of "mental representation," utilizing the aesthetic perspective I have been developing throughout. Like the narrative/nonnarrative dialectic, it addresses two fundamental functions of our visual system. To find a target object in the prismatic blur of any moving scene, such as a salient face in the vagueness of the crowd, the visual system turns the neural representation of each distinctive object on and off in serial fashion, testing each representation against a stored template. But it also pro-

cesses all the streaming objects in parallel.[121] The visual system, confusingly, is biased in favor of those neurons that represent critical features of the target, until the target emerges from its camouflage in the background. As the dim recesses of the white-cube gallery emerge when Flavin's radiant light destroys the receding darkness, our neural machinery dissolves its recursive contours for an instant to expose real space.

If we keep Strawson's narrative/nonnarrative division in mind as well as my distinction between sustained illusion and gapped mosaic, we are really talking about object recognition mechanisms in the temporal cortex. In a crowded visual scene, we typically focus our attention serially on stimuli that are relevant to our behavior. The outcome of our directed eye movements is to enhance the attentional responses of visual cortex neurons to the discrete object in question and ignore surrounding distracting features. But this eventual, post-hunting, focus on the chunklike singularity presupposes that a person knows in advance the location of the relevant object surfacing from the swirling flux. Most of our waking lives, in contrast, are spent not in instant or smooth identification but in struggling visual search.

Parallel-processing gets at those attentional mechanisms sensitive to features laden with emotion, such as color and shape, that represent the mosaiclike target features in neurons distributed throughout the visual field. While neurons synchronizing their activity occur in both focused and free gaze activities, correlation and coherence of stimuli into a single mental representation is especially complex in the latter. Think of it. The features of the target are scattered throughout a visual field filled with distractions and prolonged through the time of the search. In both cases, spatial attention enhances synchrony. But, as art movements from Mannerism to Romanticism have shown, visual search tasks in which the object is complexly defined by the conjunction of different features are particularly difficult for the viewer. The motile "binding" involved in tying together conflicting stimuli does not flow easily. Further, resistance to variance draws our notice to an internal state of tension. Coping with divergent intentional behaviors and attending to internal or external disruptions to the automatic continuity of the biological system flaunts the perceptual and cognitive labor of integration.

The notion of binding as the kinetic *performance* of bundling stimuli together as well as the spatial activity of self-collection is reminiscent of J. J. Gibson's theory of affordances. His revolutionary ecological approach to a theory of visual perception considered "viewing" to be different from perceiving. Pertinent for our consideration of mental representation is Gibson's claim that viewing is involved in the visual control of locomotion, in seeing the world in perspective.[122] That is, one's entire physical and mental behavior is based on "what one sees now from here."[123] Gibson was not a behaviorist, rather, like Kant, he argues for a simultaneous awareness of the environment and the self, but not an awareness of what is transpiring in the experiential stream itself. We can never pick up all the available information that

is out there. His technical concept of awareness thus refines current concepts about ways of perceiving because it improves our grasp of the referents of our ordinary concepts of consciousness. Nicholas Humphrey's recent argument that sensation is what matters, in fact, is quite Gibsonian.[124]

Gibson's active approach to perception has been invoked recently by Alva Noë to argue that the role of representation in perceptual theory needs to be reconsidered.[125] It has also been mobilized to consider what thinking might be in the absence of language (nonhuman animals and infants). Jose Luis Bermudez extends the ecological approach to visual perception by developing the ethological notion that an affordance is basically a resource or support that the environment offers a particular creature. Consequently, the environment is not perceived in neutral terms but with an eye to the possibility for shelter or the availability of food. Bermudez emphasizes that such affordances "are directly perceived in the patterns of light in the optic flow"—although creatures are not constrained to become "attuned" (or to resonate with) the features of the environment.[126] Nonetheless, the "protothoughts" of nonlinguistic creatures like the thoughts of linguistic beings are integrated not just with immediate activity but with mediate or inferential activity.

I think Bermudez is hampered by his paradoxically linguistic model of nonlinguistic thought. Gibson's theory of affordances, I would argue, is a correspondence theory (it has the structure of a visual *symbol,* see chapter 2) predicated on a creature's *seeing* the relational possibilities for affective action and reaction—as mirror neuron research has shown we, in fact, do. That is, in contrast to many contemporary philosophers who are wrestling with Wittgensteinian "seeing-in" theories of depiction,[127] Gibson's recognition theory forges a sensuous link between the viewer and the three-dimensional, multilayered, spatiotemporal experience she enacts while moving through the ambient. This shared condition also underwrites empathy. Understanding as emotion-tracking is gaze-following: the simulative and performative coordination with agents embedded outside the perceiver.

Significantly, unlike almost everyone else considered so far (with the exception of Noë and Bermudez), Gibson believed that there is a *direct* perceiving of the affordances. The subject becomes conscious in having sensations: as we move through the ambient we feel that we perceive. His sophisticated realism thus gets rid of both the mind/matter distinction as well as the representation/object distinction. Vivid visual awareness of an ambient object and of our own desiring self-awareness is not just Koch and Crick's modular representation of an object distributed over many neurons nor Metzinger's dreaming at the world. It is what comes next: the psychosomatic performance of presentness, the configuring of a subjective psychical state in interaction with a qualitative stimulus by the observer. As I have suggested this takes two artistic/stylistic forms: a coherencing, narrative "filling in" or ignoring of the blind spots in the eye and the visual field, and the com-

peting focus on the hard edges and contours of an object that command foveal attention.

I have attempted to show how the search for a more general theory of consciousness has inflected the concept of mental objects and mental representation. For the neurophysiological question of cognitive coherence: how does our brain, for every object of perception, bind a large set of features to yield neural synchrony, is also the question of representational coherence. If aesthetic representation, since Aristotle, has been principally about defining ways to unify the manifold into a coherent image, then mental representation has become a more complex, elusive, nonmimetic act of construction in the hands of contemporary brain scientists and philosophers of mind. While tackling the problem of cognitive dynamics, I also challenged the "language of thought" hypothesis to put a more complex notion of image back on the table and at the interface of brain-mind with external reality.

For Aristotle, the aim (*telos*) of an artifact was to appear as a purposive, teleological unity, one in which all the parts appeared to be based on an underlying idea of a goal-directed whole. Unlike dead matter, he considered living organisms as well as works of art as organic wholes whose purpose existed as a form before the specific organism came into being. Mental representation, on the contrary, seems remote from this practical aesthetics. If connected at all, it is connected ambiguously to the real world of purposes, functions, and uses. Our conceptual apparatus currently operates in the disembodied no-man's land of formal symbolization, mathematical coefficients, chemical neurotransmitters, genetic codes, neurogenetic aberrations, and cyborg technologies, where our ability to sweep together the feeling of self-awareness with our experience of the otherness of the world variously breaks down.[128] Perhaps the intense research focus on mirror neurons will integrate the biology of subjectivity with the different beings and objects to which we attend and thus make neurocognitively and phenomenologically our own.

I want to conclude by raising a related problem. Finding ways to visualize blur, vagueness, ambiguity, equivocality, and uncertainty in all areas of scientific and cultural production are, I believe, among the central issues of our time. Instead of Hiraki Sawa's micromegalic airplanes, confounding us by disappearing through cracks in doorways or just barely avoiding collision in the "sky" of the living room, strange miracles and perplexing contradictions are everywhere in evidence today. The fact that we are both conscious subjects and biochemical events is only one, if major, example of a confusing doubleness. Recognizing the unclarity of unclear things infuses the techniques of A-Life (realized through evolutionary and adaptive computing) that are opening new creative vistas where old species borders and organic/inorganic divides no longer obtain. Computational entities are being trained to find a solution to problems that even the programmer may not know how to solve.[129] Or, thanks to nanotechnology, astrobiology, and microbiology, consider

how we have been made alert to the carbon self as merely one among many objects in a shared universe composed of everything from cellular microprocessors to bizarre two-meter tube worms, eyeless crabs, and green sulfur bacterial extremeophiles thriving around caustic deep-sea hydrothermal vents.[130]

Quantum mechanics, born at the close of the nineteenth century, has made us familiar if not exactly comfortable with the bizarre and counterintuitive actions of the tiny denizens of the submicroscopic realm. Not only does quantum theory undermine particulate objects by supposing them to be waves, it injects uncertainty into their positions and movements, so that as we gain knowledge about one property, we lose it about another.[131] The quantum model has also made ambiguous that staple of our age: information. Whether we think of it as stored in images, books, on silicon, in quantum "qubits" inscribed on a cluster of atoms[132]—these multiple platforms have only made us more intensely aware of data's limits, instability, error-proneness, and, most tellingly, equivocality. Recall that the unifying *narrative* of uncertainty allows quantum objects, paradoxically, to have two mutually exclusive (and untestable) behaviors at the same time. The tempest gathering around string theory (with its opponents within the physics community maintaining it is merely an unprovable, seductive conjecture) is just the latest example of a conundrum with no clear experiment to solve the question.[133]

This blurring elision has found its way up to the macrolevel. In the IT era of simulation, morphing, cloning, and remixing—where it is difficult to separate tools from flesh, the degrees of the artificial from the unmanipulated substrate—it is not surprising that narrative as an artificially unified account of singular actions and events has become the master topos in everything from art history to anthropology to law to literary studies.[134] Perhaps most indicative of this "mushy" melding of fields is the new hybrid academic program called "services science" dedicated to the "blend" of spotting innovations, new business markets, retailing ventures, enticing products, all coupled to management skills.[135] Whether or not this is a science is debatable. But even the established "hard" sciences have not remained immune from streamlining, automated analyses, and computerized "optimization" systems. This taking the edge off what formerly, rightly or wrongly, were believed to be clarities profoundly links neurobiology to reproductive, genetic, and synthetic biology. It also brings neurocognitive research closer to research in the humanities and social sciences. In all fields, many of the distinguishing qualities—the contextualizations—that formerly divided epistemic activities, abstract objects of various kinds, and technological artifacts, are gone. What is left is not so much contamination as the opportunity for mutual learning about double- or multiple-aspect entities. This means, I think, limiting the rhetoric and practice of engulfment.

Such a narrative model and method surfaces in strange places. We witness this flow that goes on and on in the relentless stream of brain imaging scans. These have unleashed a flood of "incidental" findings[136]—unexpected observational bits

of potential clinical significance—that do not yet belong to an overall pathological account but that well might. In a different domain, consider the nebulousness of ever-expanding "personhood" in research regimes that accord "near personhood" to the embryo after fourteen days.[137] Or recall that one of the sore points in the cloning debates is that the procedure generates things that are "not really like you, but somehow belong to the same existential spectrum."[138] The clone is a cloud of possibilities. This array does not seem to possess any "essence," hovering instead among several potentials. Its biological ontology (a laboratory thing) bleeds into a political and legal ontology (a social thing).

Oddly, wherever we look in the life sciences the rhetoric of choice and the empowerment of the individual who knows best what is in his or her interest, that is, the rhetoric of individual autonomy, seems to bump up against the rhetoric of the eponymous "entity."[139] Tinkering, multifunctionality, redundancy, and modularity not only characterize the notion of a genetic "toolkit" for animal development, it spills over into the never-ending neo-Darwinian production of novel forms, wherever they might lead or whatever they might be.[140] The new technical and scientific advances are as radically uncertain in their means and ends as the social and cultural processes in which this knowledge must be embedded, and yet they get strung together into the narrative that science is expanding personal choice.

The general term that Plato uses (in the *Cratylus*) to refer to representation in the arts is *mimesis*—the intentional making of an appearance (*phainomenon, phantasma*) that resembles something of a certain kind but is not something of that kind itself. His principal thought is that "the appearance is like the original object but less real."[141] That may well be. But, in our polymodal information age, one lesson of the episodic—with its crystalline detail, its distilling gesture, its precise coordination—is that the total phenomenal melt, by contrast, reduces the range and specificity of chromatic experience. Caving into an all-embracing blur prevents us from understanding how "the well fenced out real estate of the mind"[142] can, in fact, be one with the events observed and how observing, in turn, does not necessarily entail being one with the events.

6

IMPOSSIBLE WILL?

Unconscious Organization, Conscious Focus

Autopoietic machines are autonomous; that is, they subordinate all changes to the mainte-nance of their own organization, independently of how profoundly they may otherwise be transformed in the process. Other machines, henceforth called allopoietic machines, have as the product of their functioning something different from themselves.[1]
HUMBERTO R. MATURANA AND FRANCISCO J. VARELA

Evolution is a deluge, a cascade of mistaken, tentative, branching, brocaded experiences, se-crets seemingly dormant, shouted down from the past, wills and depositions hidden in the attic. . . . It is about one instruction: "make another similar something; insert this com-mand; run; repeat." It is about the resultant runaway seed-spreading arabesques, unrelated except in all being variations on that theme. . . . Flowers inscribed with ultraviolet runways, detectable only by particular bees, wasps that live parasitically in bee bodies. The Bauhaus finesse of trapdoor spiders. Other spider strains that fish. Fish that shoot insects. . . . More bizarrerie than dreamt of in any bestiary. A species for every conceivable emblem.[2]
RICHARD POWERS

AUTOPOIESIS, OPEN AND CLOSED

A major ramification of the emergent sciences of the mind we have been explor-ing is that they offer exciting new data to the humanities and social sciences. In the process, they are also exerting pressure on, confirming, or turning upside down traditional cultural assumptions by which many of us have long lived. Identity, for example, has become an ever more complex construct—both enriched and made ambiguous by the new physiognomics of mirroring, genetic permutations, the emptying out of first-person presence from the psyche, and its dispersal in the de-tails of our surroundings. Like a Ben Gest digital photograph, solitary subjects not only get lost in reflection, their thought is lost in the automatic activity of fastening jewelry, eating leftovers at work, or holding a garbage can lid.[3] This research thus has the potential to revamp our understanding of fundamental behavioral as well as aesthetic activities. Staying with the example of identity, we are being given more refined tools for understanding both full and conscious self-possession as well as in-structive retreat from the unwanted invasions of the crowd.

Consider as well, how the origin and entrenchment of prejudice or bias is a consequence of many invisible neural mechanisms perpetuating an unconscious

reaction to certain physical traits. The stress and discomfort produced by this sight of the shell of an unfamiliar person perturbs the internal system, releases chemical neurotransmitters, and initiates a cascade of emotions. Neuroscience, I believe, enables us not just to judge and condemn, but to comprehend, and hopefully, emend these reflex tendencies from the inside out. There is a new look worn by old problems, then, after they are sieved through the cognitive turn.

My premise throughout has been that biology and culture need to be inlaid. To that end, I have been wrestling with the durable image problems, those intractable issues from configuration, schematization, imitation, symbolization, representation, that will not go away. But what remains a riddle when looked at from the vantage of a single discipline, or even a family of related areas, gets activated afresh within this mediate space. In fact, the neuroaesthetics side of neurobiology and the phenomenological wing of neurophilosophy have already entered a liminal zone where they are as preoccupied with beauty, arousal, and the metaphysics of illusion as they are with synaptic modifications, semantic dementia, and the biochemistry of altered brain states.

In this final chapter, I argue that much of the research into the new interiority takes for granted the largely self-maintaining or automatic ways by which we rearrange and categorize stimuli coming from the external world. Understanding spontaneous brain activity seems paramount even though there is a general recognition of interplay between an intrinsic dynamics and its modulation by external input during our waking states, and further, that there is a variability in responses to the activation of the spatiotemporal patterns generated by these networks.[4]

This intense, one-way experimental focus has had the perhaps accidental but no less hazardous, effect of usurping and diminishing the role of attention in cognition. Attentional behaviors variously couple neurocognitive functions to the things that are their *focus*. When automatic systems can no longer cope with conflicting information, the resulting mental objects echo the focusing process of grappling. Given the fact that we aspire to a robotic economy and that much information technology loss of employment can be attributed to automation, the concomitant "outsourcing," or movement of the work of conscious attention to other neural mechanisms and other brain locations, is troubling. One way out of this dilemma is to realize that there are different "styles" of automatic thought, not all of which totally "offshore" willed noticing to unconscious functions. While not full directed attention, there exists nonetheless subtle gradations of engagement of the cortical and thalamic networks by sensory stimuli.

In their most extreme forms, these views of automaticity can be summed up in Thomas Metzinger's phenomenological "autoepistemic closure" (the boundedness of intentional processing with regard to one's own internal representational dynamics).[5] Specifically, I want to probe what some of the cultural as well as cognitive ramifications are of an exacerbated autopoiesis, that is, self-reflexivity understood

as a "privatized" sensory phenomenology whose signals recursively loop back upon themselves to become self-sustaining.[6] Yet to handle complex problems creatively, we also need the other side of the equation: the open end of this "self-designing" system. Severely delimiting the domain of voluntary actions by neuronally "automating" them has, as I propose at the end, considerable educational and social implications.

Autopoietic systems produce their own components. Although in principle they possess some porosity, they resemble autonomy in being conceived as a sovereign agent.[7] Thus Rodolfo Llinas can speak of a "neurological apriori" in which the brain is considered "by many" to be "a closed system with its basic organization geared toward the generation of intrinsic images, where inputs specify, rather than inform, internal states."[8] We adapt to the parameters of the universe, according to his theory, because our central nervous system developed over evolutionary time as a neuronal network. It initially mediated simple reflex relations between the external ambient and sensory-motor systems. Subsequently, the generated constraints were embedded and genetically determined.

While certainly agreeing that life continually produces itself, Lynn Margulis—studying bacteria—might question Llinas's singling out of the nervous system as well as a certain privileging of the role of the gene. "All living beings, not just plants and microorganisms, perceive," she declares."[9] Investigating the root, or microbial, end of the evolutionary tree, Margulis is intrigued by how more and more types of inert matter literally sprang to life over time. These tiny biological entities incorporated not just air, food, and water, but experiences and sense impressions, and thus were directly or circuitously interconnected with one another and with the biosphere from its origins. Her thesis builds on James Lovelock's hypothesis that self-transforming life breaks out into new forms and incorporates formerly self-sufficient individuals into integral components of a larger identity.[10]

Without specifically addressing the potential solipsism that can lurk in the grand narrative of reflexive forms, Margulis undercuts any hard belief in an event done by oneself, to oneself, in complete isolation from others, and exclusively from one's own resources. In this redoubling spiral, we do not submit ourselves to a process of being taught by others. On exactly this point, as well, it is useful to recall that Francisco Varela and his collaborators moved beyond earlier autopoietic theory to develop a (somewhat allopoietic) concept of enaction. Enaction, or the active engagement of the organism with the environment, supports autopoiesis by insisting that the closure of circular processes include the organism's open perception of its surroundings.[11]

The scientific problem of how nature organizes itself and uses the same mechanisms over and over again at different scales of energy and size is mirrored in an artistic problem as well. In both cases what is at issue is the internalization of patterns and their self-maintenance in an entropic universe. I want to illuminate this

emergent aspect of aesthetic work (from *aesthesis* meaning "sensory knowing") because it simultaneously reveals something important about the connections linking human cognition to the universe as a whole. By analyzing a nested artwork—one that is "holarchically," interdependent with its viewing environment—I hope to sharpen our understanding of some of the ways by which we coordinate a largely self-constitutive inscape with a self-organizing external world.[12] Equally significant is how we come to notice what we have unwittingly coordinated.

The different venues at the 2006 Berlin Biennale for Contemporary Art (suggestively titled *Of Mice and Men*) were a creative component of this vast multimedial display. Atypically, there were four exhibition sites fanning off the historic Auguststrasse in Mitte.[13] But it was the abandoned Former Jewish School for Girls that offered the greatest opportunity for reflection on how the prolonged observation of actions and objects could become automatic, internalized as a second nature. This strangely moving, cavernous interior still contains vivid demonstrations of the artisanal skills once encouraged under the now defunct Deutsche Demokratische Republik.

The building's anonymous decorative scheme—a brocade of green tiles with interspersed mosaics—intersects with a very different collection of surviving forms. The latter are the spatial by-products living in the cultural, not the biological, "spandrels" left gaping in the otherwise totalizing architectonic system.[14] These subsidiary shapes and incidental objects developed in what was left over when dominant features, such as windows or overdoors, were embellished with decorative frames. Rather than opening out into endless flights of stairs or leading the eye down yawning corridors, these remainders self-assembled into empty niches, hollow corners, oddly-configured rooms, where extinct plumbing, a solitary floor polisher, a stray desk or forlorn modular chair, momentarily flourished before ending up on the junk heap of history.

Both in the biological and the social sphere, Steven Pinker's psychology-as-adaptive story has its limits.[15] But he is certainly right that we are not born with empty minds. Among the unexpected spandrel-cells found in the Judenschule—resulting from the abrupt meeting of a self-sustaining institutional ecology with what might be called nonadaptive features—were the individualized viewing spaces. The provocative visual collision of the bureaucratic environment with these idiosyncratic spaces revealed something essential about the artworks displayed within them that would have otherwise gone unnoticed. The case I have in mind drove home the fact that not only do we come from repetition but we internalize the world by means of it. "What could be simpler? [Richard Powers's biologist-protagonist Dr. Ressler exclaims] We all derive from the same four notes."[16] We spend our lives amid echoes.

The video *Summer Lightnings* (2004) by Viktor Alimpiev impels the viewer not just to ponder, but to reenact, a depersonalized choreography performed by an

anonymous collective.[17] It captures young Russian girls sitting in a barren Moscow classroom, which uncannily duplicates the nondescript module in which the young Jewish girls sat long ago (fig. 84). Its not-quite rectangular shape arose from the fact that the ground-floor hallway, circling the perimeter of the Berlin building, took a sharp bend. In the penetrating four-minute video—which is as much an acoustic as a visual work—the dreary fluorescent-lit classroom is a counterpoint to the dramatic landscape acting at a distance: complete with livid sky, approaching storm, and rolling thunder. Suddenly, the dull classroom is energized and everyone begins to drum on their desks, like secretaries pounding their typewriters, only in synchrony. In this communal exercise, the intent girls look straight ahead through the windows. Yet their thin or stubby fingers, distinctively characterized by chewed or chipped nails, beat in time (as the video viewers' legs also involuntarily do), capturing the mounting or subsiding rhythm of the downpouring rain. This tapping (and shaking) stops and starts, rises or falls, in obedience to the unpredictable *sons et lumières* exploding outside (fig. 85). Every nuance of its percussive accents is repercussively registered across the sweep of bodies and somatically recorded in their corresponding motions until the meteorological happening finally dies down. Remarkably, during the entire transit of this weather front, no one stole even a sidelong glance at her neighbor.

Like the institutionalized settings in which this double action occurs (the re-presentation of the video and its direct reproduction of the sonic passage of a line of squalls), there is something both unconscious as well as consciously controlled at work here. As J. J. Gibson might say about such recurrences, they are "an experiencing of things rather than a having of experiences."[18] Alimpiev has some distinguished artistic precursors in his decision to investigate instinctual repetitive actions within a collective. These range from Chardin's genre paintings (see fig. 36), exposing rote or "mindless" behaviors (copying, daily shopping for cooking, unreflectively drawing water from an urn, routinely saying grace before meals) to Proust's iterative narrative in *À la recherche du temps perdu*.[19] Such examples of deeply internalized practices, not unlike breathing or digesting or reacting to rhythms, do not require our will. The performers have learned the techniques by heart, although there is room for modulation. What Alimpiev adds to this tradition, however, is a compelling demonstration of self-organization in the group response to a protracted external stimulus.

What specifically interests me about the immediacy of such mimicking performances is the way in which they foreground both the capacity for direct (nonillusory) take-up of experience and the role of automaticity in perception. The latter enables us, mostly unconsciously, to regularize and self-organize incoming stimuli.

FIGURE 84
Victor Alimpiev, *Summer Lightnings*, detail of school girls, 2004. Video still. Courtesy of Victor Alimpiev and Regina Gallery.

FIGURE 85
Victor Alimpiev, *Summer Lightnings*, detail of drumming fingers, 2004. Video still. Courtesy of Victor Alimpiev and Regina Gallery.

But the coordinated drumming of Alimpiev's schoolgirls shows that it is something of the environment as well as the self that is the object of perceptual awareness.

As Eva Jablonka has tirelessly argued for evolutionary biology, what is important is not the solo model of Richard Dawkins's "selfish gene"—autonomously scripting variation—but the interaction between the external world and the individual.[20] Christian de Duve similarly points out that since the brain is estimated to contain one hundred billion neurons and the diploid human genome contains about five to six billion base pairs, the wiring of the brain cannot be written into the genes. Instead, it must occur epigenetically, that is, by superimposed processes that take place during development.[21]

There is an important way, then, in which Gibson's argument for directness of perceiving surprisingly links up with epigenetic considerations of the role of behavior and ecology on selection and inheritance. On a very different front, I also think it connects with the sometimes monist, and other times, dualist, theories of physicists (and mathematicians, like Roger Penrose) who say that cognitive scientists cannot ignore quantum mechanics.[22] Coming from opposite ends of the spectrum their hypotheses, nonetheless, share in the "general consensus"—voiced by those specifically studying the structure of the universe (or TOE, the "theory of everything")—that there should be some sort of "psychophysical parallelism."

This is the view that there must be a connection between the mathematical structures described in physics and the conscious experiences each one of us has.[23] Like Gibson's ecological psychology, physics has nothing to say about intrinsic content whether in the brain or in the world. Rather, the structure of observables that they both posit is held to be *"there* in the world, just as tree rings are in wood" and as they are in the brain.[24] I would add that this *thereness* is an echoic *image* of that instantaneous configuration of complementarity. It is a nonillusionistic inlay that relates, on an equal basis, the qualitative experiences of the mobile viewer with the dynamic states of matter.

Alimpiev's video, then, is a powerful demonstration against a theater of consciousness model since no representations come before the mind. The drummers, instead, would seem to be directly aware of, or are immersed in, the first-hand experience, *which transpires visually and acoustically both inside and outside the perceiver.*[25] They are thus corporeally and cognitively at one with the full-blown double-sided *image* of a sensory event that is simultaneously voluntary and involuntary. This emblazoned interface between the two parts of the divided self and the paired patterns of the world lasts only as long as the girls continue to enact the merger. Interestingly, Gibson's analysis of the mosaic of perceptual awareness brings him close to David Chalmer's integration requirements for a direct phenomenal belief, namely, that "the demonstrative and direct concepts involved be appropriately 'aligned.'"[26]

Moreover, the normally invisible, unconscious operations of automaticity, as we witnessed in the spontaneous outburst of sound-copying, get manifested in the hap-

tics of conscious enactment. I propose that such echoic performance allows us to discriminate self-generated from external stimuli. Behavior that intertwines perception and motion in a focused engagement helps us distinguish subjective from objective experiences or potentially illusory, from actual, occurrences. Fascinating experiments on singing crickets show how an animal's behavior generates a constant flow of sensory information that can update or fine-tune ongoing intrinsic motor activity. But a central difficulty encountered is that it can also desensitize the animal's own sensory pathways and become confused with external stimuli.

Before dismissing this research as irrelevant, it is important to note that even in the small nervous system of the cricket, sensory signals are processed in a similar way to more complex vertebrate systems. One solution to the big problem of sensory ambiguity, therefore, involves neural signals (called corollary discharges) being sent forward from motor to sensory regions during behavior to counter the expected self-generated feedback.[27] Without going into the details of the role played by the corollary discharge interneuron (CDI) responsible for pre- and postsynaptic inhibition, this research is suggestive of how even a higher-level organism might deal with the massive influx of, say, auditory, proprioceptive, mechanoreceptive, and visual information during sound production. It shows us how an animal can *distinguish* between internal and external stimuli, just as the flying cricket inhibits self-generated sensory signals in order to hear echo-locating calls from predating bats. Or, we may surmise—in their condition of sustained attention—it indicates how the schoolgirls might go about inhibiting everything but the influx of the rolling thunder and the bolts of zigzagging lightning.

The multiplication of parallel circuits in the six-layer structure of the cortex, all carrying different aspects of the same information, would seem to enter the field of consciousness through some kind of resonance among those differently oscillating circuits. Our cognitive system dynamically gets triggered by what our senses physically register, and our senses accommodate to the cognitive system. Another way of saying this, again with Gibson, is that perception essentially requires *involvement*. "It is a psychosomatic act, not of the mind or of the body, but of a living observer."[28] This insight appears to be corroborated by recent neurobiological research into the chaotics of self-organization.

The classic theory of attractors (fractal attractors, strange attractors) articulates the notion of auto-organization as the tendency of any dynamical physical system to begin randomly but to become oriented more and more precisely to a certain pattern. Ilya Prigogine famously forecast the possibility of order emerging out of chaotic "dissipative structures."[29] It used to be thought, then, that the chaotic oscillations of a neural network quickly subsided into a stationary ("attractor") state. According to the standard theory of this associating or coupling process, the convergence with the attractor signaled the completion of a task such as the recognition of a face.

Otherwise stated, it was believed that the brain had solved a problem when the activity of its neurons displayed a certain pattern. Synchronization studies coming out of the Max Planck Institute at Göttingen, however, have shown that the collective behavior of the neural network can be strongly and qualitatively altered by a structure that *becomes* complicated over time.[30] This means that the "representation" of the external world is less determined by attractors and more by long-lasting chaotic transients. Recall Dan Flavin's fluorescent tubes. Before they are turned on: the attractor; after they are switched on, we initially get a few flickers: the transients.

Prior to this new research, it was believed that these flickers were necessarily short in duration, because otherwise thinking would take an impossibly long time! But if synchronicity is actually brought about through the *continual* emission and absorption of individual oscillating neurons, we have a very different model for the processing of information. Take the scenario of the nuanced rhythmic drumming with its variable length, timbre, and intensity. This physical enactment, *all along,* not just at its completion, is matched by the small changes constantly occurring in the structure of the neural network. As with so many things, William James intuited this collective, vibrating uptake of input when he commented that everyone "knows what it is to start a piece of work, either intellectual or muscular, feeling stale—or *cold,* as an Adirondack guide once put it to me. And everybody knows what it is to 'warm up' to his job."[31]

According to the findings of the Göttingen group, the *binding* of neurons is achieved only after these extremely long transients. Surely, this is pretty close to being the neuronal correlate to phenomenal performance! Significantly, this research comes at a time when, more generally, neuroscientists are rethinking the "Neuron Doctrine"—the proposition put forward nearly a century ago by the Spanish anatomist and Nobel laureate, Santiago Ramón y Cajal. Imaging technologies have helped to extend his fundamental insight that a neuron is a distinct, polarized cellular unit arising through differentiation of a precursor neuroblast cell.[32] Apparently, the general agreement now is that if one is to understand brain function one needs to probe beyond Cajal's basic tenet.

These revisions are important for those of us interested in the sociocultural side of things because they have major implications stemming from the disproportionate weighting accorded to unconscious (automatic) as opposed to controlled or effortful processes. Automatic processes are so-named because they are inevitably engaged by the presentation of a specific stimulus regardless of the perceiver's intention.[33] The reason *all* of us need to pay attention to the major challenges leveled at the Neuron Doctrine, whose keystone is the punctual neuron (with its signal-receiving rootlike dendrites and transmitting long axons whose function is to couple groups and synchronize neural firing), is that, taken together, they ratchet up the number of functions operating outside conscious awareness and beyond voluntary control.

What are some of these changes? Overall, I would say the focus has shifted seismically from external to internal events, from our control of reality to mind control, that is, the deliberate accessing of intimate response mechanisms by fairly precise means.[34] As we saw from the Göttingen laboratory, there is a more graduated view of firing demonstrating the permutations of scores of integrative variables. Consequentlly, the subject is dynamically implicated at tinier moments of transcription. Additionally, there are discoveries about the importance of the synaptic cleft, the communicational role of nonneuronal cells, such as the glia, as well as ongoing molecular biological investigations into the information processing going on in the central nervous system. Neuromodulating substances have arrived on the scene (amines and neuropeptides) spurring inquiry into addiction but also (in the case of halothane and isoflurane) into anesthetic-induced unconsiousness, and the mysteries of REM sleep.[35] Delivering drugs to targeted brain areas is only part of the picture. Even pharmacogenomic products tailored to particular groups and diseases (Tay-Sachs, sickle cell anemia, cystic fibrosis) may spread into other untargeted regions. Further, brain scanning technologies (PET and fMRI) reveal how neurotransmitters activate pleasure or fear centers in the brain, accompanied by positive or negative automatic reactions.

Additionally, mathematical and quantum modeling of neuronal locking and of the crystalline structure of the visual cortex is laying down a new superimpositional neural field theory.[36] What these diverse approaches—deriving from genetics, in vivo physiology, biochemistry, optical imaging, and statistics—are doing (among other things, to be sure!) is foregrounding the unconscious shaping of conscious information. Of course, neural circuits respond to experience and learning, and plasticity is enhanced by attention because of the strengthening that goes on when we select among competing inputs. But this selection gets undercut, according to Rodolfo Llinas, by the "innate predispositions of the brain to categorize and integrate the sensory world in certain ways."[37] Bernard Baars, in turn, defines "context" as a system that (involuntarily) "computes" or shapes conscious experience "without itself being conscious at that time."[38] For Daniel Dennett, consciousness is merely a "cunning conspiracy of lesser operations."[39]

No doubt, there is a moderate view out there too. Gerald Edelman insists that at a certain stage of early development, the control of neural activity and fate "becomes epigenetic." It is not prespecificed or hardwired, but guided by patterns of constancy and variation leading to highly individual networks shaped through reentry.[40] Nevertheless, in today's fast-growing neuroscientific landscape—comprised of a multitude of disciplines, including neurology, psychology, computer science, radiology, and psychiatry—the amount of mental activity accessible to phenomenal awareness seems to be occupying a dwindling cognitive terrain. The sheer amount of research dedicated to automaticity is one key marker, I think, of the long withdrawal or slipping away of the role of the will. Direct, if distant, intervention,

paradoxically, is increasingly shaping focused cognition by correlating involuntary neural activity with specific tasks and desired experiences. I will take up the implications of this kind of "fundamentalist automatism" for experiential learning, visual education, and the tailorization of electronic media in my final section.

ENACTIVE SYSTEMS

We need to take a closer look at the types of self-assembly occurring on Margulis's autopoietic planet. This spontaneous organization of matter into coherent arrangements is a compositional principle governing diverse materials. The notion is hardly new. The ostentatiously self-sprouting, fresh-water hydra (or "polyp") both delighted and puzzled eighteenth-century naturalists (fig. 86).[41] In contrast to the early modern era, however, our contemporary nature is seen to be especially extravagant in the generation of patterns arising from automatic grouping.

This self-sustaining performativity spans the underlying granular dynamics of physical systems, the nebular whirlpools of tornadoes and hurricanes (plate 13), and the waves of pinwheeling electrical activity occurring in ventricular fibrillations of the heart.[42] Less dramatically than that terrifyingly frenzied, chaotic state, we also see such self-organization at work in naturally layered materials.[43] Think of the delicate thickness-control required to produce sedimented sea ice, the internal compartments of a crystal or living cell, or the "picturelike" concretions in igneous rocks (fig. 87). Nacre, as in the opalescent lining of an abalone shell, perfectly embodies the difficulties attending the self-fabrication of organic-inorganic composites.[44] Even the striking hexagonal lattice in the larval fruit fly's compound eye is now believed to form like the stratified emergence of atoms in a crystal. Each additional atom simply nestles in the previous row of elements, meshing without the need for a detailed blueprint.[45]

Unlike the first generation of heroic earth-altering sculptors —such as Michael Heizer, or the grand cosmological interventions of James Turrell (continuing his enduring sky work at Roden Crater in Arizona), or even the transformation-welcoming Robert Smithson (see fig. 53)—Andy Goldsworthy treads more lightly on the ground. "I like that idea, of a faint trace left in the land," he has said.[46] Just as Margulis insists that the autopoietic view of life inextricably interweaves organic beings with the biosphere, Goldsworthy's subtle installations reveal that the earth is not an inert backdrop to be forcibly recarved. Instead, it is part of an extended identity in which nature and mind become reunified.

FIGURE 86
Martin Frobène Ledermüller, reproduction and multiplication of fresh water polyps from *Amusemens microscopiques* (1768), p. 82. Colored etching. Photo: Courtesy of the National Library of Medicine, Bethesda, Md.

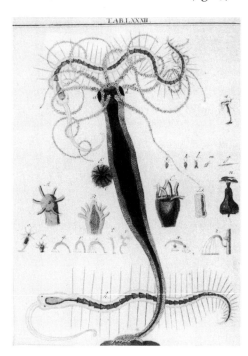

TAB.LXXII.

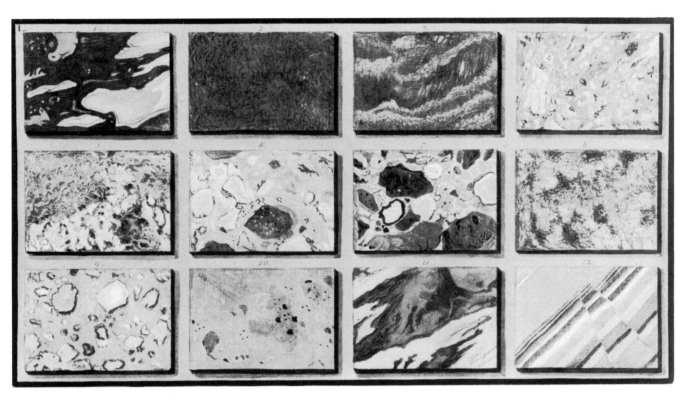

FIGURE 87
Peter Fabris, polished marble
and other stones (The "Gems"
of Vesuvius), from *Campi
Phlegraei*, ed. William Hamil-
ton, vol. 1 (1776), pl. 50. Aqua-
tint. Photo: Getty Research
Institute.

The artist's visual establishment of the fact of our "absolutely" being together in the universe is reminiscent of the Romantic Spinozism of Schelling. The latter's "originary form"—that is, the form of a *relationship* that dialectically reattaches the infinite or the unconditional with finite singular things[47]—was an attempt to go beyond Fichte's polarizing structure of ego and nonego. In the manner of Giordano Bruno, who deeply influenced his *Naturphilosophie*,[48] Schelling held that identity was a participatory totality that defied the chemistry of separation. So, too, I think, Goldsworthy.

Like the poems of William Blake or, better yet, the sonnets of Gerald Manley Hopkins, his revisionist earthworks instantiate this romantic philosophy of identity. The coordination of opposites is achieved by attending: to "dappled things— / For skies of couple-colour as a brinded cow; / For rose-moles all in stipple upon / trout that swim; / Fresh-fire-coal chestnut falls; finches' wings."[49] Goldsworthy's pantheistically revamped, Brancusian-smooth modernist matter teems instead with broken rocks, sticks, leaf mold, fungi, and lichens. These elegantly irreducible substances open up a view of nature that goes beyond personal being to point out the interdependencies existing between all physical forms.

This master of coalescent ephemera has spent several decades rearranging the British countryside, and much else to boot, to look as if the wooded land, its stony soil, and evanescent atmospheric effects had arranged themselves. Take his two

serpentine dry stone walls (perfectly dovetailed without the use of mortar) that now curve around the marvelous Celtic, Viking, and Early Roman exhibits at the Royal Museum (Museum of Scotland) in Edinburgh (fig. 88). Despite their monumentality, these arcing embrasures remain unobtrusive, blending in with vitrines that house the glinting solid silver chains, the bone-handled iron knives, and the clearly incised gold scabbard chapes of the tattooed Picts, which they protectively frame and set in relief.[50]

Similarly, his firmly contoured basketry apse of blackened interwoven twigs quite "naturally" shelters a cowrie-eyed cult statue hewn from a sapling. Like the boldly coherent unit of the dry-stone walls, or the "recreated" hemispherical hearth that he later insinuated below and between them, the recessed apse is integrally both an environmental installation for *another* work and a self-standing work in its own right. Goldsworthy has it backing onto, not fronting, the most secretive, "Druidic" section of the museum. Here we find an imposing circle of irregular boulders—bearing "Pictish symbols," those limpidly drawn or slotted-in animal and geometric motifs cut into the unequal stone surface, much like the magical scratch-

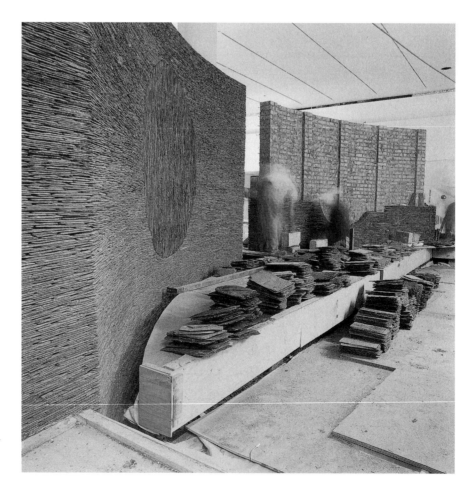

FIGURE 88
Andy Goldsworthy, *Slate Walls*, from installation of Early People's Gallery, National Museum of Scotland, Edinburgh, April–May 1998. Installation photo. Photo: Andy Goldsworthy.

ings decorating the inner walls of caves along the coasts of Fife and Moray. In this ritual space, we also discover upright cairns, startling painted pebbles, and still undeciphered runic inscriptions, sealed-off and compressed as if belonging to another dimension or category.

Unlike eighteenth-century picturesque gardeners, then, Goldsworthy finds nothing random to "improve," not even in the most hermetic, ambiguous, or scattered remains. Instead of the Humean view of association (where there are no firm causal connections and dependencies between individuals and events), Goldsworthy demonstrates that all life is necessarily a bridge-forming conjugation. Thus he carves out a midlevel "place for consciousness."[51] Human individuation subsists where ordinarily perceptible life persists, in between the quantum behavior of the subatomic realm and the expanding universe. But it is intimately related to, and constrained by, all of it.

Whether it is the concentric grouping of rocks around a numinous hole, or a starburst of icicles with their thick ends dipped in snow and water to be re-frozen, or the symmetrical creasing of rhodendron leaves to form a calyx, or rhythmic loops snaking across a solid stream in *Rivers and Tides: Working with Time* (2003), these delicately doubling installations make visible the self-shaping of the natural world (fig. 89). The artistic preoccupation with such autopoiesis-manifesting structures are impossible to imagine, I believe, without the current inward-bound scientific gaze into self-assembly. Conversely, but equally importantly, such artworks demonstrate the ways in which both natural and cultural systems are, in fact, dissipative, not closed. They import, or reuse, or reengineer prior forms in the environment: the shuffling and reshuffling of persistent designs, the legacy of stone carving reincorporated into a contemporary sea of shapes, icicles recrystallized through repeated freezing—the inlay of both/and, not either/or.

Goldsworthy is not alone in showing the tenaciousness of natural symbols under pressure for space or in illuminating the ongoing self-ordering of the teeming biological world. Chris Drury joins him in stacking stone whirlpools, diagramming moving water, and collecting smoke into momentarily perfectly balanced domes.[52] On a different front, Joyce Cutler-Shaw restores a simultaneously physical and existential opacity to the human body. In this era of rampant medical imaging—from x-rays, to ultrasound, to PET (Positron Emission Tomograpy), CAT scans (computational assisted tomography), and MRI (nuclear Magnetic Resonance Imaging)—visualization technologies are promising transparency.[53] Despite the ubiquitous hyperbole that we can "watch the brain think" or the extolling of "designer brains" so market researchers can get closer to their ideal of a "glass consumer," Shaw shows that human beings are more than the compulsive slaves to their neuronal thunderstorms.[54]

Although the body is being crisscrossed by competing medical media, what emerges is neither perceptually nor epistemologically clear. Cutler-Shaw's calli-

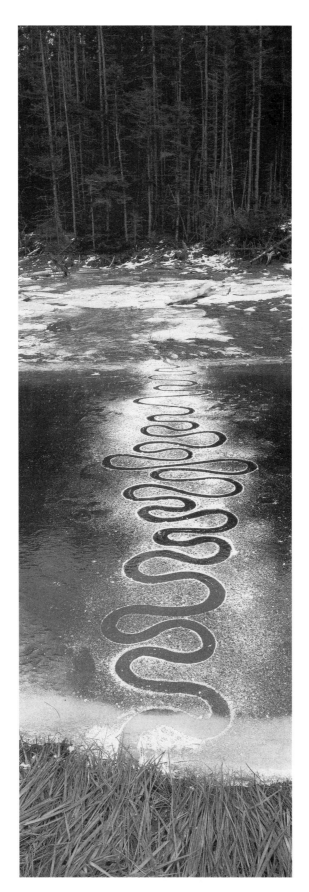

graphic wall installation, *An Alphabet of Bones* (1984 / 1985–2003), plays on this ambiguity (fig. 90). While inspired by the hollow bones of birds, these capering, suggestively anthropomorphic forms delineate both the exuberant diversity of life and our intermediate place among other organisms who, as Stephen J. Gould said, are "engaged in the struggle for personal success."[55] She locates us somewhere between warm- and cold-blooded vertebrates, feathers and reptilian feet—that is, within a sequence stretching back to *Archaeopteryx*.[56] Her drawings thus return a needed density to our thinned anatomy. Shaw's thinking person's osteology captures both our singular lumpy jottings and the intrinsic morphological grammar lying below humanity's collective skin.

The paradigm of imaging technologies as disclosing active brain structures obtains in the realm of artificial spatiotemporal architecture as well. Photographer Andreas Gursky transforms the glassy, wanting-to-be-virtual projects of global modernism into a meditation on how the built environment grades into ontology.

FIGURE 90
Joyce Cutler-Shaw, *Alphabet of Bones*. Corner installation: Geisel Library, University of California, San Diego, 2003. Graphite on Mylar drawing. Photo: Courtesy of the artist.

FIGURE 91
Andreas Gursky, *Shanghai*,
2000. Chromogenic color
print (280 × 200 cm). ©
Andreas Gursky / VG Bild-
Kunst. Courtesy of Monika
Sprüth / Philomene Magers.

His monumental urban photographs both cap-
ture and comment upon the loss of extensive and
locative referentiality by the organic body, em-
meshed as it currently is in the diaphanous ma-
terials of cybermedia.[57] Radiantly arcing floors,
suspended within a translucent skyscraper in
Shanghai, for example, stretch to infinity (fig. 91).
Perfectly repetitive, with no beginning or end,
and no perceptible individuals inside to mar the
flow, these streamlined data forms are a reminder
that the Sublime works by producing sublimity
from within itself.[58] Self-assembly shades not
only into the sensation of submersion but into
negative theology. As quantum mechanic Seth
Lloyd claims, it is not a metaphor to say that the
universe computes itself.[59]

With Gursky, we leave nature's self-organiz-
ing structures behind to enter the emergent do-
main of computer-simulated growth systems
where there is no distinction between the biolog-
ical and the mechanical. True to the principles of
self-reflexivity, scientists of all stripes are turning
to automated expert technologies in the attempt
to cope with the terabytes of data generated
daily—precisely by means of the identical computation.[60] Technology, then, not
just "smart" building technology, increasingly seems to have a mind of its own.[61]
But this IT mind, I propose, is ruled by the paradigm of the exponentially growing
efficiency of automated instrumentation.

This is not, however, the same as the development of new brain-machine
interfaces whose appropriateness, according to Andy Clark, is their potential in
"creating *whole new agent-world circuits,* ultimately allowing an agent to confront
the world."[62] Nonetheless, from growing efforts to mine human intelligence, to
the advent of the "semantic" 3.0 Web—supposedly capable of reasoning in human
fashion—people seem generally unaware how much they are depending on arti-
ficial intelligence. What concerns me about the avid commercial interest in auto-
mated intelligence systems is that they can encourage the relinquishing of inten-
tional control in what is not a relationship between equals. Who or what authority
is in charge of the hyperintensive volume-processing aspects of digitally derived in-
formation? The automaticity of production and analysis enabled by advanced com-
putation is evident in everything from the spontaneous construction and modifi-

cation of scientific data to the development of cut-rate, high through-put genome sequencing machines.[63] Is the fact that a huge amount of scientific research depends on generating and modifying a data deluge actually covertly shaping (warping?) our model of the mind's powers of self-organization? Do these aggressively self-generative processing technologies, then, by their very pervasiveness, minimize the voluntary aspects of any system, including that of cognition?

I want to return, briefly, to the vexing question of cognitive binding—now from the perspective of self-organizing structures. Recall that the mammalian visual cortex consists of numerous interconnected areas. Since the mental representation of a perceptual object and its different features involves large populations of cells distributed over different cortical areas, how are relations "established among the spatially distributed responses occurring within and between different levels of processing?"[64] These neurons temporarily become active as a unit because the brain, as Francis Crick states, "in some way" bundles together the different attributes of a perceived object.[65] As we noted, there are numerous competing hypotheses about how these vibrating, networkwide voltage ripples get coordinated into a coherent whole. But according to all of them, the central riddle remains the fact of their mysterious collaboration—reaching together beyond the body's surface—while embedded inside a closed internal functional space.[66] This "symbolic shareability" of material thought in motion is again predicated on auto-organization: the monist idea that something is capable of producing a certain type of behavior by itself because its components belong to a single state of the material world.[67]

The convergence of advanced information technology with cognitive science is, I fear, sidelining the effortful and deliberative aspects of thinking. One fall-out of the merger between automaticity and high-speed processing is that the making of cognitive meaning—emerging from acts of connecting of which we are *aware*—tends to get lost. The contribution of focused attention gets drowned in the expanding imaging technologies dedicated to ferreting out what we are thinking and in experimental regimes interested in direct brain interventions. Unlike the artworks of Alimpiev, Goldsworthy, Cutler-Shaw, or Gursky—which incite the perceiver to discover relations between herself and aspects of the environment predicated on what a person is functionally able to process—the new paradigm of massive automatic data collection, instantaneous interpretation, and simultaneous archiving bypasses both human comprehension and volition.

The idea of "rolling your own" circuits or crafting your own code, as it were, during the reflective uptake of experience would seem to be as old-fashioned as belief in the "natural" world. As Paul Virilio argued with respect to the relation between the actual and the virtual, the present-day splitting of reality in two goes far beyond simulation.[68] We see this dramatic substitution at work in the replacement of self-organizing natural materials by a new molecular and submolecular

reality.[69] Nature's primes—atoms, molecules, and colloidal particles—are not just being expanded, but replaced, by a second, self-replicating creation. Reengineered or genetically altered organic structures not only offer novel features, they impart a precise level of control over their selective interactions.[70]

Undaunted by fears of exaggeration, proponents of nanotechnology promise to rebuild the physical world, our bodies, and our brains molecular fragment by molecular fragment. The ascendancy of "wet" nanotechnology (nano-bio or bio-nano) is, in the words of Dr. Makoto Fujita, the first step toward a workable chemical biomimicry. Given the right conditions, a complexly interlocking system orders and manipulates itself the way Stephen Wolfram's computational abstractions (or cellular automata) automatically change their state according to other identical units bordering them, and so build a world.[71] The media analogy to this totalizing vision of "directed self-assembly," in which the parts are no longer oriented to a holistic preexisting organism, is Friedrich Kittler's conclusion that we are inexorably heading toward an "optoelectronic future."[72] The German media theorist argues that rather than technologies being correlated with the human body—as the gramophone, film, and the typewriter were—fiber optic networks (automatically) turn formerly distinct data flows into standardized transmission frequencies and bit formats. Ultimately, these will not depend on the discriminating work of our senses in any way.

Both the fabrication, by chemistry and synthetic biology, of new molecules or building blocks that include programmable instructions for self-assembly,[73] as well as entertainment technologies that fragment the viewer into by-products of his or her impulses comes, not coincidentally, at a time when many in the computational neurosciences view the brain as largely an autopoietic system in which the receiver's internal structure mostly unconsciously converts incoming stimuli. Let me quickly say that I am well aware that the proponents of neural Darwinism and neural constructivism (especially Gerald Edelmann or Jean-Pierre Changeux) insist that neuronal networks are established in the beginning by usage and continue to be sculpted throughout life by learning. Further, their neurobiological research does not stand alone in looking at how this input gets individually composed, in-formed, or framed—as I indicated at the outset.

The problem is that the self-reflexive side of things has taken on a life of its own. This is happening not just within certain segments of the neuroscientific community (and I include here both the hard AI roboticists and what I call the "extreme" phenomenologists), but in other disciplines that they have influenced, as well as in the popular press, and thus in the eyes of the general public. The "closed" view of automaticity, stems from two different traditions—cybernetics and thermodynamics. These propose that material entities are autoconstitutive, generating themselves as a continuous looping process.[74] The problem with these origins in circuits and

other nonliving systems as opposed to living organisms and evolving processes, however, is that they can lead to reductionism, that is, the ill-fated attempt to seek explanations only at the simplest levels of organization.[75] These twin roots are troublingly evident, for example, in the supposedly synthetic approach of neuro-economics—intent on creating "consilience" between economics, psychology, and neuroscience.[76]

This attempt to describe all human choice and decision making as a combi-nation of logical consistency—the pinpointing of specific brain components con-tributing to cooperation (anterior paracingulate cortex) or risk aversion (ventrome-dial prefrontal cortex)—has elementary neural circuitry accounting for the simplest measurable elements of behavior. This theory smacks of an impersonal, global au-tomatism deriving simultaneously from information theory as well as a mechanisti-cally conceived utility. Such reductionism is also apparent in the science-fiction sce-nario of "direct-to-mind" learning, or "direct education," which circumvents the confines of four walls and a classroom. Using Wi-Fi or Wi-Max, high-tech devices supposedly will access information from an advanced World Wide Web "as infor-mation flows directly from wireless networks into the students's consciousness."[77]

In the era of self-cloning, VR caves, "cocooning," the domestic workplace, home schooling, political isolationism, and the inner sanctum of the Internet, it is hardly surprising that a solipsistic form of autopoiesis would become the ruling model for mental operations. For better or worse, IT, or the paradigm of efficient, largely imperceptible, but, above all, automated information transfer, is invisibly threaded through the metaphors of brain self-organization. This simultaneously hyperpersonal impersonality of thought is captured in research into neuron to neu-ron communication and oscillatory switching, demonstrating how the brain is able to organize itself functionally and architectonically during development.

SNAPPING TO ATTENTION

There is a palpable strain between understanding the brain as an autonomous ma-chine in quest "for essentials," in Semir Zeki's words, and understanding the brain as a distributed system that learns how to inhabit the world *in relation* to our bodies, other people, diverse organisms, and ecology. The latter inserts the mind back into the brain by taking account of qualitative subjective unity.[78] On one hand, so the ar-gument runs, our thoughts tend not to be focused outward because the brain-mind is mostly an autopoietic self-organizing system.[79] Already in the eighteenth century, matter appeared sufficient to generate the mind and its diverse functions. La Mettrie argued for the existence of a bodily "machine" with the sensitive soul as its opera-tional force. On the other hand, we have the experiential or developmental hypoth-esis with its roots in eighteenth-century empiricism as well as in the twentieth-

century phenomenology of Merleau-Ponty.[80] Consciousness as co-apperception thus seems fluidly part of the ordinary physical world *and*, at the same time, highly reliant on the laws of its own neurobiological substrate.

Why is the fact that this research is uneasily caught between self-absorbed "maelstrom" and parallel "coexistence" also a cultural and a social issue? For a start, it renders the role of the volition ambiguous. As a result of studying many anomalies from ideomotor movement to automatic writing, cognitive psychologist Daniel Wegner argues that the strong link between automatism and the attribution of outside agency suggests that when we see an action, we immediately infer that someone did it. He concludes that "automatism is the rule, the illusion of conscious will is the exception."[81] If true, what good is this epiphenomenon of authorship? Attention, as Antonio Damasio reminds us, emerges from the emotions as "somatic markers," those unavoidable prompts of the body's interest in whatever we do and experience.[82]

Seeing as an action becomes ours because we feel ourselves doing it. We work at configuring the rebus-puzzle of the world. If the performative aspects of art that we have been considering ring true, then we do not always or just simply, exert an illusory control, as posited by Wegner's theory.[83] The significance of his position lies in showing how certain kinds of neuroscientific results get invoked broadly and indiscriminately to dismiss enactive functions like free will. On the one hand, the notion of volition's apparitionality taps into a contemporary neural Platonism. It takes to extremes the finding that even our objects of perception are not located in some external event. Our experience at any given moment of consciousness is produced by our autonomic nervous system interacting with the world. And the form of the resulting representation is more a construction of neural networks than it is a deliberate reflection about attending to aspects of that world.[84]

The minimization of the importance of focus is an extension of the argument that the brain, like the heart, functions as a self-referencing closed system. Rodolfo Llinas, for one, proposes that the "mindness" state—or class of all functional brain states in which sensorimotor images (including consciousness) are generated and which may or may not represent external reality—derives from a brain that is normally not disconnected from sensory input. He emphasizes, however, that it does not depend upon continuous input from the external world to generate perceptions "but only to modulate them contextually."[85] In either case, experience does not directly instruct but selects from among a preexisting set of alternatives.

On the other hand, from the perspective of evolutionary biologists such as Nicholas Humphrey, the bodily behavior of today developed from sensory responses in the past. Over long stretches of geological time, our sensations became recursive, looping back upon themselves to become, in the process, self-creating and self-sustaining. To be sure, such sensory activity still calls attention to the present moment in extending itself toward the actual sites of stimulation to evaluate them. But it also

remains closer to home, locked inside the arborescent grotto of the secluded nervous system. I believe his recent work, however, represents an attempt to right an imbalance by proposing that sensation is not merely the registration of a stimulus, but embodies our *interaction* with it.[86]

Like the deep-time perspective of evolutionary development, biological symbiogenesis offers a more nuanced view. This theory proposes mutual interaction involving a close physical association between "differently named organisms"[87]—a complementary process that has much to teach researchers examining tightly knit communities ranging from the microworld of dynamically interacting neuronal populations to the macroworld of today's densely concentrated megacities.[88] Significantly, such models usefully complicate the roles typically assigned to *auto-control* as opposed to *auto-organization*. They incorporate the importance of history as well as taking into account what lies beyond direct vision.[89]

In brief, while many scientific theories are more cautious or nuanced, the difficulty arises when *only* the convenient portions of such research gets mobilized. Consider, for example, the following claim by forensic psychiatrist Lawrence Tancredi: "we are getting a handle on brain biology as it relates to specific moral percepts, and in time all of them will be seen as originating, to some degree in biology."[90] He goes on to discuss the ways in which brain biology "might be responsible" for the so-called seven deadly sins, encompassing everything from obesity to sexual "addiction." This is not the place to deconstruct such reductionism. But it does seem to reduce Marc Hauser's interesting proposal that we evolved a moral instinct by generating rapid judgments about what is right or wrong.[91] This consideration sets the stage for asking: what are the ramifications for those of us concerned with visual education, in particular, of the uninflected uses of automatism, nativism, innateness, "physicalism," and hardwiring, defective or otherwise?

It is worth restating that we are actually dealing with a codependent two-way action. Specific occurrences in the external world have been causally linked to organisms over vast stretches of time and space. Human development occurs in relation to the autonomic system, the motor system, the state organizational system, the attention and interaction system, and the self-regulatory balancing system. But all of these internal systems are in continuous interaction with the changing environment, and have been so throughout its evolution.

Given the complicated two-sided nature of this issue, or its intrinsic equivocality, it seems critical for those of us convinced of the importance of learning and the role of conscious visual experience in that process to wrestle with what philosopher Rosemary Cowie calls "the hard way." This is the effortful route for arriving at truth in a particular domain by finding "the best overall account of the facts of acquisition" and then seeing how it structures the learner."[92] In the specific case of volition, it is important to register that a dichotomy exists "between parallel, effortless, pre-attentive processing and sequential, effortful processing." What matters for our

purpose is the psychophysical evidence indicating "that integration of information across visual dimensions takes place in attentional selection."[93]

The driving pedagogical question is how do we instruct the remaining nonauto-poietic 10 percent of the self actively fashioned by, and open to, sensory input coming from the environment? Since so many basic systems are encoded invisibly and unconsciously in the body, and face permanently inward, what makes us direct our attention outward at all, patiently opening our eyes to the manifold appearances unfurling before them? Even higher level consciousness is borne aloft on an ocean of "automatic life regulators" (the recent estimate is 90 percent)—much like digestion or the secretion of bile.[94] The observations of neurobiology have thus fundamentally altered the meaning of perception, memory, emotion, image, so that we humanists can no longer continue with outdated notions about the grounds of our contact with the natural world. This means, among other things, that we have to reconceptualize the archaic and divisive nature-nurture debate.[95] A different, more remote and automated, picture of the inner cosmos is emerging, complicating that to which we are perhaps accustomed. But despite much current research focus (the extreming of auto-organization verging on determinism), autopoiesis is not everything.

What are the larger consequences of putting attention almost wholly in the service of microcircuits, cerebral localization, processing-perceptual systems, and other inbuilt constancies? Although inseparable from it, this question extends far beyond education. In light of the "killer economy," where a hypermarket has become the ruthless self-organizing system fueling our Western high-consumption lifestyle, are we aware that we are being induced to consume and to work harder in order to do so?[96] Speaking of the self-maintaining processes of corporate outsourcing and restructuring, the French sociologist Robert Salais wryly comments: it is perverse, but true, the category of unemployment is disappearing. But, he hastens to note, "fabricating" jobs is not the same as "creating" them.[97]

Why should anyone struggle to *see* things as they, in fact, are? If the human brain models the world for each individual, why confront experience at all to test one's perceptions? As in Keatsian negative capability, why not just linger among too many possibilities or too many unconstrained alternatives? Although Jean-Pierre Change-aux has valiantly proposed using the workspace model—whereby the widespread accessibility of information within neural networks permits the evaluation of hypotheses in relation to other information with respect to "truth"[98]—he leaves unanswered the question of why go outside in search of a framing context or "reality" in the first place? Although similarly optimistic about human ingenuity and the potential for developing specialized expertise, social historian Harold Perkin does not explain how "automation, 'lean production,' biochemistry, and biotechnology" will realize a "third revolution," that is, the rise of an equitably *distributed* professional class.[99] Daniel Cohen's and Barry Lynn's visions regarding convergent big business

or the coming "great consolidation" are bleaker. The irony underlying today's sup-posed industrial "commons" is that it is largely out of most people's control.[100]

One could argue that the late twentieth-century "Decade of the Brain" project, too, is caught up in a never-ending spiral. But its initial aspiration to study higher cortical functions in humans has now expanded in all directions.[101] Moving beyond the 1990s research focus on CT, PET, and fMRI *localizing* brain-imaging technolo-gies, the neurosciences of the twenty-first century also pursue something more elu-sive: the decentralized brain-in-the body as well as its deanthropomorphized code-pendence on the shifting external environment and its miscellany of animals and plants, from bacteria to primates.

As indispensable and revolutionary as these imaging technologies are, they also possess a dark side of inevitability. Not all predictions are borne out by events. As we know from brain lateralization studies, it is not just our global functional states that are skewed in the inbound direction. Humans have brains that are asymmetric, just as our hands, hearts, livers, kidneys, and amino acids are asymmetric.[102] Language-related processes have long been lateralized in the left hemisphere and the more ho-listic spatial and perceptual functions have been assigned to the right hemisphere. Yet this neat division of labor has been shown (especially through research on brain lesions) to be something of a cognitive illusion. Both left and right hemispheres work together to create a single individual. Actually, one side often automatically fills in for damaged functions belonging to its mirror opposite with the help of the corpus callosum—the large bundle of fibers by which they communicate and coop-erate. The mind, therefore, is not a blank slate. Even before we begin to reason, it is weighted with a diverse repertoire of somatic images carrying with them a load of affective valences that color any occasioning impinging object.

The argument—whether explicit or implicit—for special-purpose faculties be-longs to what Rosemary Cowie has termed the "nativist" position, or the appeal to innateness against a competing developmental account.[103] To flesh out a bit what this means, I cite as an example some recent work on the "dedicated mechanisms" of language. Challenges to the Whorfian hypothesis that language determines thought support the neurobiological findings that when humans mimic behavior or acquire a language, they learn to express it in concepts already present in their pre-linguistic systems.[104] In other words, the necessary representational apparatus for these cognitive operations *preexists* our exposure to gestures and speech. Typically, advances in functional neuroimaging have stimulated efforts to be even more spe-cific about localization. Not only are grammatical rules ascribed to an "innate sys-tem" in the brain, but the left frontal regions are identified as the "grammar center" reflecting "the universal nature of grammatical processing."[105]

I mention these inquiries into the fixities of language—continuing the distin-guished lineage stretching, recently, from Chomsky to Pinker but, before them, back to the universal language devisers of the seventeenth and eighteenth centuries—

because they themselves belong to a larger set of investigations into inborn dedicated neural mechanisms. These parsing experiments extend to the visual cortex. The work of Zeki and Ramachandran shows that the dissection of the receptive field continues unabated.[106] The "receptive field" of a neuron in the visual system "is the region over which the firing of that cell can be influenced."[107] Further, it refers to the fact that stimuli composed of coherent features are integrated by our visual system into perceptual entities. These preattentive capabilities of grouping, mutual facilitation, and figure/ground separation require self-organizing neural mechanisms. The difficulty with this atomization of the processes of segmentation is that it can have the effect of dissociating seeing from thoughtful, that is, learned action.[108]

From this perspective, it is notable that the majority of neurological investigations citing artworks use them to demonstrate auto-organization, not auto-control (willed actions). It is a sad irony that while art and cultural historians have been almost exclusively focusing on the social side of image history for over three decades, the role of conscious vision in the construction of experience has been whittled away. The studies of Zeki and Ramachandran are especially pertinent on this score because they have made genres that play either with the automaticity of illusion or, like caricature, predictably distort and thus exaggerate distinctive features, central to their research into the modularity of vision. Not unlike certain phenomenologically inflected studies in cognitive science—trying to account for the fact that things have fleeting appearances—their findings underscore the near-simultaneity of stimulus and response.

Zeki explores how the simple constants in our heterogeneous field of vision are picked up by many visual areas outside area V1 (important for form and orientation) of the visual cortex. These adjacent areas (V2, V3, V3a, V4 [important for color], V5 [important for motion]) are specialized to process and perceive different attributes of the visual scene.[109] He is thus constructing a bottom-up modular prototype of vision by looking at discreteness: how brain cells are excited by very selective object properties (orientation, edge, etc.). To prove this, he examines paintings by artists ranging from Paul Cézanne to Albert Gleizes to René Magritte. Zeki demonstrates how certain formal features constrain humans to pick out and attend to the constancies present in their field of vision, screening out the noisy background. Additionally, his inquiry into constants leads to the top-down question of universals, or the "laws" of the brain—the anonymous and autonomous perceptual grouping and binding of features always going on below the surface and over which we have no control.

Ramachandran, in turn, analyses the multiple ways in which the limbic system reinforces certain perceptual and cognitive constants of reality. When activated, the limbic system's nontopographic color and motion maps bind wavelengths coming from geographically separated features in our field of vision. This temporary con-

junction of distant points elicits a pleasurable kinesthetic sensation: the "ah-ha" of recognition.[110] Like Zeki's, his focus is Janus-faced, intent on discovering correlations between human pattern recognition (using the extreme, hypersalient forms of caricature, as well as the extreme orientation-selective concealed shapes of anamorphoses) and the limbic system (see fig. 70). Undeniably such equivocal forms have long been the staples of art.[111] But they are only one part of a much larger and complicated story.

Ramachandran also tackles the problem of costructuring from the evolutionary angle. He notes, in his "fourth law of isolationism and understatement," that our brains evolved in highly camouflaged environments. Therefore, there can be no simultaneous patterns of overlapping neural activity. He stresses that, "even though the human brain contains 100 billion nerve cells, no two patterns may overlap" since intentional resources are allocated to one thing at a time.[112]

The pursuit of universals of form, corresponding either to a basic neurological function of our visual system or emerging at a basic stimulus level (the "peak shift" effect), does not just retool twentieth-century "biogenetic structuralism."[113] It updates, while radically materializing, late eighteenth-century neurognostic theories and compressive compositional practices. Remember the Romantic longing to reimagine the remote origins of art by abstracting simple or "primitive" building blocks (verticals, horizontals, diagonals) or visual formulas from the increasingly complex varieties of aesthetic production proliferating in the modern world.

Searching for an unconditional "grammar of expression" was grounded in the belief that affective information is embedded within the basic compositional organization of nature as well as in the basic structure of the mind. Then as now, visual properties like form, direction, hue—clearly discernible in elementary geometric shapes, diagrammatic verticals and horizontals, and color primaries—composed a body-based semiotic system connecting cognition with environment (see plate 1). That we are routinely able to detect these primitives of experience beneath more complex appearances accounts for the frequent sensation of a generic familiarity glinting below the noisy montage of daily images.

Hewing out compositional units—squares, circles, rectangles, and other rudimentary figures—from the crowded and distracting flux of actuality tacitly acknowledged that perception operates largely at the unconscious level. But this earlier generation's inquiry did not stop there. Inferencing from affect-laden and abbreviated "real symbols" was believed possible because there was a perceived symmetry between these perceptual entities and mental structure. While definitely a precursor to Zeki and Ramachandran's neuroaesthetics, the Romantic version of a natural history of aesthetics was also a type of niche construction. Its formulators intuited that a cultural species produces environmental change and that the environment, in turn, directs cognitive evolution. They were intimately aware that focused perception *guides* action.[114]

The role of the environment, the dazzling plasticity of the nervous system, the importance of learning, all point to the need to reassess the role of experience in brain development from birth to maturity. Gerald Edelman, for example, discusses neuronal networks by analogy to Darwinian selection. While growing neurons continuously establish transient connections with one another in a random fashion, these connections rapidly unravel unless some outside influx causes them to be utilized, amplified, and thus stabilized. Or, in the words of Jean-Pierre Changeaux, "the Darwinism of the synapses takes over from the Darwinism of the genes."[115]

I am not disputing that the microstudies of seeing and cognizing by Zeki and Ramachandran are illuminating. For one thing, their work should prompt a serious reconsideration of the formal side of historical art making. But given both the diversity of image making, the existence of conflicting stimuli, and the complexity of awareness, the narrow-bore focus on localization-as-identification has its limitations. While a network distributed throughout the brain orchestrates the perception and memory of facts and events, this systemwide functional feature also creates configurational associations between the experiencing subject and external stimuli. This codependence derives, in part, from evidence that sensory cues get selectively represented in multiple cortical areas according to their varying impact on pre-existing brain functions. Since neurons must be capable of rapid, predictive reorganization of focus depending on myriad cues incoming from the environment we are—usually without realizing it—creatures composed of many independent consciousnesses.

As I see it, then, three intertwined notions emerging from the revolutionary findings of the modern neurobiologic sciences have, I believe, fundamental implications for visual or sensory-based education. Significantly, these ideas reverse or, at least, challenge us to reconsider powerful earlier epistemological models. They are, first, that cognition does not function like seeing an imitative painting—a venerable analogy spanning Plato to Locke. I have made the case, instead, for an alternative inlay or blazon model operating at the interface between the template of neural machinery and prismatic sensory experience. Second, kinesis has become an increasingly central factor in the scientific study of vision. The primacy of movement to seeing is being validated in studies of the bioelectrical activity of cortical neurons, demonstrating that all perception is necessarily associated with a motor function.[116] Obviously, this is a finding with which the Italian Futurists or the Op[tical] artists of the 1960s, like Bridget Riley and Victor Vasarely, would concur.

According to the new dynamics of apprehension, the mobile perceiver is "dilated" by the concrete sights of her surroundings.[117] But this extensional impulse to select what the brain detects is done in accordance with it own self-organizing structure. Consciousness as coapperception is thus fluidly part of the ordinary physical world and, at the same time, highly reliant on the laws of its own neuro-

biological substrate.[118] Very different studies on neuroplasticity—with their amazing findings that apparently dead-locked adult human brains are capable of functional reorganization—show the importance not only of sensory-input increase to the circuit-reactivating process, but of repeated movements as well.[119]

The compression of the role of deliberate focus, hence vision, and its concomitant link to movement, third, is accompanied by its automization. What the brain detects is done in accordance with it own self-organizing structure. Perceptual acts are not directed to some new object, but to the same delimited "thingly environment" congruent with our framing cognitive architecture. Even when our perspective changes, these sudden shifts still serve to disclose the more persistent workings of the brain. That is, even when we depart from the habitual or the expected, such switching reveals the normal stimuli to which the brain-mind is receptive and toward which it is generally oriented.

My larger point in this final section has been that the growing evidence for sensory-input independence, supported by the importance of automatic processes in cognitive activity, places special pressure on what I have been calling the remaining attentive 10 percent. David Lewis Williams, in his probing study of the geometric zigzags, grids, dots, and superimposed lines found globally in the patterned caves of the Upper Paleolithic (c. 45,000–10,000 BCE), provocatively argues that art making depends to a great extent on mental imagery, especially the inward-directed kind, rather than higher-order intelligence. Entoptic phenomena, originating between the retina and the visual cortex, are wired into the human nervous system. Hence, all people have the potential to experience them with eyes open or shut.[120] As we have seen, affect, episodic-like (event) or semantic-like (fact) memory, intuition, intentionality, dreaming, hypnagogic states, the conscious and unconscious coherence of the evolving self, have all been put under the microscope.[121]

One could argue that Giambattista Vico, in his *Principles of a New Science* (1734), already proposed that the human mind gives shape to the world and the world, in turn, is in the shape of the human mind. Yet his mythopoetic system—focused on the historical origins of public communication and rearticulated by the Romantics—offers a telling contrast to today's solipsistic neural functionalism fascinated by everything from autism to sensory deprivation. This obsession with the mostly world-independent "language of thought"[122] is also evident in an explosion of hybrid fields: cognitive anthropology, cognitive linguistics, cognitive memory studies, neuroaesthetics, neuroeconomics, and neuroethology.

If the brain-mind has once again become a shadowy cavern, we may well ask: what do we actually see? Surely not, as Plato would have it, flickering copies of outside appearances projected on the unifying screen of the mind. If it is indeed a structuring global workspace generating schemata that organize the world into corresponding categories,[123] how much do we depend upon vision in our symbolization

of the world? If, in its continuous incorporation of external objects our body's nervous system is "neurosymbolic," just as the ongoing electrochemical activity "wiring" together different self-maps is neurophenomenal,[124] is "visual literacy" a concept adequate to this emerging view of the cosmos in the brain?

Putting the action back into perception means putting *voluntary* action back into perception. Going beyond life on auto pilot entails making the processes of willed seeing visible again. In sum: I have expressed concern about the joint tendency to turn vision into a response to a stimulus and the will into an illusion. In light of motor experience, performatively or even viscerally being able to dissolve the gap between subject and object, should we be thinking, perhaps, of situational rather than of visual or media studies (dominated by the continuity-editing conventions of film as opposed to video layering or televisual juxtapositive technologies)?[125]

This binding dynamic—going beyond cinematographic flow—would take into account that the motor-sensory organs are both altered and extended during their spatiotemporal convergence with constantly adjusting appearances. As in David Leatherbarrow and Mohsen Mostafavi's "situational architecture," they enfold "all materials that are available within the limits of a given [biological], social, economic, and cultural condition."[126] This is cognitive construction actively struggling to integrate and reconcile images of different origins. Being alive to these "situational" adjustments would take into account how preattentive seeing, like the varieties of memory, the secondary consciousness, and other autonomous physiological processes—taken together—become amplified by selective attention and conscious conceptualization.

Creativity may well lie in escaping, not giving in to, our autopoietic machinery and focusing carefully on the world. This proactive proposition defies a hyperphenomenological theory of consciousness—recently challenged by John Searle[127]—that we can never perceive the real world but only our mental representations and that even these re-representations are driven by inaccessible mechanisms.[128] Searle also usefully argues that individual or first-person perspective is not reductively identical to an objective description of the underlying neuronal processes. Feelings are a prime example of organic intensity that exceeds mere physiochemical processes. Antonio Damasio has shown that while these perceptions of arousal occurring in the brain's body map refer to parts of the body and states of the body, they are also integrally cognitive *ideas* about the body. Consequently he distinguishes feelings from the truly primal emotions, those evolved subcortical action networks encoded within an ancient nervous system.[129]

What we broadly call art—that is, deliberate design or spatiotemporal pattern making—is a principal example of such willed perception imaginatively and publicly working on the world.[130] Recall the enduring importance of ritual or performance to the neurocognitive foundations of human symbolic activity. Thinking

arises from motor movement. While motion (as directionality and repetition) is essential to the very concept of an auto-organizing self,[131] an outward-directed attentiveness to the thereness of an object or event within an ambient, not just to our private experience of it, captures aspects of high-level cognition such as intention, organization, and selection, bringing them back into the circle of awareness.

We are so caught up in the alternate reality spun by mass media—not multi-, but individually tailored media designed to interlock with specific brain functions—that the question becomes what impels us to resist insinuating forces that shape how we think? Whatever still remains of our conscious mental operations is being sharply undercut by the proliferation of autopoietic devices and zombie apparatus. The teaming of "entertainment electronics"—delivering user-desired emotions—with nonconscious technologies of the reflex (blinking, humming, oscillating, vibrating) will, no doubt, have formidable consequences. Not in the least because these affect- and idea-sculpting devices are intrinsically compatible with our brain's endlessly self-configuring and inward-zooming remote control. In fact, as Malcolm Gladwell suggests, humans are adept at screening out what does not matter and at reaching "snap" judgments. In a significant shift, the new non-Freudian notion of the adaptive unconscious is conceived as always poised to leap to conclusions. This means that behavior and decisions often depend on thin slices of experience.[132] Certainly, we must be able to synthesize, internalize, and evaluate a signature pattern fast (say, a call for help) in order to respond quickly to the identification problem at hand. Automate this activity—as portable immersive technologies can do—and someone or something else strategically determines our cognition or behavior in line with their invisible purpose.

To various degrees, we experience this machinic filtering of the external world in solipsistic cell phones, environment-screening Bose headsets, mobile microsized PDAs or removable MP3 players, and virtual reality gaming systems.[133] Such technology-inspired partitioning is also strangely evident in the new corporate habit of hiring not whole people but modular "minds" or "solvers" to do the work of knowledge commoditization.[134] The prime site for robotic response, however, is no longer advertising's creation of corporate logos and global brands. Rather, it is the allure of intimately personalized medicine and the promise of pharmacogenomically changing lives.

Beverly Fishman's beguiling multipaneled neural landscapes are graphic embodiments of the largely automatic forces currently shaping our biological and cognitive self. In an ecstatic allegory of the new psychotropic human condition, candy-colored pill-like entities and pharmaceutical monograms—the encircled V of Valium, the shimmering K of Klonopin, or the swollen H of Haldol—enticingly flash above the pulsating horizon promising universal narcotized relief.[135] Specifically, her *Dividose* series (deriving its name from segmented tablets), evokes a frenzied

inscape composed of fluorescent moiré patterns that capture both the effect and the seduction of such emotion-altering substances (plate 14). These works are what they represent: stimulants. Fishman's glamorous drugs are fabricated of shiny vinyl strips applied to vividly lacquered aluminum panels. Sleek and disorienting, they are as indisputably in control of our reflexive nervous system as the uppers and downers we live by. For all their Lotus Eater delights, her pictures have a stealthier message. Seeing, not seeing as, enables knowledge to grow. By reincorporating volition and effort into vision, we can turn the world into one of our own making.

CODA

Reverberations

"The echoic power of humans" derives from the fact that episodes in real life happen only once. Our recursive "habit of immediately reviewing or rehearsing whatever grabs our attention strongly is a sort of inadvertent self-conditioning that drives these events into the storehouse of episodic memory. We remember what has been played and obsessively replayed by our brain. There is no need for a sharp dividing line between conscious and unconscious experience."[1] DANIEL DENNETT

We resonate with echoes and rhymes. Robinson [Crusoe] visited a desolate valley, a narrow gorge which threw back the last word of the verse he had uttered aloud: "my soul," "my soul," "my soul," repeated until silence, the multiplying mirror of his cogito.[2]
MICHEL SERRES

THINNING THE ICE

A small, easily overlooked side room at the 2006 Berlin Biennale contained the stark black and white video, *Father and Son* (1998), by the Estonian Jaan Toomik.[3] Bereft of narrative and almost eventless, this short piece presents the naked artist darting from the front of the screen and skimming across a frozen lake until vanishing as a tiny spot in the distance. Alone and disengaged from any social relationship, his features become atomized within an enveloping nature. Just as abruptly, this singular figure glides back again, growing larger and fleshed out when nearing the empty shore. During these oscillating movements, we catch him in deep reflection, subtly inhabiting and taking leave of his body as he retreats into an "object" or emerges into a "subject." Everything comes together into a synoptic image—as in neural synchronization—when we grasp that these comings and goings mirror the continuous and discontinuous phenomenology of the material world as well as our underlying brain states. These recurring disappearances and reappearances are accompanied by a plain-chant soundtrack, an ethereal requiem sung by his invisible ten-year-old son who whispers "amen" just as the solitary revenant melts into the horizon (fig. 92).

There is something primal, then, about this concentrated image. It dissolves the membrane of first-person perspective and distributes the pointillist individual into a wider third-person system only to recrystallize him again. Attenuating the "I"

FIGURE 92
Jaan Toomik, *Father and Son,*
1998. Video still. Courtesy of
Jaan Toomik and Center for
Contemporary Arts, Estonia.

makes it easier to merge performer with the performance. Because there are no trappings, Toomik makes manifest both our self-organizing neural functions, tied up with rhythmically repetitive activity, and our executive functions attentive to change. The austerity of this mosaic vision—breaking down the unified contours of autobiographical identity and building an interrelational subject up again from dispersed material bits—seems eerily close to the position of Daniel Dennett. Spontaneous brain operations appear to dominate us, that is, ongoing network activity not governed by any particular sensory input, but generated by the combination of the intrinsic electrophysical properties of neurons and synaptic interactions in these networks.[4] When it comes to self-consciousness, Dennett has argued, one has to make oneself really big. This expansion comes from intuitively as well as deliberately incorporating the mindlike properties of our physical surroundings rather than shrinking to the isolated point of view of the Cartesian ego.

My central argument has been that the composite image—variously instantiated as visual formula, emblem, symbol, and correlational montage from video to electronic media—is the prototype for how we integrate sensation and concept. These blazon-type formats—inlaying our neural template alongside the discrete components of the world—let the viewer experience their unification. Openwork, mesh, lattice, grid, as well as opaque connecting patterns, specifically, create an interface where the prismatic facets of the environment get visibly superimposed or set down side by side our qualitative sensations. This dovetailing makes us not only conscious of ourselves as a subject but as an object. In sum, fretwork and intarsia compositions demonstrate the cognitive work performed by encapsulating images: the craftlike ways in which they solicit attention, stimulating the beholder to reenact the gathering, compounding, and synthesizing of information into a compact idea-thing. Such formats importantly reveal the interpenetration of our cellular and synaptic biophysics with the elements of our external ambient. Self-consciousness and context-consciousness are shown to be inextricable.

I can identify with Toomik's skater at another level as well. At the beginning of this book, I skated out as one kind of person and, at its conclusion, I have returned as quite another. I ventured forth with a narrative definition of myself as a historian of images. At its end, I view myself as episodic, still in process and being transformed by the complex and mixed disciplinary worlds I have been inhabiting during these past years.

My project was experimental, spurred by revolutionary neuroscientific findings having the potential to revitalize how we look at cultural objects. The current art world and the humanities more generally face new realities. The blunt fact is that fields that traditionally were thought of as nonhumanistic are tackling topics such

as abstracting, idealizing, modeling, pattern forming, and imagining, usually believed to be the province of the fine arts. As I wrote, however, I became increasingly aware that the neurosciences are being reformed by culture as well. We echo one another's optimisms, dilemmas, and anxieties. Perhaps by collaborating, we could try to develop a new relational research that does not shy away from identifying and investigating the durable problems shared by the arts and sciences. In that spirit, the centerpiece of this book is a type of "information-hungry" image, in Andy Clark's words, that is not merely illustrative of ideas but that conspicuously binds the patchwork of the senses.

I began by proposing that the neurosciences, cognitive science, and the new philosophy of mind need to come together with the variegated historical, humanistic, or cultural-based studies of images. These, in fact, are the real-life phenomenological instantiations of such elusive operations as spontaneous order, oscillation, synchrony, representation and memory, as well as structural-functional relationships, which are the focus of neurological research. The divided brain sciences, as well as the competing epistemological theories swirling around them, would thus gain an enriched view of pattern making and pattern recognition as both enduring and evolving correlational practices. When considered complementary rather than oppositional, the arts and sciences reveal two aspects of the same self-image relationship. Different genres signal ways of "putting deliberate marks on the environment."[5] As Daniel Dennett observes, the brain lays down trails to distinguish what, for us, are the environment's most important features. Evolution, in turn, may have sculpted the brain to respond optimally to components of the visual environment. Therefore, I have paid special attention to "artisanal" images that inlay outgoing with incoming patterns, thus manifesting the physical and material crafting of thought.

The cognitive work of images does not just make our complex environment simpler to ingest. It makes aspects of the world perceptually salient and cognitively distinctive for us. While I agree with Steven Pinker that the visual arts both create and flag objects worth paying attention to in the environment, they do much more than this.[6] They do not just push our "pleasure buttons." Rather, given that our neuronal responses are largely the result of autopoietic processes, compressive graphic systems snap us to attention: they make us awake and aware of the present. Thus they model how stimuli self-assemble and summon us to the analogous high-order labor of unification. In this nonlinear combinatorial process, compound images demand that we consciously pull ourselves together much as the electrical signals delivered by the eyes' rods and cones are patched together into synoptic perceptions.

Certainly, many types of composition contribute to Dennett's "pandemonium of the mind"—with its chaotic sequence of unconscious cognitive demons.[7] But overtly hybrid forms *present*—not represent—the normally hidden mechanisms of correlation. I compare these optical and neural fundamentals to the affective impact

made by a coat of arms, which, like the primary imaging system, is checkered with shrill colors and gridded with horizontal and vertical lines. Seeing thought under construction is precisely like confronting the brain's blazonlike encoding of raw electrical signals. Such heraldic imagery, moreover, has an unrecognized advantage over language—an advantage literature itself has long recognized on those occasions when it formally mimics mosaic or fretwork designs. Such nonillusionizing, nonnarrative structures make manifest how the brain dynamically assembles a picture of the world from its discrete states in conjunction with shifting aspects of the environment. This cobbling of inner with outer space, time, and motion meets at the interface of intentional perception. Attentional behaviors suture the self with ambient in the lived moment.[8] To be conscious of a juxtapositive object is to be conscious of oneself as a complex combination.

I also argued that humanists need to come to grips with basic neuroscientific findings—encompassing everything from subjective states (in animals, humans, machines, the Internet), to the affective vividness of qualia, to how we visualize personal pain and empathize with the pain of others. Such concerns are central for rethinking human subjectivity as profoundly intertwined with the development of integrated configurational practices. There is much to be gained, including new data about the acquisition and organization of content, old and new: about pattern seeing, dreams, hallucinations, memories, emotions. Further, the floundering humanities—complaining that no one knows what they are or what purpose they still serve in peoples' lives[9]—might well discover a new compass in emerging models of neural functioning, perception science, and theories of biological evolution. How do images become generic or prototypical or universal? What do we know when we see? What makes images powerful, generative, shareable? What neural processes do different kinds of imagery presuppose and engage in the observer? I have focused specifically on images as condensed objectlike forces for brain-mind convergence and cognitive-organic integration.

Contemporary artists are leading the way; we historians, theorists, and critics have to catch up. I find it significant that, currently, the humanities, neurosciences, neurophilosophy, and cognitive science are mired in identical quandaries. We are internally, not just externally, divided over basic matters of interpretation regarding the fundamental objects of our inquiries and the methods by which to unlock them. Substantial phenomena concern us both. Both the liberal arts and the biological sciences have problems with categories. We both experience difficulty in transferring things and meanings not just from one domain into another, but into a greater commonwealth of research and scholarship as well as to the educated public at large. This suggests that not only do we need to leap across C. P. Snow's territorial chasm, but to step across the many narrow, no less hobbling, rifts within our respective subfields.

THE NEW PRIMES

To break the ice, and build a zone of exchange both sides are going to have to contribute something. Let's begin with the humanities. We are going to have to admit that there are lawlike aspects to art. As I demonstrated in chapter 1, an important wing of Romanticism was fascinated by what V. S. Ramachandran has called "the grammar of perception."[10] These pathos-laden *schema*—discernible in the features of ancient sculpture and on the facades of archaic buildings (pyramidal towers, temple mountains)[11]—offered perspicuous insight into how human beings came to unify self-consciousness, consciousness of one's body, and environmental consciousness into a formal logic. Visual "universals" or visual formulas capture how we synoptically structure neural content.

Both particular and general, these root forms continue to be expressive in the present. Constituting an ancient semiotic system, such diagrammatic and chromatic configurations were taken to demonstrate that different cultures generated similar intuitions. They were seen as portals opening out to past physical, mental, and social conditions still accessible and alive in the modern world.

From their structural and comparative analysis of mythology and archaic art, the Romantics concluded that natural and cultural histories were not only intertwined but, collectively, constituted humankind's cognitive history. Concise signs were the smallest units of graphic structure offering glimpses, or blazing a trail, into the material archive of prehistoric geology and actual living conditions that correspondingly shaped our inner landscape. This late-eighteenth century generation of artist-theorists recognized the palm prints of catastrophic impacts (comets smashing into the Indian Ocean, volcanoes, earthquakes, solar eclipses, and, of course, epic deluges) in the universal grammar of signs of fear, tranquility, or joy discernable on archeological monuments.[12] Such abbreviated "real" symbols or concrete universals, correlating geocosmology with psychology, revealed how humans processed affective input and how the sight of the earth's transformed features got imprinted on the "visiospatial sketchpad" of our working memory.[13] Today, we intuitively recognize and affectively respond to their traces, deposited in the carpentered external world, precisely because our neural machinery is attuned to its contours and edges.

For the generation of thinkers following Kant, such parsimonious schema manifested empirical concept acquisition. This epistemological function of natural signs signified known things once directly experienced and unconsciously as well as consciously internalized. But such primal marks also encouraged the reconciling jumps of analogy, enabling us to infer from what we see to what we do not see. As early tribal groups wandered and populations dispersed as a result of the dramatic resculpting of our planet, understanding the rules governing their movements and

the underlying design of their monuments became more complex. But the old primes—helping roving bands to recognize what others were thinking or feeling thus furthering cooperation, goal-directed action, and decision making in a dangerous universe—became engrained as fear or empathy shaping our moral judgments. Works of art were thus held to communicate complex natural and cultural information across vast stretches of space, time, and collective organization. They also help to explain the suspicion of others who are unlike us and our instinctive reaction to what we take to be true or false appearances.

The problem before us today is to identity the new primes in light of massive human diaspora and even species migration. Are there still common rules or an unconscious grammar governing how we grasp intelligent content? I offer one telling example confronting us daily in the pages of international newspapers, on television's nightly news, and on the global Internet that suggests the afterlife of what Walter Benjamin called "the involuntary memory of humanity."[14] One can think of many others as well. Consider, for example, the broad recognition of "religious signs," materialized in the head scarf, Sikh's turban, and the Christian crucifix. I cite these instances specifically because they were singled out in the recent law passed by the French Assemblée Nationale in February 2004. Appositively, such generic objects or schematic images were taken to embody specific and universally comprehensible content. As the result of the charge of Jacques Chirac to his administration, such brandlike insignia, when publicly worn, were deemed to "express membership in a religion by its open visibility alone," and were thus judged to be illegal.[15]

In chapter 2, I moved from geohistorical ideas about the development of the human mind and its abstracting operations to consider how we weld complex sensory data into a pictoral unit. I examined how inlaying heterogeneous materials—or the method of interpolating foreign substances and unrelated concepts—mimics the biological ingestion of once-alien organisms. The tiling of surfaces with shapes to create both repetitive and nonrepetitive patterns (the latter studied by mathematician Roger Penrose), and the research conducted by life scientists on mitochondria and the origin of the eukaryotic cell depends on what might be termed *intarsia or inset styles* of conjunction.[16] The problem of actualizing a complex molecular whole through symbiosis and symbiogenesis is also the problem of how organelle-like bits and cell-like pieces of free-standing artistic compositions "invade" other frameworks to create new cultural forms. These compressed and compounded artifacts similarly incorporate extraneous material into a singular image whose novelty ages, mutates, and eventually dies out.

The interdependent behavior of the lowly organelle as well as of the humble artisanal mosaic is a sort of protest against grander narratives of self-creation. They take advantage of a broader range of resources. These anonymous assortments or aggregated collectives challenge both the heroic Stoic as well as the solipsistic Cartesian concept of individual self-making. The patched together format of the emblem

and the fractured symbol make manifest the shared neural mechanisms by which we correlate information, not a personal object smoothed by someone's narrative habit of thinking. Yet, as both filtering and immersive new media are demonstrating, we are far from reaching the end point of the long tradition in Western philosophy of identity as *autarkeia*—that is, the withdrawal or maximal independence of the subject from all external factors as the highest goal.[17]

By contrast, neural Darwinism proposes an organic interaction model of interlocking inner and outer relationships. Gerald Edelman points toward the construction of a new kind of observer liberated from epistemic autonomy, but also distinct from a Marvin Minsky–type computational system of semiautonomous and autonomous agents that become wired together to produce awareness. Avoiding the potential determinism of the programming model, Edelman proposes that selective pressures have caused changes in the populations of synapses throughout the brain and that, over time, these have resulted in new mental capacities. His theory of reentry would seem to suggest that those constantly invasive and metamorphosing "phatic" products of visual culture might, in turn, reenter our brain strengthened. Such augmented images would then reconfigure the neural-synaptic organization of the brain before getting distributed in the outside world again. Explicit advertisements, shock waves of video, salient film clips, "mashed" digital media, the polymorphous World Wide Web, all design the neurons and the neural networks redesign popular culture.

The way people interact with the environment and with a host of new technologies is less mechanistic and more about understanding face- and shape-selection activation in the brain. How did cooperation between different beings evolve? When we talk about subjective experience, we are not talking about some boxlike faculty inside ourselves but about how we interface with something lying beyond ourselves. Apparently, vast populations of neurons must become synchronized at around a 40 hertz frequency of electrical pulses for conscious activity to occur. Similarly, at the macrolevel, for unrelated people to form coherent social groups, their divergent behavior must somehow also become synchronized. Mirror neuron experiments into the hardwiring of shared emotions (discussed in chapter 3) have given new support to a venerable aesthetics and poetics of imitation. Mimesis recognizes the contagious effects of mimicry, and the fact that empathy begins with reciprocal seeing and involuntary duplicating of another person's behavior. But it also requires emotional control, the executive decision to resist drowning in another person's pain so as to formulate an appropriate course of action.

Because it can be both other-oriented and self-aware, we see empathy as a way to achieve congruence between inside and outside experience. Direct simulation or reperformance is thus not just a powerful Darwinian fitness tactic but an acquired social skill.[18] It speaks to the importance of memory, the role of instinct, inferring, and most importantly from my perspective, the connection between vision and affective

attachment. Because empathy allows us to infer another person's subjective experience, it supports Hume's insight that emotions are perceptive or thoughtlike. We inquiringly reach out, moving beyond the borders of our body, by means of association so as to "environmentalize" our internal milieu and personalize our surroundings. From mirrors, to windows, to gardens, to paintings, we bring a continuous stream of images into our private ambient—not just to behold them but to reenact, relate, or otherwise "appraise" the visible. Not just face recognition, but nonface object-recognition (round clocks, spherical fruits, circular contours) elicit responses from cells in three discrete regions of the temporal lobe (see fig. 44).[19] Among other things, then, works of art expose the complexity of this bi-directional form processing by which shape tuning meets up with affect-sharing and emotion regulation. Updating Aristotle, perhaps this perspective taking also engages in Steven Pinker's words, "the pleasure circuits of the brain and delivers little jolts of enjoyment."[20]

Let's now turn to the neurosciences. What must they concede? First and foremost, they need to acknowledge that they have learned and, indeed, borrowed much from the humanities. As important as such a public gesture would be, it is not enough. The cultural material typically mobilized by certain neuroscientists, cognitive scientists, and neurophilosophers in the construction of their hypotheses or theories needs to be seriously diversified and expanded. Rather than seeing images as the mere illustration of some modular function, the range and variety of the cognitive *work* they perform needs to be better understood. Avoiding both Plato's claim that they are necessarily the sensible copies of paradigmatic ideas and more recent phenomenological claims that they are entirely generated from the brain's intrinsic activity, I treat them as boundary events. Compound images in particular are the medium or interface where world and subject get co-constructed, that is, echoically presented to one another's view.

The work of the senses goes beyond vision. The intermodal performative arts make manifest the process of self-definition as we journey through space and time.[21] We become aware of a personal or private interiority only through acts of exchange with the material conditions of our embodied existence. The discrete senses are called into action in combination with our size, orientation, facing, handedness, ranges of motion, reach and grasp, our thick or thin skins, our sensitivities and vulnerabilities, even our responses to the diurnal and nocturnal components of the twenty-four-hour daily cycle.

One effect of the current pervasive use of brilliant night lighting has been to make us forget the complexity of darkness. While our megacities are now routinely studded with hotspots of illumination, for much of the earth's history a vast number of species, including our own on occasion, welcomed darkness. An adverse effect of the recent bright night sky and ubiquitous "photopollution" is that obscurity tends to get negatively coupled with disorientation, with the precession

of imaginary, dreamlike, and misleading effects.[22] But the absence of light also held positive values not associated with visual mastery. Darkness was necessary to hide from enemies, to catch prey, to mate, to perform group rituals, to see visions (see chapter 4). Obscurity brings out a different kind of cartographic perception.[23] It establishes a space of representation that cannot be contained within a frame. This absence of division helped one come in touch with an undelimited, thus interior, space expanding perception, reducing personal autonomy, and provoking the interpenetration of feeling with sight. Low-light settings allowed different dimensions to bleed into one another.

The metaphysical and epistemological view of darkness as mere lack or emptiness informs certain "virtual reality" theories of mind based on the model of a hallucinatory inner landscape or penumbral theater. Specifically, the metaphor of a dim architectural interior—a shifting perceptual arena housing no one, yet cinematically registering the transit of neural dynamics on an occasionally spot lit stage—is an important feature of global workspace theory and, more generally, is central to the phenomenological side of the neurosciences. For Thomas Metzinger, unlike Roger Penrose or Stuart Hameroff, there is a sharp division between the world described by physics and our immersive internal space.

According to Metzinger's theory, we are all "neurophenomenological cavemen." What the perspective from the humanities, in this case, offers the neurosciences is the observation that Plato's famous subterranean location has become thoroughly *Neoplatonized*. There is no *chiaroscuro* in Metzinger's cavern. Rather, it uncannily resembles a no-exit "smart" device. Ghosts flit inside this nocturnal shell, possessing a sort of online identity. This neurophilosopher, who devised the self-model theory of subjective experience, actually conjures up our contemporary grotto of bits.[24] In a significant departure from Plato's metaphor, the *phenomenal* shadows—unlike the classic view of mediated apparitions cast upon the wall from flames—are "low dimensional projections of internal or external objects in the conscious state space opened within the central nervous system of a biological organism."[25]

Significantly, the humanistic tradition presents other interpretive options. That is, one does not inevitably have to go down the road of an immersive negative dialectics. Metzinger's position represents an extreme, late antique theurgic phenomenology. He has, of course, updated this Neoplatonism of the Cave by invoking new virtual environments in which the multiple operations of the physical organism project inward from all directions, but no subject is there. Think of what his self-organizing systems model—exploiting the autistic dimension of our autopoietic neural operations—*might* have looked like had Metzinger relied on contemporary sensor-based technology as his prototype instead of passive virtual reality. Instead of embedding the participant in an engulfing and enslaving delusion, such reciprocal media environments—replete with, among other things, Chinese dragons or

will-o'-the-wisp autonomous agents—foreground the fact that it is the player who is actively responsible for the generation of images. I am thinking of work such as *Body Electric* (2003), developed by Simon Penny and Malcolm McIver, which shows the user interacting with a real-time 3D avatar (fig. 93). One sees the person and his cyber-replica in a greenish glow, in the midground. And, most importantly, one sees that the Cave has outlines.

Certainly more modulated neuroscientific theories exist, emphasizing the gradations of automaticity involved in the generation of self-consciousness.[26] Antonio Damasio, while underscoring the importance of homeostatic regulation, does not appear to embrace the flight simulator model of first-person experience.[27] Like background emotions, these bioregulatory devices are perpetually poised to keep us going and to avoid any loss of integrity. True, here, as well, no central "I" does the maintaining. The inertial system's need to grapple with intentional behavior and external input is a way of incorporating, rather than bypassing, the environment. Further, if the conscious self is not a thing but rather, as Metzinger claims, a "shaded surface," might it not be more productive to draw on cultural geography rather than on virtual reality, and on maps or mapping for charting the power that symmetry, geometry, and schematization exert on our sense of reality?[28]

The implict model of continuous narrative underlies the hyperphenomenological view that the body is in the machine and that we are only given to ourselves in an ongoing simulated flow. Online communication (which I believe deeply informs

FIGURE 93
Simon Penny and Malcolm McIver, *Body Electric*, 2003. User and realtime 3-D avatar. Courtesy of Simon Penny.

Metzinger's model)—as self-generating electronic files ceaselessly streaming into one another—can be seen as the media reuse of what Mark Turner refers to as "conceptual blending" and Jerome Bruner calls "the narrative creation of self."[29] In chapter 5, I wrestled with this dominant view of mental representation or self-making as a kind of literary development of plot or story. Instead of linguistic models of representation, I put forward visual models of presentation (heraldic devices, blazons, mosaics) demonstrating how thought interpenetrates the components of sensation and the elements of sensation enter into thought. This correlational combinatoric requires that the observer reperform and reinvent them. Such conspicuous composites demonstrate that representations do not hang about in our heads. Rather, as Kevin O'Regan points out (with some help from J. J. Gibson) when you open your eyes and actively interrogate the visual scene, what you see is that aspect, or the physical fragments, of the environment that you perform.[30] In other words, the process is not one of representation but manifestation at the interface where the neural and sensory registers dovetail or become superimposed into a whole.

Like skating, thinking is both an acquired activity and a configurative performance. Derek Melser comments that we have many ways of knowing actions: by observing, demonstrating, miming or simulating, abbreviating them into gestures or schemas, and empathizing or trying them out.[31] Different genres of visual images variously fit together or compact the blazonlike primitives of perception. These vivid, qualia-suffused compoundings become "present to mind" depending on our degrees of attention and on their saliency. This delicate joining of self to world and of world to self, as J. J. Gibson argued in his theory of affordances, is predicated on an organism's response to the visual features of the environment that *matter* to it.[32] The existential and situational problem thus resides not merely in being acquainted with the world we live in. Rather the problem inlaying art formats specifically illuminate is interaction or the cognitive work of conscious crafting.

The automaticity of much of our thought, as discussed in chapter 6, is accentuated by mass or tailored multimedia specifically geared to the unreflective features of rapid cognition, in contrast to activating intentional behavior and the executive function associated with structures in the prefrontal cortex, the cingulum, and the parietal cortex. Touting drugs that precisely target the pleasure-enhancing and pain-modulating neural regions such as the hypothalamus also promotes the unnuanced notion of brains as totally "automatic, rule-governed, determined devices."[33] The advent of personalized medicine and the creation of more pharmecogenomic products proposing specific genetic interventions or addressing particular ethnic and racial groups has further muddled our notion of information selection and the role played by the will. Although this fatalistic view is sometimes mitigated with the caveat that "people are personally responsible agents, free to make their own decisions,"[34] it is unclear how this is supposed to occur.

If determinism mostly rules neural mechanisms then the structures of attention become all the more important. Art formats that accentuate the work of selection and the integration of patterns counter the prevalent "neuromarketing" view of brain function. Spurred by functional neuroimaging this position denies that thinking or the intentional shaping of information, like seeing, is a learned skill. If scientists, like humanists, have wider responsibilities than just to science itself, then the cognitive work of images as actively constructed and constructing "real" concepts must once again take center stage in the now denuded cave of the mind.[35]

NOTES

INTRODUCTION

1. Susan Blackmore, "Stuart Hameroff," in *Conversations on Consciousness: What the Best Minds Think about the Brain, Free Will, and What It Means to Be Human* (Oxford: Oxford University Press, 2005), p. 115.

2. Rudolf Arnheim, "Ein Plaidoyer für Anschauliches Denken," in *Neue Beiträge* (Cologne: DuMont Verlag, 1991), p. 184; translation mine.

3. Sten F. Odenwald, *Patterns in the Void. Why Nothing Is Important* (New York: Westview Press, 2002), p. 9. Nancy Forbes, *Imitation of Life. How Biology Is Inspiring Computing* (Cambridge, Mass.: MIT Press, 2004) p. 67.

4. Alan Richardson, "Literature and the Cognitive Revolution," Special Issue, *Poetics Today* 23 (Spring 2002): 3.

5. As Joseph Dumit noted the anthropologist Victor Turner led the way by relating ritual processes to such findings. See Joseph Dumit, "A Digital Image of the Category of the Person. PET Scanning and Objective Self-Fashioning," in *Cyborgs & Citadels*, ed. Gary Lee Downey and Joseph Dumit (Santa Fe: School of American Research Press, 1997), pp. 83–87.

6. John W. Yolton, *Realism and Appearances. An Essay in Ontology* (Cambridge: Cambridge University Press, 2000), p. 31n8. Elliott S. Valenstein, *The War of the Soups and the Sparks. The Discovery of Neurotransmitters and the Dispute over How Nerves Communicate* (New York: Columbia University Press, 2005).

7. Stanley Cavell, "Something Out of the Ordinary," in *Philosophy the Day After Tomorrow* (Cambridge: Belknap Press of Harvard University, 2005), p. 10.

8. See my *Visual Analogy. Consciousness as the Art of Connecting* (Cambridge, Mass.: MIT Press, 1999).

9. George Lakoff and Mark Johnson, *Philosophy in the Flesh. The Embodied Mind and Its Challenge to Western Thought* (New York: Basic Books, 1999), p. 555.

10. The term is Daniel Dennett's. See his *Sweet Dreams. Philosophical Obstacles to a Science of Consciousness* (Cambridge, Mass.: MIT Press, 2005), p. 171.

11. David Howes, *Empire of the Senses. The Sensual Culture Reader*. Sensory Foundations Series (Oxford and New York: Berg, 2005), p. 5.

12. Maurice Bloch has criticized this tendency specifically within social anthropology. See his "Language, Anthropology, and Cognitive Science," Frazer Lecture, in *Man*, n.s., 26 (1990): 183.

13. Gregory Bateson, *Mind and Nature. A Necessary Unity* (Toronto and New York: Bantam Books, 1980), p. 76. On the continuing importance of Bateson, see: Susan Greenwood, *The Nature of Magic. Anthropology of Consciousness* (Oxford and New York: Berg, 2005), p. 95.

14. Robert A. Wilson, *Boundaries of the Mind. The Individual in the Fragile Sciences. Cognition* (Cambridge: Cambridge University Press, 2004), p. 4. On the considerable spontaneous activity in neuronal networks, see the recent, wide-ranging review by Alain Destexhe and Diego Contreras, "Neuronal Computations with Stochastic Network States," *Science* 314 (October 6, 2006): 85–94.

15. Vilayanur Ramachandran, *The Emerging Mind* (London: BBC in Association with Profile Books Ltd., 2005), and Blackmore, *Conversations on Consciousness*.

16. Alexander Marshack, "The Meander as a System: The Analysis and Recognition of Iconographic Units in Upper Paleolithic Compositions," *Form in Indigenous Art. Schematizations in the Art of Aboriginal Australia and Prehistoric Europe*, ed. by Peter J. Ucko, *Prehistory and Material Culture Series*, no. 13 (Canberra: Australian Institute of Aboriginal Studies, 1977), p. 291.

17. While I respect the effort at engaging the detail, this is not a New Historicist enterprise. See, most recently, Catherine Gallagher and Stephen Greenblatt, *Practicing New Historicism* (Chicago: University of Chicago Press, 2000), p. 4. I do think it is time to reassess structuralism, however. See the reassessment of Levi-Strauss in Clifford Geertz, *Works and Lives. The Anthropologist as Author* (Stanford: Stanford University Press, 1988), p. 33.

18. Dror Wahrman, *The Making of the Modern Self. Identity and Culture in Eighteenth-Century England* (New Haven: Yale University Press, 2004), p. 46.

19. See, for example, Soraya de Chadarevian and Nick Hopwood, eds., *Models. The Third Dimension of Science* (Stanford: Stanford University Press, 2004).

20. See Hans-Jörg Rheinberger, *Toward a History of Epistemic Things. Synthesizing Proteins in the Test Tube* (Stanford: Stanford University Press, 1997), pp. 28–29.

21. John Johnston, "A Future for Autonomous Agents: Machinic *Merkwelten* and Artificial Evolution," *Configurations* 10 (2004): 473–516.

22. Alfred North Whitehead, *Science and the Modern World* (1925; New York: Mentor Book, New American Library, 1964), p. 134.

23. Bruno Latour, *Pandora's Hope. Essays on the Reality of Science Studies* (Cambridge, Mass.: Harvard University Press, 1999), p. 29.

24. See, for example, Mary Poovey, *Making a Social Body. British Cultural Formations 1830–1864* (Chicago: University of Chicago Press, 1995), p. 3, and John Hyman, *The Objective*

Eye. Color, Form, and Reality in the Theory of Art (Chicago: University of Chicago Press, 2006), p. xvii. Joseph Tabbi, *Cognitive Fictions* (Minneapolis: University of Minnesota Press, 2002). Ellen Spolsky, *Gaps in Nature. Literary Interpretation and the Modular Mind* (Albany: SUNY, 2003).

25. See, for example, Francesca Bordogna, *Negotiating Boundaries: Philosophy and the Human Sciences in the Work of William James* (forthcoming).

26. Eli Zaretsky, *Secrets of the Soul. A Social and Cultural History of Psychoanalysis* (New York: Alfred A. Knopf, 2004), p. 5.

27. Jeffrey M. Schwartz, *The Mind and the Brain. Neuroplasticity and the Power of Mental Force* (New York: HarperCollins Publishers, Inc, 2002), p. 23.

28. Michael Hardt and Antonio Negri, *Empire. Die neue Weltordnung*, trans. Thomas Atzet and Andreas Wirthensohn (Frankfurt and New York: Campus Verlag, 2000), pp. 38–39.

29. Slavoj Zizek, *The Parallax View* (Cambridge, Mass.: MIT Press, 2006), pp. 162–63.

CHAPTER ONE

1. Terrence W. Deacon, *The Symbolic Species. The Co-Evolution of Language and the Brain* (New York: W. W. Norton, 1997), pp. 111–12.

2. Cited in *Poetics of the New American Poetry*, ed. Donald Allen and Warren Tallman (New York: Grove Press, 1973), p. 38.

3. Hamsa Walker, "Mirror, Mask, Monitor, Myth," *Joan Jonas: Lines in the Sand. The Shape, the Scent, the Feel of Things*, exh. brochure (Chicago: Renaissance Society, May 2–June 13, 2004).

4. Robert Irion, "As the Galaxies Turn," *Science* (January 7, 2005): 64–65.

5. Lynn Meskell, *Object Worlds in Ancient Egypt. Material Biographies Past and Present* (Oxford and New York: Berg, 2005), p. 140.

6. Sean Cubitt, "Grayscale Video and the Shift to Color," *Art Journal* 65 (Fall 2006): 46.

7. Jean Gagnon, "A Demo Tape on How to Play Video on the Violin," *Art Journal* 65 (Fall 2006): 72–74.

8. V. S. Ramachandran, *A Brief Tour of Human Consciousness. From Impostor Poodles to Purple Numbers* (New York: PI Press, 2003), p. xi.

9. Marjorie Grene and David Depew, *The Philosophy of Biology. An Episodic History* (Cambridge: Cambridge University Press, 2004), pp. 340–41.

10. Ellen Spolsky, "Towards a Theory of Embodiment for Literature," *Poetics Today* 24 (Spring 2003): 128–29.

11. See, especially Paul de Man, "The Dead-End of Formalist Criticism, in *Blindness and Insight. Essays in the Rhetoric of Contemporary Criticism,* 2nd ed. (Minneapolis: University of Minnesota Press, 1983), pp. 229–45. Also see the essay by Richard Strier, "How Formalism Became a Dirty Word" (forthcoming).

12. David L. Stern, "Morphing into Shape," *Science* 313 (July 7, 2006): 50–51.

13. David Bordwell, *Figures Traced in Light. On Cinematic Staging* (Berkeley: University of California Press, 2005), p. 238.

14. Cited in Brian Boyd, "Evolutionary Theories of Art," in *The Literary Animal. Evolution and the Nature of Narrative*, ed. Jonathan Gottschall and David Sloan Wilson (Evanston, Ill.: Northwestern University Press, 2005), p. 155.

15. Albert Gell, *Art and Agency. An Anthropological Theory* (Oxford: Oxford University Press, 1998), p. 20.

16. Yudhijit Bhattacharjee, "Neuroscientists Welcome Dalai Lama with Mostly Open Arms," *Science* 310 (November 18, 2005): 1104.

17. Richard Monastersky, "What Happens to Your Brain While Praying," *Chronicle of Higher Education* 52 (May 26, 2006), A14.

18. Mihaela C. Fistioc, *The Beautiful Shape of the Good. Platonic and Pythagorean Themes in Kant's Critique of the Power of Judgment* (New York: Routledge, 2002), p. 104.

19. Gerald M. Edelman, *Wider than the Sky. The Phenomenal Gift of Consciousness* (New Haven: Yale University Press, 2004), pp. 16–17.

20. Joseph E. Bogan, "On the Neurophysiology of Consciousness: An Overview," in *Essential Sources in the Scientific Study of Consciousness,* ed. Bernard J. Baars, William P. Banks, and James B. Newman (Cambridge, Mass.: MIT Press, 2003), p. 891.

21. See, Martha Whittington's *Pitch*, an installation she exhibited at the University of Georgia Lamar Dodd School of Art, Athens, Ga. (September 7–October 8, 2004).

22. Abner Shimony, "On Mentality, Quantum Mechanics and the Actualization of Potentialities," in Roger Penrose, *The Large, the Small and the Human Mind* (Cambridge: Cambridge University Press, 1997), p. 158.

23. Roger Penrose, *Shadows of the Mind. A Search for the Missing Science of Consciousness* (Oxford: Oxford University Press, 1994), pp. 368–69.

24. Stuart Hameroff, "Consciousness, the Brain, and Spacetime Geometry," in *Cajal and Consciousness. Scientific Approaches to Consciousness on the Centennial of Ramon y Cajal's Textura*, ed. Pedro C. Marijuan, *Annals of the New York Academy of Sciences* 929 (April 2001): 74.

25. Wilson also creates animations. See Bruce Jenkins, ed., *Errant Behaviors. Anne Wilson,* with audio remix by Shawn Decker (Bloomington, Ind.: SoFA Gallery, Indiana University, 2005), p. 3.

26. John A. McCarthy, *Remapping Reality. Chaos and Creativity in Science and Literature (Goethe-Nietzsche-Grass)* (Amsterdam, New York: Rodopi, 2006), pp. 61–63.

27. John Sutton, *Philosophy and Memory Traces. Descartes to Connectionism* (Cambridge: Cambridge University Press, 1998), pp. 48, 154.

28. Cited in Edward S. Casey, *Remembering. A Phenomenological Study* (Bloomington, Ind.: Indiana University Press, 1987), pp. 49–50.

29. Gyorgy Kepes, *Language of Vision* (Mineola, N.Y.: Dover Publications, 1995).

30. F. Robert Rodman, *Winnicott. Life and Work* (Cambridge, Mass.: Perseus Publishing, 2003), p. 153.

31. David Rudrauf and Antonio Damasio, "A Conjecture Regarding the Biological Mechanism of Subjectivity and Feeling," *Journal of Consciousness Studies* 12, nos. 8, 9, 10 (2005): 239–40.

32. Alfred Gell, *The Art of Anthropology. Essays and Diagrams*, ed. Eric Hirsch, London School of Economics Monographs on Social Anthropology, 67 (London and New Brunswick, N.J.: Athlone Press, 1999), pp. 11–13.

33. Clifford Geertz, *Works and Lives. The Anthropologist as Author* (Stanford: Stanford University Press, 1988), p. 37.

34. Tim Crane, "The Intentional Structure of Consciousness," in *Consciousness. New Philosophical Perspectives*, ed. Quentin Smith and Alexander Jokic (Oxford: Clarendon Press, 2003), p. 33.

35. Isaiah Berlin, *Three Critics of the Enlightenment. Vico, Hamann, Herder* (Princeton and Oxford: Princeton University Press, 2000), pp. 46–52.

36. Christopher Drew Armstrong, "Myth and the *New Science:* Vico, Tiepolo, and the Language of the Optimates," *Art Bulletin* 87 (December 2005): 649–50.

37. J. A. Scott Kelso and David A. Engstrøm, *The Complementary Nature* (Cambridge, Mass.: MIT Press, 2006), pp. 85–87.

38. For the aesthetic and philosophical importance of analogy as a method of structuring the world, see my *Visual Analogy. Consciousness as the Art of Connecting* (1999; Cambridge, Mass.: MIT Press, 2001).

39. Johann Gottfried Herder, "Plastik. Einige Wahrnehmungen über Form und Gestalt aus Pygmalions Bildendem Träume," in *Herder und die Anthropologie der Aufklärung, Herder Werke,* ed. W. Pross (Munich: Carl Hanser Verlag, 1987), 2:470. Quotes taken from Herder, *Plastik,* ed. and trans. Jason Gaiger (Chicago: University of Chicago Press, 2002).

40. Ibid., p. 528.

41. Albert-Laszlo Barabasi, "Network Theory—The Emergence of the Creative Enterprise," *Science* 308 (April 29, 2005): 639–40.

42. Isaiah Berlin, "A Letter on Human Nature" (February 24, 1986), reprinted in the *New York Review of Books* (September 22, 2004), p. 26.

43. On the nineteenth-century uses of grammar in the creation of a formalist art history from Charles Blanc, Owen Jones, to Alois Riegl, see Claire Barbillon, "La grammaire comme modèle de l'histoire de l'art," lecture delivered June 5, 2004, Colloque International, *Histoire de l'histoire de l'art en France au XIXe siècle.*

44. Marc D. Hauser, *Moral Minds. How Nature Designed Our Universal Sense of Right and Wrong* (New York: HarperCollins, 2005).

45. Robert M. May, "Uses and Abuses of Mathematics in Biology," *Science* 303 (February 6, 2004): 788–89. Also see, Robert Zimmer, "Abstraction in Art with Implications for Perception," in *The Abstraction Paths. From Experience to Concepts.* Papers of a Theme Issue, ed. by L. Saitta, *Philosophical Transactions of the Royal Society* 358 (July–September 2003): 1287.

46. Deacon, *The Symbolic Species*, p. 89.

47. Robert A. Wilson, *Boundaries of the Mind. The Individual in the Fragile Sciences* (Cambridge: Cambridge University Press, 2004), p. 147.

48. Suzanne Küchler, *Malanggan. Art, Memory and Sacrifice* (Oxford and New York: Berg, 2002), p. 11.

49. Marie Mulvey Roberts, "Hogarth on the Square. Framing the Freemasons," in *British Journal for Eighteenth-Century Studies* 26 (2003): 262.

50. William Hogarth, *The Analysis of Beauty. Written with a View to Fixing the Fluctuating Ideas of Taste* (London: Printed by J. Reeves for the Author, 1753), pp. 139–40.

51. Eva Jablonka and Marion J. Lamb, *Evolution in Four Dimensions. Genetic, Epigenetic,*

Behavioral, and Symbolic Variation in the History of Life (Cambridge, Mass.: A Bradford Book, MIT Press, 2005), p. 201.

52. See Casey, *Remembering*, p. 98.

53. Max Wertheimer, "Über das Denken der Naturvölker," in *Drei Abhandlungen zur Gestalttheorie* (Darmstadt: Wissenschaftliche Buchgesellschaft, 1967), p. 108.

54. Franco Moretti, *Graphs, Maps, Trees. Abstract Models for a Literary History* (London and New York: Verso, 2005), pp. 1, 8.

55. Raphael Rosenberg, "Le schema de composition. Outil et symptôme de la perception du tableau," lecture presented at the Colloque International, Histoire de l'art en France au XIXe siècle (June 5, 2004).

56. Franziska Lentsch, ed., *Füssli. The Wild Swiss*, exh. cat. (Zurich: Kunsthaus Zurich, 2006), pp. 103–6.

57. Christof Koch, *The Quest for Consciousness. A Neurophysiological Approach* (Englewood, Colo.: Roberts and Company, Publishers, 2004), p. 165.

58. See Eric R. Kandel, *In Search of Mind. The Emergence of a New Science of Mind* (New York: W. W. Norton, 2006).

59. Robert Rix, "'Letters in a Strange Character': Runes, Rocks, and Romanticism," *European Romantic Review* 16 (December 2005): 597–99.

60. Although speaking of the rise of capitalism and the new social space it entailed, Mary Poovey's remarks are pertinent for earlier moments of the Industrial Revolution as well. See her, *Making a Social Body. British Cultural Formation 1830–1864* (Chicago: University of Chicago Press, 1995), p. 31.

61. Magic, as an alternative state of consciousness, may exist alongside the most acute processes of rationalization. See Susan Greenwood, *Magic, Witchcraft and the Otherworld. An Anthropology* (Oxford and New York: Berg, 2000), pp. 26–27.

62. Stefan Willer, "Zur Poetik der Zeugung um 1800," in *Generation. Zur Genealogie des Konzepts-Konzepte von Genealogie*, ed. Sigrid Weigel, et al. (Munich: Wilhelm Fink Verlag, 2005), pp. 130–31.

63. See Robert J. Richards, *The Romantic Conception of Life. Science and Philosophy in the Age of Goethe* (Chicago: University of Chicago Press, 2002), p. 59.

64. Volker Langbehn, "The Lacanian Gaze and the Role of the Eye in Early German Romanticism," *European Romantic Review* 16 (December 2005): 619.

65. Gerald L. Bruns, *Maurice Blanchot. The Refusal of Philosophy* (Baltimore: Johns Hopkins University Press, 1997), p. 149.

66. Peter T. Struck, *Birth of the Symbol. Ancient Readers at the Limits of Their Texts* (Princeton: Princeton University Press, 2004), p. 275.

67. Stanislas Dehaene, Veronique Izard, Pierre Pica, Elizabeth Spelke, "Core Knowledge of Geometry in an Amazonian Indigene Group," *Science* 311 (January 20, 2006): 381–84.

68. Citing Harvard psychologist Elizabeth Spelke, a coauthor with Nicholas Bakalar, "Mastering the Geometry of the Jungle (or Doin' What Comes Naturally)" *New York Times,* Science Times (January 24, 2006), D3.

69. Paul Elliott, "Erasmus Darwin, Herbert Spencer, and the Origins of the Evolutionary World View in British Provincial Scientific Culture, 1770–1850," *Isis* 94 (2003): 9.

70. Semir Zeki, *Inner Vision. An Exploration of Art and the Brain* (Oxford: Oxford University Press, 1999), p. 81.

71. Maurice Oleander, *The Language of Paradise. Aryans and Semites. A Match Made in Heaven* (New York: Other Press, 1992), pp. 4–5.

72. Jean-Pierre Changeux, *The Physiology of Truth. Neuroscience and Human Knowledge,* trans. M. B. DeBevoise (Cambridge, Mass.: Belknap Press of Harvard University Press, 2004), pp. 215–18.

73. Zeki, *Inner Vision,* pp. 94–96.

74. On the connection between physiognomics and the long tradition of canons of the body, see Claire Barbillon, *Les Canons du corps humain au XIXe siècle. L'Art et la règle* (Paris: Odile Jacob, 2004), pp. 86–91.

75. Joaquin M. Fuster, *Cortex and Mind. Unifying Cognition* (Oxford: Oxford University Press, 2003), pp. x–xi.

76. John van Wyhe, *Phrenology and the Origins of Victorian Scientific Naturalism* (Burlington, Vt.: Ashgate, 2004), p. 74.

77. Carl Linfert, *Die Grundlagen der Architekturzeichnung. Mit Einem Versuch über Französische Architekturzeichnungen des 18. Jahrhunderts,* Forschungen, *Wiener Jahrbuch,* vol. 1 (1933): 135–36.

78. George F. Striedter, *Principles of Brain Evolution* (Sunderland, Mass.: Sinauer Associates, 2005), pp. 8–13.

79. Daniel C. Dennett, *Kinds of Mind. Towards an Understanding of Consciousness* (New York: Basic Books, 1996), p. 63.

80. Kate Wong, "Frühe Spuren des Menschlichen Geistes," *Spektrum der Wissenschaft,* 12 (2005): 35–49.

81. Terrence Deacon has also said that archaeological evidence is one of the few windows through which we can glimpse mental activity of a prehistoric society. See his *Symbolic Species,* p. 366.

82. Ramachandran, *A Brief Tour of Human Consciousness,* p. 38.

83. Joaquin M. Fuster, *Cortex and Mind. Unifying Cognition* (Oxford: Oxford University Press, 2003), pp. vii–viii.

84. Timothy D. Wilson, *Strangers to Ourselves. Discovering the Adaptive Unconscious* (Cambridge, Mass.: Harvard University Press, 2002), p. 19.

85. Charles Rzepka, *Lyrical Empiricism. British Romantic Poetry, the Sciences of Prehistory, and Literary Detection* (forthcoming).

86. Cited in Chris McManus, *Right Hand, Left Hand. The Origins of Asymmetry in Brains, Bodies, Atoms, and Cultures* (Cambridge, Mass.: Harvard University Press, 2002), pp. 62–64.

87. On the influence of Paracelsus (1493–1541) on chemistry, medicine, and natural philosophy, see Mi Gyung Kim, *Affinity, That Elusive Dream. A Genealogy of the Chemical Revolution* (Cambridge, Mass.: MIT Press, 2003), pp. 23–24.

88. J. P. S. Uberoi, *The European Modernity. Science, Truth and Method* (Oxford: Oxford University Press, 2002), pp. 54–55.

89. David Jasper, *The Sacred and Secular Canon in Romanticism. Preserving the Sacred Truths* (London: MacMillan Press, 1999), p. 21.

90. See Deacon, *Symbolic Species*, p. 117.

91. William H. Calvin, *A Brain for All Seasons. Human Evolution and Abrupt Climate Change* (Chicago: University of Chicago Press, 2002), pp. 47–56.

92. See David Talbot, "The Deceit Detector," in *Technological Review* (June 2003), pp. 67–69, on the use of gold-colored infrared-light emitters surrounded by detectors that measure light reflected from the prefrontal cortex in action.

93. See Charles Siebert, "An Elephant Crackup," *New York Times Magazine* (October 8, 2006). I thank Mara Naselli for this reference.

94. Sigrid Weigel, "Zur Dialektik von Geschlecht und Generation um 1800. Stifter's *Narrenburg* als Schauplatz von Umbrüchen," in *Generation*, p. 110.

95. Peter Ackroyd, *Blake* (London: Sinclair-Stevenson, 1995), pp. 184–86.

96. James Gorman, "The Unbearable Loneliness of Being Homo-Sapiens," *New York Times,* Science Times (March 15, 2002), B1.

97. Steven Mithen, *The Singing Neanderthals. The Origins of Music, Language, Mind and Body* (London: Weidenfeld and Nicolson, 2005), p. 138.

98. David Lewis Williams, *The Mind in the Cave. Consciousness and the Origins of Art* (London: Thames and Hudson, 2002), pp. 66–67.

99. Daniel Rosenberg, "Louis-Sebastien Mercier's New Words," *Eighteenth-Century Studies* 36 (2003): 370.

100. Noam Chomsky, *Cartesian Linguistics. A Chapter in the History of Rationalist Thought* (New York: Harper and Row, 1966), p. 52. Steven Pinker, *The Language Instinct. How the Mind Creates Language* (New York: HarperCollins, 1994), p. 239.

101. Brian P. Copenhaven, "Number, Shape, and Meaning in Pico's Christian Cabala: The Upright *Tsade*, the Closed *Mem*, and the Gaping Jaws of *Azazel*," in *Natural Particulars. Nature and the Disciplines in Renaissance Europe*, ed. Anthony Grafton and Nancy Siraisi (Cambridge, Mass.: MIT Press, 1999), pp. 28–37.

102. Michael J. B. Allen, "Marisilio Ficino (1433–1499): Daemonic Mathematics and the Hypotenuse of the Spirit," in *Natural Particulars*, pp. 122–26.

103. Tristan Dagron, "La doctrine de l'essence du Giordano Bruno," in *Mondes, formes et société selon Giordano Bruno*, ed. Trisan Dagron et Hélène Vedrine (Paris: Librairie Philosophique J. Vrin, 2003), pp. 133–41.

104. Ingrid D. Rowland, *The Scarith of Scornello. A Tale of Renaissance Forgery* (Chicago: University of Chicago Press, 2004), p. 20.

105. James J. Bono, *The Word of God and the Languages of Man. Interpreting Nature in Early Modern Science and Medicine*, vol. 1: *Ficino to Descartes* (Madison: University of Wisconsin Press, 1995), pp. 193–98.

106. Linda C. Mitchell, *Grammar Wars. Language as a Cultural Battlefield in Seventeenth- and Eighteenth-Century England* (Burlington, Vt.: Ashgate, 2001), pp. 3–11.

107. For the continuing relevance of emblematic structure, see Gregory L. Ulmer, *Internet Invention. From Literacy to Electracy* (New York: Longman, 2003), pp. 247–49.

108. Deidre Shauna Lynch, *The Economy of Character Novels, Mass Culture, and the Business of Inner Meaning* (Chicago: University of Chicago Press, 1998), p. 133.

109. Jonathan Ree, *I See a Voice. Deafness, Language and the Senses. A Philosophical History* (New York: Metropolitan Books/Henry Holt and Company, 1999), pp. 272–76.

110. See John Flenley and Paul Bahn, *The Enigmas of Easter Island* (Oxford: Oxford University Press, 2004), and Jo Anne Van Tilburg, *Among Stone Giants. The Life of Katherine Routledge and Her Remarkable Expedition to Easter Island* (New York: Scribner, 2004).

111. See Ann Gibbons, "Dates Revise Easter Island History," *Science* 311 (March 10, 2006): 1360; and Terry L. Hunt and Carl P. Lipp, "Late Colonization of Easter Island," *Science* 311 (March 17, 2006): 1603–6.

112. David Cox, Ethan Meyers, Pawan Sinha, "Contextually Evoked Object-Specific Responses in Human Visual Cortex," *Science* 304 (April 2, 2004): 115–17.

113. The term "wonder tissue" was first coined by Daniel Dennett in *Consciousness Explained* (Boston: Little Brown, 1991), and has been used many times since. Jean-Pierre Dupuy, *The Mechanism of the Mind. On the Origins of Cognitive Science*, trans. M. B. DeBevoise (Princeton: Princeton University Press, 2000).

114. Aileen Forbes, "'Sympathetic Curiosity' in Joanna Baillie's Theater of the Passions," *European Romantic Review* 14 (2003): 32.

115. Edwin Block, Jr., "Heinrich von Kleist: 'On the Puppet Theater,' the Broken Jug, and Tensions in the Romantic Theatrical Paradigm," in *European Romantic Review* 14 (2003): 65–66.

116. Alan Richardson, *British Romanticism and the Science of the Mind* (Cambridge: Cambridge University Press, 2001), p. xiv.

117. Werner Hofmann, *Caspar David Friedrich. Naturwirklichkeit und Kunstwahrheit* (Munich: Verlag C. H. Beck, 2000), p. 66.

118. Semir Zeki, "A Theory of Microconsciousness," Lecture-Seminar "Recherches / Mixités: Arts-Science-Technologies" (Paris: IRCAM, April 25, 2003).

119. On historicism, see Michael Podro, *The Critical Historians of Art* (New Haven: Yale University Press, 1982); and Mari Hvattum, *Gottfried Semper and the Problem of Historicism* (Cambridge and New York: Cambridge University Press, 2004).

120. Cited in Peter Schjeldahl, "The Prophet. Malevich's Revolution," *New Yorker* (June 2, 2003), p. 92.

121. Charlie Wylie, introduction to *Thomas Struth 1977–2002* , exh. cat. (Dallas: Dallas Museum of Art, 2002), pl. 48: *Louvre IV, Paris* (1989).

122. Ibid., pl. 121: *Notre Dame, Paris* (2001). Wolf Dieter Heilmeyer, introduction to *Pergamon Museum. 1/2/3/4/5/6* (Munich: Schirmer Verlag, 2004), Pergamon Museum 6.

123. Lev Manovich, *The Language of New Media* (Cambridge, Mass.: MIT Press, 2001), p. 218. *Joelle Tuerlinckx. Chicago Studies: Les étants données.* exh. brochure (Chicago: Renaissance Society, May 4–June 15, 2003).

124. Mark B. N. Hansen, "Cinema Beyond Cybernetics, or How to Frame the Digital Image," *Configurations* 10 (2002): 52.

125. Latour, "Circulating Reference. Sampling Soil in the Amazon Forest," in *Pandora's Hope*, pp. 55–56.

126. Bruno Latour, "Drawing Things Together," in *Representation in Scientific Practice*, ed. Michael Lynch and Steve Woolgar (Cambridge, Mass.: MIT Press, 1990), p. 26.

CHAPTER TWO

1. Lynn Margulis, "The Conscious Cell," in *Cajal and Consciousness. Scientific Approaches to Consciousness on the Centennial of Ramon y Cajal's Textura*, ed. Pedro C. Marijuan, *Annals of the New York Academy of Sciences* 929 (April 2001): 55.

2. Friedrich Schlegel, *Literarische Notizen [Literary Notebooks], 1797–1801*, ed. Hans Eichner (Frankfurt-am-Main, Berlin, Vienna: Ullstein Materialien, 1980), p. 32n103.

3. Andy Clark, *Being There. Putting Brain, Body, and World Together Again* (Cambridge, Mass.: MIT Press, 1997), pp. 167–68.

4. David Rudrauf and Antonio Damasio, "A Conjecture Regarding the Biological Mechanism of Subjectivity and Feeling," *Journal of Consciousness Studies*, nos. 8–10 (2005): 259.

5. Steven Feld, "Places Sensed, Senses Placed. Toward a Sensuous Epistemology of Environments," in *Empire of the Senses. The Sensual Culture Reader,* ed. David Howes (Oxford and New York: Berg, 2005), p. 188.

6. Victor Turner, *The Forest of Symbols. Aspects of Ndembu Ritual* (Ithaca, N.Y.: Cornell University Press, 1967), p. 99.

7. Semir Zeki, *A Vision of the Brain* (Oxford: Blackwell Scientific Publishers, 1993), p. 144.

8. John Manning, *The Emblem* (London: Reaktion Books, 2002), p. 15. In the first half of the sixteenth century, the emblem was also called a *symbolum*.

9. Jakob von Uexkull's idea of an *Umwelt* was based on the vision of different animals inhabiting different effective environments derived by the parameters that matter to that animal. Cited in Andy Clark, *Being There,* pp. 24–25.

10. *Porphyry*, introduction, translation, and commentary by Jonathan Barnes (Oxford: Clarendon Press, 2003), p. 42.

11. Christoph Weigel, *Gedanken Muster und Anleitungen. Worinnen eine grosse Zahl nicht allein sumarischer sondern auch moral Emblematischen Figuren in vier Sprachen als Lat., Franz., Ital., und Teutsch vorstellet samt nach eines Stambuchs schöner Anweisungen woraus bey jeder Gelegenheit aus Solchen etwas kan gezogen werden* (1666), nos. 11, 169, 230.

12. Henri Focillon, *Vie de Formes* (Paris: Librairie Ernest Leroux, 1934), p. 41. Also see the computer graphics work coupling geometric crystallography with the generation of periodic tilings in L. Loreto, R. Farinato, M. Tonetti, "Crystallography and Plane Ornaments: Interactive Multi-window Computer Graphics," in *The Visual Mind: Art and Mathematics,* ed. Michele Emmer (Cambridge, Mass.: MIT Press, 1993), pp. 187–89.

13. Humberto R. Maturana and Francisco J. Varela, *Autopoiesis and Cognition. The Realization of the Living* (Dordrecht and Boston: D. Reidel Publishing Company, 1980), p. 13. Also see J. A. Scott Kelso and David A. Engstrom, *The Complementary Nature* (Cambridge, Mass.: MIT Press, 2006), p. 124.

14. Citing the NIH biologist Benjamin C. Gruenberg in Evelyn Fox Keller, *Making Sense of Life. Explaining Biological Development with Models, Metaphors, and Machines* (Cambridge, Mass.: Harvard University Press, 2002), pp. 20; 202–3.

15. On the mechanism of segmentation in biology more generally, see Alessandro Minelli, "Bits and Pieces," *Science* 306 (December 3, 2004): 1693–94.

16. Cary Wolfe, "From Dead Meat to Glow in the Dark Bunnies. Seeing 'the Animal Question' in Contemporary Art," *Parallax* 12, no. 1 (2006): 103. Daniel S. Russell, *The Emblem and Device in France* (Lexington, Ky.: French Forum, Publishers, 1985), pp. 23–24.

17. Bernadette Bensaude-Vincent and Isabelle Stengers, *A History of Chemistry* (Cambridge, Mass.: Harvard University Press, 1996), p. 206.

18. On self-organization and self-maintenance, see Wolfgang Krohn and Günter Küppers, "Self-Organization: A New Approach to Evolutionary Epistemology," in *Issues in Evolutionary Epistemology*, ed. Kai Hahlweg and C. A. Hooker (Albany: State University of New York Press, 1989), p. 157.

19. Felice Frankel, *Envisioning Science. The Design and Craft of the Science Image* (Cambridge, Mass.: MIT Press, 2002), pp. 176–77. See especially the section on photography through a stereomicroscope using UV light. For a review of a three-day conference organized by Frankel on scientific visualization, see Margaret Wertheim, "The Imageers. Science Shows Its (New) Visual Side," *LA Weekly* (August 19–25, 2005).

20. "Argonne Dedicates New Center for Nanoscale Materials," *Argonne National Laboratory News* 59 (October 2, 2006): 1–2.

21. Andrew Barry, "Pharmaceutical Matters. The Invention of Informed Materials," *Theory, Culture, and Society* 22, no. 1 (2005): 59.

22. James J. Bono, "Perception, Living Matter, Cognitive Systems, Immune Networks. A Whiteheadian Future for Science Studies," *Configurations* 13 (2005, forthcoming), pp. 8, 16.

23. Alfred North Whitehead, *Science and the Modern World* (New York: Free Press, 1967), p. 4.

24. David J. Chalmers, *The Conscious Mind. In Search of a Fundamental Theory* (Oxford and New York: Oxford University Press, 1996). Also see Hameroff, "The Brain and Space-Time Geometry," p. 78.

25. Rodolfo R. Llinas, *I of the Vortex. From Neurons to Self* (Cambridge, Mass.: MIT Press, 2001), p. 2.

26. Bono, "Perception, Living Matter, Cognitive Systems, Immune Networks," p. 19.

27. Natasha K. Hussain and Morgan Sheng, "Making Synapses: A Balancing Act," *Science* 307 (February 25, 2005): 1207.

28. Elisabeth Pennisi, "Synthetic Biology Remakes Small Genomes," *Science* 310 (November 4, 2005): 769.

29. For recent exhibitions, see especially, the excellent *Gene(sis). Contemporary Art Explores Human Genomics*, Mary and Leigh Block Museum of Art, Northwestern University (Evanston, Ill. September 10–November 28, 2005).

30. Hal Cohen, "Bioscience Moves into Galleries as Bioart," *Scientist* (November 11, 2002): 57–58.

31. Richard Gallagher, "One Lumper or Two," commentary, *Scientist* (November 11, 2002): 12. Also see, Andrew Pollack, "Custom-Made Microbes, at Your Service," *New York Times*, Science Times (January 17, 2006), D1, D4.

32. Suzanne Anker, *Reprotech. Building Better Babies?* exhibit, New York Academy of Arts and Sciences (New York: May 13–June 19, 2004). Also see her book with Dorothy

Nelkin, *The Molecular Gaze. Art in the Genetic Age* (Woodbury, N.Y. Cold Spring Harbor Laboratory Press, 2004).

33. Robert Deliege, *Levi-Strauss Today. An Introduction to Structural Anthropology* (Oxford, New York: Berg, 2004), p. 96.

34. Rainer Naegele, "The Laughing Tear: Constructions of Allegory in Modernism," in *New Directions in Emblem Studies,* vol. 4, ed. Amy Wygant (Glasgow: Glasgow Emblem Studies, 1999), p. 86.

35. William Gibson, *Pattern-Recognition* (New York: G. P. Putnam's Sons, 2003), p. 8.

36. Daniel Russell, *Emblematic Structures in Renaissance French Culture* (Toronto, Buffalo, London: University of Toronto Press, 1995), pp. 238–41.

37. Jan-Mathijs Schoffelen, Robert Oostenveld, and Pascal Fries, "Neuronal Coherence as a Mechanism of Effective Corticospinal Interaction," in *Science* 308 (April 1, 2005): 111, 113. Also see Ingrid Wickelgren, "Vision's Grand Theorist," *Science* 314 (October 6, 2006): 78–79.

38. Alfred Gell, *Art and Agency. An Anthropological Theory* (Oxford: Clarendon Press, 1998), p. 6.

39. Hans Sedlmayr, "Brueghel's *Macchia* (1934)," in *The Vienna School Reader. Politics and Art Historical Method in the 1930s,* ed. Christopher S. Wood (New York: Zone Books, 2000), p. 325. Amazingly, Sedlmayr never mentions emblematic structure in discussing Brueghel's middle-period paintings.

40. Mark A. Meadows, *Pieter Brueghel the Elder's Netherlandish Proverbs and Practice of Rhetoric* (Zwolle: Waanders Publishers, 2002). On splitting or metapictoral strategies, see also Victor I. Stoichita, *The Self-Aware Image. An Insight into Early Modern Meta-Painting,* trans. Anne-Marie Glasheen (Cambridge: Cambridge University Press, 1997), pp. 67–68.

41. Anne Burkus-Chasson, "Visual Hermeneutics and the Act of Turning the Leaf: A Genealogy of Liu Yuan's *Lingyan ge,*" in *Printing and Book Culture in Late Imperial China,* ed. Cynthia J. Brokaw and Kai-wing Chow (Berkeley, Los Angeles, London: University of California Press, 2001), pp. 372–76.

42. Juliet Fleming, "How to Look at a Printed Flower," *Word and Image* 22 (April-June, 2006), pp. 165–87. On the creative component of reading as selecting, assembling, and roaming through a text, see Anna Sigrídur Arnar, "'A Modern Popular Poem'. Stéphane Mallarmé on the Visual Rhetorical, and Democratic Potential of the fin-de-siècle Newspaper," *Word and Image* 22 (October–December 2006), esp. pp. 318–26.

43. This is not the hermeneutic sense of emphasis as equivocality or double meaning but the rhetorical sense of underscoring. For the first sense see, Claudia Schmolders "'Sinnreiche Gedancken.' Zur Hermeneutik des Chladenius," in *Archiv fur Geschichte der Philosophie* 58, no. 3 (1976): 248.

44. I thank John T. Hamilton for drawing my attention to Roman Jakobsen's argument that the "phatic" is the sixth function of language and possesses a pointing or indicative function—as, indeed, does *enargeia.*

45. Paul Virilio, *The Vision Machine* (Bloomington: University of Indiana Press, 1994), p. 14. Also see Warren Neidich, "Constructing Global Consciousness," in *The Body and Architecture,* ed. Deborah Hauptman (forthcoming).

46. See the discussion of Marc Jeannerod, *La nature de l'esprit. Sciences cognitives et cerveau* (Paris: Odile Jacob, 2004), pp. 85–89. Although he does not mention Gibson, Nicholas Humphrey comes close to his position when he identifies sensation with self-consciousness. See his *Seeing Red. A Study in Consciousness* (Cambridge, Mass.: Belknap Press, 2006), p. 71.

47. Herman Pleij, *Colors Demonic and Divine. Shades of Meaning in the Middle Ages and After*, trans. Diane Webb (New York: Columbia University Press, 2004), p. 80.

48. Jean Menestrier, *Traité des Tournois, joustes, carrousels, et autres spectacles publics* (Lyon: Chez Jacques Muguet, 1669), pp. 6, 235–36.

49. Charles C. Mann, "Cracking the Khipu Code," *Science* 300 (June 13, 2003): 1650–51.

50. Russell, *Emblem and Device in France,* pp. 163–66.

51. Daniel de La Feuille, *Essay d'un Dictionnaire contenant la connoissance du monde, des sciences universelles, et particulièrement celle des médailles, des passions, des moeurs, des vertus et des vices, etc. Représenté par des Figures Hiéroglyphiques, expliqués en prose & en vers* (Amsterdam: Chez Daniel de La Feuille, 1700), p. 24.

52. On the punctual self, see Charles Taylor, *Sources of the Self* (Cambridge: Cambridge University Press, 1989), pp. 158–62.

53. Caesare Ripa, *Iconologie ou la science des emblèmes, devises, etc.,* augmented by J. B. de l'Académie Françoise (Amsterdam: Chez Adrian Braakman, 1698), 2:2–3.

54. The debate as to whether early sign systems do or do not encode language is alive and well. See Andrew Lawler, "The Indus Script—Write or Wrong?" *Science* 306 (December 17, 2004): 2026–29.

55. Arielle Saiber, *Giordano Bruno and the Geometry of Language* (Burlington, Vt: Ashgate, 2005), p. 49. Jaap Maat, *Philosophical Languages in the Seventeenth-Century. Dalgarno, Wilkins, Leibniz* (Dordrecht, Boston, London: Kluwer, 2004), p. 12.

56. Ingrid D. Rowland, "A Lesson of September 11," *New York Review* (October 7, 2004), p. 34.

57. For the tradition of "sumarie forms and pictures," see *The Heroicall Devises of M. Claudius Paradin (1591),* with an introduction by John Doebler (Delmar, N.Y.: Scholars' Facsimiles and Reprints, 1984), p. vi.

58. On the importance of *imitatio* to emblem construction, see Hieronymus Ammon, *Imitatio Crameriana (Nuremberg 1649),* with an introduction by Sabine Modersheim (Turnhout: Brepolis, 1999), p. 12. See also Daniel Russell, "The Ornamental Image. Memory, Decoration, and Emblems," in *Emblem Studies,* p. 200.

59. Christof Koch, *The Quest for Consciousness* (New York: Roberts and Company, 2004), p. 42.

60. Elizabeth A. Wilson, *Psychsomatic. Feminism and the Neurological Body* (Durham: Duke University Press, 2004), p. 69.

61. V. S. Ramachandran, *A Brief Tour of Human Consciousness. From Impostor Poodles to Purple Numbers* (New York: PI Press, 2003), p. 25.

62. See my *Visual Analogy. Consciousness as the Art of Connecting,* esp. chap. 4: "Recombinancy. Binding the Computational New Mind to the Combinatorial Old Mind"; see also "Levelling the New Old Transcendence. Cognitive Coherence in the Era of Beyondness," *New Literary History,* special issue on Coherence, 35 (Spring 2004): esp. 324–28.

63. Natasha K. Hussain and Morgan Sheng, "Making Synapses: A Balancing Act," *Science* 307 (February 25, 2005): 1207.

64. Samuel Taylor Coleridge, *Lay Sermons*, ed. R. J. White (Princeton: Princeton University Press, 1972), p. 64.

65. Her opponent, Christian de Duve, holds to the other main theory, the primitive phagocyte. See his *Singularities. Landmarks on the Pathways of Life* (Cambridge: Cambridge University Press, 2005), pp. 190–97.

66. Margulis, "The Conscious Cell," p. 59.

67. The term originated with James Lovelock. See Tim Flannery, *The Weather Makers. How Man Is Changing the Climate and What It Means for Life on Earth* (New York: Atlantic Monthly Press, 2006).

68. Paul F. Gehl, "Moral Analogies in Print: Emblematic Thinking in the Making of Early Modern Books," in *Diagrams and the Anthropology of Space*, ed. Kenneth J. Knoespel, special issue, *Philosophica* 70 (2002): 92–93.

69. Lynn Margulis and Dorian Sagan, *Acquiring Genomes. A Theory of the Origin of the Species* (New York: Basic Books, 2002), p. 91.

70. William S. Heckscher, "Concluding Remarks," in *Andrea Alciato and the Emblem Tradition. Essays in Honor of Virginia Woods Callahan*, ed. Peter M. Daly (New York: AMS Press, 1989), p. 285.

71. Sabrine D. Dyall, Mark T. Brown, Patricia J. Johnson, "Ancient Invasions. From Endosymbionts to Organelles," *Science* 304 (April 9, 2004): 253–57.

72. Konrad Hoffmann, "Alciato and the Historical Situation of Emblematics," in *Andrea Alciato and the Emblem Tradition. Essays in Honor of Virginia Woods Callahan*, ed. Peter M. Daly, p. 19.

73. Jaap Maat, *Philosophical Languages in the Seventeenth Century. Dalgarno, Wilkins, Leibniz* (Dordrecht, Boston, London: Kluwer, 2004), pp. 271–75.

74. John R. Searle, "Consciousness. What We Still Don't Know," *New York Review* (January 13, 2005), p. 36.

75. On the actual leading of double lives, see Benedict Carey, "The Secret Lives of Just About Everybody," *New York Times* (January 11, 2005), D1.

76. V. S. Ramachandran and Lindsay M. Oberman, "Broken Mirrors. A Theory of Autism," *Scientific American* 295 (November 2006): 67.

77. Vittorio Gallese and Thomas Metzinger, "Motor Ontology. The Representational Reality of Goals, Actions, and Selves," in *Philosophical Psychology* 16 (September 2003): 365–88.

78. George Lewis, "Briefing," Stanford University, January 11–13, 2001, for National Research Council, *Beyond Productivity. Information Technology, Innovation, and Creativity* (Washington, D.C.: National Academies Press, 2003).

79. F. John Odling-Smee, Kevin N. Laland, and Marcus W. Feldman, *Niche Construction. The Neglected Process in Evolution* (Princeton: Princeton University Press, 2003).

80. The anthropologist Victor Turner first asked whether the cultural category of "the person" should be infused by new findings coming from medicine and neuroscience. Cited in Joseph Dumit, "A Digital Image of the Category of the Person / PET

Scanning and Objective Self-Fashioning," in *Cyborgs and Citadels,* ed. Gary Lee Downey and Joseph Dumit (Santa Fe: School of American Research Press, 1997), pp. 83–87.

81. For a recent re-examination of Wordsworth's "spots of time" from an autobiographical perspective, see Eugene Stelzig, "Wordsworth's Bleeding Spots. Traumatic Memories of the Absent Father in *The Prelude,*" *European Romantic Review* 15 (December 2004): 533–46.

82. Paul Youngquist, *Monstrosities. Bodies and British Romanticism* (Minneapolis: University of Minnesota Press, 2005), p. 118.

83. Matthew Green, "Outlining the 'Human Form Divine'. Reading Blake's Thoughts on Outline and Response to Locke Alongside Lavater and Cumberland," *European Romantic Review* 15 (December 2004): 514.

84. James King, *William Blake. His Life* (London: Weidenfeld and Nicolson, 1991), pp. 28–29.

85. Daniel H. Pink, "Revenge of the Right Brain," *Wired* (February 2005): 68–72.

86. V. S. Ramachandran, *A Brief Tour of Human Consciousness,* p. 52.

87. Karel Portman, "Emblem Theory and Cultural Specificity," in *Aspects of Renaissance and Baroque Symbol Theory,* ed. Peter M. Daly and John Manning (New York: AMS Press, 1999), pp. 3, 8.

88. Mary V. Silcox, "Ornament of the Civil Life. The Device in Puttenham's *The Arte of English Poesie [1589],*" in *Aspects of Renaissance and Baroque Symbol Theory,* ed. Daly and Manning, p. 43.

89. Daniel S. Russell, "Perceiving, Seeing and Learning. Emblems and Some Approaches to Reading Early Modern Culture," in *Aspects of Renaissance and Baroque Symbol Theory,* ed. Daly and Manning, pp. 81–82.

90. Peter T. Struck, *Birth of the Symbol. Ancient Readers at the Limits of Their Texts* (Princeton: Princeton University Press, 2004), pp. 5–6.

91. Ibid., p. 189. For the negative side of this Neoplatonic project, see the still magisterial study of Wesley Trimpi, *Muses of One Mind. The Literary Analysis of Experience and Its Continuity* (Princeton: Princeton University Press, 1983).

92. Michael W. Dols, "The Theory of Magic in Healing," in *Magic and Divination in Early Islam,* ed. Emilie Savage-Smith (Burlington, Vt.: Ashgate, 2004), p. 88.

93. See, for example, Bernard de Montfaucon, *L'Antiquité expliquée et représentée en figures* (Paris: 1719), II.II, pl. 137: a collection of "mains votives."

94. Emilie Savage-Smith and Marion B. Smith, "Islamic Geomancy and a Thirteenth-Century Divinatory Device. Another Look," in *Magic and Divination in Early Islam,* pp. 212–20. See also Giulio Tononi, "An Information Integration Theory of Consciousness," *BMC Neuroscience* 5, no. 42 (2004).

95. David Morgan, *The Sacred Gaze. Religious Visual Culture in Theory and Practice* (Berkeley, Los Angeles, London: University of California Press, 2005), pp. 13–15.

96. See my essay, "Revealing Technologies / Magical Domains," in *Devices of Wonder. From the World in a Box to Images on a Screen,* exh. cat. (Los Angeles: Getty Research Institute, 2001), pp. 1–19; and in the same volume, Frances Terpak, "Wunderkam-

mern and Wunderkabinette," pp. 148–57. On the Sublime's overcoming our rational powers, see Philip Shaw, *The Sublime. The New Critical Idiom*, ed. John Drokakis (New York: Routledge, 2006), p. 5.

97. Götz Adriani, Andreas Kärnbach, Karin Stempel, *Kunst im Reichstagsgebäude* (Cologne: DuMont Verlag, 2001), pp. 71–73. Also see, Andreas Kärnbach, "Das Reichstagsgebäude. Kunst," in *Der Der Deutsche Bundestag im Reichstags-Gebäude. Geschichte und Funktion. Architektur und Kunst* (Berlin: Deutsscher Bundestag, 2002), pp. 274–75.

98. Russell, *Emblem and Device in France*, p. 23.

99. See recent research on human choice: Benedetto de Martino, Dharshan Kumaran, Ben Seymour, Raymond J. Dolan, "Frames, Biases, and Rational Decision Making in the Human Brain," *Science* 313 (August 3, 2006): 684–87.

100. For the contemporary brandishing of ghoulish lopped off heads, see Otto Karl Werckmeister, *Der Medusa-Effekt. Politische Bildstrategien seit dem 11. September 2001* (Berlin: form ± zweck Verkag, 2005), pp. 22–23.

101. Warren Neidich has argued that today we witness a system of visual and cognitive ergonomics at play whereby the brain, in the secondary repertoire, is now sculpted according to experiential contingencies: in particular, by large conglomerates of re-mediated media stimulation. See his *Blow-Up. Photography, Cinema, and the Brain* (New York: DAP, 2003), pp. 23–30.

102. David J. Butler, *Adapting Minds. Evolutionary Psychology and Persistent Quest for Human Nature* (Cambridge, Mass.: MIT Press, 2005), p. 54.

103. Gerald Edelman, *The Remembered Present* (New York: Basic Books, 1989), pp. 45–46.

104. Jean-Pierre Changeux, *The Physiology of Truth. Neuroscience and Human Knowledge* (Cambridge, Mass.: Belknap Press, 2002), p. 31.

105. S. Dehaene and L. Naccache, "Towards a Cognitive Neuroscience of Consciousness: Basic Evidence and a Workspace Framework," in *The Cognitive Neuroscience of Consciousness,* ed. S. Dehaene (Cambridge, Mass.: MIT Press, 2001), p. 15.

106. Struck, *Birth of the Symbol*, pp. 94, 204.

107. Eirwen Nicholson, "Soggy Prose and Verbiage. English Graphic Political Satire as a Visual/Verbal Construct," *Word and Image* 20 (January–March 2004): 28–30. Also see Howard D. Weinbrot, *Menippean Satire Reconsidered* (Baltimore: Johns Hopkins University Press, 2005), p. 29.

108. See my "From 'Brilliant Ideas' to 'Fitful Thoughts'. Conjecturing the Unseen in Late Eighteenth-Century Art," *Zeitschrift für Kunstgeschichte* 48, *Sonderdruck* (1985): 329–63.

109. Dorothy Nelkin and Suzanne Anker, *The Molecular Gaze. Art in the Age of Genetics* (Woodburg, N.Y.: Cold Spring Harbor Laboratory Press, 2003).

110. Andrew Lawler, "The Indus Script—Write or Wrong?" *Science* 306 (December 17, 2004): 2026–30.

111. Francis E. Peters, "Hermes and Harran. The Roots of Arabic-Islamic Occultism," in *Magic and Divination in Early Islam,* ed. Emilie Savage-Smith (Burlington, Vt.: Ashgate, 2004), p. 74.

112. György Buzsáki and Andreas Draguhn, "Neuronal Oscillations in Cortical Networks," *Science* 304 (June 25, 2004): 1926.

113. Ibid., p. 1928. Also see György Buzsáki, *Rhythms of the Brain* (Oxford: Oxford University Press, 2006).

114. On the possibility that our brains are continuing to adapt, see, "Are Human Brains Still Evolving? Brain Genes Show Signs of Selection," News of the Week: Evolution, *Science* September 9, 2005): 1662.

115. See especially V. S. Ramachandran, "Aesthetic Experience," *Journal of Consciousness Studies* 6 (1999): 6–7; Semir Zeki, *Visual Art and the Visual Brain*, the Woodhull Lectures, *Proceedings of the Royal Institution GB* 68 (1997): 29–63.

116. I follow Rosemary Freeman's lead in this; see Peter M. Daly, *Literature in Light of the Emblem. Structural Parallels between the Emblem and Literature in the Sixteenth and Seventeenth Centuries,* 2nd ed. (Toronto: University of Toronto Press, 1998), p. 117.

117. Struck, *Birth of the Symbol,* p. 222.

CHAPTER THREE

1. David Rudrauf and Antonio Damasio, "A Conjecture Regarding the Biological Mechanism of Subjectivity and Feeling," *Journal of Consciousness Studies,* nos. 8–10 (2005): 237.

2. Yoko Tawada, "Canned Foreign," *Übersetzungen/Überseezungen:* lecture/performance in seminar, "On the Movement of Genres" (Wissenschaftskolleg zu Berlin, January 11, 2006).

3. Jaak Panksepp, *Affective Neuroscience. The Foundations of Human and Animal Emotions* (New York and Oxford: Oxford University Press, 1998), p. 40.

4. Constance Holden, "The Origin of Speech," *Science* 303 (February 27, 2004): 1316–19. Jacqueline Gottlieb and Pietro Mazzoni, "Action, Illusion, and Perception," *Science* 303 (January 16, 2004): 317. Also see Scott Kelso and David Engstrøm, *The Complementary Nature* (Cambridge, Mass.: MIT Press, 2006), p. 150.

5. Daniel C. Dennett, *Kinds of Minds* (New York: Basic Books, 1996), p. 13.

6. See Jean Decety's fMRI research on the anterior cingulated cortex and the anterior insula: Lydialyle Gibson, "Mirrored Emotion," *University of Chicago Magazine* (April 2006): 37.

7. Pamela H. Smith, "Art, Science, and Visual Culture in Early Modern Europe," *Isis* 97 (March 2006): 91.

8. Antonio R. Damasio, *Looking for Spinoza. Joy, Sorrow, and the Feeling Brain* (New York: Harcourt, 2003), p. 192.

9. Antonio R. Damasio, *The Feeling of What Happens. Body and Emotion in the Making of Consciousness* (New York: Harcourt Brace, 1999), p. 39.

10. Hallvard Fossheim, "Mimesis in Aristotle's *Ethics,*" in Ovind Anderson and Jon Haarberg's *Making Sense of Aristotle. Essays in Poetics* (London: Duckworth, 2001), p. 75.

11. See Stephen Halliwell, "Aristotelian Mimesis and Human Understanding," in *Making Sense of Aristotle,* pp. 89, 102. In the same volume, see also Terrence Cave, "The Afterlife of the Poetics," p. 205.

12. Greg Miller, "Reflecting on Another's Mind," *Science* 308 (May 13, 2005): 945–47.

13. Mark B. N. Hansen uses the term *facialization* to describe the computer-mediated work of digital artist Jeffrey Shaw. See his *New Philosophy for New Media* (Cambridge, Mass.: MIT Press, 2004), p. 109.

14. Kiyoshi Nakahara and Yasushi Miyashita, "Understanding Intentions: Through the Looking Glass," *Science* 308 (April 29, 2005): 644–45.

15. V. S. Ramachandran, *A Brief Tour of Human Consciousness. From Impostor Poodles to Purple Numbers* (New York: PI Press, 2003), p. 37.

16. See the exhibition *Joseph Beuys. Lebenslauf-Werklauf. A Tribute to Joseph Beuys on the 20th Anniversary of His Death* (Berlin: Hamburger Bahnhof, January 21–April 23, 2006).

17. Richard Gregory, "Hypothesis and Illusionism: Explorations in Perception and Science," in *New Representationalisms,* ed. Edmond Wright (London and Brookfield, Vt.: Ashgate, 1993), p. 236.

18. Michael Fried, *Absorption and Theatricality. Painting and Beholder in the Age of Diderot* (Chicago: University of Chicago Press, 1980), pp. 13–16.

19. Nicholas Penny, ed., *Reynolds,* exh. cat., Royal Academy of Arts, London (London: Weidenfeld and Nicolson, 1986), pp.216–17n49.

20. For an itemization of the family jewels, see Maya Jasanoff, *The Edge of Empire. Conquest and Collecting in the East, 1750–1850* (London: Fourth Estate, 2005), pp. 41–43.

21. William Vaughan, *Friedrich, Art and Ideas* (London: Phaidon, 2004), pp. 176–79.

22. Werner Hofmann, *Caspar David Friedrich. Naturwirklichkeit und Kunstwahrheit* (Munich: C. H. Beck, 2000), p. 135.

23. David Premack, "Is Language the Key to Human Intelligence?" *Science* 303 (January 16, 2004): 318.

24. See Sandra Blakeslee, "Cells That Read Minds," *New York Times,* Science Times (January 10, 2006), D1, D4.

25. Jean-Pierre Changeux and Paul Ricoeur, *What Makes Us Think?* (Princeton and Oxford: Princeton University Press, 2000), p. 165.

26. See my *Visual Analogy. Consciousness as the Art of Connecting* (Cambridge, Mass.: MIT Press, 1999).

27. See the fascinating research on corvids (crows, jays, ravens, and jackdaws) demonstrating that they share with apes the ability to reason by analogy. Nathan J. Emery and Nicola S. Clayton, "The Mentality of Crows: Convergent Evolution of Intelligence in Corvids and Apes," *Science* 306 (December 10, 2004), pp. 1903–7.

28. James George Frazer's *The Golden Bough* is the *locus classicus* for the discussion of sympathetic magic. For an updated analysis, see Michael Taussig, *Mimesis and Alterity. A Particular History of the Senses* (New York: Routledge, 1993), p. 48.

29. Scott Atran and Ara Norenzayan, "Religious Evolutionary Landscape: Counterintuition, Commitment, Compassion, Communion," in *Behavioral and Brain Sciences* 27 (December 2004): 724.

30. Alan S. Brown, *The Déjà Vu Experience* (New York and Hove: Psychology Press, 2004), pp. 12, 184.

31. Nancy Kanwisher, "What's in a Face?" *Science* 311 (February 3, 2006), pp. 617–18. Also see Doris Tsao, "A Dedicated System for Processing Faces," *Science* 314 (October 6, 2006): 72–73.

32. Laurence Sterne, *The Life and Opinions of Tristam Shandy, Gentleman* (New York: Modern Library, 2004), 3:xxx, xii.

33. Jean-Luc Petitot, "Constitution by Movement: Husserl in Light of Recent Neuro-

biological Findings," in *Naturalizing Phenomenology* (Stanford: Stanford University Press, 1999), p. 231.

34. Stanley Finger, *Minds behind the Brain. A History of the Pioneers and Their Discoveries* (Oxford: Oxford University Press, 2000), pp. 91–95.

35. Antonio R. Damasio, *Descartes' Error. Emotion, Reason, and the Human Brain* (New York: G. P. Putnam's Sons, 1993), pp. 14–15.

36. Charles Siebert, "The Animal Self," *New York Times Magazine* (January 22, 2006), pp. 50–55, 72.

37. Etienne Danchin, Luc-Alain Giraldeau, Thomas J. Valone, Richard H. Wagner, "Public Information: From Nosy Neighbors to Cultural Evolution," *Science* 305 (July 23, 2004): 487–89.

38. Luiz Pessoa, "Seeing the World in the Same Way," *Science* 303 (March 12, 2004): 1617–18.

39. David Bordwell, *Figures Traced in the Light. On Cinematic Staging* (Berkeley, Los Angeles, London: University of California Press, 2005), pp. 46–47. Also see Pia Tikka, "Cinema as the Externalization of Consciousness," in *Screen Consciousness,* ed. Robert Pepperell and Michael Punt (Amsterdam and New York: Rodopi, 2006), pp. 140–41.

40. Marilyn Fabe, *Closely Watched Films. An Introduction to the Art of Narrative Film Technique* (Berkeley, Los Angeles, London: University of California Press, 2004), pp. 48–52. On Bergson and cinematographical knowledge, see Martha Blassnigg, "Clairvoyance, Cinema, and Consciousness," in *Screen Consciousness*, ed. Pepperell, pp. 105–7, 110.

41. Robert B. Glassman, "Good Behavioral Science Has Room for Theology: Any Room for God," *Behavioral and Brain Sciences* 27 (December 2004): 738.

42. Marc Jeannerod, *La nature de l'esprit. Sciences cognitives et cerveau* (Paris: Odile Jacob, 2002), p. 47.

43. *Theophrastus on the Senses*, in *Theophrastus and the Greek Physiological Psychology before Aristotle*, ed. George Malcolm Stratton (Amsterdam: E. J. Bonset and P. Schippers N.V., 1964), pp. 67, 71–77.

44. Leslie A. Zebrowitz and Joann M. Montepare, "Appearance DOES Matter," *Science* 308 (June 10, 2005): 1565–66.

45. Tania Singer, Ben Seymour, John O'Doherty, Holgar Kaube, Raymond J. Dolan, Chris D. Frith, "Empathy for Pain Involves the Affective but Not the Sensory Components of Pain," *Science* 303 (February 20, 2004): 1158.

46. Emma Barker, *Greuze and the Painting of Sentiment* (Cambridge: Cambridge University Press, 2005), p. 49.

47. Derek Matravers, *Art and the Emotions* (Oxford: Clarendon Press, 1998), pp. 117–19.

48. Damasio, *Looking for Spinoza*, p. 217.

49. Peter de Bolla, *The Education of the Eye. Painting, Landscape, and Architecture in Eighteenth-Century Britain* (Stanford: Stanford University Press, 2003), pp. 45–46.

50. Barker, *Greuze and the Painting of Sentiment*, p. 50.

51. Steve Silberman, "How Brain Scans Are Reinventing the Science of Lie Detection," *Wired* (January 2006): 142–49.

52. William Hirstein, *Brain-Fiction. Self-Deception and the Riddle of Confabulation* (Cambridge, Mass.: MIT Press, 2005).

53. For the multiple editions and translations of this sensationally successful publication, see Mary Lynn Johnson, "Blake's Engravings for Lavater's *Physiognomy:* Overdue Credit to Chodowiecki, Schellenberg, and Lips," in *Blake/An Illustrated Quarterly* 38 (Fall 2004): 52–74.

54. John Graham, "Lavater's *Physiognomy* in England," *Journal of the History of Ideas,* 22, no. 4 (1961): 563.

55. See, for example, Johann Caspar Lavater, *Physiognomische Fragmente* (Leipzig and Winterthur, 1775–78), IV, pl. 6: "Six Male Hands."

56. Joshua Davis, "Face-Blind," *Wired* (November 2006): 202.

57. Kristine H. Onishi and Renée Baillargeon, "Do 15-Month-Old Infants Understand False Beliefs," *Science* 308 (April 8, 2005): 255–58.

58. Naomi J. Eisenberger, Matthew D. Lieberman, Kipling D. Williams, "Does Rejection Hurt? An fMRI Study of Social Exclusion," *Science* 302 (October 10, 2003): 290–92.

59. Michael Margolis, "Truth Decay," *Cornell Alumni Magazine* (July–August 2004), p. 31. Joseph Dumit has critiqued the way brain images are coming to be taken as facts about kinds of brains. See his *Picturing Personhood. Brain Scans and Biomedical Identity* (Princeton and Oxford: Princeton University Press, 2004), p. 5.

60. David M. Eagleman, "The Where and When of Intention," *Science* 303 (February 20, 2004): 1144–45.

61. Jaak Panksepp, "Feeling the Pain of Social Loss," *Science* 302 (October 10, 2003): 238.

62. Paul Sant Cassia, "When Intuitive Knowledge Fails," in *Mixed Emotions. Anthropological Studies of Feeling,* ed. Kay Milton and Maruska Svasek (Oxford and New York: Berg, 2005), p. 124.

63. Elfriede Jelinek, *The Piano Teacher,* trans. Joachim Neugroschel (London: Serpent's Tail, 1989), pp. 20–21.

64. S. L. Hurley, *Consciousness in Action* (Cambridge, Mass.: Harvard University Press, 1998), p. 3; also see Merlin Donald, "The Mind Considered from an Historical Perspective. Human Cognitive Phylogenesis and the Possibility of Continuing Cognitive Evolution," in *The Future of the Cognitive Revolution,* ed. David Martel Johnson and Christine E. Erneling (Oxford and New York: Oxford University Press, 1997), pp. 360–61.

65. J. R. Watson, "Wordsworth, North Wales, and the Celtic Landscape," in *English Romanticism and the Celtic World,* ed. Gerard Carruthers and Alan Rawes (Cambridge: Cambridge University Press, 2002), p. 94.

66. Michael Morgan, *The Space between Our Ears. How the Brain Represents Visual Space* (London: Weidenfeld and Nicolson, 2003), p. 115.

67. Timothy van Gelder, "It's About Time: An Overview of the Dynamic Approach to Cognition," in *Mind as Motion. Explorations in the Dynamics of Cognition,* ed. Robert F. Port and Timothy van Gelder (Cambridge, Mass.: MIT Press, 1995), p. 3.

68. Bernard Pachaud, "The Teleological Dimension of Perceptual and Motor Intentionality," in *Naturalizing Phenomenology,* ed. Jean Petitot (Stanford: Stanford University Press, 199), pp. 198–208.

69. Yoko Tawada, *Pulverschrift Berlin,* live performance, Lesenkan Theater, Berlin, February 17–18, 2006.

70. Yoko Tawada, "Writing in the Web of Words," from *Übersetzungen/Überseezungen. Prosa* (Tübingen: Konkursbuch Verlag Claudia Gehrke, 2002), p. 31.

71. Andy Clark, *Natural-Born Cyborgs. Minds, Technologies, and the Future of Human Intelligence* (Oxford: Oxford University Press, 2003), p. 87.

72. Vittorio Gallese, "A Neuroscientific Grasp of Concepts: From Control to Representation," in *The Abstraction Paths: From Experience to Concept*, ed. L. Saitta, papers of a theme issue, *Philosophical Transactions of the Royal Society* 358 (July–September, 2003), p. 1178.

73. See, for example, Sydney J. Segalowitz and Daniel Bernstein, "Neural Networks and Neuroscience"; see also Itiel E. Dror and Marcelo Dascal, "Can Wittgenstein Help Free the Mind from Rules?" in *The Future of the Cognitive Revolution*, ed. Johnson and Erneling, pp. 209, 219.

74. Andy Clark, *Being There. Putting Brain, Body, and World Together* (Cambridge, Mass.: MIT Press, 1997), pp. 165–67.

75. John W. Yolton, *Locke and the Compass of Human Understanding. A Selective Commentary on the "Essay"* (Cambridge: Cambridge University Press, 1970), pp. 18–22.

76. This is still the question; see Marc Jeannerod, *La nature de l'esprit. Sciences cognitives et cerveau* (Paris: Odile Jacob, 2002), p. 128.

77. John W. Yolton, *Realism and Appearances. An Essay in Ontology* (Cambridge: Cambridge University Press, 2000), p. 43.

78. William Hogarth, *The Analysis of Beauty. Written with a View of Fixing the Fluctuating Ideas of Taste* (London: Printed by J. Reeves for the Author, 1753), pp. 24–25.

79. J. Leo van Hemmen, Jack D. Cowan, Eytan Domany, eds., *Models of Neural Networks IV. Early Vision and Attention* (New York and Berlin: Springer, 2001), pp. 278–79.

80. James J. Bono has studied the antimechanistic tradition of vital matter in the seventeenth- and eighteenth-centuries stretching from William Harvey to Julien Offray de La Mettrie. See, most recently, his "Perception, Living Matter, Cognitive Systems, Immune Networks: A Whiteheadian Future for Science Studies," *Configurations* 13 (April 2005, forthcoming): esp. pp. 2–10.

81. Michael Rosenthal, *The Art of Thomas Gainsborough. "A Little Business for the Eye"* (New Haven: Yale University Press, 1999), pp. 81–82, 91.

82. Cited in John Sutton, *Philosophy and Memory Traces. Descartes to Connectionism* (Cambridge: Cambridge University Press, 1998), pp. 225–27.

83. Michael Friedman, "Transcendental Philosophy and A Priori Knowledge. A Neo-Kantian Perspective," in *New Essays on the A Priori*, ed. Paul Boghossian and Christopher Peacocke (Oxford: Clarendon Press, 2000), p. 367.

84. Steven S. Pinker, *The Blank Slate. The Modern Denial of Human Nature* (London: Allen Lane, 2002), p. 407.

85. William Morris, "David Hume," *Encyclopedia of Empiricism*, ed. Don Garrett and Edward Barbanell (Westport, Conn.: Greenwood Press, 1997), pp. 150–52.

86. David Hume, *A Treatise on Human Nature*, I.iii, 7, 8, 10.

87. John Passmore, "Enthusiasm, Fanaticism, and David Hume," in *The Science of Man in the Scottish Enlightenment. Hume, Reid, and Their Contemporaries*, ed. Peter Jones (Edinburgh: Edinburgh University Press, 1989), p. 86.

88. Peter Jones, *Hume's Sentiments. Their Ciceronian and French Context* (Edinburgh: Edinburgh University Press, 1982), pp. 17–18.

89. Jonathan Lamb, "Modern Metamorphoses and Disgraceful Tales," *Critical Inquiry* 28 (Autumn 2001): 137.

90. Francis Hutcheson, *An Essay on the Nature and Conduct of the Passions and Affections, With Illustrations on the Moral Sense*, edited and with an introduction by Aaron Garrett (Indianapolis: Liberty Fund, 2002), p. 17.

91. Nicholas Wolterstorff, *Thomas Reid and the Story of Epistemology* (Cambridge: Cambridge University Press, 2004), p. 101.

92. J. C. Bryce, "Lectures on Rhetoric and Belles-Lettres" (1748–1763), in *Adam Smith Reviewed*, ed. Peter Jones and Andrew Skinner (Edinburgh: Edinburgh University Press, 1992), pp. 2–11.

93. This is Paul Machen's concept of the triune brain organized in three strata of evolutionary progression (the third is the neomammalian brain in the neocortex). Cited in Panksepp, *Affective Neuroscience*, p. 42.

94. Peter J. Bowler, "Darwin on the Expression of the Emotions: The Eclipse of a Research Program," in Milton and Svasek, *Mixed Emotions*, p. 43.

95. George F. Striedter, *Principles of Brain Evolution* (Sunderland, Mass.: Sinauer Associates, 2005), p. 337.

96. Hutcheson, *Essay*, p. 18.

97. Ibid., p. 80.

98. Ibid., p. 110.

99. Dror Wahrman, *Making of the Modern Self. Identity and Culture in Eighteenth-Century England* (New Haven: Yale University Press, 2004), p. 197.

100. David Chalmers, *The Conscious Mind. In Search of a Fundamental Theory* (New York and Oxford: Oxford University Press, 1996), p. 225.

101. Nancy Forbes, *Imitation of Life. How Biology Is Inspiring Computing* (Cambridge, Mass.: MIT Press, 2004), p. 69.

102. Warren Neidich, *Blow-Up: Photography, Cinema, and the Brain* (Riverside: DAP and University of California Press, 2003), pp. 22–30.

103. Warren Neidich, *Earthling (A Collection of Photographs)* (New York: Pointed Leaf Press, 2005).

104. See the exhibition catalog of *Das Spiel mit dem Geschlecht* at the Museum Ludwig in Cologne (Berlin: Verlag Hatje Cantz, 2006).

105. Gerald M. Edelman, *Wider than the Sky. The Phenomenal Gift of Consciousness* (New Haven: Yale University Press, 2004), p. 36.

106. Jack Burnham, "Alice's Head: Reflections on Conceptual Art," in *Conceptual Art: A Critical Anthology*, ed. Alexander Alberro and Blake Stimson (Cambridge, Mass.: MIT Press, 1999), p. 216.

107. She is citing the theory of the Cubist painter, Joseph Schillinger; see, Lucy R. Lippard and John Chandler, "The Dematerialization of Art," in *Conceptual Art*, ed. Alberro and Stimson, pp. 46–47.

108. Thomas Natsoulas, "'To See Things Is to Perceive What They Afford': James J. Gibson's Concept of Affordances," *Journal of Mind and Behavior* 25 (Fall 2004): 342–43.

109. G. H. Murray Pittock, "Scott and the British Tourist," in *British Romanticism*, ed. Carruthers and Rawes, p. 155.

110. Claude-Henri Watelet, *Essay on Gardens. A Chapter in the French Picturesque*, ed. and trans. Samuel Danon, with an introduction by Joseph Disponsio (Philadelphia: University of Pennsylvania Press, 2003), p. 5.

111. For a summary of new developments in the history of landscape gardening (as well as cultural geography), see Stephen Daniels, "Landscape History: Material and Metaphorical Regimes," *Journal of the Society of Architectural Historians* 65 (March 2006): 16–18.

112. Frank Wilson, *The Hand. How Its Use Shapes the Brain, Language and Human Culture* (New York: Pantheon Books, 1998), pp. 35ff. Also see, Doug Stowe, "Back to School. Exploring the Role of the Woodshop in General Education," *Woodcraft Magazine* (August 2005): 53.

113. Graziella Tonfoni with James E. Richardson, "Imagining Textual Machines," http://www.intellectbooks.com/iconic/text/text.htm.

114. For the debates on criminal physiognomy and biology, see Jennifer Michael Hecht, *The End of the Soul. Scientific Modernity, Atheism, and Anthropology in France* (New York: Columbia University Press, 2003), pp. 227–35.

115. Michael Heim, *The Metaphysics of Virtual Reality* (New York and Oxford: Oxford University Press, 1993), p. 82.

116. Francisco J. Varela and Evan Thompson, *The Unity of Consciousness*, ed. Axel Cleeremans (Oxford: Oxford University Press, 2003), p. 279.

CHAPTER FOUR

1. David Lewis-Williams and David Pearce, *Inside the Neolithic Mind. Consciousness, Cosmos and the Realm of the Gods* (London: Thames and Hudson, 2005), pp. 250–51.

2. "The Descent of Istar," in Erica Reiner's *Your Thwarts Are in Pieces, Your Mooring Rope Uncut. Poetry from Babylonia and Assyria* (Ann Arbor: Horace H. Rackham School of Graduate Studies, University of Michigan, 1985), p. 30.

3. William Illsey Atkinson, *Nanocosm. Nanotechnology and the Big Changes Coming from the Inconceivably Small* (New York: AMACOM, 2003), p. 4.

4. Eric R. Kandel, *In Search of Memory. The Emergence of a New Science of Mind* (New York: W. W. Norton, 2006), pp. 308–9.

5. Matthew Potolsky, *Mimesis. The New Critical Idiom,* ed. John Drakakis (New York: Routledge, 2006), pp. 16–17.

6. See Edward Castronova, *Synthetic Worlds. The Business and Culture of Online Games* (Chicago and London: University of Chicago Press, 2005).

7. Alison Abbott, "In the Hands of a Master," *Nature* (February 9, 2006): 648–50.

8. Barry J. Everitt, "From the Dark Side to the Bright Side of Drug Addiction," *Science* 314 (October 6, 2006): 59–60.

9. Roland Barthes, "Le monde-objet," in *Essais critiques* (Paris: Seuil, 1964), p. 28. Also see the lecture by Jean-François Chevrier, "L'hallucination artistique, un ailleurs du réalisme," delivered at the Auditorium du Musée du Louvre, June 12, 2006.

10. Gaston Bachelard, *La poétique de l'espace* (Paris: Quadrige / Presses Universitaires de France, 1981), pp. 35–37.

11. Tom J. Wills, Colin Lever, Francesca Cacucci, Neil Burgess, John O'Keefe, "Attractor Dynamics in the Hippocampal Representation of the Local Environment," *Science* 308 (May 6, 2005): 873–74. Also see Kandel, *In Search of Memory*, pp. 311–13.

12. Greg Miller, "Embryologists Polarized Over Early Cell Fate Determination," *Science* 308 (May 6, 2005): 782.

13. Nancy Forgione, "Everyday Life in Motion: The Art of Walking in Late Nineteenth-Century Paris," *Art Bulletin* 87 (December 2005): 669.

14. For the poet-artist's active pursuit of visual form, see Sarah Wyman, "The Poem in the Painting. Roman Jakobson and the Pictorial Language of Paul Klee," *Word & Image* 20 (April–June 2004): 139.

15. Gerhard Neuweiler, "Was Hat aus Primaten einen Menschen Gemacht? Die Motorische Intelligenz," *Jahrbuch* (Berlin: Wissenschaftskolleg, 2002–3): 257.

16. Reinhart Meyer-Kalkus, "Klangmotorik und verkörpertes Hören in der Musik Helmut Lachenmanns," *Zeitschrift für Neue Musik* (2006): 87–90.

17. Michael Morgan, *The Space between Our Ears. How the Brain Represents Visual Space* (London: Weidenfeld and Nicolson, 2003), pp. x–xi.

18. Susan Kruglinski, "When the Vision Goes, the Hallucinations Begin," *New York Times*, Science Times (September 14, 2004), D7.

19. Thomas Metzinger, *Being No One. The Self-Model Theory of Subjectivity* (Cambridge, Mass. and London: MIT Press, 2003), p. 15.

20. Peter Ralf Behrendt and Claire Young, "Hallucinations in Schizophrenia. Sensory Impairment and Brain Disease: A Unifying Model," *Behavioral and Brain Sciences* 27 (December 2004): 771.

21. Julian Jaynes, *The Origins of Consciousness in the Breakdown of the Bicameral Mind* (1976; Boston and New York: Houghton Mifflin Company, 1990), p. 75.

22. August Schmarsow, "The Essence of Architectural Creation," in *Empathy, Form, and Space. Problems in German Aesthetics, 1873–1893*, trans. Harry Francis Mallgrave and Eleftherios Ikonomou, *Texts and Documents* (1893; Los Angeles and Chicago: Getty Center for the History of Art and the University of Chicago Press, 1994), p. 286.

23. Paul C. Bressloff, Jack D. Cowan, Martin Golubitsky, Peter J. Thomas, and Matthew C. Wiener, "Geometric Visual Hallucinations, Euclidean Symmetry and the Functional Architecture of the Striate Cortex," *Philosophical Transactions of the Royal Society London B* 356 (2001): 299–330. For the history of the crystal model, see Jean-Pierre Changeux, *Neuronal Man. The Biology of Mind* (Princeton: Princeton University Press, 1985), pp. 59–63.

24. Roger Penrose, *The Large, the Small and the Human Mind* (Cambridge: Cambridge University Press, 1997), p. 3.

25. Wolf Singer, "Neuronal Synchronization. A Solution to the Binding Problem," in *The Mind-Brain Continuum. Sensory Processes*, ed. Rodolfo Llinas and Patricia S. Churchland (Cambridge, Mass. and London: MIT Press, 1996), p. 104.

26. Susan Zimmerman, "Duncan's Corpse," *A Feminist Companion to Shakespeare*, ed. Dympna Callaghan: Blackwell Publishers, 2000), p. 322.

27. William Kentridge, *Black Box / Chambre Noir*, exhibition, Berlin: Deutsche Guggenheim, October 29, 2005–January 15, 2006.

28. Justin Barrett's construction of the evolutionary innovation of the "good trick" or the hyperactive agent detective device (HADD) is described by Daniel C. Dennett in *Breaking the Spell. Religion as a Natural Phenomenon* (New York: Viking, 2006), pp. 109–11.

29. George Kubler, *The Shape of Time. Remarks on the History of Things* (New Haven: Yale University Press, 1962), p. 75.

30. Valerie Hillings, "Hanne Darboven Hommage à Picasso," exh. brochure (Berlin: Deutsche Guggenheim, February 4–April 23, 2006).

31. François Berthier, *Reading Zen in the Rocks. The Japanese Dry Landscape Garden*, trans. Graham Parks (Chicago and London: University of Chicago Press, 2000), p. 119.

32. See Daniel C. Dennett, *Breaking the Spell. Religion as a Natural Phenomenon* (New York: Viking, 2006).

33. Nina P. Azari and Dieter Birnbacher, "The Role of Cognition and Feeling in Religious Experience," *Zygon* 39 (December 2004): 911.

34. The term was coined in the 1920s by Gordon Childe, the leading archaeologist of the prewar period. See Steven Mithen, *After the Ice. A Global Human History, 20,000–5,000 B.C.* (London: Weidenfeld and Nicolson, 2003), p. 60.

35. Jacques Cauvin, *The Birth of the Gods and the Origins of Agriculture*, trans. Trevor Watkins (Cambridge: Cambridge University Press, 2000), pp. 7, 122–23.

36. Paul S. Martin, *Twilight of the Mammoths. Ice Age Extinctions and the Rewilding of America* (Berkeley: University of California Press, 2005).

37. Lewis-Williams and Pearce, *Inside the Neolithic Mind*, pp. 9, 193.

38. Galen A. Johnson and Michael B. Smith, ed. and trans., *The Merleau-Ponty Aesthetics Reader. Philosophy and Painting* (Evanston, Ill.: Northwestern University Press, 1993), p. 126.

39. Max Robinson, "Place-Making: The Notion of Centre," in *Constructing Place. Mind and Matter*, ed. Sarah Menin (London and New York: Routledge, 2003), p. 144.

40. Clement Cheroux, Andreas Fischer, Pierre Apraxine, Denis Canguilhem, Sophie Schmit, *The Perfect Medium. Photography and the Occult*, exh. cat. (New York: Metropolitan Museum of Art, 2005).

41. David Lewis-Williams, *The Mind in the Cave. Consciousness and the Origins of Art* (London: Thames and Hudson, 2002), pp. 126–27, 204.

42. Oliver Sacks, "In the River of Consciousness," *New York Review of Books* (January 15, 2004), pp. 41–44.

43. C. D. Laughlin and Christopher McManus, *Brain, Symbol, and Experience. Towards a Neurophenomenology of Human Consciousness* (New York: Columbia University, 1992), p. 171.

44. Paul C. Bressloff, Jack D. Cowan, Martin Golubitsky, Peter J. Thomas, Matthew C. Wiener, "What Geometric Visual Hallucination Tell Us About the Visual Cortex," *Neural Computation* 14 (2002): 356.

45. Paul C. Bressloff and Jack D. Cowan, "The Visual Cortex as a Crystal," *Physica D* 173 (2002), pp. 227–28.

46. Ibid., p. 253.

47. Bressloff, Cowan, et al., "What Geometric Visual Hallucination Tell Us About the Visual Cortex," 473–74.

48. Cary Goldberg, "For Addicts, Desire May Be Function of 'Extreme Memory,'" *International Herald Tribune,* Health/Science (May 17, 2006), 1–3. Also see George F. Koob and Michael Le Moal, *Neurobiology of Addiction* (London: Academic Press, 2006).

49. Cave art shares with Net Art this compulsion to dissolve the interface. On the Net, see Anna Munster, *Materializing New Media. Embodiment in Information Aesthetics* (Hanover, N.H.: Dartmouth College Press, 2006), p. 138.

50. Gianfranco Dalla Barba, *Memory, Consciousness, and Temporality* (Dordrecht and Norwell, Mass.: Kluwer Academic Publishers, 2002), p. 7.

51. Andrew Pickering, *The Mangle of Practice. Time, Agency, and Science* (Chicago and London: University of Chicago Press, 1995), p. 6.

52. Josephine Flood, *Rock Art of the Dreamtime. Images of Ancient Australia* (Sydney: Angus and Robertson, 1997), p. 159.

53. For Robin Dunbar's "social brain" hypothesis of human evolution, see Michael Balter, "Seeking the Key to Music," *Science* 306 (November 12, 2004): 1121–22.

54. Howard Morphy and Frances Morphy, "Tasting the Waters. Discriminating Identities in the Waters of Blue Mud Bay," *Journal of Material Culture* 11, nos. 1/2 (2006): 81.

55. The term is Nancy Munn's and stems from her groundbreaking study of the Walbiri. See Stephen Mueck, "Towards an Aboriginal Philosophy of Place," in *Speaking Positions. Aboriginality, Gender and Ethnicity in Australian Cultural Studies*, ed. Penny van Tooris and David English (Melbourne: Department of Humanities, Victoria University of Technology, 1995), p. 172.

56. John Gage, "Current Australian Aboriginal Painting," lecture delivered at the Humanities Research Centre, Australian National University, Canberrra, August 9, 2003.

57. *rarrk. John Mawurndjul. Journey through Time in Northern Australia,* exhibition, Basel: Museum Tinguely, September 21, 2005–January 29, 2006.

58. Peter Sutton, *Dreamings. The Art of Aboriginal Australia* (New York: Viking, 1988), p. 48.

59. Ibid., p. 19.

60. Flood, *Rock Art of the Dreamtime,* pp. 84–87.

61. Jonathan Ree, *I See a Voice. Deafness, Language, and the Senses. A Philosophical History* (New York: Metropolitan Books, Henry Holt and Company, 1999), p. 170.

62. Sutton, *Dreamings,* p. 60.

63. Laughlin and McManus, *Brain, Symbol, and Experience,* pp. 106, 212.

64. Alexander Marshack, *The Roots of Civilization. The Cognitive Beginnings of Man's First Art. Symbol and Notation,* rev. ed. (Mount Kisco, N.Y.: Moyer Bell Limited, 1991), p. 393.

65. Constance Holden, "Human Quadrupeds," *Science* 311 (March 17, 2006): 1531. I cannot agree with R. Dale Guthrie, *The Nature of Paleolithic Art* (Chicago: University of Chicago Press, 2006), that hand prints can be reduced to testosterone-driven adolescents and hence primarily children's art.

66. Stephen Grossberg, "Neural Dynamics of Motion Perception, Recognition Learning, and Spatial Attention," in *Mind as Motion. Exploration in the Dynamics of Cognition,* ed. Robert F. Port and Timothy van Gelder (Cambridge, Mass. and London: MIT Press, 1995), p. 467.

67. Mueck, "Aboriginal Philosophy of Place," p. 177.

68. For a recent discussion of site projects as a "spatial-cultural discourse," see Miwon Kwon, *One Place after Another. Site-Specific Art and Locational Identity* (Cambridge and London: MIT Press, 2002), p. 2.

69. *Robert Smithson. Spiral Jetty. True Fictions, False Realities,* ed. Lynne Cook and Karen Kelly (New York: Dia Art Foundation, 2005), pp. 32–33.

70. Laurence Corbel, "Robert Smithson—eine Kartographie der Kunst," *Atopia,* special issue, *Terra Incognita* (October 15, 2005).

71. Harold Rosenberg, "Primitive à la Mode. Jean Dubuffet," in *The De-Definition of Art. Action Art to Pop to Earthworks* (New York: Horizon Press, 1972), pp. 81–82.

72. Jennifer L. Roberts, *Mirror-Travels. Robert Smithson and History* (New Haven: Yale University Press, 2004), p. 47.

73. See the photograph of the well-beaten trail, in Melissa Sanford, "The Salt of the Earth Sculpture," *New York Times* (January 13, 2004), B1.

74. Michel Serres, *Les cinq sens. Philosophie des corps mêlés. Essai* (Paris: Bernard Grasset, 1985), p. 18. Georg Simmel, *Philosophie des Geldes,* 2nd rev. ed. (Leipzig, 1907), p. 11. Also see Jutta Müller-Tamm, "Distance. On the Space and Spatiality of Aesthetic Experience," paper delivered at the Workshop: Spaces of Experience, Berlin, Wissenschaftskolleg, April 28, 2006.

75. Merlin Donald, *Origins of the Modern Mind* (Cambridge, Mass.: Harvard University Press, 1991).

76. Andy Clark, *Mindware. An Introduction to the Philosophy of Cognitive Science* (New York and Oxford: Oxford University Press, 2001), pp. 4–5.

77. Jean-Luc Marion, "The Distance of the Requisite and the Discourse of Praise," in *The Idol and Distance. Five Studies,* trans. Thomas A. Carlson (New York: Fordham University Press, 2001), p. 153.

78. Anca Vasiliu, "Secret ou mensonge: Le mythe et l'image dans le discours platonicien (la face cachée de Narcisse ou le secret du détour égyptien)," *Les secrets: D'un principe philosophique à un genre littéraire,* Colloquium (Chicago and Paris: Newberry Library and CNRS, 2002), p. 6.

79. Geoffrey Galt Harpham, *On the Grotesque. Strategies of Contradiction in Art and Literature* (Princeton: Princeton University Press, 1982), p. 58.

80. Greg Miller, "How Are Memories Stored and Retrieved?" *Science* 309 (July 1, 2005): 92.

81. See my "Revealing Technologies / Magical Domains," in *Devices of Wonder: From the World in a Box to Images on a Screen,* exh. cat. (Los Angeles: Getty Research Institute, 2001).

82. The term *mediasphere* is Regis Debray's. See his *Media Manifestos. On the Technological Transmission of Cultural Forms,* trans. Eric Rauth (London and New York: Verso, 1996), p. 26.

83. See, for example, Albert Borgmann, *Holding on to Reality. The Nature of Information at the Turn of the Millennium* (Chicago: University of Chicago Press, 1999), p. 185.

84. Steve Redhead, *Paul Virilo. Theorist for an Accelerated Culture* (Toronto and Buffalo: University of Toronto Press, 2004), p. 14.

85. On hermeneutics as the elucidation of obscurity, see John T. Hamilton, *Soliciting Darkness, Pindar, Obscurity, and the Classical Tradition* (Cambridge, Mass.: Harvard University Press, 2003), pp. 3–6.

86. Steven Pinker, *The Blank Slate. The Modern Denial of Human Nature* (London: Allen Lane, 2002), p. 201.

87. Cave art helps to make the case for the connectionist hypothesis. See Andy Clark, *Mindware*, pp. 141–42.

88. Ulf T. Eysel, "Illusions and Perceived Images in the Primate Brain," *Science* 302 (October 31, 2003): 789–80.

89. See Richard L. Gregory's three-fold categorization of physical, physiological, and cognitive illusions in his "Hypothesis and Illusion," in *New Representationalisms*, ed. Edmond Wright (London and Brookfield, Vt.: Ashgate, 1993), p. 249.

90. Dawn Ades and Michael Taylor, *Dali*, exh. cat. (Philadephia: Philadelphia Museum of Art and Rizzoli, 2005).

91. John North, *The Ambassadors' Secret. Holbein and the World of the Renaissance* (London and New York: Hambledon and London, 2002), p. 76.

92. Thomas Buser, "Miracle in Giovanni Paolo Panini's *The Marriage at Cana*," *Source. Notes in the History of Art* 20 (Summer 2001): 32–33.

93. See especially William Empson's ambiguities of the second and third type in *Seven Types of Ambiguity* (London: Hogarth Press, 1953), pp. 102–3, 48–49.

94. Bernard J. Baars, *In the Theater of Consciousness. The Workspace of the Mind* (New York and Oxford: Oxford University Press, 1997), p. 17.

95. Ray Jackendoff, *Foundations of Language. Brain, Meaning, Grammar, Evolution* (Oxford: Oxford University Press, 2002), pp. 58–59.

96. Nina P. Azari, "The Role of Cognition and Feeling in Religious Experience," *Zygon. Journal of Religion and Science* 39 (December 2004): 911.

97. Karl von Eckartshausen, *Aufschlüsse sur Magie aus geprüften Erfahrungen. Über verborgene philosophische Wissenschaften und verdeckte Geheimnisse der Natur* (Brünn: Joh.-Sylv. Siedler, 1788/90), 1:50–51.

98. For accounts of Robertson's séances, see Laurent Mannoni, *The Great Art of Light and Shadow. Archaeology of the Cinema* (Exeter: University of Exeter Press, 2000); and Stafford and Terpak, *Devices of Wonder*.

99. Stefan Andriopoulos, "The Magic Lantern of Philosophy. Ghosts in Kant, Hegel, and Schopenhauer," *Deutsche Vierteljahrschrift für Literaturwissenschaft und Geistesgeschichte* 80, no. 2 (2006): 173–211.

100. The anthropologist Suzanne Küchler has reflected on the cultural complexity of recalling the dead. See her "The Place of Memory" in *The Art of Forgetting*, ed. Adrian Forty and Susanne Küchler (Oxford and New York: Berg, 1999), p. 59.

101. Marshack, *The Roots of Civilization*, p. 112.

102. Oliver Grau has traced what he calls "virtual immersion spaces" back to antiquity. But he does not address the cognitive dimension of this work. See his *Virtual Art* (Cambridge, Mass. and London: MIT Press, 2003), p. 13.

103. Eva Schuermann, "Concept and Experience of Perception. Merleau-Ponty and James Turrell," lecture delivered at the University of Chicago, November 11, 2005. Also see her *Erscheinen und Wahrnehmen* (Munich: Wilhelm Fink Verlag, 2000).

104. Craig Adcock, *James Turrell. The Art of Light and Space* (Berkeley, Los Angeles, Oxford: University of California Press, 1990), p. 6.

105. Baars, *In the Theater of Consciousness*, p. 133.

106. See the exhibition catalogue, *Ecstasy. In and About Altered States* (Los Angeles: Museum of Contemporary Art, 2005), which showcases the imaginative projects of, among others, Olafur Eliasson, Fred Tomaselli, Tom Friedman, Damien Hirst, Pierre Huyghe, Veronica Janssens, and Takashi Murakami.

107. Laura Kurgan, "Smart Maps," lecture delivered at the Fieldworks Art/Geography Symposium, UCLA Center for Modern and Contemporary Studies at the Hammer Museum, May 5, 2005.

108. See the excellent exhibition at the Kunsthaus Zurich, *The Expanded Eye,* presenting Op Art from the 1950s and linking it to a spectrum of twenty-first-century kinetic objects, film, and video installations. Bice Curiger, et. al., *The Expanded Eye* (Zurich: Hatje Cantz, 2006).

109. Cited in Saara Liinamaa, "Awaiting the Disaster. Olafur Eliasson's *The Weather Project,*" *Public* 29 (Summer 2004): 78.

110. On the importance of Friedrich to the Danish "heftige Malerei" of the 1980s (and beyond), see E. M. Bukdahl, *C. D. Friedrich's Study Years at the Royal Danish Academy of Fine Arts and His Importance for the Painters of the Golden Age and of the Present Day* (Copenhagen: Det Kongelige Danske Kunstakademis Billedkunstkoler, 2005), p. 6.

111. Susan May, "Meteorologica," in *Olafur Eliasson. The Weather Station*, exh. cat., ed. Susan May (London: Tate Publishing, 2003), p. 19.

112. Geert Lovinck, "Rethinking Media Aesthetics. An Interview with Norbert Bolz," in *Uncanny Networks*, ed. Geert Lovink (Cambridge, Mass. and London: MIT Press, 2004), p. 21.

113. Slavoj Zizek, *The Parallax View* (Cambridge, Mass. and London: MIT Press, 2006), p. 162.

114. Will Wright, "Dream Machines," *Wired* (April 2006): 111.

CHAPTER FIVE

1. Jean-Pierre Changeux, *Neuronal Man. The Biology of Mind* (Princeton: Princeton University Press, 1985), p. 63.

2. Cited in Cynthia Zarin, "Seeing Things. The Art of Olafur Eliasson," *New Yorker* (November 13, 2006), p. 83.

3. Benjamin Kunkel, "Am I Am. Beckett's Private Purgatories," *New Yorker* (August 7–14, 2006): 84–89.

4. The concept of intimacy is John Haugeland's. See his "Mind Embodied and Embedded," in *Having Thought. Essays in the Metaphysics of Mind* (Cambridge, Mass.: Harvard University Press, 1998), p. 208.

5. Eric Wilson, *Emerson's Sublime Science* (London: MacMillan Press, 1999), p. 67.

6. Joseph Nechvatal, "Immersive Excess in the Apse of Lascaux," *Technonoetic Arts* 3, no. 3 (2005): 182.

7. Andy Clark, "Reinventing Ourselves. The Plasticity of Embodiment, Sensing, and Mind," paper for *Tribute to Francisco Varela*, Sorbonne, Paris (delivered June 2004, forthcoming), p. 7.

8. Exactly how these oscillations influence each other and coordinate processing at the single-neuron and population levels is still unknown. See R. T. Canolty, E. Edwards, S. S. Dakakm, M. Soltani, S. S. Nagarajan, H. E. Kirsch, M. S. Berger, N. M. Barbaro, R. T. Knigh, "High Gamma Power Is Phase-Locked to Theta Oscillations in Human Neocortex," *Science* 313 (September 15, 2006): 1627–28.

9. Joseph Roach, *Cities of the Dead. Circum-Atlantic Performance* (New York: Columbia University Press, 1996), p. xi.

10. Walter Benjamin, "Toys and Play. Marginal Notes on a Monumental Work," 1928 in *Walter Benjamin Selected Writings,* ed. Marcus Bullock and Michael W. Jennings and trans. Rodney Livingstone (Cambridge, Mass.: Belknap Press, 1996–2004), 2:116.

11. *The Merleau-Ponty Aesthetics Reader. Philosophy and Painting*, ed. Galen A. Johnson and Michael B. Smith (Evanston, Ill.: Northwestern University Press, 1993), pp. 127–28.

12. Herman Pleij, *Colors Demonic and Divine. Shades of Meaning in the Middle Ages and After*, trans. Diane Webb (New York: Columbia University Press, 2004), p. 26.

13. *The Seminar of Jacques Lacan,* book 10, *The Four Fundamental Concepts of Psychoanalysis,* ed. Jacques-Alain Miller and trans. Alan Sheridan (New York: W. W. Norton, 1990), p. 96.

14. Michael Thau, *Consciousness and Cognition* (Oxford: Oxford University Press, 2002), p. 35.

15. Daniel C. Dennett, *Kinds of Minds. Toward an Understanding of Consciousness* (New York: Basic Books, 1996), p. 88.

16. See, for example, Michael Wheeler, who proposes an anti-Cartesian Heideggerian approach: *Reconstructing the Cognitive World. The Next Step* (Cambridge, Mass.: MIT Press, 2005), p. 121ff.

17. Erik Blaser, Zenon W. Pylyshyn, and Alex O. Holcombe, "Tracking an Object through Feature Space," *Nature* 408 (November 2000): 196–99.

18. Cited in Carlo Ginzberg, "Making It Strange. The Prehistory of a Literary Device," in *Wooden Eyes. Nine Reflections on Distance*, trans. Martin Ryle and Kate Soper (New York: Columbia University Press, 2001), p. 3.

19. Haugland, *Having Thought*, p. 170. James S. Kelly, "Semantic Presence," in *New Representationalisms*, ed. Edmund Wright (London, Brookfield, VT: Ashgate, 1993), p.153.

20. Ray Jackendoff, *Foundations of Language. Brain, Meaning, Grammar, Evolution* (Oxford: Oxford University Press, 2002), p. 21.

21. Gerald M. Edelman, *Wider Than the Sky. The Phenomenal Gift of Consciousness* (New Haven: Yale University Press, 2004), p. 174.

22. Jean-Pierre Changeux and Paul Ricoeur, *What Makes Us Think?* (Princeton and Ox-

ford: Princeton University Press and Oxford University Press, 2000), pp. 81–82.

23. Francis Crick and Christof Koch, "The Problem of Consciousness," in *The Hidden Mind,* special issue, *Scientific American* 10 (2002): 11–12.

24. Peter W. Culicover and Ray Jackendoff, *Simpler Syntax* (Oxford: Oxford University Press, 2005), p. 20.

25. Haugeland, *Having Thought,* pp. 174, 195–98.

26. Jackendoff, *Foundations of Language,* p. 68.

27. On this point, see Carlo Ginzberg, "Idols and Likenesses. A Passage in Origen and Its Vicissitudes," in *Wooden Eyes,* p. 108.

28. Zenon W. Pylyshyn, "Visual Indexes, Preconceptual Objects, and Situated Vision," *Cognition* 80 (2001): 128–29. I thank Andy Clark for referring me to this important essay.

29. Michael Levey, *Sir Thomas Lawrence* (New Haven: Yale University Press, 2005), p. 73.

30. John Sutton, *Philosophy and Memory Traces. Descartes to Connectionism* (Cambridge: Cambridge University Press, 1998), pp. 242–43.

31. John Y. Yolton, *Reality and Appearance* (Cambridge: Cambridge University Press, 2000), pp. 75–78.

32. Mark Blackwell, "The People Things Make. Locke's *Essay Concerning Human Understanding* and the Properties of the Self," *Studies in Eighteeenth-Century Culture,* vol. 35, ed. Jeffrey S. Ravel (London: Johns Hopkins University Press, 2006), p. 87.

33. Keith Lehrer, "Beyond Impressions and Ideas. Hume versus Reid," in *The Science of Man in the Scottish Enlightenment. Hume, Reid, & Their Contemporaries,* ed. Peter Jones (Edinburgh: Edinburgh University Press, 1989), p. 111.

34. Manfred Kühn, "Reid's Contribution to 'Hume's Problem', in *The Science of Man,* p. 132.

35. Elizabeth Wayland Barber and Paul T. Barber, *When They Severed Earth from Sky. How the Human Mind Shapes Myth* (Princeton: Princeton University Press, 2004).

36. Mohen Matthen, *Seeing, Doing, and Knowing. A Philosophical Theory of Sense Perception* (Oxford: Oxford University Press, 2005).

37. Narcisse P. Bichot, Andrew F. Rossi, Robert Desimone, "Parallel and Serial Neural Mechanisms for Visual Search in Macaque Area V4," *Science* 308 (April 22, 2005): 529.

38. John Hyman, *The Objective Eye. Color, Form, and Reality in the Theory of Art* (Chicago: University of Chicago Press, 2006), pp. 15, 55–56.

39. Pylyshyn, "Visual Indexes," p. 130.

40. Volker Langbehn, "The Lacanian Gaze and the Role of the Eye in German Romanticism," *European Romantic Review* 16 (December 2005): 615.

41. Thomas W. Clark, "Killing the Observer," *Journal of Consciousness Studies* 12, nos. 4/5 (2005): 39.

42. For the role of the belief in animal spirits in the historical formulation of representation without resemblance, see Sutton, *Philosophy and Memory Traces,* pp. 57–60.

43. J. B. Mound, "Representation, Pictures, and Resemblance," in *New Representationalisms,* ed. Edmund Wright (London, Brookfield, Vt.: Ashgate, 1993),p. 47.

44. Hyman, *The Objective Eye,* pp. 232, 237.

45. Friedrich Schlegel, *Literarische Notizen 1797–1801,* ed. Hans Eichner (Frankfurt-am-Main, Berlin, Vienna: Ullstein Materialien, 1980), fragment 537, p. 71.

46. Daniel C. Dennett, *Kinds of Mind. Towards an Understanding of Consciousness* (New York: Basic Books, 1996), p. 155.

47. Bernard J. Baars, *In the Theater of Consciousness. The Workspace of the Mind* (New York and Oxford: Oxford University Press, 1997), p. 41; italics mine.

48. Thomas Metzinger, *Being No One. The Self-Model Theory of Subjectivity* (Cambridge, Mass.: MIT Press, 2003), p. 313.

49. Robert A. Wilson, *Boundaries of the Mind. The Individual in the Fragile Sciences. Cognition* (Cambridge: Cambridge University Press, 2004), p. 48.

50. Cited in Ned Block, "Neurophilosophy or Philoneuroscience," *Science* 301 (September 5, 2003): 1328.

51. Jesse J. Prinz, *Furnishing the Mind. Concepts and Their Perceptual Basis* (Cambridge, Mass.: MIT Press, 2002), p. 103.

52. Andy Clark, *Associative Engines. Connectionism, Concepts, and Representational Change* (Cambridge, Mass.: MIT Press, 1993).

53. Colin McGinn, *Mind Sight. Image, Dream, Meaning* (Cambridge, Mass.: Harvard University Press, 2004), p. 5.

54. Ibid., pp. 43, 59–60.

55. Samuel Taylor Coleridge, *Biographia Literaria,* 1817, in *Samuel Taylor Coleridge,* ed. H. J. Jackson (Oxford: Oxford University Press, 1985), pp. 222–23.

56. This problem is rooted in late Neoplatonism and its reception. See my *Visual Analogy. Consciousness as the Art of Connecting* (Cambridge, Mass.: MIT Press, 1999).

57. Pedro C. Marijuan, "Cajal and Consciousness," in *The Centennial of Ramon y Cajal's Textura,* ed. Pedro C. Marijuan, *Annals of the New York Academy of Sciences* 929 (April 2001): 6.

58. David Jasper, *The Sacred and Secular Canon in Romanticism. Preserving the Sacred Truths* (London: MacMillan Press, 1999), p. 64.

59. Dietrich Lehmann, "Brain Electric Microstates as Building Blocks of Mental Activity," *Fechner Day 2004,* ed. A. M. Oliveira, M. P. Teixeira, G. F. Borges, and M. J. Ferro (Coimbra: International Society for Psychophysics, 2004), pp. 140–45.

60. Galen Strawson, "A Fallacy of Our Age," *Times Literary Supplement* (October 15, 2004), p. 12.

61. Gary D. Fireman, Ted E. McVay, Jr., and Owen J. Flanagan, eds. *Narrative and Consciousness* (Oxford: Oxford University Press, 2003), pp. 4–5.

62. Mark Freeman, "Rethinking the Fictive, Reclaiming the Real. Autobiography, Narrative Time, and the Burden of Truth," in *Narrative and Consciousness,* ed. Fireman, McVay, and Flanagan, p. 126.

63. Hans Ulrich Gumbrecht says something similar when he talks about "historical simultaneity" as a way of representing the past that avoids the sequential quality of narrative. See his *In 1926. Living at the Edge of Time* (Stanford: Stanford University Press, 1997).

64. Rosamond Wolfe Purcell and Stephen J. Gould, *Finders Keepers. Eight Collectors* (London: Pimlico, 1992).

65. Michael S. Cullen, *Der Reichstag. Parlament, Denkmal, Symbol* (Berlin: be.bra Verlag, 1995), pp. 251–54.

66. Hal Foster, "'Go, Modernity,'" review of *Catalogue. Foster and Partners,* ed. David Jen-

kins (Munich: Prestel Verlag, 2006), in *London Review of Books* (June 22, 2006): 11.

67. Vanessa R. Schwartz, "Walter Benjamin for Historians," *American Historical Review* 106 (December 2001): 1739.

68. Mark Turner, *The Literary Mind* (New York and Oxford: Oxford University Press, 1996), p. 61.

69. "Preserving Memories," Editor's Choice, *Science* 309 (July 15, 2005): 361.

70. Greg Miller, "How Are Memories Stored and Retrieved?" *Science* 309 (July 1, 2005): 92.

71. "The Last Pageant of the Century," in *Art Beat* 2, no. 4 (1999). Also see http://www.foapom.com.

72. Cited in Joseph Roach, *Cities of the Dead. Circum-Atlantic Performance* (New York: Columbia University, 1996), p. 3.

73. Elizabeth Pennisi, "How Did Cooperative Behavior Evolve?" *Science* 309 (July 1, 2005): 93.

74. Richard W. Burkhardt, Jr., *Patterns of Behavior. Konrad Lorenz, Niko Tinbergen, and the Founding of Ethology* (Chicago: University of Chicago Press, 2005).

75. Jesse J. Prinz, *Gut Reactions. A Perceptual Theory of Emotion* (Oxford: Oxford University Press, 2004), p. 163. For the connection between Romantic poets and Italian *improvvisatore*, see Jerome McGann, *The Poetics of Sensibility* (Oxford: Oxford University Press, 1996), p. 255.

76. For the importance of improvisation, in contrast to inspiration, see Angela Esterhammer, "The Cosmopolitan *Improvvisatore:* Spontaneity and Performance in Romantic Poetics," *European Romantic Review* 16 (April 2005): 161.

77. *Max Ernst. A Retrospective*, ed. Werner Spies and Sabine Rewald (New York and New Haven: Metropolitan Museum of Art; Yale University Press, 2005).

78. See my "From 'Brilliant Ideas' to 'Fitful Thoughts'. Conjecturing the Unseen in Late Eighteenth-Century Art," *Zeitschrift für Kunstgeschichte*, Sonderdruck, 48, no. 1 (1985): 329–63.

79. See the research on social conformity and the difficulties of taking an antigroup stance in Sandra Blakeslee, "What Other People Say May Change What You See," *New York Times* (June 28, 2005), D 3.

80. Paul D. Miller, a.k.a. DJ Spooky that Subliminal Kid, *Rhythm Science* (Cambridge, Mass.: MIT Press, 2004), p. 61.

81. William J. Mitchell, *Placing Words. Symbols, Space, and the City* (Cambridge, Mass.: MIT Press, 2005), p. 136.

82. Warren Neidich, *Blow-Up. Photography, Cinema, and the Brain* (New York: Distributed Art Publishers, 2005), p. 21.

83. Neil Gaiman, "Remix Planet," *Wired* (July 2005): 116.

84. See my essay "To Collage or E-Collage?" *Harvard Design Magazine*, special issue, *Representations/Misrepresentations* (Fall 1998): 34–36.

85. William Gibson, "God's Little Toys. Confessions of a Cut and Paste Artist," *Wired* (July 2005): 118; my italics.

86. Andy Clark, *Natural-Born Cyborgs. Minds, Technologies, and the Future of Human Intelligence* (Oxford: Oxford University Press, 2003), p. 57.

87. Esterhammer, "The Cosmopolitan *Improvvisatore,*" p. 158.

88. Even the remix is being rethought. See Eric Steuer, "The Infinite Album," *Wired* (September 2006): 172–74.

89. Geert Lovink, *A Nihilist Theory of Blogging* (New York: Routledge, 2007).

90. Andy Clark, *Natural-Born Cyborgs*, p. 57.

91. Simon Baron-Cohen, Rebecca C. Knickmeyer, Matthew K. Belmonte, "Sex Differences in the Brain. Implications for Explaining Autism," *Science* 310 (November 4, 2005): 819–23.

92. V. S. Ramachandran and Lindsay M. Oberman, "Broken Mirrors. A Theory of Autism," *Scientific American* 295 (November 2006): 62–69.

93. Ingrid Wickelgren, "Autistic Brains Out of Synch?" *Science* (June 24, 2005): 1856.

94. Gerald Edelman, *Neural Darwinism* (New York: Basic Books, 1987), p. 106.

95. Gerald Edelman, *Remembered Present* (New York: Basic Books, 1994).

96. Jonathan C. W. Edwards, "Is Consciousness Only a Property of Individual Cells?" *Journal of Consciousness Studies* 12, nos. 4–5 (2005): 60.

97. See my *Artful Science. Enlightenment, Entertainment, and the Eclipse of Visual Education* (1994; Cambridge, Mass.: MIT Press, 1996), pp. 73ff. For the role of optical technologies in this rhetoric of deception, see my "Revealing Technologies / Magical Domains," in Barbara Maria Stafford and Frances Terpak, *Devices of Wonder. From the World in a Box to Images on a Screen*, exh. cat. (Los Angeles: Getty Research Center, 2001), especially pp. 47–78.

98. Iain Boyd White, "The Expressionist Sublime," in *Expressionist Utopias. Paradise, Metropolis, Architectural Fantasy*, exh. cat., ed. Timothy O. Benson (Los Angeles: Los Angeles County Museum of Art, 2005), p. 123.

99. Clive Wilmer, "Song and Stone. Donald Davie Reappraised," *Times Literary Supplement* (May 6, 2005), p. 12.

100. For an overview of machine art, see Linda Dalrymple Henderson, "I. Writing Modern Art and Science—An Overview; II. Cubism, Furturism, and Ether Physics in the Early Twentieth Century," *Science in Context* 17, no. 4 (2004): 423–66.

101. Tiffany Bell, "Fluorescent Light as Art," in *Dan Flavin. The Complete Lights 1961–1996*, exh. cat., ed. Michael Govan and Tiffany Bell (New Haven: Yale University Press, 2005), p. 77.

102. Donald Judd, *Complete Writings: 1959–1975* (Halifax: Nova Scotia College of Art and Design Press, 2005), p. 187.

103. Andreas Kratky, *Soft Cinema. Navigating the Database*, DVD (Cambridge, Mass.: MIT Press, 2005). On the cinematic language of new media, see Lev Manovich, *The Language of New Media* (Cambridge, Mass.: MIT Press, 2001).

104. Alva Noë, *Action in Perception* (Cambridge, Mass.: MIT Press, 2004), p. 3.

105. Nancy C. Andreasen, *The Creating Brain. The Neuroscience of Genius* (New York and Washington, D.C.: Dana Press, 2005), p. 63.

106. David Bordwell, *Figures Traced in the Light. On Cinematic Staging* (Berkeley, Los Angeles, London: University of California Press, 2005), p. 44.

107. Yi-Fu Tuan, "The Pleasures of Touch," in *The Book of Touch*, ed. Constance Classen (London: Berg, 2005), pp. 76–78. Also see the exciting new research on the multitude of animal species possessing whiskers who perceive their environment though whis-

ker sensation. The comparable brain area in humans processes signals from finger-tips. See Jeremy Manier, "Taking Robots to the Next Level—by a Whisker," *Chicago Tribune* (November 14, 2006), pp. 1–2.

108. Gregory Volk, *Hiraki Sawa*. Hammer Projects (Los Angeles: Hammer Museum, 2005), brochure.

109. Joaquin M. Fuster, *Cortex and Mind. Unifying Cognition* (Oxford: Oxford University Press, 2003), pp. 144–45.

110. Jean-Pierre Changeux and Paul Ricoeur, *What Makes Us Think?* (Princeton and Oxford: Princeton University Press, 2000), p. 44.

111. Francis Crick and Christof Koch, "The Problem of Consciousness," *Scientific American* 10 (2002): 11.

112. Changeux, *What Makes Us Think?* p. 78.

113. Thomas W. Clark, "Killing the Observer," *Journal of Consciousness Studies* 12, nos. 4–5 (2005): 45.

114. William Illsey Atkinson, *Nanocosm. Nanotechnology and the Big Changes Coming from the Inconceivably Small* (New York: AMACOM, 2003), p. 143.

115. Wilson, *Boundaries of the Mind,* p. 165.

116. Rudrauf and Damasio, "A Conjecture," pp. 242–43.

117. Darren H. Hibbs, "Who's an Idealist?" *Review of Metaphysics* 58 (March 2005): 567.

118. Metzinger, *Being No One,* p. 385.

119. Ralf Peter Behrendt and Claire Young, "Hallucinations in Schizophrenia, Sensory Impairment, and Brain Disease. A Unifying Model," *Behavioral and Brain Sciences* 27 (December 2004): 771–72.

120. Robert A. Wilson, *Boundaries of the Mind. The Individual in the Fragile Sciences* (Cambridge: Cambridge University Press, 2004), pp. 184–88.

121. Narcisse P. Bichot, Andrew F. Rossi, and Robert Desimone, "Parallel and Serial Neural Mechanisms for Visual Search in Macaque Area V4," *Science* 308 (April 22, 2005): 529–34.

122. Thomas Natsoulas, "Viewing the World in Perspective, Noticing the Perspective of Things," *Journal of Mind and Behavior* 24 (Summer–Fall, 2003): 265–68.

123. Thomas Natsoulas, "'To See Things Is to Perceive What They Afford': James J. Gibson's Concept of Affordance," *Journal of Mind and Behavior* 25 (Fall 2004): 323–48.

124. Thomas Natsoulas, "Consciousness and Gibson's Concept of Awareness," *Journal of Mind and Behavior* 16 (Autumn 1995): 305–28. Strangely, Nicholas Humphrey does not mention Gibson in his *Seeing Red. A Study in Consciousness* (Cambridge, Mass.: Belknap Press, 2006).

125. Noë, *Action in Perception,* p. 22.

126. Jose Luiz Bermudez, *Thinking without Words* (Oxford: Oxford University Press, 2003), pp. 47, 51–52.

127. See, for example: Robert Hopkins, "The Speaking Image. Visual Communication and the Nature of Depiction," in *Contemporary Debates in Aesthetics and the Philosophy of Art*, ed. Matthew Kieran (Malden, Mass. and Oxford: Blackwell, 2006), p. 147. And for a less Richard Wolheimian angle, see in the same volume Dominic McIver Lopes, "The Domain of Depiction," p. 171.

128. "New Neurons Strive to Fit In," News Focus, *Science* 311 (February 17, 2006): 938. N. K. Hayles, *How We Became Post-Human* (Chicago: University of Chicago Press, 1999).

129. See the research project, "Computational Intelligence, Creativity and Cognition. A Multidisciplinary Investigation," headed by Margaret Boden (Sussex, UK), commencing May 2005 and running for three years. For further information contact paul@paul-brown.com.

130. John Bohannon, "Microbe May Push Photosynthesis into Deep Water," *Science* 308 (June 24, 2005): 1855.

131. Charles Seife, "Do Deeper Principles Underlie Quantum Uncertainty and Nonlocality?" *Science* 309 (July 1, 2005): 98.

132. Charles Seife, "Teaching Qubits New Tricks," *Science* 309 (July 8, 2005): 238.

133. For a discussion and review of recent books on this "postmodern" aspect of physics, see Jim Holt, "Unstrung," *New Yorker* (October 2, 2006).

134. The implicit stranglehold of a unified modernist architectural narrative has been critiqued in the excellent article by Sarah Williams Goldhagen, "Something to Talk About. Modernism, Discourse, Style," *Journal of the Society of Architectural Historians* 64 (June 2005): 150–51.

135. Steve Lohr, "Academia Dissects the Service Sector, but Is It a Science?" *New York Times* (April 18, 2006), C1, C4.

136. Judy Illes, Matthew P. Kirschen, Emmeline Edwards, L. R. Stanford, Peter Bandettini, Mildred K. Cho, Paul J. Ford, Gary H. Glover, Jennifer Kulynych, Ruth Macklin, Daniel B. Michael, Susan M. Wolf, and members of the Working Group on Incidental Findings in Brain Imaging Research, "Incidental Findings in Brain Imaging Research," *Science* 311 (February 10, 2006): 783–84.

137. Sheila Jasanoff, *Designs on Nature. Science and Democracy in Europe and the United States* (Princeton: Princeton University Press, 2003), p. 150.

138. Giuseppe Testa and John Harris, "Ethics and Synthetic Gametes," *Bioethics* 19, no. 2 (2005): 146–49.

139. Helga Nowotny, "The Changing Nature of Public Science," in *The Public Nature of Science Under Assault. Politics, Markets, Science, and the Law,* ed. Helga Nowotny, Dominique Pestre, Eberhard Schmidt-Assmann, Helmuth Schulze-Fielitz, and Hans-Heinrich Trute (Berlin: Springer, 2004), pp. 2–3.

140. Sean B. Carroll, *Endless Forms Most Beautiful. The New Science of Evo Devo and the Making of the Animal Kingdom* (New York: W. W. Norton, 2005).

141. Hyman, *The Objective Eye,* p. 61.

142. John Haffenden, *William Empson,* vol. 1, *Among the Mandarins* (Oxford: Oxford University Press, 2005).

CHAPTER SIX

1. Humberto R. Maturana and Francisco J. Varela, *Autopoiesis and Cognition. The Realization of the Living* (Dordrecht and Boston: D. Reidel Publishing Company, 1980), p. 80.

2. Richard Powers, *The Goldbug Variations* (New York: William Morrow and Company, 1991), pp. 250, 252.

3. Hamsa Walker, "Cogito Sum," exh. brochure, Renaissance Society, University of Chicago, November 12–December 22, 2006.

4. Taking for granted brain scan information as facts about the world has been critiqued by Joseph Dumit, *Picturing Personhood. Brain Scans and Biomedical Identity* (Princeton and Oxford: Princeton University Press, 2004), p. 5. He, however, is looking at issues of normality and abnormality—not the automation of processing.

5. Thomas Metzinger. *Being No One. The Self-Model Theory of Subjectivity* (Cambridge, Mass.: MIT Press, 2003), p. 57. See Alain Deste.

6. Nicholas Humphrey, *The Mind Made Flesh. Essays from the Frontiers of Psychology and Evolution* (Oxford: Oxford University Press, 2002), p. 113.

7. Ira Livingston, *Between Science and Literature. An Introduction to Autopoiesis* (Urbana: University of Illinois Press, 2006), p. 80.

8. Rodolfo Llinas, "Brain as a Closed System Modulated by the Senses," in *Brain-Mind Continuum*, ed. Rodolfo Llinas and D. Pare (Cambridge, Mass.: MIT Press, 1996), pp. 4–5.

9. Lynn Margulis and Dorion Sagan, *What Is Life?* (London: A Peter N. Nevraumont Book, Weidenfeld and Nicolson, 1995), p. 32.

10. James Lovelock, *The Ages of Gaia* (New York: W. W. Norton, 1988).

11. N. Katherine Hayles, *My Mother Was a Computer. Digital Subjects and Literary Texts* (Chicago: University of Chicago Press, 2005), p. 178.

12. Margulis and Sagan, *What Is Life?* p. 71.

13. *Von Mäusern und Menschen / Of Mice and Men,* exh. curated by Maurizio Cattelan, Massimiliano Gioni, Ali Subotnick (Berlin: March 25–May 28, 2006).

14. Stephen Jay Gould and Richard.C. Lewontin, "The Spandrels of San Marco and the Panglossian Paradigm. A Critique of the Adaptionist Program," *Proceedings of the Royal Society of London* 205 (1979): 281–88.

15. H. Allen Orr, "Darwinian Storytelling," *New York Review of Books* (February 27, 2003), pp. 17–20.

16. Powers, *Goldbug Variations*, p. 25.

17. *Kurzführer zur Ausstellung. Von Mäusern und Menschen / Of Mice and Men.* Fourth Berlin Biennial for Contemporary Art (Berlin: HatjeCantz, 2006), p. 58.

18. Thomas Natsoulas, "Virtual Objects," *Journal of Mind and Behavior* 20 (Autumn 1999): 363.

19. Robin Adele Greeley, "Chardin, Time, and Mastery," *Word and Image* 19 (October–December, 2003): 283.

20. Eva Jablonka has addressed this most recently in "Expanding Evolution Beyond the Selfish Gene," lecture (Wissenschaftskolleg zu Berlin, May 24, 2006).

21. Christian de Duve, *Life Evolving. Molecules, Mind, and Meaning* (Oxford: Oxford University Press, 2002), p. 211.

22. For a review of the theories of Roger Penrose, Henry Stapp, and Quentin Smith, see Barry Loewer, "Consciousness and Quantum Theory: Strange Bedfellows," in *Consciousness. New Philosophical Perspectives,* ed. Quentin Smith and Aleksandar Jokic (Oxford: Clarendon Press, 2003), pp. 514–15.

23. Don N. Page, "Mindless Sensationalism. A Quantum Framework for Consciousness," in *Consciousness. New Philosophical Perspectives*, ed. Smith and Jokic, p. 468.

24. Michael Lockwood, "Consciousness and the Quantum World Putting Qualia on the Map," in *Consciousness. New Philosophical Perspectives*, ed. Smith and Jokic, p. 459.

25. See the analysis of "firsthand" and "secondhand" experiences in Natsoulas, "Virtual Objects," p. 362.

26. David J. Chalmers, "The Content and Epistemology of Phenomenal Belief," in *Consciousness. New Philosophical Perspectives*, ed. Smith and Jokic, p. 236.

27. James F. A. Poulet and Berthold Hedwig, "The Cellular Basis of a Corollary Discharge," *Science* 311 (January 27, 2006): 518–20.

28. J. J. Gibson, *The Ecological Approach to Visual Perception* (1979; Hillsdale, N.J.: Erlbaum, 1986), p. 240. Also see Thomas Natsoulas, "Consciousness and Gibson's Concept of Awareness," *Journal of Mind and Behavior* 16 (Summer 1995): 319.

29. Ilya Prigogine and Isabelle Stengers, *Order Out of Chaos* (1984), pp. 302–3.

30. Alexander Zumdieck, Marc Timme, Theo Geisel, Fred Wolf, "Long Chaotic Transients in Complex Networks," *Physical Review Letters* 93: 244103 (December 10, 2004).

31. William James, "The Powers of Men," in *Essays on Religion and Morality*, ed. Frederick Burkhardt and Fredson Bowers (Cambridge, Mass.: Harvard University Press, 1982), p. 147.

32. Theodore H. Bullock, Michael V. L. Bennett, Daniel Johnston, Robert Josephson, Eve Marder, R. Douglas Fields, "The Neuron Doctrine, Redux," *Science* 310 (November 4, 2005): 791–93.

33. John E. Kihlstrom, "The Cognitive Unconscious," in *Essential Sources in the Scientific Study of Consciousness*, ed. Bernard J. Baars, William P. Banks, and James B. Newman (Cambridge, Mass.: MIT Press, 2003), p. 780.

34. For national policy implications, see Jonathon D. Moreno, *Mind Wars. Brain Research and National Defense* (New York: Dana Press, 2006).

35. Michael T. Alkire, Richard J. Haier, James H. Fallon, "Toward a Unified Theory of Narcosis. Brain Imaging Evidence for a Thalamocortical Switch as the Neurophysiologic Basis of Anesthetic-Induced Unconsiousness," in *Essential Sources,* ed. Baars, Banks, and Newman, pp. 913, 924–25. Erica Goode, "Why Do We Sleep?" *New York Times,* Science Times (November 11, 2003), D9. Also see Keith Wailoo and Stephen Pemberton, *The Troubled Dream of Genetic Medicine. Ethnicity and Innovation in Tay-Sachs, Cystic Fibrosis, and Sickle Cell Disease* (Baltimore: Johns Hopkins University Press, 2006).

36. See W. Gerstner, J. L. van Hemmen, and J. D. Cowan, "What Matters in Neuronal Locking?" *Neural Computation* (1996): 1653–76; and Jack D. Cowan, *Statistical Neural Field Theory* (2007, forthcoming).

37. Rodolfo Llinas and Denis Paré, "Commentary. Of Dreaming and Wakefulness," in *Essential Sources,* ed. Baars, Banks, and Newman, p. 971.

38. Bernard J. Baars, "The Fundamental Role of Context. Unconscious Shaping of Conscious Information," in *Essential Sources*, ed. Baars, Banks, and Newman, p. 761.

39. Daniel C. Dennett, *Sweet Dreams. Philosophical Obstacles to a Science of Consciousness* (Cambridge, Mass.: MIT Press, 2005), p. 72.

40. Gerald M. Edelman, *Wider Than the Sky. The Phenomenal Gift of Consciousness* (New Haven: Yale University Press, 2004), p. 29.

41. It was central to Johann Friedrich Blumenbach's concept of *Bildungstrieb* and thus to

speculative *Naturphilosophie*. See Timothy Lenoir, "The Göttingen School and the Development of Transcendental Naturphilosophie in the Romantic Era," *Studies in the History of Biology*, vol. 5 (Baltimore: Johns Hopkins University Press, 1981), p. 137.

42. William Bialek and David Botstein, "Introductory Science and Mathematics Education for 21st-Century Biologists," *Science* 303 (February 6, 2004): 787.

43. William L. Ditto, "Spatio-Temporal Nonlinear Dynamics. A New Beginning," in *Nonlinear Dynamics and Chaos. Where Do We Go from Here?* (Bristol and Philadelphia: Institute of Physics Publishing, 2003), pp. 350–51.

44. Sylvain Deville, Eduardo Salz, Ravi K. Nalla, Antoni P. Tomsia, "Freezing as a Path to Build Complex Composites," *Science* 311 (January 27, 2006): 515.

45. Adrian Cho, "Recipe for Flies' Eyes. Crystallize," *Science* 308 (April 8, 2005): 193.

46. Deborah Solomon, "Stone Diaries," *New York Times Magazine* (April 2006), p. 67.

47. Stephan Otto, Le 'Symbole de la vraie philosophie' La *Nolana Philosophia* et sa transmission a Schelling par Jacobi," in *Mondes, formes et société selon Giordano Bruno*, ed. Tristan Dagon and Helene Vedrine (Paris: Librairie Philosophique J. Vrin, 2003), p. 188.

48. Michaela Boenke, "Giordano Bruno dans la philosophie de l'identité de Schelling," in *Mondes, formes et société*, ed. Dagon and Vedrine, pp. 201–3.

49. *The Poetical Works of Gerald Manley Hopkins*, ed. Norman H. MacKenzie (Oxford: Clarendon Press, 1990).

50. Anna Ritchie, *Picts. An Introduction to the Life of the Picts and the Carved Stones in the Care of Historic Scotland* (Edinburgh: Crown Copyright Historic Scotland, 1989), pp. 7–8. Also see George and Isabel Henderson, *The Art of Picts. Sculpture and Metalwork in Early Medieval Scotland* (New York: Thames and Hudson, 2004), pp. 60–65.

51. Gregg Rosenberg, *A Place for Consciousness. Probing the Deep Structure of the Natural World* (Oxford: Oxford University Press, 2004), pp. 88, 131.

52. Chris Drury, *Silent Spaces* (London: Thames and Hudson, 1998), p. 71.

53. Jose van Dijck, *The Transparent Body. A Cultural Analysis of Medical Imaging* (Seattle: University of Washington Press, 2005), p. 4.

54. "Watching the Brain Think," interview Hans-Joachim Heinze, *Humboldt Kosmos*, special issue, *The Power of Images* 86 (December 2005): 28–30.

55. Stephen J. Gould, *The Structure of Evolutionary Theory* (Cambridge, Mass.: Harvard University Press, 2002), pp. 126–27.

56. Stephen Jay Gould, *Ever Since Darwin. Reflections in Natural History* (New York: W. W. Norton, 1977), p. 189.

57. On virtual simulation and its effects, see Anna Munster, *Materializing New Media. Embodiment in Information Aesthetics* (Hannover, N.H.: Dartmouth University Press, 2006), p. 88.

58. Peter De Bolla, *The Discourse of the Sublime. Readings in History, Aesthetics, and the Subject* (Oxford: Basil Blackwell, 1989), p. 35.

59. See the interview regarding his new book, *Programming the Universe*, by Kevin Kelly, "Life, the Universe, and Everything," *Wired* (March 2006): 64.

60. Steven H. Muggleton, "Computing: Exceeding Human Limits," *Nature* 409–10 (March 23, 2006): 2020.

61. On the relentless proliferation of technology, see Joline Blais and Jon Ippolito, *At the*

Edge of Art (London: Thames and Hudson, 2006); and Charlie Gere, *Art, Time, and Technology* (London: Berg, 2006).

62. Andy Clark, "Reinventing Ourselves. The Plasticity of Embodiment, Sensing, and Mind," paper delivered at the *Tribute to Francisco Varela* (Paris: Sorbonne, June 2004), p. 4.

63. Robert F. Service, "The Race for the $1000 Genome," *Science* 311 (March 17, 2006): 1544–46. On a future Web that does not merely follow user commands, see John Markoff, "Entrepreneurs See a Web Guided by Common Sense," *New York Times,* November 12, 2006, pp. 1, 28.

64. Wolf Singer and Charles M. Gray, "Visual Feature Integration and the Temporal Correlation Hypothesis," in *Essential Sources,* ed. Baars, Banks, and Newman, p. 1089.

65. Francis Crick, *The Astonishing Hypothesis. The Scientific Search for the Soul* (New York: Charles Scribner's Sons, 1994), p. 208.

66. Nicholas Humphrey, *The Mind Made Flesh. Essays from the Frontiers of Psychology and Evolution* (Oxford: Oxford University Press, 2002), pp. 9–12.

67. Joseph Tabbi, *Cognitive Fictions* (Minneapolis: University of Minnesota Press, 2002), p. xxiv.

68. Steve Redhead, *Paul Virilio. Theorist for an Accelerated Culture* (Toronto and Buffalo: University of Toronto Press, 2004), p. 122.

69. David Talbot, "Bright Lights, Molecular World," *Technology Review* (March 2003): 29.

70. Sharon G. Glotzer, "Some Assembly Required," *Science* 306 (October 15, 2004): 419.

71. Stephen Wolfram, *A New Kind of Science* (Champaign, Ill.: Wolfram Media, Inc., 2001), see esp., ch. 7: "Mechanisms in Programs and Nature," pp. 297–361.

72. William Illsey Akinson, *Nanocosm. Nanotechnology and the Big Changes Coming from the Inconceivably Small* (New York: AMACOM, 2003), p. 251. Friedrich Kittler, *Gramophone, Film, Typewriter,* trans. G. Winthrop-Young and M. Wutz (Stanford: Stanford University Press, 1999), p. 2. Also see, Mark B. N. Hansen, "Cinema Beyond Cybernetics, or How to Frame the Digital Image," *Configurations* 10 (2002): 60.

73. Robert F. Service, "How Far Can We Push Chemical Self-Assembly," *Science* 309 (July 1, 2005): 95.

74. Gertrude van de Vijver, introduction, *Auto-Organisation, autonomie, identité. Revue Internationale de Philosophie* 59, no. 2 (2004): 140, 148.

75. Ernst Mayr, *What Makes Biology Unique? Considerations on the Autonomy of a Scientific Discipline* (Cambridge and New York: Cambridge University Press, 2004), warns of the attempts to reduce biology to physics under the aegis of E. O. Wilson's groundplan for interscientific "consilience."

76. Paul W. Glimcher and Aldo Rustichini, "Neuroeconomics. The Consilience of Brain and Decision," *Science* 306 (October 15, 2004): 447–52.

77. Robert Sanborn, Adolfo Santos, Alexandra L. Montgomery, and James B. Caruthers, "Four Scenarios for the Future of Education," *The Futurist* (January–February 2005): 27–28.

78. Semir Zeki, *Inner Vision. An Exploration of Art and the Brain* (Oxford : Oxford University Press, 1999), p. 1. See John R. Searle, *Mind. A Brief Introduction* (New York: Oxford University Press, 2004), p. 154.

79. Heidi Morrison Ravven, "Spinoza's Anticipation of Contemporary Affective Neuroscience," *Consciousness and Emotion* 4, no. 2 (2003): 273–79.

80. Maurice Merleau-Ponty, *The Primacy of Perception. And Other Essays on Phenomenological Psychology, the Philosophy of Art, History, and Politics,* ed. James M. Edie (Evanston, Ill.: Northwestern University Press, 1964).

81. Daniel M. Wegner, *The Illusion of Conscious Will* (Cambridge, Mass.: MIT Press, 2002), p. 143.

82. Antonio Damasio, D. Tranel, and Hanna Damasio, "Somatic Markers and the Guidance of Behavior. Theory and Preliminary Testing," *Frontal Lobe Function and Dysfunction,* ed. H. S. Levin, H. M. Eisenberg, and A. L. Benson (New York and Oxford: Oxford University Press, 2001), pp. 217–29.

83. Wegner, *Illusion of Conscious Will,* pp. 330–32.

84. Charles D. Laughlin et al., *Brain, Symbol, and Experience. Towards a Neurophenomenology of Human Consciousness* (New York: Columbia University, 1992), pp. 43, 171.

85. Rodolfo R. Llinas, *I of the Vortex. From Neurons to Self* (Cambridge, Mass.: MIT Press, 2001), p. 7.

86. Ibid., pp. 91, 112. Also see Nicholas Humphrey, *Seeing Red. A Study in Consciousness* (Cambridge, Mass.: Belknap Press, 2006), pp. 19, 26.

87. Lynn Margulis and Dorion Sagan, *Acquiring Genomes. A Theory of the Origins of the Species* (New York: Basic Books, 2002), p. xi.

88. Max Robinson, "Place-Making: The Notion of Centre," in *Constructing Place. Mind and Matter,* ed. Sarah Menin (London and New York: Routledge, 2003), p. 147.

89. Although it does not mention contemporary cognitive research, see Keith Moxey's provocative study, "Impossible Distance. Past and Present in the Study of Dürer and Grünewald," *Art Bulletin* 86 (December 2004), esp. pp. 750–51.

90. Laurence R. Tancredi, *Hardwired Behavior. What Neuroscience Reveals about Morality* (Cambridge: Cambridge University Press, 2005), p. 9.

91. See Marc D. Hauser, *Moral Minds. How Nature Designed Our Universal Sense of Right and Wrong* (New York: HarperCollins, 2006). Significantly, Hauser's positing of "an unconscious grammar of action" comes close to the "grammars of expression" that obsessed the Romantics. But understanding the origins of moral reasoning partly as making inferences about visible behavior is not the same as believing we are born with specific moral rules.

92. Fiona Cowie, *What's Within? Nativism Reconsidered* (New York and Oxford: Oxford University Press, 1999), p. 305.

93. Ernst Niebur, Laurent Itti, and Christof Koch, "Controlling the Focus of Visual Selective Attention," in *Models of Neural Networks,* vol. 4, ed. J. Leo van Hemmen, Jack D. Cowan, Eytab Domany (New York and Berlin: Springer, 2002), p. 266.

94. Jaak Panksepp, "Damasio's Error?" in *Consciousness & Emotion* 4, no. 1 (2003): 112.

95. See, for example, John E. Dowling, *The Great Brain Debate. Nature or Nurture?* (Washington, D.C.: Joseph Henry Press, 2004).

96. Paul Stiles, *Is the American Dream Killing You? How "The Market" Rules Our Lives* (New York: HarperCollins, 2006).

97. Robert Salais, "Acting through Tables. Constructing Employment and the European

Political Method," colloquium, Berlin, Wissenschaftskolleg, April 4, 2006.

98. Jean-Pierre Changeux, *The Physiology of Truth. Neuroscience and Human Knowledge*, trans. M. B. DeBevoise (Cambridge, Mass.: Harvard University Press, 2004).

99. Harold Perkin, *The Third Revolution. Professional Elites in the Modern World* (London and New York: Routledge, 1996), p. xii.

100. See Daniel Cohen, *Globalization and Its Enemies*, trans. Jessica B. Baker (Cambridge, Mass.: MIT Press, 2006), p. 54, on the inequalities of the third age of the postindustrial economy; and Barry C. Lynn, *End of the Line. The Rise and Coming Fall of the Global Corporation* (New York: Doubleday, 2005), pp. 153–54.

101. Daniel Charles, "Corn That Clones Itself," *Technology Review* (March 2003): 33–41.

102. Chris McManus, *Right Hand, Left Hand. The Origins of Asymmetry in Brains, Bodies, Atoms, and Cultures* (Cambridge, Mass.: Harvard University Press, 2002), pp. xv, 168ff.

103. Cowie, *What's Within?* p. 47.

104. Rachel Gelman and C. R. Gallistel, "Language and the Origin of Numerical Concepts," *Science* 306 (October 15, 2004): 441–43.

105. Kuniyoshi L. Sajau, "Language Acquisition and Brain Development," *Science* 310 (November 2005): 815, 817.

106. Sarah R. Cohen, "Chardin's Fur. Painting, Materialism, and the Question of Animal Soul," *Eighteenth-Century Studies*, 38 (Fall 2004): 50.

107. K. Funke, Z. F. Kisvarday, M. Volgushev, and F. Wörgoetter, "Integrating Anatomy and Physiology of the Primary Visual Pathway. From LGN to Cortex," *Models of Neural Networks*, vol. 4, ed. Van Hemmen, Cowan, Domany, pp. 99, 184.

108. Derek Melser, *The Act of Thinking* (Cambridge, Mass.: MIT Press, 2004), p. 12.

109. Zeki, *Inner Vision,* p. 16.

110. V. S. Ramachandran and W. Hirstein, "The Science of Art. A Neurological Theory of Aesthetic Experience," *Journal of Consciousness Studies* 6 (1999): 15–51.

111. Dario Gamboni, *Potential Images. Ambiguity and Indeterminacy in Modern Art* (London: Reaktion Books, 2002), pp. 13–14.

112. V. S. Ramachandran, *A Brief Tour of Human Consciousness. From Impostor Poodles to Purple Numbers* (New York: PI Press, 2003), p. 52.

113. Charles D. Laughlin, Jr., John McManus, and Eugene G. d'Aquili, *Brain, Symbol and Experience. Toward a Neurophenomenology of Human Consciousness* (New York: Columbia University Press, 1992), p. 44.

114. Alva Noë, *Action in Perception* (Cambridge, Mass.: MIT Press, 2004), p. 18.

115. Cited in Christian de Duve, *Life Evolving. Molecules, Mind, and Meaning* (Oxford: Oxford University Press, 2002), p. 213.

116. Jean-Luc Petitot, "Constitution by Movement. Husserl in Light of Recent Neurobiological Findings," in *Naturalizing Phenomenology. Issues in Contemporary Phenomenology and Cognitive Science,* ed. Petitot (Stanford: Stanford University Press, 1999), p. 221.

117. Bernard Pachaud, "The Teleological Dimension of Perceptual and Motor Intentionality," in *Naturalizing Phenomenology,* ed. Petitot, pp. 198–203.

118. For Searle's "biological naturalism," see, *Mind. A Brief Introduction,* pp. 113–14.

119. Jeffrey M. Schwartz, *The Mind and the Brain. Neuroplasticity and the Power of Mental Force* (New York: HarperCollins Publishers, Inc., 2002), p. 200.

120. David Lewis Williams, *The Mind in the Cave. Consciousness and the Origins of Art* (London: Thames and Hudson, 2002), p. 127.

121. Yasushi Miyashita, "Cognitive Memory. Cellular and Network Machineries and their Top-Down Control," *Science* 306 (October 15, 2004): 435–40. See my "Levelling the New Old Transcendence. Cognitive Coherence in the Era of Beyondness," *New Literary History*, special issue on Coherence, 35 (Spring 2004): 321–38.

122. Rachel Gelman and C. R. Gallistel, "Language and the Origin of Numerical Concepts," *Science* 306 (October 15, 2004): 441–43.

123. While much has been written since George Lakoff and Mark Johnson, *Philosophy in the Flesh. The Embodied Mind and Its Challenge to Western Thought* (New York: Basic Books, 1999), pp. 17, 552–55, their insight that neural beings must categorize and that conceptualization only happens through the body, still holds.

124. For new light being shed on the relations between Husserlian phenomenology (as well as that of Merleau-Ponty) and contemporary efforts toward a scientific theory of cognition—still largely under the influence of Behaviorism—see Jean-Michel Roy, et al. "Beyond the Gap. An Introduction to Naturalizing Phenomenology," in Jean Petitot, *Naturalizing Phenomenology. Issues in Contemporary Phenomenology and Cognitive Science* (Stanford: Stanford University Press, 1999), pp. 9–10.

125. On the latter, see Marsha Kinder, "Screen Wars. Transmedia Appropriations from Eisenstein to a TV Dante and Carmen Sandiego," in *Language Machines. Technologies of Literary and Cultural Production*, ed. Jeffrey Masten, Peter Stallybrass, and Nancy Vickers (New York: Routledge, 2000), pp. 169–72.

126. David Leatherbarrow and Mohsen Mostafavi, *Surface Architecture* (Cambridge, Mass.: MIT Press, 2002), p. 175.

127. John Searle, "Consciousness. What We Still Don't Know," *New York Review of Books* (January 13, 2005), pp. 36–39.

128. Christof Koch, *The Quest for Consciousness* (New York: Roberts and Company, 2004).

129. Antonio Damasio, *Looking for Spinoza. Joy, Sorrow, and the Feeling Brain* (Orlando: Harcourt, 2003), pp. 12, 80–86.

130. For the labor implications of autopoiesis and distributed consciousness, see my essay review of Pamela H. Smith's *The Body of the Artisan,* "Working Minds," *Perspectives in Biology and Medicine* 48, no. 4 (2005).

131. Robert F. Port and Timothy van Gelder, *Mind as Motion. Explorations in the Dynamics of Cognition* (Cambridge, Mass.: MIT Press, 1995). See especially their essay, "It's About Time. An Overview of the Dynamical Approach to Cognition," pp. 3ff, which argues against the computationalists that the cognitive system is not a computer but a dynamical system comprising brain, nervous system, body, environment.

132. Malcolm Gladwell, *Blink. The Power of Thinking without Thinking* (New York: Little, Brown and Company, 2005), p. 23.

133. "Will Consoles Continue to Rule the Videogame Market, Ping," *Wired* (January 2005): 31.

134. Arnold Brown, "The Robotic Economy. Brave New World or a Return to Slavery?" *The Futurist* (July–August 2006): 53.

135. Joe Houston, *Beverly Fishman*, exh. cat. (Paris: Galerie Jean-Luc and Takako Richard, 2005), p. 3.

CODA

1. Daniel C. Dennett, *Sweet Dreams. Philosophical Obstacles to a Science of Consciousness* (Cambridge, Mass. and London: MIT Press, 2005), p. 170.

2. Michel Serres, *Les cinq sens. Philosophie des corps mêlés,* tome 1 (Paris: Bernard Grasset, 1985), p. 148; translation mine.

3. *Von Mäusern und Menschen / Of Mice and Men. Kunstführer / Exhibition Guide,* curated by Maurizio Cattelan, Massimiliano Gioni, and Ali Subotnick (Berlin: Hatje Cantz, 2006), p. 122.

4. Susan Blackmore, "Daniel Dennett," in *Conversations on Consciousness* (Oxford: Oxford University Press, 2005), pp. 87–90. Also see Alain Destexhe and Diego Contreras, "Neuronal Computations with Stochastic Network States," *Science* 314 (October 6, 2006): 85

5. Daniel C. Dennett, *Kinds of Minds. Toward an Understanding of Consciousness* (New York: Basic Books, 1996), pp. 134–35, 139.

6. Steven Pinker, *How the Mind Works* (New York and London: W. W. Norton, 1997), pp. 526–28.

7. For a recent critique of Dennett's "hardline," see Merlin Donald, *A Mind So Rare. The Evolution of Human Consciousness* (New York and London: W. W. Norton, 2001), pp. 29–30, 39–43.

8. Although I have difficulties with the almost entirely linguistic focus of this book, it goes beyond Piaget's work on the development of children as intention-recognizing agents. See Michael Tomasello, *The Cultural Origins of Human Cognition* (Cambridge, Mass. and London: Harvard University Press, 1999), pp. 70–74.

9. Norman Bradburn, "What About the Humanities . . . ?" A Working Discussion, Cultural Policy Center, Harris School of Public Policy, University of Chicago (May 20, 2006).

10. V. S. Ramachandran, *The Emerging Mind,* Reith Lectures (London: BBC with Profile Books Ltd., 2003), pp. 46–50.

11. For a recent, fully "Romantic," analysis of the great temple mountains of Cambodia, see Michael W. Meister, "Mountain Temples and Temple-Mountains. Masrur," *Journal of the Society of Architectural Historians* 65 (March 2006): esp. 39–42.

12. The cataclysmic theories of the Romantics might interest the members of the recently formed "Holocene Impact Working Group." See Sandra Blakeslee, "Ancient Crash, Epic Wave," *New York Times,* Science Times (November 14, 2006), D1, D4.

13. Alan D. Baddeley, "Verbal and Visual Subsystems of Working Memory," *Essential Sources in the Scientific Study of Consciousness,* ed. Bernard J. Baars, William P. Banks, and James B. Newman (Cambridge, Mass. and London: MIT Press, 2003), p. 390.

14. Cited in Eli Friedlander, "The Measure of the Contingent. Walter Benjamin's Dialectical Image," paper delivered at The Sawyer Seminar, The Problem of Non-Discursive Thought from Goethe to Wittgenstein, University of Chicago, October 7, 2006.

15. Astrid Reuter, "Religious Controversies within the Secular Order of Freedom and Equality," colloquium, Wissenschaftskolleg Berlin (April 11, 2006).

16. See, for example, Nick Lane, *Power, Sex, Suicide. Mitochondria and the Meaning of Life* (Oxford: Oxford University Press, 2005), pp. 130–31.

17. Carlo Strenger, *Individuality, the Impossible Project: Psychoanalysis and Self-Creation* (Madison, Conn.: International University Press, Inc., 1998), pp. 82–83.

18. Elizabeth Pennisi, "How Did Cooperative Behavior Evolve?" *Science* 309 (July 1, 2005): 93. Also see the research of Jean Decety in Lydia Gibson, "Mirrored Emotion," *University of Chicago Magazine* (April 2006): 36.

19. Jesse J. Prinz, *Gut Reactions. A Perceptual Theory of Emotion* (Oxford: Oxford University Press, 2004), p. 52.

20. Steven Pinker, *How the Mind Works* (New York and London: W. W. Norton, 1997), p. 264.

21. David Summers, *Real Spaces. World Art History and the Rise of Western Modernism* (London: Phaidon Press Limited, 2003), pp. 41–43.

22. Catherine Rich and Travis Longcore, eds., *Ecological Consequences of Artificial Night Lighting* (Washington, D. C.: Island, 2005), pp. 413–15.

23. On the geometry of mapping, see Christian Jacob, *The Sovereign Map. Theoretical Approaches in Cartography throughout History,* trans. Tom Conley, ed. Edward H. Dahl (Chicago: University of Chicago Press, 2006), pp. 105, 109.

24. I am punning on William J. Mitchell's, *City of Bits. Space, Place, and the Infobahn* (Cambridge, Mass.: MIT Press, 1995).

25. Thomas Metzinger, *Being No One. The Self-Model Theory of Subjectivity* (Cambridge, Mass. and London: MIT Press, 2003), p. 548.

26. Pinker, *How the Mind Works*, p. 264.

27. Damasio, *The Feeling of What Happens*, pp. 53–54.

28. See, for example, Denis Cosgrove and Stephen Daniels, eds., *The Iconography of Landscape. Essays on the Symbolic Representation, Design, and Use of Past Environments* (Cambridge: Cambridge University Press, 1988).

29. Mark Turner, *The Literary Mind* (New York: Oxford University Press, 1996), pp. 57–58. Jerome Bruner, *Making Stories. Law, Literature, Life* (New York: Farrar, Straus and Giroux, 2002), p. 65.

30. Blackmore, "Kevin O'Regan," in *Conversations on Consciousness,* p. 168.

31. Derek Melser, *The Act of Thinking* (Cambridge, Mass. and London: MIT Press, 2004), p. 247.

32. See the discussion of affordances in John Haugeland, *Having Thought. Essays in the Metaphysics of Mind* (Cambridge: Harvard University Press, 1998), pp. 221–23.

33. Annalee Newitz, "The Coming Boom," *Wired* (July 2005): 106–10.

34. Michael S. Gazzaniga, *The Ethical Brain* (Washington, D.C.: Dana Press, 2005), p. 90.

35. John Bryant, Linda Baggott la Velle, John Searle, *Introduction to Bioethics* (Chichester: John Wiley and Sons Ltd., 2005), p. 211.

INDEX

Note: Italicized page numbers indicate figures.

Summer Lightnings (Alimpiev), 178–80, *179*
supernatural, the, 127
Suprematism, 38
Sutton, John, 15, 143
symbiogenesis, 59–63, 67, 194, 210
symbols: atomistic, 58; as compressing space and time, 52; directionality and orientation and, 29; enactive, 24, 34; Hogarth's geometrical symbolism, 21; mantic, 70; Neolithic revolution in symbolism, 113; real, 153, 199, 209; solid, 45, 65; sympathetic, 73; in theory of holistic speech, 32; Vico on apprehension of, 18, 19–20; vision in symbolization of the world, 201–2
symbolum, 45
sympathetic magic, 81
sympathy, 55, 73, 90, 97, 98
Symposium (Plato), 12
synapses, 14, 48–49, 59, 100, 200, 211
synchrony: combinatorial symbols externalizing, 46; interstructural artwork revealing cerebral, 43, 45; lacking in abnormal conditions, 114; neuronal, 11, 72, 73, 109–10, 169, 171; photography and film revealing, 84
synthesis, 48
systems art, 163–64

tableaux vivants, 156–58
talismans, 67, 81
Tancredi, Lawrence, 195
tapestry, 55–56
Tate Modern, 132, *133*
Tawada, Yoko, 75, 93
Taylor, Richard, 107
thalamus, 68, 83, 108, 109, 161
Theophrastus, 84–85
Theory of Color (Goethe), 29–30
thinking. *See* thought
third revolution, 196
Thompson, D'Arcy, 11
thought: in absence of language, 170; as acquired activity and configurative performance, 215; as act of the brain, 26; as arising in motor movement, 202–3; art stimulating, 11; brain reorganization and

rational reflection, 27–28; as image that incites us to reperform what we perceive, 148; intentional making and origin of abstract, 28; neurofunctionalist obsession with "language of thought," 201; as not separate from its object, 147; as unfurling self-talk, 153; Whorfian hypothesis on language and, 197. *See also* cognition
to krupton, 121
Tonfoni, Graziella, 103
Tononi, Giulio, 67
Toomik, Jaan, 205–6, *206*
touch, Herder on, 19
Traité des Tournois (Menestrier), 55
transgenic art, 47, 49–50
Treatise on Human Nature, The (Hume), 96–97
tripartite faculty psychology, 143
Tristram Shandy (Sterne), 82
Tuerlinckx, Joelle, 40
Turbine Hall (Tate Modern), 132, *133*
Turner, Joseph Mallord William, 30, 151–52
Turner, Mark, 215
Turner, Victor, 45
Turrell, James, 129–31, *130, 184*
Two Men Looking at the Sea (Friedrich), *80*

Uecker, Günther, 68, *69*
uncertainty, quantum mechanical, 172
Universal Flood, The (Zahn), *18*
universals: of form, 199; universal language, 32–34, 197–98; visual, 209
Upper Paleolithic period, 32, 113, 120, 129, 201

Varela, Francisco J., 46, 175, 177
Vasarely, Victor, 132, 200
Vasulka, Staina, 10
Venus and Mars (Palma Il Giovane), 154, *156*
Vermeer, Jan, 131
verum factum, 18
Vexierbilder, 126
Vico, Giovanni Battista, 17–18, 19, 26, 28, 32, 201
Village Betrothal (Greuze), 86, *87*
Virilio, Paul, 53, 123, 191
virtual reality, 104, 122, 148, 193, 203, 213
visceral brain, 98